African Art and the Colonial Encounter

African Art
AND THE
Colonial Encounter

Inventing a Global Commodity

Sidney Littlefield Kasfir

Indiana University Press
Bloomington and Indianapolis

Publication of this book is made possible in part with the assistance of a Challenge Grant from the National Endowment for the Humanities, a federal agency that supports research, education, and public programming in the humanities. Any views, findings, conclusions, or recommendations expressed in this publication do not necessarily reflect those of the National Endowment for the Humanities.

This book is a publication of

Indiana University Press
601 North Morton Street
Bloomington, IN 47404–3797 USA

http://iupress.indiana.edu

Telephone orders 800–842–6796
Fax orders 812–855–7931
Orders by e-mail iuporder@indiana.edu

The paper used in this publication meets the minimum requirements of American National Standard for Information Sciences—Permanence of Paper for Printed Library Materials, ANSI Z39.48–1984.

Manufactured in the United States of America

LIBRARY OF CONGRESS CATALOGING-IN-PUBLICATION DATA

Kasfir, Sidney Littlefield.
 African art and the colonial encounter : inventing a global commodity / Sidney Littlefield Kasfir.
 p. cm.
 Includes bibliographical references and index.
 ISBN 978-0-253-34892-0 (cloth : alk. paper)—ISBN 978-0-253-21922-0 (pbk. : alk. paper) 1. Samburu (African people)—Material culture.
2. Idoma (African people)—Material culture. 3. Art, African—Western influences. 4. Great Britain—Colonies—Africa. 5. Spears—Kenya.
6. Colonies in art. 7. Exoticism in art. 8. Art and globalization. I. Title.
 DT433.545.S26K37 2007
 305.896'33—dc22
 2007007408

1 2 3 4 5 12 11 10 09 08 07

For Melania (Aduke) and Elisabetta (Omolabake),
who grew up with masquerades and *lmugit*

CONTENTS

CONTENTS

PREFACE

Books have their own stories quite apart from their published contents. When I first began putting together the ideas for this one in 1994, I wanted to address some of the big questions in African art that had surfaced since my graduate school days. The dominant ideas from the 1960s and '70s were about theories of style and genre (Fagg 1965, 1970; Sieber 1961, 1966; Sieber and Rubin 1968; Fraser and Cole 1972; Picton 1974; and Bravmann 1973), aesthetics (Thompson 1973; later Abiodun 1983 and Hallen 2000), performance (Thompson's paradigm-shifting *African Art in Motion,* 1974), and artistic process (Cole's 1969 series of articles on "Art as a Verb in Igboland"). All of these except the minefield of style were derived wholly from on-the-ground evidence from Africa and couched in functionalist assumptions (e.g., the internal coherence of traditional communities and their symbolic practices). My academic generation began in the '80s to expand upon (and, in the case of style and notions of the traditional, to question) these ideas in detailed field studies of particular art and ritual genres (Cole and Aniakor 1984; Drewal and Drewal 1983; Nunley 1987; Lawal 1996; Ross 1998; Strother 2000). By then these studies were also enriched by '70s feminist anthropology and occasional departures into structuralism, especially in architectural studies (Blier 1987) and masking (Jedrej 1980).

There is a telling disjuncture between art history and anthropology in how generational influences have played out in the study of African art in the United States. In Europe, the academic study of African art usually resides in anthropology departments, but in the United States and in Africa itself, it is typically found under the disciplinary umbrella of art history or in art schools connected to

universities. During the 1970s, a senior group of Africanist art historians at Yale University, Columbia University, Indiana University, the University of Iowa, UCLA, the University of London's School of Oriental and African Studies, and UC–Santa Barbara trained a cohort of students who have now taken their places.

But an equally influential triumvirate of Africanist cultural anthropologists—James Fernandez in Gabon (1966, 1973), Simon Ottenberg in Nigeria (1975, 2006), and Warren D'Azevedo in Liberia (1973, 1980)—all students of Melville Herskovits at Northwestern University, although they trained few successors in the African art field, nonetheless provided the structural-functionalist template for in-depth village-based African fieldwork for almost all of us. Their more recent counterparts in urban art and popular culture have been Johannes Fabian (1996) and Bogumil Jewsiewicki (1991), anthropologist and historian respectively, who have been working in Lubumbashi since the '70s. The shift in theoretical model has been beneath the surface but has been emblematic of the shift in interest among the emerging scholar generation from an ethnically defined and mainly rural to a class-defined, primarily urban subject-world, not only in African art history but in African anthropology as well.

At the same time that members of my academic generation began to publish their first work, the broader fields of art history and cultural anthropology began to be strongly affected by what was happening in literary theory and by the intrusion of cultural studies and postcolonial theory. Levi-Strauss, the intellectual cult figure of our student generation, was dethroned by other French theorists, most notably Bourdieu, Derrida, and Foucault. Reflexivity created a crisis around the idea of fieldwork itself, so much so that by the '90s, most of my own graduate students had abandoned village-based artists for their urban counterparts and the rural mud compounds with their resident lineages for the heterogeneity of the African city. The shift also embraced the study of postcolonial genres, leaving behind the diviners, masqueraders, and sacred kings in their symbolic spaces for the study of postcolonial urbanites and their hybrid arts and spectacles, some high, others low, and many of them migratory.

The high-art category has been theorized and brought to center stage by a group of mainly African transnational artists and intellectuals, foremost among them Salah Hassan (1995, 2001), Okwui Enwezor (2001), Ikem Okoye (1996), Sylvester Ogbechie (forthcom-

ing), Olu Oguibe (1996), and Chika Okeke (1995). Like William Fagg, Roy Sieber, Robert Farris Thompson, and Herbert Cole a generation before, all but Okoye and Ogbechie have used exhibitions and their catalogue essays in preference to books to establish their most important claims. Foremost among these is Enwezor's contention, made in the blockbuster *Short Century* exhibition, that African modernisms developed along with anticolonial political movements, not through grateful art students in some donor-recipient model of progress. Implicit in this is a powerful critique of current, mainly European, collecting and exhibition practices that assume that only "popular" art (art based outside the academy) can be the legitimate heir to the art of the premodern African past and that the productions of formally trained artists are little more than an ahistorical mimicry of Western modernism. This position was largely demolished by 1995 with the *Seven Stories about Modern Art in Africa* show at Whitechapel Gallery in London, but until the *Short Century* exhibit at p. 5. 1, the Museum of Modern Art's Queens, New York, affiliate in 2001, no persuasive model of African modernism had been put in its place.

Modernism, the "posts" (postmodernism, poststructuralism, postcolonialism), and now transnationalism and globalization—the new "modernization"—have become the intellectual horizon upon which new work in African art is largely situated. The New York–, London-, and Paris-based museum/dealer/collector art-world of traditional genres has been left to the older generation to continue to study and analyze. For collectors, this is a slowly shrinking inventory of work by "anonymous dead artists" (Morphy 1995). Nonetheless these older genres are still widely accepted, both by the museum-going public and by the institutions that own and display them as the paradigmatic "African art," even if fewer people are actively engaged in their study. Some (I include myself) are dismayed by the younger generation's abandonment of interest in the premodern African past; others welcome it as a break with the old salvage paradigm of colonial anthropology. But writing this book confirmed for me that I was not yet finished with it, particularly the early-to-middle British colonial period from the 1880s to 1930s in which this comparative history is initially located. At the same time, modernity, especially the emergence of an international globalizing market in African art, was an equally important part of the story. My question then became how to frame this narrative to encompass both.

My doctoral thesis at the School of Oriental and African Studies in 1979 was an attempt to write Lower Benue Valley, especially Idoma, art history through the institutions of masking and sacred kingship. I did this by focusing on the key migrations, rituals, and Fulani jihadist and British interventions that had been deployed to construct a modern Idoma identity. In 1991, I left off working in Nigeria to begin research in Kenya's semi-arid North Rift with Samburu blacksmiths and pastoralists and their own encounter with modernity. Initially I was confident that pastoralists didn't have masquerades and that their aesthetic practices were a different matter from those of West African yam farmers. Not only that, I felt that their encounter with modernity was different from any in central Nigeria. But the longer I worked in Kenya, the less certain I was of these distinctions, and I began to think comparatively about the two groups. The result is this book, which looks closely at the way colonialism (and in the case of the Samburu, their overlapping discovery by tourists, filmmakers, and photographers) affected warriorhood and its aesthetic practices in these two very different places where I have done sustained fieldwork.

Although neither Robert Farris Thompson nor Herbert Cole was my teacher, their work on mask performance and artistic process, respectively, are very clear intellectual debts. I have based my equating of Samburu warrior theatre with Idoma warrior masquerades on Thompson's principle that icon defines itself as act: both Idoma and Samburu assemblages of form and performance are kinds of masks. I have also relied strongly on Herbert Cole's notion of African art as processual in order to understand the ways blacksmiths and sculptors were able to create new forms in the face of repressive colonial regulations meant to put them (or at least their clients) out of business.

In order to simplify a complex undertaking (early colonial through postcolonial time periods, two cultures), I have structured the comparison in four parts: warriors and warriorhood (chapters 1 and 2), the artists and artistic processes involved in representing them (chapters 3 and 4), the objects themselves (masks, spears, the decorated body; chapters 5 and 6), and the commodification and subsequent globalization of objects and of warriorhood itself (chapters 7, 8, and 9).

The introduction presents both the historical setting and the major art-historical issues the book addresses. These include the

ways artisanal knowledge (that of Samburu blacksmiths and Idoma sculptors), embedded in particular cosmologies and cultural scripts, was related to systems of objects (weapons, masks) and how these undergirded cultural practice (especially the ritual system and the patronage of artisans). It discusses the classificatory problems that ensued when Western museums and collectors began to subsume these objects into their own systems of classification. The chapter also introduces the idea of warrior theatre, using the metaphor of the script to describe the construction of masculinity through body arts, masquerade, dance, and comportment.

Chapter 1, after briefly comparing nineteenth-century inscriptions of East and West Africa, develops the representation of Maasai warriorhood in the nineteenth-century accounts of Krapf and Thomson and then considers government and settler texts from 1901 to the eve of independence (1963). These focus on the idealization of Maa-speaking pastoralists as fearless, self-assured, and both mentally and physically superior to other Africans—in a word, like "us" ("us" being the British settler aristocracy). The second part of the chapter presents a case study of (Maa-speaking) Samburu warriorhood through government documents of the Powys murder case in 1931, attempting to show how the treatment of Samburu moran was depoliticized and embedded in a discourse of pastoralist warrior behavior. The actors in this drama included virtually everyone on the 1930s colonial stage in Kenya—politically prominent white settlers, colonial administrators, Samburu moran, and numerous other interlocutors. The chapter argues that the case was less about the murder of a white man than about the spatialization of power in the contested landscape of the Pinguan, which was being encroached upon by settler farms, and that it was useful to the government to frame the spear-bloodings by moran as "adolescent mischief."

Chapter 2 explores the Idoma case by first embedding it in a West African nineteenth-century imperial discourse of white malaise, headhunting, cannibalism, human sacrifice, and fetish worship. It links the establishment of Lugard's policy of indirect rule to the establishment of a Department of Anthropology in the Northern Nigerian provincial administration in 1924, which attempted to inscribe the "customs" of the Idoma as seen through Hausa interpreters. The chapter attempts to reconcile my Idoma informants' views of the Oglinye masquerade with the colonial documents and the discourse

of earlier explorers, especially that of Burdo. It traces the absorption of the Oglinye and Ichahoho masquerades into the *aiuta*, a law enforcement constabulary. In this way, councils of elders acted to preserve the martial character of Oglinye while stripping it of some of its antisocial aspects. The 1880s–1908 period was followed by the imposition of the Pax Britannica (1908) and the ban on headhunting (1917) and their effects on the Oglinye masquerade. Ultimately the British had to rely on the "secret societies" to maintain law and order, whether they wanted to or not.

Chapter 3 explores the effect of the Samburu spear ban and the proscribing of the Idoma Oglinye masquerade on blacksmiths and carvers, respectively. Far from limiting their possibilities to innovate, these conditions actually stimulated innovation by introducing new patronage and (in the Idoma case) by redefining warriorhood itself. Samburu smiths began making spears for Turkana and Rendille, which in turn modified practice. Later, with the onset of the postcolonial border war with Somalia, these changes in design became ingrained by necessity. (Still later, the introduction of tourist patronage in the encapsulated form of game park safaris made one type of spear into a souvenir and an aesthetic rather than utilitarian object; this is explored fully in chapter 8 on commodification.) Idoma carvers transformed the former practice of using trophy heads of victims into the practice of using wooden masks in Oglinye masquerades. In doing so, they fundamentally altered the Idoma cultural script. By aestheticizing Idoma warriorhood, they made it into a symbolic statement about manhood; this was made possible only by the ban on headhunting. In this sense, the Idoma only finished what the British started.

Chapter 4 uses the well-known inscriptions of the African blacksmith as a powerful "other" or pariah in nineteenth-century and colonial narratives to explore the differences between the myth and practice of the smith. It also examines the internal discourse within Samburu culture regarding the smith as other and presents the smith's own discourse of his power. It notes that warriorhood crosscuts smith and nonsmith in Samburu culture and supersedes it as a marker of identity. Finally, it approaches the paradox of the smith's status (socially low, ritually high) as part of the larger question of the paradox of the artisan's status and explores its implications for carvers as well as smiths.

Chapter 5 shifts the focus from smith and sculptor to their objects in order to offer a set of arguments about how masks and spears can be read outside their historical narratives. It begins with a consideration of all material objects as texts and asks the question: If they indeed speak, how does what they say differ with the various audiences, both local and far, who apprehend them? The same concerns spill over into the Western museum classification of art and artifact, which have no grounding in the cultures that produced the objects being classified. And finally, it asks: What difference, if any, does it make when either art or "thing" becomes commodified? Or becomes a souvenir?

Chapter 6 takes Idoma and Samburu warrior roles as instances of the ritualized body, defined here to include the body and its embellishments and disguises. It argues that the mask is an extension of the ritualized body, particularly that class of masks that have their origin in the trophy head. In Samburu, the ritualized body of the warrior extends beyond his weapons and decorations to his spear, upon which he carries part of the victim's body as metaphor for his own virility. The chapter also explores hairstyles and painting of the body with ochre as important ways of constructing social and sexual masculinity.

Chapters 7 and 8 contrast the mask and spear in new systems of exchange. Chapter 7 explores the Idoma case, in which geographical isolation and an absence of tourism has limited commodification to the dispersion of a limited inventory of "original" masks and figures to either colonial district officers or trader middlemen. It brings other mask-producing cultures in West and East Africa (e.g., Senufo, Dogon, Maconde) into this comparison, since the commodification of masks is both common and follows the same dynamic as that of Samburu spears. Chapter 8 describes the commodification since the early 1980s of one type of Samburu spear as a souvenir in response to safari tourism. Expanding on this idea, it deals with so-called tourist art in relation to notions of art, artifact, and souvenir and compares the various current discourses on authenticity that are applied in the wider system of exchange where these objects now circulate.

The ultimate postcolonial commodity is the Samburu warrior himself as subject of postcards, tourist snapshots, and commercial Hollywood films. The final chapter analyzes the Samburu appearance in and experience of making two Hollywood films shot on location

in Africa, *The Air Up There* and *The Ghost and the Darkness*. Finally, it applies these experiences to the representation and self-fashioning of contemporary Samburu warriorhood in an attempt to demonstrate that they are a means by which the marginalized pastoralist competes in Kenyan political discourse as well as the cash economy.

ACKNOWLEDGMENTS

The research for this book has spanned almost my entire career, so my indebtedness is to many people and institutions. My early intellectual mentors Nelson Kasfir, James Fernandez, and John Picton guided me to and through graduate school and my initial Idoma fieldwork. In Nigeria, the late Ajene Okpabi, Och'Idoma II, and the late Ekereke Odaba, Och'Akpa, not only sheltered me for several years but also "put me through," as Nigerians like to say. Justice Paul Anyebe relished the role of devil's advocate and greatly sharpened my ability to distinguish sense from nonsense. Robert G. Armstrong, S. O. O. Amali, and Erim O. Erim provided the platform of modern Idoma scholarship on which I was able to erect my own ideas.

In Kenya, my husband Kirati Lenaronkoito has accompanied me on every interview for the past fifteen years. His ideas and his knowledge of Samburu custom and colonial history underlie much of the book's substance and have brought it alive. I have also relied greatly on the exemplary work of Paul Spencer, Michael Rainy, John Galaty, Corinne Kratz, and Susan Rasmussen for their modeling of pastoralist social relations and the issues of hierarchy, distance, and reciprocity. Roy Larick's work on Samburu smithing and smelting and Atieno Odhiambo's study of the Powys murder case also figured crucially in my interpretations, as did Neil Sobania's history of the Lake Turkana region. The best personal insights into Samburu character and the late colonial milieu (Clark Gable and Ava Gardner included) came from Terence Gavaghan, district commissioner in the early '50s, and from the photographs of Nigel Pavitt over a 30-year period.

Institutional support for research at various stages came from the School of Oriental and African Studies, the University of Jos, the

ACKNOWLEDGMENTS

University of Ibadan, Dartmouth College, Northwestern University, Emory University, the Social Science Research Council, and the Rockefeller Foundation. At Emory, Ivan Karp read the first version of the book, and several years later, my graduate seminar read the last. I particularly thank my graduate students for lobbying to retain the movie chapter when it was in danger of being jettisoned. Two anonymous reviewers greatly improved the book's organization, and my Indiana University Press editor, Dee Mortensen, and copyeditor Kate Babbitt helped me to distinguish the woods from the trees at all levels. But without my daughters Elisabetta, who organized my evacuation by the Flying Doctors Service after a near-fatal road accident in Samburu district, and Melania, who came to Kenya to bring me home to the United States, this book truly would never have seen publication. It is dedicated to them with love.

African Art and the Colonial Encounter

Introduction

COLONIAL POWER
AND AESTHETIC PRACTICE

*A Masai warrior is a fine sight. Those young men have, to
the utmost extent, that particular form of intelligence that we
call chic:—daring, and wildly fantastical as they seem, they
are still unswervingly true to their own nature . . . and their
weapons and finery are as much a part of their being as are
a stag's antlers.*

—ISAK DINESEN, *Out of Africa* (1937)

*The South was, for the most part, held in thrall by Fetish wor-
ship and the hideous ordeals of witchcraft, human sacrifice and
twin murder. The great Ibo race to the East of the Niger . . . and
their cognate tribes had not developed beyond the stage of primi-
tive savagery.*

—FREDERICK LUGARD, "Report on the Amalgamation
of Northern and Southern Nigeria" (1919/1968)

Where does the new come from in an artist's practice? In this
book, I explore an unexpected source, colonial authority, and trace
the ways widely different late-nineteenth- and early-twentieth-century
European impressions of Kenya and Nigeria and the subsequent
British colonizing policies toward their imperfectly understood sub-
ject peoples intervened in and transformed the objects and practices
of two groups of African artists. Equally, this book is about the ways
those artists—sculptors and smiths—reinvented these objects and
created a new artisanal practice. Because the two cultures, Idoma
in Nigeria (one of Lugard's "cognate tribes") and Maa-speaking
Samburu in Kenya, are geographically remote and superficially very

different, the common thread of the institution of warriorhood helps weave the comparison. At a more immediate level, this book is also about real people—the warriors, the artists, and the blacksmiths— and how they strategized and made choices to circumvent the authority of colonial rule and to create new forms.

HEADHUNTING, SPEAR-BLOODING, AND THE BRITISH

In 1976, near the beginning of my Idoma fieldwork, the Akpa district head led me to a large tree overhanging the Otobi village playground and pointed out where enemy heads were once displayed. That same year, my diviner-carver friend Ojiji told me, "We do only three things here: farm, hunt and play."[1] He left out fighting, which was forcibly suppressed under the British pacification around 1910. But things are never that straightforward. There were no more Idoma warriors in the literal sense, but there were the "plays." The colonial government passed a law in 1917 making headhunting a crime punishable by hanging (an irony not lost on the chief), but the forbidden trophy heads resurfaced as carved likenesses. Many Idoma say that when masquerades (in this case, a warriors' dance with decorated human crania) are outlawed by authorities, they don't cease to exist but return to the bush instead. The bush is the home of masks.

In 1931, on the opposite side of the continent, a group of Samburu warriors speared a lone white man at a place the Samburu call the Pinguan, which was north of Mt. Kenya, where white settler farms encroached near Samburu grazing lands. They left the body, which was later consumed by lions, but they took the head as a trophy. If it had been a traditional enemy, they would have mutilated the corpse and taken the genitalia instead. Because the farm's owner was a British aristocrat with connections in high places, the case was taken all the way to Whitehall. In retaliation, the colonial government placed a ban on Samburu warriors carrying spears for more than twenty years. The warriors responded by concealing their spears in the bush, an area of thousands of square miles of semidesert and montane forest the government in faraway Nairobi could not effectively police. The bush became the home of spears.

When I first heard the 1931 story in the early days of my Samburu fieldwork, I wondered what, other than the taking of a head as a piece of flamboyant warrior theatre, the Samburu case might have in com-

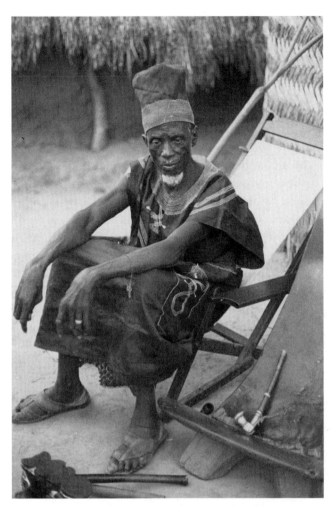

mon with the Idoma one. This book is partly an attempt to under-
stand these two cases' shared experience of colonial power and their
construction of masculinity within its limits in these widely different
situations. It is also an attempt to draw the aesthetics out of these two
sets of warrior practices, one of which, the Idoma Oglinye masquer-
ade, is perceived by Western museums and collectors as art because
it involved fashioning a representation, the enemy head, in wood.
By contrast, the focus of attention in the Samburu case has been on
the warrior himself with his weapons and decorations, who through
his persistence over time is usually seen by Western (and also elite
Kenyan) spectators as a living anachronism and artifact of a dying

world. Both cases are embedded in practices in which the warrior's youthful daring is paired with the visualization of his masculinity through behavior and dress. I use their highly self-conscious sense of theatre to argue that both deserve to be thought of as masquerade.

THE COLONIZATION SCENARIO

It was a useful strategy for the Foreign, and later Colonial, Office to represent the Idoma and their Middle Belt neighbors as head-hunting pagan tribes compared with the residents of the North, which was dominated by civilized Muslim emirates the British preferred to deal with. The subordination of Idoma rulers such as the Andoma of Doma to the Emir of Lafia and the Ots'ana of Keana to the Emir of Nasarawa, as well as the creation of a previously nonexistent Och'Idoma south of the Benue River and his induction as a paramount chief into the Northern House of Chiefs were all ways of maintaining indirect control while attempting to overshadow or preempt the local authority of the secret societies, their mask organizations, and the ancestral cult.

But the British did not have to do this preempting alone, because the Fulani had begun the Islamization process in the nineteenth century. In northern Nigeria and the Middle Belt, the jihad of Uthman dan Fodio that began in 1804 had already established the power of the reformist Fulani emirs before the British arrived. Both the spatial and temporal dimensions of these two "civilizing" (and globalizing) thrusts overlapped in crucial ways: spatially, the jihad progressed southward from Sokoto toward the Benue. Its cavalry was eventually rendered ineffective by the Benue River, but it infiltrated northern Yorubaland and converted the Igala king, the Idomas' closest historical partner. Overlapping these events at mid-century, British and other explorers came up the Niger from the coast and the former began establishing trading and missionary stations as far north as the Niger-Benue confluence. Finally, in 1903, British troops conquered the Sokoto caliphate and by 1910–1915 had "pacified" the unconverted peoples south of the Benue. Lugard later announced his policy of indirect rule, which depended for its success on viable (and preferably centralized) local structures of governance.

The situation in East Africa, in particular the region that was to become the Kenya colony, had its parallels (Muslim rulers of city-states

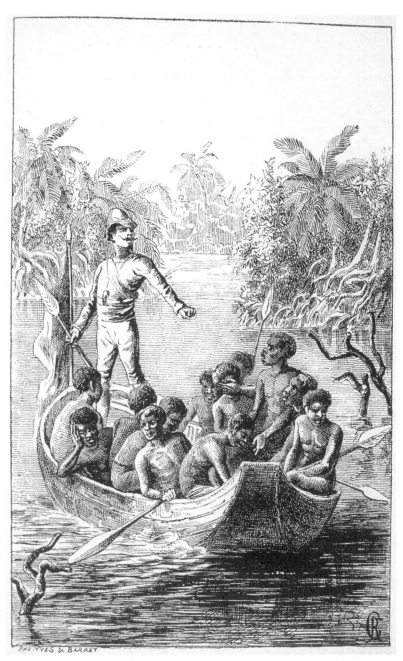

FIGURE INTRO.2. "Courage, strong men of Kroo!" *Source: Adolphe Burdo, A Journey up the Niger and Benueh (1880).*

along the Swahili coast, "barbarians" inland), but an entirely different colonizing discourse developed there, in part because its temperate climate and sparse population and the presence of wild game in huge numbers made it highly desirable for white settlers. Beyond this, the "barbarians" did not fit the West African model at all—they were not headhunters, fetishists, cannibals, or practitioners of human sacrifice. Rather they were tall, aristocratic-looking cattle nomads, Rousseau's noble savages inhabiting a Golden Land. For these groups, who had no centralized authority figures, indirect rule was replaced by a sparsely administered group of outposts where wild game were often more numerous than the natives.

But in both cases there were warriors requiring pacification, to be followed by some form of administrative control so that they did not interfere in the extractive processes of the palm oil (and later other) trade in Nigeria or the coffee- and tea-producing white settler farms in Kenya. The institution of warriorhood, because it was embedded in both the ritual system and the system of objects, works here as the point of comparison for precolonial and early colonial inscriptions of Idoma (in Nigeria) and Maasai-Samburu (in Kenya) cultural practice as well as for the colonial and postcolonial commodification of warriorhood's principal cultural symbols through a globalized trade in art and artifact. The transformation of these symbols and the aesthetic practices that created them occurred within three successive time frames: the eve of colonialism in Kenya and Nigeria, ca. 1890–1900; the period following World War I when the British policy of indirect rule in Nigeria created an official interest in "customs" a decade after the Pax Britannica had suppressed practices that contravened the "civilizing mission"; and the period since World War II in which international art, craft, and souvenir markets affected artisanal practice in much of the continent.

REPRESENTATIONS, ARTISANAL KNOWLEDGE, AND AESTHETIC PRACTICE

While this story reads at one level as a straightforward "colonial incursion" narrative accompanied by an "empire fights back" counternarrative, it can also be read at a deeper level as a story of innovative aesthetic practice in the face of a radically altered patronage system. The strongest thread running through both the historical

and aesthetic narratives concerns representation: first, the widely divergent British official representations of warriorhood in the two places (Lugard's "primitive savagery" in Nigeria versus a district commissioner's "adolescent mischief" in Kenya); second, the changing representation of warriorhood's objects as art or ethnographic specimen and finally as commodity; and in the end, the image of the warrior himself, on movie screens, on postcards, in coffee-table books, and seen from a Land Rover while on safari. The earliest are written inscriptions such as travel narratives, memoirs, and colonial reports—the more recent ones produced in the camera's eye. But all of them speak to iconic power and the use of representations as a rhetorical medium in both colonial and postcolonial spaces.

These representations are not simply free floating but are connected to both knowledge and practice. As David Scott (1999, 12) observes, colonial representations constituted an "archive of authoritative knowledge [much of it wrong or misleading] through which colonial subjects were narrowly perceived and acted upon." For example, in representing the Maasai as people who "think as we do," unlike the typical native, whose thought patterns "twist and turn in all kinds of queer channels where we can't follow"(quoted in Huxley 1948/1975, 240), the Kenyan settler could justify indulgence toward Maasai behavior. In Nigeria, by contrast, colonial officials such as C. K. Meek seamlessly conflated headhunting with cannibalism, even though one was a common mode of fighting and the other a rare and usually highly ritualized practice, such as the new Yoruba king ritually consuming the heart of his dead predecessor. In doing so, it became easy to attribute a barbaric otherness to southern Nigeria and justify repressive measures there.

In a parallel way, representations and productions that result from actual artisanal practice also depend on an archive of knowledge that colonialism, in different instances, expanded or foreclosed upon. In my own work, the best-known and most widespread example is surely the eclipse of iron smelting everywhere due to the importation of ready-made mild steel by colonial governments. The remains of iron-smelting furnaces at Taruga, near the Doma (Idoma) kingdom north of the Benue in Nigeria have been dated to as early as the fifth century BC (Tylecote 1975). Throughout Idomaland, district officers reported the recent remains of smelting furnaces in the early colonial period (Armstrong 1955). That these furnaces and their

attendant technologies should have remained in active use well into the twentieth century was proof of their essential role in production and as a rich source of symbolism for other kinds of processes in the societies that created them. Amazingly, such knowledge has all but disappeared in the space of barely three generations (that is, from the 1920s to the present). In both Nigeria and Kenya, iron smelting had ceased by the early to mid-1930s, not long after the two regions were brought under British administration.

When I first began to spend time with blacksmiths, I imagined knowledge as something that accrues and is cumulative but less often as a thing that can be lost through lack of use and subsequent forgetting. Since then I have recorded accounts from a number of old Idoma and Samburu smiths, born around the turn of the twentieth century, who could give detailed descriptions of their furnaces and smelting procedures. All of these men are now dead, and their knowledge exists primarily as ethnographic texts. So to ask what the blacksmith "knew" is to ask a pointedly historical question—one whose answer changed radically over the twentieth century. For in both Idoma and Samburu, the smith was also the smelter of iron. In shedding the smelter's role under colonialism, he left behind an important mythic dimension of his identity—that of the bringer of civilization through iron tools and weapons who can manipulate earth, air, and fire to his own ends. In Samburu, the residue of that power still exists in the blacksmith's ability to invoke a curse and his distancing as outsider.

Artisanal knowledge and aesthetic practices are filtered in various ways, and this was as true in the colonial period as it is now: if the carver's patronage base is not exclusively local, his knowledge of it may be filtered through an intermediary, and when that happens, the intermediary frames the knowledge to suit his or her interests. The reverse is also true, and consumers frequently derive their knowledge of the artist and his/her production through intermediaries rather than directly. This nowadays creates mythologies among producers who are divorced from the distribution and consumption of whatever they produce as well as corresponding mythologies among consumers who are similarly distanced (Appadurai 1986, 48).

For example, Kamba carvers in Kenya produce not only naturalistic animal sculpture but also napkin rings with animal heads on them to be sold in craft outlets there and abroad. Since they do not participate in the culture of napkin ring usage themselves, most have

no idea what function these objects have for their far-off consumers and have invented a variety of interesting explanations—child's toy, baby's bracelet—of what Europeans must do with them. Western consumers create parallel mythologies about African artists and their production: the more distant they are, the easier it is to create narratives to support either the uniqueness or the sameness of their objects and the exoticism of their practice (see Spooner 1986).

Representations act as filters in both directions, but not in symmetrical ways. Most often (again from Appadurai's classic 1986 essay "Commodities and the Politics of Value" in *The Social Life of Things*), the collector comes from a complex capitalist economy and the faraway artist/artisan from an informal economy that exists on a much smaller scale. In the first case, not only is knowledge fragmented among many categories of consumers, producers, and intermediaries but knowledge of commodities is also itself commodified in the form of credentialed expertise (1986, 54). The elite collector of African art does not rely solely on personal judgment but consults appraisers and specialists before buying, thereby creating not just one but a whole cluster of representations concerning authenticity, distinction, and value.

There is no doubt that British popular and literary representations of Kenya and Nigeria acted as filters in the enforcement of colonial policies, but uncovering the aesthetic account that lies beneath the historical one means recuperating not only artisanal knowledge but also the practices that embodied this knowledge. Artisanal knowledge is a very complex thing—part technical, part epistemic and cosmological, part representation and mythology, part accidental and idiosyncratic, but all of its parts are brought into play in the gelling of the artist's practice.

Practice can be described, following Bourdieu, as the outcome of a dialectic between sociocultural structure and a structuring habitus, the external and the embodied (1980/1990, 52–65).[2] When modernity intruded in the form of colonialism, new structures forced changes in practice, whose implementation called upon existing competencies that I equate with habitus. For example, the making of iron and brass ornaments was traditional smith's work. In the late nineteenth century, brass rods were plentiful as a staple of ivory- and slave-trading caravans. In turn, they supplied smiths with a usable model for the working with other imported metal; all he needed to do was alter the form to fit the new material's unique characteristics,

such as greater or lesser malleability and tensile strength and differing aesthetic properties such as luminosity and patina. With the intrusion of colonial goods, it was a short step for the Samburu smith from learning to repair imported aluminum cooking pots to cutting them apart into strips to make bracelets and leglets for women to wear.

On the other hand, some older practices remain side by side with new ones because the combination of knowledge, patronage, and available materials still exists to make them happen. Wives of Samburu smiths possess a knowledge of how to heat and draw brass or copper wire and *urauri*, the double-coiled copper or brass earrings worn by elders of both sexes as well as by *laibartok* (newly circumcised initiates), are still being made today.

At the same time, the smith's artisanal knowledge has broadened to comply with a new kind of practice, the upkeep and repair of machines—cars, trucks, motorcycles—that were initially brought by the colonizers. In both Kenya and Nigeria, "bush mechanics" are often blacksmiths, pressed into this new occupation by their own special competence in working with metal. It is this competency coupled with inventiveness that has enlarged the smith's repertory of practice at the same time that his historical knowledge has shrunk.

The most recent reconfiguration of artisanal practice has taken place in a small Samburu enclave of warriors on the Kenya coast far from the strictures of their caste-based existence in northern Kenya. Here both objects and artisanship are redefined in the context of a new patronage system created by tourism. At the coast, boundaries are effaced not only between gender-based artisanal practices such as beadworking but also between casted *lkunono* and noncasted members of the same warrior age-set. Finally, the system of objects itself is reconfigured to create the entity of the tourist spear, modeled after the smaller-sized youth's spear in the traditional weapon repertory. To an observer, this all looks very casual and ad hoc, but behind it, changes in patronage as well as in materials and technology are forcing changes in the order of artisanal knowledge.

Smithing and metallurgical arts are crucial to this study, but for most high-art collectors and museum curators, it is the changes in the basic ground rules of the sculptor's art brought about by colonialism that have been the most far reaching. I return to the initial situation of the Idoma carver's knowledge on the eve of colonization in order to construct a historical framework for understanding the transformation in his practice. Ideally, a full description of this knowledge

would include his technology, his technique and personal style, the prevalent method of training in which he learned to carve (formal apprenticeship, informal learning), and the extent and character of his market, including clients' requirements and preferences and his own deviations from these. But for what African artists working in the early 1900s do we know all these things? Maybe for a few renowned Yoruba sculptors, but certainly not for anyone in Idoma. Much of this is now irretrievable and where it does exist, the explanations are of the second and third order (the stories told by the artists' descendants). Such stories generally smooth out irregularities and idiosyncrasies so that what is left is a largely idealized narrative.

CREATIVITY AND AESTHETIC PRACTICE

How does the new actually happen? It occurred in Idoma when crania were replaced by masks and in Samburu twice with radically new spear types, but what exactly transpired? Explanations about how innovation occurs in traditional workshop settings require an understanding of how practice really works. But for the art historian, there is disappointingly little in the social theory of practice that deals with creativity. It is necessary to move constantly back and forth between two levels of practice: the one we are accustomed to thinking of straightforwardly as "artistic practice" in the sense of an activity made familiar through the habits of training and experience that results in the production of concrete things—a painting, a building, a mask, a spear, and practice in the more complex Bourdieuian sense of constantly engaging both structure and habitus (1990, 52). The first is easily observable while the second is less open to the eye and requires a broader understanding of milieu.

Jean Comaroff provides a clearer idea of the dynamic of practice in its social sense in her study of South African Zionism as a form of ritualized resistance to colonial hegemony (1985). She focused on the signifying practices of the individual body as mediating and constructing the collectivity of the social body and proposed this reading of practice as the "process through which persons, acting upon an external environment, construct themselves as social beings" (6). I take it here that artistic practice might work the same way—that is, by the artist as an individual mediating and constructing his or her own practice as part of the larger collectivity. The key words in this postmodern and hybrid age must be "negotiate" or "mediate," but

they clearly echo the more confident and black-and-white modernist explanations of a generation ago concerning the tension between tradition and the new, between copying and innovation (e.g., Ackerman 1963).

The greatest challenge is what to do with the notion of originality or inventiveness in the context of a theory of practice. Is it located within the embodied, the habitus, in which case one arrives at the interesting conclusion that originality is actually located in preexisting knowledge. Or is it located in the constantly changing external structures the artist must negotiate? In either case, it is found within practice itself as the result of this ongoing dialectic.

The constant renegotiations of form, genre, and technique that resulted from colonial interventions can also be understood more readily using concepts from practice theory. In this book, I explain how change in the spheres of ritual and, in the colonial sense, "custom" were initiated by changes in the prevailing system of objects (see Baudrillard 1968).[3] One way to understand such changes is by close reading of particular sets of artifacts as they constitute clusters of meanings in a specific time and place. Art-historical and ethnoarchaeological studies are especially crucial for situating objects in this way because most American and British social anthropologists with any interest in "theory" divorced themselves from museum ethnography over a half century ago and have been inclined to overlook certain things that make artifacts different from events and processes.

The crux of the difference, which complicates certain social science assumptions about practice, lies in the free-floating nature of objects and their subsequent ability to migrate among very different practices, as do Samburu spears. The recent resurgence of interest in materiality has been led by literary scholars and a vanguard of anthropologists rather than art historians and archaeologists, with the result that close readings of the formal qualities of objects—the sites where transformation so often resides—are frequently left out of the analysis.[4]

SCRIPTING AND PERFORMING
THE COLONY AND WARRIOR THEATRE

How existing structures are undermined, overridden, or simply followed can also be expressed through the metaphor of the cultural script, whose particular usage I borrow here from the critical-legal

scholar Duncan Kennedy (1994). By invoking the script in this way, I convey the primacy of cultural inscription, of the "writing in" of rules and representations that are constantly open to revision. Both Idoma and Samburu culture were written into a colonial script in ways that set the parameters of British policies toward warriorhood in the two regions. This colonial script existed not in a vacuum but in a "confusion of tongues" (Geertz 1973, 28) brought on not least by the fact that the Idoma and Samburu were operating out of quite different scripts of their own making, especially as regards warfare. In the metaphor of inscription derived from Ricoeur (1971), this means that the script, while it functions as a blueprint for action, is constantly being revised by its actors.

Yet not all scripts are equally volatile: both Idoma and Samburu culture, if charted on some global continuum of receptivity to change, would come out on the conservative end. This is not only in relation to contemporary Western norms but in relation to their own neighbors: the Idoma relative to the Tiv or the Samburu compared to the Turkana. Spencer (1965) described the Samburu as conformists, and certainly there is less room for maneuverability in a typical Samburu life, where most important decisions are referred to a small group of male elders, than in, say, an American one. Yet the example explored in this study of the Samburu blacksmiths and their brokerage of caste relations in a situation of economic change makes it clear that even in quite conservative social groups, the cultural script is open to revision and recasting.

Another example of a script being recast in major ways is the Idoma response to the British colonial creation of a paramount chieftaincy in the office of Och'Idoma. While the ideology of sacred kingship (the king, or *oche*, as spiritual leader) was deeply embedded in the twenty-odd Idoma polities long before colonial intervention, each polity was administratively independent of the others. Yet the British administration successfully inscribed the office of Och'Idoma as not only expeditious but even a seemingly natural consequence of the existence of several contiguous chiefdoms with no overarching authority among them. This was done skillfully; the heads of each chiefdom[5] formed a "traditional council" (also an innovation at that level) that in turn elected the first Och'Idoma.

Early district officers complained of Idoma intransigence and lack of cooperation, but by the early 1950s the Idoma clearly saw the advantage of having a more powerful ruler to deal with the British

as well as with the Tiv, Igala, and other neighboring groups. In this case, the external structure was at first modified by colonial intervention but was reconfigured and "made traditional" by the Idoma themselves.[6] There are many such examples in Idoma history, including the history of Idoma art: one of the most powerful, the transformation of the Oglinye masquerade, is a major focus of two chapters in this study. Both Oglinye and the colonial and postcolonial transformations of the Samburu spear are examples of important reconfigurations of structure (the cultural script) through changes in practice.

While the reorganization of Idoma chieftaincy was institutional and the transformation of the warrior masquerade centered on the Idoma system of objects, cultural scripts occasionally were played out through performance alone. Ritual is something practiced, hence performed, and in Samburu it involves both body symbols and aesthetic strategies of embodiment. This process is critical for the Samburu in constructing masculine identity through a series of *lmugit,* or rites of transition, in which the uncircumcised, unsocialized male child becomes a member of an age-set cohort of warriors and over a fourteen-year span moves through various stages of maturation.[7]

But these aesthetic strategies also carry over into everyday Samburu practice in a set of self-representations that I call "warrior theatre," in keeping with the metaphor of the cultural script. It involves a number of fighting rituals, scrupulous attentiveness to body arts at all times (hair arrangement, ochre, the wearing of beads, feathers, and ivory) and a self-consciously aloof comportment that precludes the public expression of strong emotion. The warrior adopts a mode of behavior that Isak Dinesen (1966, 146) described in *Out of Africa* as "the rigid, passive, insolent bearing of the Moran." While his comportment may come across to strangers as arrogant, to the girls and young women as well as other warriors he hopes to impress, it is seen as worldly and sophisticated. Its theatricality is elegant and highly practiced. It also serves him well in masking the pain of circumcision, which is his first opportunity to adopt this persona, as well as later during fighting such as cattle raids or the physical stress of long periods in the bush without food or other comforts. I can still couch this in the present tense because the age-grade system, with warriorhood at its core, still operates in Samburu life. There is still fighting as well as dancing and just "being seen."

Warrior theatre for the Idoma, on the other hand, moved from actual fighting to its aesthetic representation in mask performance

early in the twentieth century. Before that, it was as intimately tied to the construction of social manhood as it is in Samburu culture: no Idoma woman would marry a man who had not taken an enemy head. Later other ways of satisfying this requirement developed: fighting in Burma for the British in World War II, fighting in the Nigerian Civil War from 1967 to 1970, killing an elephant or leopard. The theatricality of confrontation is played out in the masquerade by challenging another man while dancing with a machete. The dance is fast and athletic, with the body held compact and low to the ground. Special drums and flute music set the beat. The same confrontational posture and footwork are used in all the warrior dances whether or not a mask is worn.

The British tried many times to ban warrior theatre by getting rid of warriorhood itself. In Kenya they eventually gave up these ploys, as has the postcolonial government, which essentially cut the Samburu loose from Kenyan society by ignoring what goes on in the North Rift. In Nigeria, the British succeeded in eliminating warriorhood as an occupation but not the mask societies. In the end, their compromise was indirect rule through the local Idoma chiefs, who with the administration's knowledge, if not exactly its blessings, used the mask societies for village-level law enforcement.

SAMBURU AND IDOMA PRACTICE
AND ENCOUNTERS WITH MODERNITY

The cattle-herding Samburu, because of their remote location in Kenya's North Rift and seminomadic movement patterns, were less radically affected by colonialism than the Idoma. But since about 1980, they have come into sporadic contact with a postcolonial patronage system through the incursion of tourism and wildlife safaris. The Idoma, in contrast, have not yet encountered any significant degree of non-Idoma patronage for their cultural production. Unlike the well-studied and patronized Dogon, Senufo, or Yoruba sculptors and smiths, the Idoma have no contact with tourists and no carvers' associations making masks or figures for export or for sale to West African traders. Their sporadic entry into the sphere of commodification has come through the migration of Idoma ritual objects, by theft or sale, into wider systems of exchange made possible by colonization and later a reconfigured trans-Saharan commodity trade. This explains the unequal exposure the two cultures receive here—there are no

Hollywood films or postcards or coffee-table books about the Idoma, so their version of the postcolonial world is not a part of this story.[8]

The Samburu's very geographic remoteness and their colonial literary and popular representation as "aristocratic warriors," or equally as "disappearing people" has made them and their objects all the more desirable to travelers on wildlife safaris and adventurers, such as the writer-photographer Wilfred Thesiger, in search of an unspoiled continent. So paradoxically, the Samburu, while less "developed" in their relations to a larger economy, have nonetheless refocused certain aspects of artisanship toward an external patronage system in a way the Idoma have not. Yet because they are still enmeshed in a ritual and aesthetic system linked to warriorhood and their age-grade organization, they still actively make and circulate both ornaments and weaponry within a Samburu cultural matrix.

Despite recent commodification of spears and the refashioning of artisanal practice to meet the demands of new patronage, smiths remain a segregated caste and their relations to other Samburu are not radically different from what they were a generation ago. Part of the reason for this lies in the comparative spatial isolation of blacksmiths' practice and the fact that most Samburu sections have no blacksmith lineages at all. These do not seem to be conditions that would encourage innovation. Yet Rasmussen (1992) has shown how Tuareg smiths mediate change through their position in the caste structure. While Samburu society is not stratified in the Tuareg sense, it is tightly embedded in an age-grade system that crosscuts the endogamous caste of smiths. As each new warrior age-set is formed, it strives to identify itself by specific innovations that distinguish it from the previous set. The focus of artisanal innovation then becomes the warrior age-grade of the blacksmith caste.

Hardin has argued that structure shapes but does not determine action, since the potential for new arrangements of properties is already embedded in action (1993, 269–272). If so, the Samburu are caught in a balancing act between structure (what I refer to as the script) and action (artisanal practice), in which economic exigencies and the propensity for innovation have come together in the Lkurroro age-set, who became warriors in 1976 and were the first age-set to encounter external patronage. The result has been a refocusing of artisanal practice even while the features of caste distancing and endogamous marriage have been retained. To put this

in Bourdieu's terms, the habitus has had a powerful braking effect on change but has not prevented it from happening.

Idoma, by contrast, presents a picture in which the most radical change happened early in the colonial occupation. In a wide region from the Lower Niger to the Cross River and from the Atlantic coast to well above the Benue River, the taking of enemy heads was an integral part of regional military tactics prior to British pacification, which took place after World War I. For the Idoma, the practice of headhunting had triple significance: it deterred enemy attack, it proved a young man's suitability for marriage by proving his biological and social manhood, and it was ritually efficacious in that it increased a young man's potency as a warrior. But colonization tends to create new symbolic orders through a process of bricolage whereby "complexes of signs are thus disengaged from their former contexts" and take on new, transformed meanings (Comaroff 1985, 119). The imposition of the Pax Britannica brought the inevitable aestheticization of warfare and warriorhood in which the former enemy cranium became a carved mask and the warrior himself a performer of masked dance or masquerade that represents but no longer actually is the successful outcome of fighting an enemy.

In neither Samburu nor Idoma culture has the precolonial order been overturned or cast off decisively. In Idoma, a group of formerly independent chiefdoms were brought into the sphere of British colonial administration and later that of the postcolonial Nigerian state. The alteration of Idoma economic and political relations, though they are still centralized around sacred chiefship/kingship and regulatory societies and are lived in the context of mainly subsistence agriculture, have brought about important structural changes through the incorporation of formerly independent polities into the larger colonial and postcolonial state. The effect of these has been to make redundant the past role of fighting as the primary occupation of warriorhood. Another has been to loosen the former control of the gerontocratic councils of hereditary title-holders over younger men. Yet because artisanship has not resided in any endogamous caste but has been distributed throughout Idoma society, the artist's role has been less vulnerable to social change. It is also the case that masquerading, a young men's age-group preoccupation, was still strong in the '90s even though the older warrior masquerades were rarely performed when I began my fieldwork twenty years earlier. Idoma aesthetic

practices seem to be holding up but within an altered sociopolitical landscape.

ART AND COMMODITY
IN AN EXPANDING PATRONAGE BASE

The cultural brokerage of African art from local to international phenomenon has happened in three phases. Initially it was driven by the specimen-collecting of natural history museums and enabled by the acquisition of African colonies by European states in 1884–1885. After about 1910, the acquisition and display of African artifacts bifurcated along the parallel and often overlapping lines of art-museum and ethnology-museum practice. Modernist assumptions separated sculpture from other African genres in natural history collections and absorbed it (minus its ambiguous nonsculptural accoutrements) in the fine art museum's rhetoric of high art instead. Early-twentieth-century modern art dealers and collectors of Art Nègre such as Paul Guillaume and Henry David Kahnweiler were a major influence in this repositioning. Carl Einstein's *Negerplastik* (1915) provided the authoritative formalist critique and necessary scholarly validation to bestow on African sculpture its high-art status. This status came with two corollaries: colonialism had degraded this art by exposing it to Western desire, so "pure" examples had to come from a time before this moment of contact; therefore, it was perforce the work of anonymous, long-dead artists (e.g., Morphy 1995; Kasfir 2002a). The third phase of this enlarged and internationalized space of patronage was the rise of the African souvenir market after World War II and the growth of tourism in the independence decade of the '60s, which revised these modernist corollaries and produced a new set of representations concerning African artisanship.

These high and low globalized markets, while parallel and sometimes awkwardly convergent, operate on different premises: the high-art market for "traditional African art" such as Idoma masks and figure sculpture is self-limited to plastic arts that have since lost their cultural dominance (this is often not true, but it is one of the fundamental assumptions of the antiquarianist). The economic implications are clear: since it is an art of the past, the market supply is finite and ever dwindling, causing increasing rarity and greater market worth. Souvenirs, on the other hand, are assumed to exist

in unlimited supply since they are produced by living artists. Very broadly, souvenirs are either attempted copies of these past works or variants that introduce new forms of older prototypes such as Asante maternity figures that have been "improved" by butterfly beadwork inlays or the miniaturized and embellished Samburu tourist spear or altogether new inventions such as bas-relief hardwood storage chests or furniture.

When the copies of older genres are so skillful that they deceive the experts, they effectively cross over into the high-art category, at least until detected. A second crossover group would be precolonial or early colonial souvenirs that can now be thought of as work by dead artists and therefore an example of bygone cultural values because of their age. Twentieth-century genres such as easel painting, even those originally intended for a popular audience in Africa, frequently are given high-art status in the West either because of the way they are marketed on the gallery circuit or due to the modern (national or transnational) identities of the artists. One type of work that resists both high-art and souvenir status as they are described here is the output of exceptionally gifted artists whose formal ties are with souvenir-producing workshops or cooperatives but who bypass souvenir work in favor of following their own career trajectory by working on commission only. High art and souvenir are therefore neither all inclusive nor mutually exclusive categories, but for the two kinds of objects I am writing about they work well.

When one considers the economic flow of artworks within and from Africa since World War II, the broad workings of the souvenir and craft market (versus the high-art or gallery-driven art market) are separate but also converge at the trader level. Much souvenir art is sold through carvers' and craft cooperatives to itinerant African traders or are directly exported abroad to department stores and shopping malls. The old precolonial genres such as masks and their newly made imitations both circulate initially through a network of long-distance traders, who sell them to galleries or shopping outlets abroad and in Africa, the final disposition depending on age, technical quality, and adherence to a recognized traditional canon. Whereas a generation ago African traders tended to sell in the general region where they acquired their stock, this long-distance trade is now globalized. As everyone who has seen the video *In and Out of Africa* knows, African art traders first established an American

beachhead in New York City and are now seen making regular rounds in their minivans from Texas to Florida and points north.

GLOBAL, LOCAL, AND TRANSNATIONAL FRAMES

Certain terms require a fuller definition: art, artifact, souvenir, commodity. Each refers in its everyday usage to a class of objects, yet they are far from parallel concepts and often overlap and collide rhetorically. Is it possible to construct a difference between "art" and "artifact" in the way their makers deal with signification or change? Masks and spears are treated very differently in African art discourse and museum display, the former as "art," the latter as "ethnographic object." Yet in connection to the institution of warriorhood, they are conceptually similar; both are extensions of the ritualized warrior body. I also investigate the commodification of warriorhood as a series of icons (the postcard, the coffee-table book) or even as the literal breach of the boundaries of the body, as in the temporary liaisons between Samburu warriors and female tourists—what Judith Schlehe (2001a, 2001b) and Arjun Appadurai (2001, 3) refer to as "globalization from below."

How do commodified and uncommodified forms of masks or figure sculpture or weaponry relate to each other, especially when made by the same artists or blacksmiths or members of the same workshop? Is a commodified form automatically to be thought of as "globalized" because it is moving into new systems of exchange? And in discussing the movement of these commodities, how are they transformed as they are traded from local to national to transnational markets? Nomadic pastoralists in Africa are inherently "transnationals" who ignore political frontiers in search of water and grass for their animals. Is this part of the reason for the Samburu blacksmith's propensity toward cultural brokerage? That is, is he in some sense cut loose from the moorings of locality that hold the Idoma sculptor, for example, firmly within the social bounds of a permanent community in its own defined space?

The issues of space (national, local) and identity (collective or individual) have become the special preserve of postmodern and postcolonial cultural geography (Soja 1989; Pred and Watts 1992). But they easily reach back into the era of conquest and colonization when the British decided who was "Idoma" and who was not through boundary demarcation, for example. Prior to the onset of British administra-

tion, the nineteenth-century Fulani jihad of Uthman dan Fodio created refugee populations within Idomaland south of the Benue River, many of which had their own distinctive masking and sculpture traditions, who the British later incorporated into Idoma District boundaries, eventually bestowing on them an Idoma identity. Colonialism itself then becomes a major source of both identity formation and the commodification of art forms through their collection as specimens; the two converge in the idea of the "tribal style" affirmed in auction catalogues and museum displays (Kasfir 1984b, 1997).

Although it is well understood that African artisanship of all kinds underwent important redefinition and transformation as a result of the colonial experience, surprisingly little attention has been paid to the actual process. Beginning in the late colonial period of the 1950s, most African art scholarship (and this includes my own work on Idoma art in the 1970s and '80s) focused on "salvaging" through fieldwork what researchers were still able to piece together of a rapidly receding precolonial past. While colonial rule obviously had affected on-the-ground realities for nearly a century by then, the most common strategy in the '70s was to try to factor it out rather than engage with it, by employing the now obsolete but deeply modernist notion of an "ethnographic present" free of contamination by outsiders. In sharp contrast to this, most of the new generation trained since the 1990s has focused on modern genres of art formed by the urbanization process or by broader intellectual movements formed out of the volatile combination of literacy, the colonial education system, and independence politics.[9] All of this leaves the colonial encounter with African art a subject buried in the generational shift from precolonial to postcolonial African art studies.[10]

Studies of the postcolonial commodification of precolonial genres (e.g., Richter 1980b; Steiner 1994; Nevadomsky 2005) have tended to focus on producers, middlemen, and consumers rather than the actual role of colonialism. Yet important theoretical studies by economic and social anthropologists (e.g., Appadurai 1986; Comaroff 1985) have made it clear that material culture—in particular, the framing and disposition of "things"—are subject to the same exigencies and forces as the nonmaterial aspects of culture that were transformed by colonialism.

Another concept that requires revisiting in Idoma and Samburu is the broadly accepted spatialization of art and expressive culture into

explicit or implicit centers and peripheries. In precolonial days, the "center" could be a style center such as a major workshop, a sacred site, a trading entrepôt, or the locus of a royal court, but it was always assumed to be the focal point of art patronage and artistic production. In Idoma these would have been very complex networks of trade and patronage involving most of the foregoing—courts of sacred kings, shrine priests, and heads of masquerade and dance societies. The periphery in this model was seen as either a receptor of ideas from the center or as a frontier zone where cultural forms were more fluid and hybridized. In Idoma, these frontier zones occurred along the borders of Igala, Igbo, Ogoja,[11] and Tiv lands south of the Benue and Afo, Bassa, Jukun, Tiv, and the Fulani emirates north of the river. In other words, nineteenth-century Idomaland roughly fit a center-periphery model, though with twenty-odd independent chiefdoms there were so many centers and peripheries that as a whole, it more closely resembled a network. The other critique of the model that it offers is that innovations just as frequently occurred at the peripheries in boundary zones as they did in political and ritual centers.

But a seminomadic culture such as Samburu, in which people lived and moved seasonally with their animals, was essentially center-less until the British established administrative outposts in the colonial period. One important exception was the smelting and smithing of iron that had to be located at the source of ores, typically near the bases of mountains. With the onset of colonialism and the cessation of smelting, the structural rigidity of these centers and their peripheries broke down and even smiths could move seasonally during droughts. The other, and more permanent, Samburu centers are certain sacred sites located on the slopes of mountains such as Kulal and Marsabit and at springs such as Kisima that are revisited in initiatory rituals as places of origin. But these are not centers of economic or political consequence or even major concentrations of population, so they are fundamentally different from Idoma centers of local politics and patronage.

Colonialism created a larger overlay upon the indigenous center-periphery model, in which all African centers were now also peripheries to the European metropole from which power and policy emanated.[12] In Nigeria in the 1920s, district officers became field collectors of African sacra destined for the British Museum, the Pitt Rivers Museum, and others, first in order to narrate the colony and

in doing so to validate colonial intervention itself, and second to fuel the Anglo-German rivalry over ethnographic collections. Within the colonies themselves, the central administration created a reshuffling of African centers. For example, the British and later the postcolonial Kenyan government developed game reserves and safari tourism, turning remote places such as Archer's Post in the Samburu lowlands into a safari destination. Beach resorts on the Swahili coast also appeared, helping reestablish Mombasa as an economic center in the face of the declining dhow trade. As different as these policies in Kenya and Nigeria were, they all mined the resources of the colonial periphery in keeping with Lugard's dual mandate. In art-world terms, this peripheral status still exists: to develop career-sustaining patronage for their work, African artists are advised either to migrate to the West or participate at a distance in the international biennale system. Dak'Art, the Dakar biennale, is an attempt to create a center within Africa, though artists from most African countries are still in its periphery.

Finally, at the end of the postcolonial era, "global cities" emerged as power sites that redefine centers and peripheries once again, this time without the need for national sovereignty as their source of power and influence. Because they concentrate resources of all kinds, to some degree they are able to function independently of limitations imposed by the nation-state in which they are located (Sassen 2001, 263). Thus, certain African cities such as Lagos or Abidjan can operate as centers on this global level even though they may be situated in partly dysfunctional states.

But if art (or artists or art institutions or the critical apparatus that accompanies them) is the commodity being propagated by a global city, which art gets peripheralized in such a model? Anything lying beyond the global city's reach that is both enabled and limited by the flow of enclaved commodities such as art to viable markets elsewhere. In Africa, those beyond its reach will include not only less-well-connected artists in other countries but even many just beyond the pale within the same modern state. Take Nigeria: if almost all the art-world interaction is in Lagos and one lives 700 miles away in Jos, one is as removed from the art scene as Knoxville is from New York City. But unlike the old genres, modern ones tend not to exist in hybridized frontier zones located between patronage centers because the new genres are predominantly urban, whereas the older

ones, such as masks, were produced in mainly rural communities.[13] The distribution of the new is therefore discontinuous and mainly confined to an urban envelope.

Modernist and postmodernist high-art genres, while not the subject of this study, form the most discussed and written-about part of the global market for African art even though they account for only a small fraction of the total corpus. I conclude with them here in order to stress that the African art market, while fragmented into several distinct niches, is both labile and at the same time limited by the structures and current tastes of mainly Western collecting. Few art museums have successfully resolved what to do with modernist African art: Does it belong in the Modern department with the Matisses, in which case it is likely to be overlooked, or in the African department with the canonized historical genres, where it does not fit the ethnically based precolonial logic of display? It risks being misunderstood in either one.

Modernist African art also follows a different market trajectory than traditional genres, crafts, and souvenirs. Because there are far fewer specialized collectors, dealers, and galleries than for "primitive" art, ex-colonial cultural organizations (British, French, German, Portuguese) carry much of the weight of promotion and sale of this work unless it is sufficiently congruent with current art-world taste to draw the attention of international curators. At this writing, a handful of such curators, collectors, and art journal editors, virtually all of them operating in the West or Japan, shape critical opinion, and therefore the market, for this art.

Part 1

WARRIORS

1

MAA WARRIORHOOD
AND BRITISH COLONIAL DISCOURSE

If ever the dreams of European colonists are realised in
Central Africa it will, without doubt, be on those portions of
the Leikipia and Kenia [Kenya] plateau which are between
5,000 and 7,000 feet above the sea-level.

—LUDWIG VON HÖHNEL, *Discovery of Lakes*
Rudolf and Stefanie (1894)

The vultures are dropping on the Pinguan to eat one loved by
the people of Nairobi.

—Song of Samburu warriors after the Powys murder,
quoted in Atieno Odhiambo "'The Song of the Vultures':
Concepts of Kenyan Nationalism Revisited" (1973)

The Samburu (Lokop)[1] are Maa-speaking pastoralists who herd
cattle, sheep, goats, and sometimes camels in the remote mountain
fastnesses, temperate highlands, and hot dry lowlands of the Great
Rift Valley corridor and its surrounding ranges south and east of Lake
Turkana in northern Kenya.[2] Their social relations are structured
and mediated by an age-grade system in which formal warriorhood
occupies an extended period of up to fourteen years between the
major life-cycle transitions of circumcision and marriage.[3] It is a stage
of life that is not only ritually marked but sharply focused on body
arts and weaponry as highly visible and volatile metaphors for viril-
ity and bravery. Admired by their girlfriends and indulged by their
mothers, these young moran[4] exist in a state of tension and rivalry
with both the warriors of unallied Samburu sections and the older
age-sets of men who have left warrior status for a more sober and
powerful (but considerably less glamorous) elderhood.

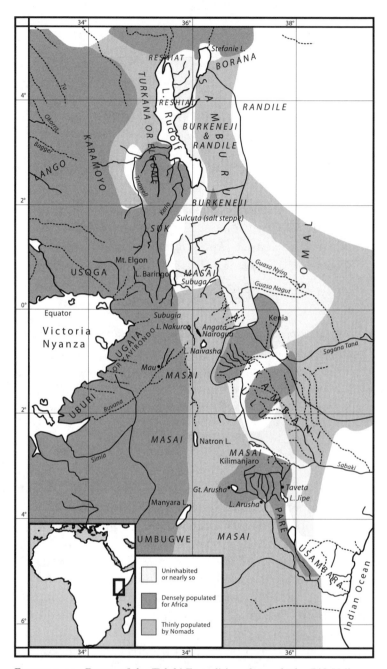

FIGURE 1.1A. Route of the Teleki Expedition through the Rift Valley, East Africa, 1887–1888. *Source: Ludwig von Höhnel,* Discovery of Lakes Rudolf and Stefanie *(1894).*

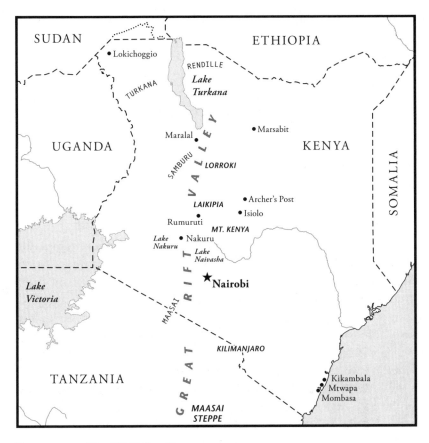

FIGURE 1.1B. The Rift Valley, Kenya, ca. 1970.

In this chapter, I excavate the nineteenth-century and colonial-period literature on Maa-speaking pastoralists, first through travelers' and settlers' accounts meant for a popular readership and then through the 1950s Hollywood safari film genre. To show the effects of these representations on colonial policy, I focus on a case study of the Samburu spear ban (1934–1956) and its consequences that is contained in colonial government documents and interpretations by historians (Odhiambo 1973) and anthropologists (Spencer 1965). The events that precipitated the ban took place in 1931, when a group of Samburu warriors were implicated in a homicide. It was unusual in two ways: the victim was a white man and (contrary to Samburu practice) they took the head. What followed was a long investigation in which the accused killers eventually were allowed to go free.

Comparing these official and popular narratives, I try to demonstrate the colonial ambivalence concerning Samburu warriorhood that on the one hand romanticized the Maa-speaking pastoralists as disappearing signs of an aristocratic primordial Africa and on the other saw "spear-blooding" as unruly and unacceptable adolescent behavior that needed to be contained. In the next chapter I will contrast this with the unequivocally harsh British policy toward "headhunting" in Nigeria during the same period; the terms themselves mirror very different colonial perceptions of what were actually similar fighting practices.

AN OPEN LANDSCAPE

East Africa, blessed with higher altitudes and a more temperate climate than West Africa except along the coast, was vast, mountainous, and sparsely populated. Kenya—especially the central highlands—was depicted as a kind of paradise: astride the equator yet with a healthy and bracing climate and fertile uplands that were favorable to European settlement. There are no elevations in West Africa with permanent snowfields like Mt. Kilimanjaro, Mt. Kenya, and the Rwenzoris, nor is there anything comparable to the Great Rift Valley. "We have in East Africa," intoned Sir Charles Eliot, governor of the East Africa Protectorate, "the rare experience of dealing with a *tabula rasa*, an almost untouched and sparsely inhabited country, where we can do as we will" (Eliot 1905, 103). An important subtext in this landscape was the presence of wild game that was impervious to tsetse fly and roamed the savanna in huge numbers. This allowed great scope for the aristocratic pastime of hunting and made of the hunter an actor on the stage of this seemingly primordial and limitless space.

The vastness and emptiness of Kenya's Northern Frontier District also gave rise to a rhetoric of heroism and endurance in which the colonial administrator could participate: by framing Samburuland, which was far from the outposts of "civilization," as a part of the wild, he made not only the Samburu but also himself an adventurer within it. In his annual report for 1936, a district commissioner compared the typical daily routine in Rumuruti, the administrative center for Laikipia and its white settler community, with that of the district's newer administrative outpost in Maralal, farther north in the Samburu highlands:

Rumuruti. A ride round the prison shamba and the swamp draining work in the early morning. A meeting of the European School Committee at 9:30 a.m. Court 10:30 a.m. to noon, chiefly masters and servants, petty thefts and trespass cases. Noon to 1 p.m.: interviews with settlers re various matters. Afternoon: a few native "shauris."

[versus]

Samburu (Maralal). With the morning tea the boy reports a leopard has eaten the tame cheetah. As one leaves the bath, the head syce [groom] reports that two elephants have broken into the cattle boma and spent part of the night there. They have not molested the Government stock however. After breakfast a headman reports that lions have killed a bullock and mauled a man in his village. The cattle boma is inspected and ordered to be mended, a gun-trap is set for the leopard and then the day's work begins.[5]

There was much to dine out on here when recounting stories back home in England. Whereas West Africa produced a litany of complaints, administering the Northern Frontier District of Kenya was heroic and exhilarating. The danger there was not a sudden and ignominious death from blackwater fever but being killed by a lion. There was wild game in Nigeria too, of course (and there still is), but the very high population density even in the early colonial period precluded the possibility of large herds occupying vast uninhabited tracts of land. In Kenya, the combination of wild game in great numbers, the dramatic landscape of montane forests and wide valleys, and the domination of the landscape by warrior-pastoralists allowed the development of a colonial discourse that contrasted sharply with the discourse on West Africa.

INSCRIPTIONS OF FEARSOME NOBILITY
AND CANNIBAL JOKES

The reading of Maasai superiority into the nineteenth-century record of European exploration can be traced initially to missionary J. Lewis [Ludwig] Krapf's brief account, which was first published in German in 1858. The twin discourses on Maasai beauty and fearlessness begin here. On Maasai military reputation, Krapf reported that

FIGURE 1.2. Dry season in Ldoinyo Lorroki, Samburu District, Kenya.
Photo by author.

"they are dreaded as warriors, laying all waste with fire and sword, so
that the weaker tribes do not venture to resist them in the open field,
but leave them in possession of their herds, and seek only to save
themselves by the quickest possible flight. . . . [They] do not make
slaves of their prisoners, but kill men and women alike in cold blood"
(1860/1968, 359, 364). Of their physical beauty, Krapf had less to
say than writers who followed him and noted only that "their forms
are tall and slender, with handsome and rather light-complexioned
features" (361).

The more detailed description of Maasai physicality, which has
been repeated in only slightly varied form by innumerable writers up
to the present day, was laid out in Joseph Thomson's *Through Masai
Land* a generation later:

> Spendidly built young savages—indeed the most magnifi-
> cently modelled men conceivable. . . . They show little of
> the knotted and brawny muscle characteristic of the ideal
> Hercules or typical athlete. The Apollo type is the more char-
> acteristic form, presenting a smoothness of outline which
> might be called almost effeminate. In most cases the nose is
> well raised and straight, frequently as good as any European's.
> (1887, 250)

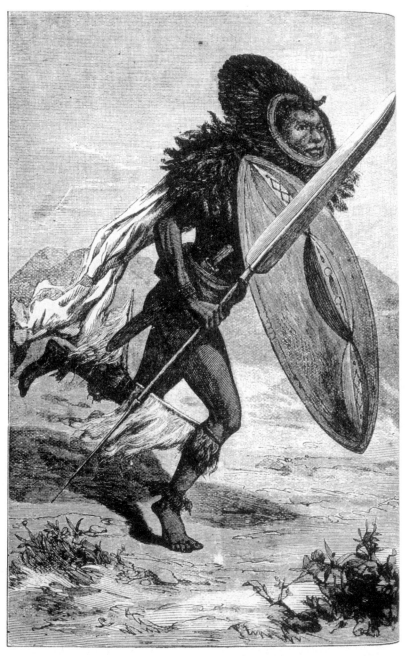

FIGURE 1.3. Maasai warrior running. *Source: Joseph Thomson,*
Through Masai Land *(1885).*

Elsewhere in the book Thomson praised their "aristocratic dignity" and natural fluency, composure, and grace while speaking (1887, 90). This combination of beauty and self-assured comportment was a heady mix for Europeans expecting either vile savages or easily intimidated natives before whom it was effortless to feel superior. In 1885, the same year as the initial publication of *Through Masai Land,* the young Thomson was invited to visit Nigeria, which left him with a lasting distaste for West Africa and its supposed barbarisms. With reference to the cannibal tales popular in Victorian circles, he quipped, "The only circumstance which serves to maintain an air of romance about the Niger negro is the knowledge we possess that he still loves his neighbor, to the extent of becoming at times literally one flesh with him" (quoted in Johnston 1897, 182–183).

Thomson was only in his twenties when he met the Maasai and when he went to Nigeria. To be generous, some of his attempts at witty irreverence (and they abound in *Through Masai Land* also) could be attributed to callow ideas of Oxbridge humor.[6] Some of this was inserted, perhaps at the publisher's urging, into the 1887 revised edition, a part of the series known as Low's Popular Library of Travel and Adventure along with titles such as Stanley's *How I Found Livingstone* and H. H. Johnston's *The River Congo from Its Mouth to Bôlóbò.* Still, it is perhaps revealing that cannibal jokes about Nigeria were a part of the British explorer/imperialist repertory in the 1880s and 1890s.

Cannibals also appeared simultaneously—not as jokes but as serious representations—in the more romantic accounts of Niger and Benue river exploration such as Adolphe Burdo's. After traveling through their country, Burdo wrote that the Akpotos (Idoma) and Mitshi (Tiv) were "utterly barbarous, practice idol-worship, offer human sacrifices, and cannibalism flourishes among them" (1880, 246). By the turn of the century these contrasting narratives on warriorhood in Africa were established literary genres for describing the Maasai and the people of the Lower Niger and Benue regions—one celebrating the warrior as a fearless but elegant Apollo and the other reviling him as an idol-worshipping barbarian.

A third major element entered Maasai literary representation in 1901 with the publication of Sidney and Hildegarde Hinde's *The Last of the Masai.* This was nostalgia: the sense that not only were the Maasai unique in their "Hamitic" beauty and proud culture but that it was fast disappearing. Sidney Hinde wrote, "By the 'Last of the Masai'

I do not mean the last individuals of the race, but rather the last of the rapidly decreasing band of pure blood, whose tendencies, traditions, customs and beliefs remain uncontaminated by admixture with Bantu elements and contact with civilization" (1901, xiii). This narrative of purity and pollution, or uniqueness unmarred through assimilation, forms the final recurrent theme in Maasai representation.

Hinde's argument that it was only with the pacification of the country under British administration that the Maasai began to absorb "outside influences" is an exaggeration. Nineteenth-century accounts make it clear that the Maasai not only confiscated the cattle of but routinely traded with other East African people.[7] In the colonial period, they frequently took Kikuyu wives to offset the lower fertility of Maasai women or to satisfy the demands of polygyny. In fact, Maasai and Samburu social theory maintains an ideology of assimilation while at the same time professing social distinctiveness from non-Maa, nonpastoralist "others"—what Hinde saw as the "contaminating" Bantu elements.[8]

Krapf was a Basel-trained missionary with the evangelical Church Missionary Society, Thomson a Scottish geologist sponsored by the Royal Geographic Society, and Sidney Hinde a collector for the British East Africa Protectorate. Together they wrote the Maasai into the early colonial imagination. This inscription had three parts: the Maasai were fearless (Krapf), self-assured and magnificent-looking (Thomson), and the last vestige of a disappearing noble race (Hinde). Such an elegiac representation carried its own Rousseauian corollary in the minds of the educated classes: the Maasai perforce led a happy and contented life, devoid of stress, all of which is introduced through the process of civilization. Although it contains only a stereotypical fragment of truth, this widely held conviction has survived colonialism and is still heard in the 1990s from those seeking an authenticating experience with the Maasai or Samburu.

There was another much more calculated and less idealized side to British indulgence toward the Maasai, however. This was their cynical use of them as collaborators in the early conquest of Kenya. In a "fragile regional economy set on edge by rinderpest and famine," the British formed an alliance with the Rift Valley Maasai against the Gikuyu, Nandi, Luyia, Luo, Kamba, and many others (Lonsdale 1992, 26–28). From 1893 to 1906, nearly all the small pacification campaigns led by a company or two of the East African Rifles were

supported by several hundred Maasai auxiliaries. The policy was to destroy houses and crops and capture livestock so as to enforce submission. The Maasai were awarded much of the stock they captured, enabling them to recover from their earlier losses from rinderpest and reclaim some of their old grazing lands (27).[9]

But once these campaigns were nearly over and white settlement became an urgent political consideration, the Maasai were removed from the Rift Valley in 1904 and then forcibly removed from Laikipia in 1911 through a series of maneuvers by three successive governors. Sir Charles Eliot, Sir Donald Stewart, and Sir Percy Girouard all conspired in various ways with their senior officers to make it appear to the Foreign Office that the Maasai were "willing and anxious to move" (Sorrenson 1968, 192–209). This was far from the truth, and stories persisted well into the 1940s of the ruthlessness of the government in confiscating and publicly burning the shields and spears of the Maasai warriors to prevent opposition to the relocation (Hanley 1971, 297). Legalishu, one of the two main representatives of the northern Maasai and an opponent of the second move, engaged a Mombasa barrister to challenge the legality of the second treaty. But after two years of petty obstructions by the government, the High Court finally heard the case in 1913 and dismissed it on the legal technicality that the Maasai were "not subjects of the Crown . . . but protected foreigners, who, in return for that protection, owe obedience" (Sorrenson 1968, 207–208).[10] Thus betrayed in exchange for their loyalty to the government, the Maasai withdrew in disgust from the rhetoric of the "civilizing mission."[11]

OUT OF AFRICA: THE SETTLER'S VOICE

Prominent early settlers such as Lord Delamere, who in 1903 was granted 100,000 acres of Maasai pastures in the Rift Valley (Sorrenson 1968, 42), often saw no inconsistency between admiring the Maasai and usurping their land at the same time. There are many echoes of feudalism in colonialism: the British in particular but also the writer Isak Dinesen (Karen Blixen), herself a Danish aristocrat and one of Kenya's best-known white settlers, idealized the code of honor of the feudal aristocrat and saw it materialized in certain African peoples. For the British writer Beryl Markham, the code was exemplified by

the Nandi warriors of the Rift Valley and for Karen Blixen, by the Maasai.

Paradoxically, the white upper classes in colonial Kenya saw the Maasai as both more like themselves than other Africans were (and therefore worthy of respect that bordered sometimes on indulgence) and as the embodiment of an independent way of life that strongly resisted assimilation (and therefore appealing to the romantic imagination). Tzvetan Todorov has argued that the historical reluctance of Europeans to accept that non-European people could be genuinely different from themselves but equally human has led them to see these others as either inferior (less human) or as "just like us," but for the superficial layers of time, place, and circumstance (Todorov 1984, 185–186, 190–191). Most colonized Africans were viewed as the former, but nomadic pastoralists, especially those who were fierce fighters and raiders, occupied a separate niche in the colonial imaginary.

This European identification with the Maasai began, once again, with Thomson (1887, 239). After describing the affinity of the Maasai language with those of the Nilotic Sudan and North Africa and therefore its classification by Victorian philologists as "Hamitic," he continued: "The Masai are in no sense negroes. . . . In their cranial development, as in their language, they are widely different from the natives of Central and South Africa, occupying in the former respect a far higher position in the scale of humanity." Such a belief allowed colonials to identify with the Maasai without compromising their own sense of racial superiority—a view that, however inadvertently, Maasai (including Samburu) assumptions of superiority in their relations with non-Maa-speakers reinforced.[12]

The question of intellect would later become not one of "cranial development," a nineteenth-century obsession, but of a style of thinking that was characterized as more direct and pragmatic than that of other Africans: "We Europeans can never really get to the bottom of the Bantu mind, it twists and turns in all kinds of queer channels where we can't follow. But these Nilotic peoples—they think as we do. Our minds work the same way"(fellow settler quoted in Huxley 1948/1975, 240). This belief has persisted among Europeans in Kenya and reappears in a post–Mau Mau, preindependence description of social interactions among Maasai, Gikuyu, and white people such as Gerald Hanley (British, an ex-soldier and sympathetic):

"The Masai had come forward, to fight or to talk with the white men
. . . while the Kikuyu had hung back, suspicious" (Hanley 1971, 276,
278). In a backcountry bar, the author drinks beer and chats with a
group of Maasai elders while a lone Gikuyu refuses his invitation to
join them. Hanley imagines the Gikuyu's reasons:

> It is we who have learned the hard way, not you [Maasai].
> That is why it burns my heart to see you all laughing and talk-
> ing with the white man in this way. You seem to have no
> understanding that all that past you talk about is gone and
> finished, and you have no schools, no doctors, no politicians,
> only your spears and your thorn trees after seventy years of
> the white man in this land.

Aside from intellect, other qualities prompted European settlers
in Kenya, especially the British landed aristocrats, to see Maasai-
speaking warrior-pastoralists as more like themselves than, say, the
Gikuyu they displaced in the central highlands. Hammond and
Jablow (1970/1992, 164) observed that the ideal of manliness is
capable of transcending cultural distance, which partly explained the
"almost worshipful" British attitude toward the Maasai. The British
upper classes saw themselves, however myopically, mirrored in the
Maasai, and such recognition became a kind of test of whether one
was the "right sort" of Englishman (Dick-Read 1955, 212).

The supposed common qualities, taken out of context, were strik-
ing: one was the seemingly "chivalric preoccupation with warfare," in
which the warrior with spear became the logical analog to the knight
on a horse (Hammond and Jablow 1970/1992, 165). To this were
added an "impassioned interest in domestic animals," an "apprecia-
tion of the value of pedigree" for both human and beast, a disdain
for commerce, and an ideal of disciplined self-possession (ibid.). And
like the European aristocrat, the Maasai were not a part of anyone's
labor force. Compared with the dawn-to-dusk routine of the farmer,
that of the pastoralist is more leisurely and for men with warrior sons
or younger brothers consists more of livestock management than of
direct labor. Of course, such a comparison conveniently leaves out
crucial aspects of Maasai life, especially the stark realities of pastoral-
ism itself: the threat of drought, famine, and periodic impoverish-
ment or even starvation as well as a Spartan existence with very few
material comforts compared with those of the farming population.

Combined with these perceived similarities (and perhaps more crucial) were European notions of the aristocratic body. Maasai physicality contrasted sharply with that of most other Africans colonized by the British. Slender and often delicately boned, frequently straight-nosed and thin-lipped, they exhibited the languid grace and many of the physical features Europeans idealized in their own aristocracy and contrasted with their stereotype of a short, blunt-featured, and sturdy peasantry in both Europe and Africa.

In Karen Blixen's eyes, this alleged contrast between the aristocrat and the peasant was played out in the Maasai and Gikuyu who were her neighbors. The Gikuyu peasant farmers were accepting, like the poor people of Europe—"they judge you not, but sum you up . . . not for what you do to them . . . but for what you are" (Dinesen 1966, 138). The Maasai, on the other hand, were judgmental and very capable of bearing a grudge (137). *Out of Africa* echoes a common assumption that while peasants are resilient, aristocrats are fragile; for example, Blixen felt that however brave the Maasai warrior might be, he could not endure captivity. She repeated her Somali servant Farah's assertion that the Maasai had never been made slaves (which was probably true) nor could they be kept in prison (which was certainly false), for in either case they would die: "This stark inability to keep alive under the yoke has given the Maasai, alone amongst all the Native tribes, rank with the immigrant aristocracy" (160).[13]

The other aspect of this supposed inability to endure was the Maasai's total refusal to adapt to changing conditions. Thus, recounted Blixen, "From the farm, the tragic fate of the Masai tribe [on] the other side of the river could be followed from year to year. They were fighters who had been stopped fighting, a dying lion with his claws clipped, a castrated nation" (141). In fact, their real tragedy was not that they had been stopped from fighting their enemies and rivals but that their vast and fertile grazing lands in the Rift Valley had been taken away from them and allocated to white settlers (such as Karen and Bror Blixen and Lord Delamere) in the two ill-fated treaties signed with the government in 1904 and 1911.

Out of this conviction that the Maasai were a dying people, a living anachronism, Blixen developed the idea that they were in some sense artifacts:

> He had acquired the Masai carriage of the head with the chin stretched forward, as if he were presenting you his sullen

arrogant face upon a tray. He also had the general rigid, pas-
sive and insolent bearing of the Moran that makes of him an
object of contemplation, such as a statue is, a figure which is
to be seen, but which itself sees nothing. (146)

Meanwhile, in the sometimes self-contradictory logic of British
colonial thinking, the Gikuyu and other agricultural people who
reluctantly went to work for the European settlers earned official
approval but private disdain for being receptive to change.[14] The
transplanted British aristocracy in the Kenya highlands held their
acceptance of Christianity and Western education in contempt.
Unsurprisingly, it was the more adaptive Gikuyu who first achieved
political and economic power in Kenya, while the Maasai continued
to be marginalized.

OTHER INSCRIPTIONS:
THE "NATURAL MAN" HYPOTHESIS

A major challenge in characterizing discourse on the Maasai in
the colonial record is the sheer cacophony of voices. In selecting
representative texts it is very easy to skew the results either toward
the "nobility" (the aristocratic settler voice) of the Maasai or their
conservatism, which was read as "primitiveness" (the voice of colonial
administrators bent on "development"). For example, Knowles and
Collett's (1989) analysis of how the colonial government negatively
mythologized the Maasai with regard to their resistance to develop-
ment puts forth a convincing-sounding argument that on the social
evolutionary scale employed by those who governed Kenya, pastoral-
ists such as the Maasai were seen as closest to nature (and Natural
Man was characterized as primitive and indolent), Europeans were
seen as closest to culture (civilized and industrious), and agricul-
turalists such as the Gikuyu were perceived to be somewhere in the
middle.

As soon as one accepts that this was the prevailing belief, every
negative comment from the government about Maasai conservatism,
resistance to progress, and refusal to cooperate in schemes to improve
their lives or livestock falls neatly into place. As Knowles and Collett
put it, "The jigsaw of colonial thought is now complete: societies were
placed on a scalar order according to their economic practices, and
the transformation of a society to a higher point on the scale was only

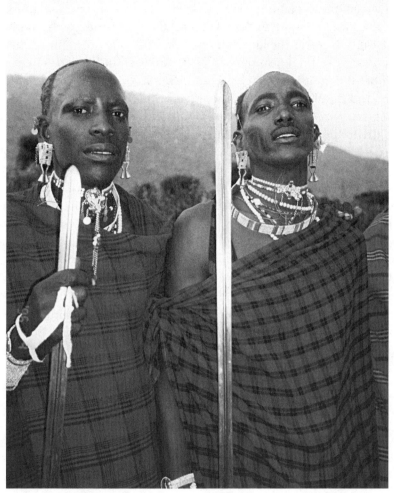

FIGURE 1.4. Kisongo Maasai warriors, Tanzania, 1998. *Photo by author.*

possible through the acceptance of the gifts of colonialism. . . . Out of the chaos of nature would come order" (439).

Since this scalar model places the Maasai as far as possible from Europeans and I have suggested in the preceding section exactly the opposite conclusion for one (powerful and influential) group of Europeans, the settler aristocrats, this caveat is apropos: the analysis of polyphonic discourse always takes place within the constructed and subjective frame of the author, and the greater the number of

voices being represented, the greater the likelihood that competing explanations will emerge. How did we arrive at opposite conclusions in this case? First, we were looking at different issues, cross-cultural encounters versus the implementation of colonial policy. But equally important to their seamless analysis, Knowles and Collett chose to ignore the unofficial but clearly admiring view of the Maasai in memoirs and novels and articles in popular magazines such as this one in *National Geographic:* "These Spartan Aristocratic Warriors, Scornful of Civilization, Fearlessly Hunt Big Game with Spears and Swords" (1954, 487).

Rather, they chose to cite three anti-Maasai narratives for the early years: the calculated civilizing vision of Sir Charles Eliot, a governor who surreptitiously sold Maasai land to South African settlers at the beginning of the century and then, when he was about to be sacked, justified it to the Foreign Office by depicting the Maasai as beastly immoral savages (Sorrenson 1968, 76); the opinions of W. S. and K. Routledge, who, having lived many years among the rival Gikuyu, would understandably have taken a pro-Gikuyu, anti-Maasai stance; and Sir Richard Burton, from whom the model of the "Natural Man" is apparently derived, though only by judiciously omitting Burton's well-known opinion that all Africans were barbarians compared to the "civilized" Arab slave traders in whose *zaribas* he sought hospitality.

In contrast to these, the authors hold up Joseph Thomson's view of the Maasai as an example of ethnographic accuracy that the later architects of colonial government policy chose to ignore. Knowles and Collett argue that J. L. Krapf's representation of the Maasai as ruthless warlords was favored over Thomson's depiction of them as dignified and self-assured. One might posit that there is a rather fuzzy line between the noble and the natural in discourse about the Maasai, between "scorning civilization" and merely lacking it. Yet accepting either argument in its pure form would move colonial policymakers step by step toward two opposite conclusions. The contrasting results help to explain how it was that the British view of warriorhood could present such different faces in Kenya and in Nigeria.

A NORTHERN WILDERNESS

In the nineteenth century, the Maasai controlled vast tracts of land in the territory that would become British East Africa. They were

a presence that could not be ignored by any caravan attempting to reach the Central African lakes from the Swahili coast, and were consequently repeatedly described by travelers and missionaries. At the start of the colonial period, until the 1911 treaty and the relocation of the Maasai south of the Uganda Railway, some sections (e.g., Purko, Kaputiei, Keekonyokie) lived in close proximity with Rift Valley and highlands settlers.[15] As a result, there are many textual references to core Maasai in exploration and settler narratives. The same is not true for the Samburu, who historically occupied the northernmost periphery of the area where Maasai-speaking people lived, from as far south as the Cherangany Hills near Lake Baringo to Mt. Kulal and the eastern side of Lake Turkana in the north. Since this was not a well-traveled path of European exploration, nineteenth-century references mention only a few actual encounters with the Samburu.[16]

Von Höhnel, the chronicler of the Count Teleki expedition to Lake Turkana (which Teleki named Lake Rudolf) in 1888, described Samburu only as a place-name, following Krapf (1860), but referred to the people he and other expedition members met on Mt. Nyiro as "Burkeneji" (*loibor kineji,* people of the white goat) and asserted that they were "closely related alike in genealogy and language to the Masai" (1894, 2:74). The Teleki expedition unknowingly took place in the midst of a prolonged calamity the Samburu and other Rift Valley pastoralists experienced in which bovine pleuropneumonia (early 1880s), smallpox (1888 and after), and finally a rinderpest epidemic (1890–1891)[17] destroyed perhaps 90 percent of their herds and all but decimated the Samburu through disease and starvation.

The scant descriptions are mainly of women who tried to trade with the caravan. Of warriors, we can glean only that they had distended earlobes, wore a few beads and a coarse wool cloth (or nothing) about the hips, and resembled closely the people of Nyemps (Njemps, Chamus), sedentarized Maa-speakers near Lake Baringo (von Höhnel 1894). A early description that sounds more familiar came a decade later from an Englishman, Captain M. S. Wellby, who described his journey in 1899 from Addis Ababa southward around Lake Rudolf in a posthumous memoir titled '*Twixt Sirdar and Menelik* (1901). East of the lake he met the "Lokub" (Lokop, Samburu),

> A race of very finely made men, with long hair stretching
> down to the waist; they wear no clothing except beads round
> the neck, and rings of iron round the arms. They live on

milk, meat, and probably fish, whilst flour and vegetables are
unknown in their menu. The physique of the men speaks
much in favour of a milk and meat diet. (236)

By then, the Samburu had begun to recover from the setbacks of
the 1880s. Aside from the mistaken assumption concerning fish,
(Samburu avoid all contact with fish, a practice that divides the
Samburu and other Maasai sections from the El Molo and Turkana),
this might well have been a description of the core Maasai in its mat-
ter-of-fact tone of admiration.

Stigand's account of his journey in 1909 to Abyssinia (Ethiopia)
through Samburu country confirms that the attitude of the Samburu
toward white strangers was as restrained and unimpressed as that of
the Maasai had been in their encounter with Thomson a generation
earlier. Stigand later complained, "Finally the herdsman appeared,
cast a casual glance in my direction, and unconcernedly walked on, as
if a white man sitting beside the road was the most ordinary object in
the world. I was astonished and somewhat piqued at his want of inter-
est in me" (1910, 56). From then until World War II, there are virtu-
ally no descriptions of the Samburu outside government archives.
The fullest account of the postwar colonial period comes from a
recently published memoir, *Of Lions and Dung Beetles* (1999), by
Terence Gavaghan, who served as district commissioner in Samburu
district from 1952 to 1956. Gavaghan and his motley team of seven-
teen officers attempted to strike a judicious balance between overly
indulgent "Maasai-itis" (209) and colonial development programs
such as the destocking schemes that were so unpopular with pasto-
ralists. His character portraits are meticulous and ironic, especially
those of encounters between the Samburu and their colonial rul-
ers. Visiting Maralal while on his official governor's safari, the "most
aristocratic of aristocrats," Sir Evelyn Baring, delivered a dedicatory
address in the new Samburu Council Hall dressed in formal white
colonial splendor complete with sword, gloves, and plumed helmet
as well as buckskin breeches and spurs.

> Having studied Swahili, he enunciated carefully chosen
> phrases, such as "*Ninafurahi sana kuonana na wewe*"—delighted
> to meet you. . . . Stilted mannerisms seemed curiously suited
> to the pomp and circumstance of both Colonial hierarchy and
> Samburu patriarchy. . . . Lengerassi and his elders engaged

in lengthy, undulating hand clasping, meaningful looks and assurances that all was well except for a passing list of needs. . . . The Guard of Honour of Moran spearmen looked bravely straight ahead, as if we were not there, but stealing glances like Guardsmen everywhere. (200–201)

During his tenure, Gavaghan played a pivotal role as a cultural broker, introducing the Kimaniki age-set of Samburu warriors to Hollywood and vice versa. When he heard that the MGM safari film *Mogambo* was going to be made somewhere in the Kenyan hinterland, he traveled to Nanyuki to meet with director John Ford and the film's stars, Clark Gable, Ava Gardner, and Grace Kelly, to propose that they make it in Samburu District.

> We would offer a significant actor/Chief with up to 1,000 war-
> riors armed with spears on location near the humped moun-
> tain of Ololokwe on the Marsabit road. MGM would provide
> 3½ yards of best quality red silk cloth per man present on site,
> plus twenty-five shillings each for the 1,000 spears made by
> our metal workers and 7 pounds of meat per man per day [!],
> based on 300–400 Samburu steers, the hides to be retained
> for cash. In addition two refrigerators would be left for the
> new hospitals [at Maralal and Wamba] and a Willys 4-wheel
> drive station wagon ambulance would be imported and coach
> built locally. The agreement struck was unwritten but faith-
> fully adhered to. (202)

What is missing in this account is a sense of how the Samburu moran reacted to all of the sudden attention from this American cultural juggernaut, though Gavaghan does record their response (a "uni-versal growl") to Ava Gardner and her "undulating dove grey silk slacks" (202). In the final chapter, I take up this (literal) variant on warrior theatre with two Hollywood films of the 1990s for what they reveal about cultural capital, self-representation, and identity claims in postcolonial Kenya.

After their appearance in *Mogambo,* the Samburu "became some-thing of a cult for photographers and Hollywood film makers" in the 1950s; the films produced as a result of this contact included *Udongo* with Victor Mature and Janet Leigh and *Safari* with Rhonda Fleming and Macdonald Carey (203). But despite these government-approved celebrity incursions, Samburu District, unlike Laikipia

District to the south, allowed no white settlers and no tourist safari destinations. Political problems with Ethiopia and Somalia on its northern and eastern borders kept travelers as well as settlers out of Samburu country before the 1970s. Between 1963 and 1968, directly following Kenya's political independence, Kenya and Somalia each claimed ownership of the vast Northern Frontier District. The dangers of Somali *shifta* fighters armed with rifles kept the district closed to travel, and it was not until the reopening of the Northern Frontier District that outsiders other than government officials began to have any regular contact with Samburu.[18]

Just as it had been popular as a filming location in the 1950s, the Samburu Game Reserve at Buffalo Springs near Archer's Post on the Uaso Nyiro (Uwaso Ng'iro) River later became a destination for safari tourists. The Kenya Ministry of Tourism as well as Nairobi-based safari companies incorporated the Samburu into their advertisements about the unspoiled African bush much as they had used the core Maasai to advertise the popular southern game reserves of the Maasai Mara and Amboseli. This new postcolonial spectatorship was greatly multiplied by the production of coffee-table books (Ricciardi 1977; Saitoti and Beckwith 1980; Fisher 1984; Amin 1981; Amin and Willetts 1987; Pavitt 1991) and postcards that effectively merged the core Maasai and Maa-speaking Samburu into a single noble warrior representation beginning sometime in the late 1970s.

GOVERNMENT VOICES: SAMBURU

But it is important to realize that at the time of the Powys case in 1931, this romantic view of the Samburu had not yet been inscribed in colonial accounts. If there is a single word to describe the tenor of official reports on the Samburu in the 1920s and '30s, it would have to be "annoyance." The same good/bad, noble/primitive dichotomy found in descriptions of core Maasai appears in representations of the Samburu, despite the relative scarcity of literary accounts. The natives (in the Samburu District reports specifically, though Knowles and Collett cite very similar government complaints about the core Maasai) are unreliable, devious, useless, ineffectual, and lazy. Translated into more neutral language, this usually meant that while exhibiting a surface degree of civility and cooperation, they had no intention of obeying government directives that did not suit them

and in fact did not do so. As Terence Gavaghan learned at his first meeting with Samburu elders through their spokesman Lengerassi, even their public acknowledgment of colonial authority was contingent: "We see you, but we do not bid you welcome since we do not know you. When we have come to know you, we shall tell you what we think of you" (1999, 166).

In the Samburu case, the proof of their unreliability/deviousness/ ineffectuality was the fact that the government-appointed headmen could not or would not control the delinquencies of warriors. The British were reluctant at first to believe that the Maasai and Samburu had no traditional "chiefs" through whom they could affect their preferred policy of indirect rule. Lacking traditional centralized authority structures in most of Kenya, they were forced to resort to direct rule of the colony instead, though as Gavaghan (1999, 19) has pointed out, the white settlers in Kenya with their lobbying power and frequent social connections to Whitehall provided an otherwise missing layer of privilege, the essence of indirect rule, between the colonial government and the local population.

Among the core Maasai, certain *laibons* (prophets or diviners) were men of considerable influence who became de facto colonial chiefs.[19] Colonial administrators assumed that they held the same degree of influence in Samburu, though they rarely did. Thus, when the Samburu *loibonok* and the government-appointed headmen could not control the practice of what the British called spear-blooding, the government felt itself betrayed by the very men who were drawing a munificent salary of five rupees a month to spread the word that such behavior was not acceptable to the British. One of the accusations against Samburu warriors in these reports, that they were "cowards," is at first very surprising.[20] It appears in the earliest direct reference to spear-blooding in official texts, and initially one is hard put to explain why identical behavior by Maasai moran in the nineteenth century was regarded as "fearless" (Krapf 1860) but by 1921 in Samburu District was "cowardly."

But exploration is one thing, administration another. Apparently once pastoralists came under British administration, the details of some of their methods of fighting appeared considerably less heroic. In important ways they did not conform to the English notions of rules of military engagement or a gentlemanly code of honor: women and children were not spared. Lone, defenseless people were

sometimes attacked. Male fighters were routinely disemboweled and emasculated.

The focus of this disapproval was not on the core Maasai, who had already "had their claws clipped" by the government at the beginning of the colonial period, but on the outlying Samburu, far off in the Northern Frontier District, whose raiding activities could not be easily monitored or prevented. Yet not all British military officers disapproved of Samburu moran. Captain Erskine, the first acting district commissioner who made the charge of cowardliness, was an officer in the 5th KAR (King's African Rifles) who in 1921 began patrolling the Northern Frontier District from the supply depot at Archer's Post. A generation later when Nigel Pavitt (1991, 222) arrived in Kenya, also as an officer of the KAR, he had several Samburu in his command whom he characterized as fearless in action and "among my best men." Individual officers differed, but it obviously made a difference whether the Samburu were under one's command, in which case they could easily be heroic, or under one's surveillance and more likely to be the object of disapproval.

The main rivals of the Samburu were and still are the Turkana, who are much more numerous and whose desiccated land west and south of Lake Rudolf (now Lake Turkana) is much more marginal for the practice of cattle pastoralism. For reasons partly to do with culture and partly to do with sheer survival, the Turkana were more willing than the Samburu to cooperate with British schemes to incorporate them into the wage economy and provided willing labor for government projects as well as herding and milking on European farms in Laikipia.[21] They appear in reports as "virile, fertile and hardy" fighters and game poachers "who can survive anywhere and "eat up everything, from an elephant to a lizard, that they can lay their hands on."[22] The Turkana therefore were seen as a danger to the preservation of wild game and were constantly encroaching on Samburu grazing lands, but they were admired for their ability to endure under conditions of extreme hardship and approved of for their willingness to cooperate with government.

Samburu, in contrast, were not seen as a danger to game because they did not hunt and kill wild animals except in response to famine and predation and their numerous ritual food prohibitions precluded eating almost all wild species. They often were portrayed in these reports as annoyingly difficult and intractable compared to the

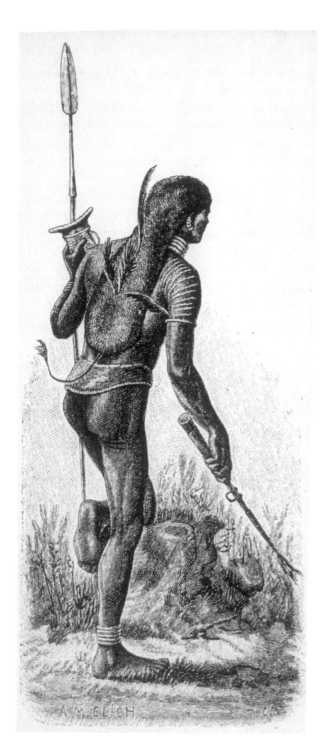

FIGURE 1.5.
A native of
Turkana.
*Source: Ludwig
von Höhnel,*
Discovery of
Lakes Rudolf
and Stefanie
(1894).

"earthy and simple" Turkana. For example, most administrators were either mystified or alienated by the seeming bizarreness and theatricality of the Samburu (and Maasai) practice of "shaking," a stress-induced bodily practice displayed by moran in the context of rivalry or preparing to fight that expresses the building up of an impossible level of tension.[23] This can escalate from initial shivering (*ikirikir*) to uncontrollable spasms (*ipush*) in which the affected person goes into convulsions and must be controlled by age-mates (e.g., Spencer 1985, 146–147, 149).[24] In my own conceptual framework it is part of that complex behavioral pattern of warrior theatre. Whatever it was, it certainly was not English and did not fit the conception of the fighting man as a rational actor or cog in the military machine. As an officer in Baragoi put it, "In the event of war, the Turkana would certainly win, as they would be able to mobilise 300 or 400 warriors while the Samburu were still working themselves up into the traditional state of frenzy."[25] It is in this context of official skepticism and the belief that young warriors were prone to irrational acts of violence that the government's handling of the Powys case must be seen.

SAMBURU SPEAR-BLOODING: THE POWYS CASE

On the 19th of December, 1931, a European named T. L. Powys disappeared while riding his pony to inspect a borehole on Lady Eleanor Cole's farm in Laikipia, the large fertile plateau north of Mt. Kenya and at the southern edge of Samburu grazing lands. This part of the plateau, located near Suguta Naibor, is known to the Samburu as the Pinguan. The next day, a search party found remnants of Powys's clothing, a boot containing one foot, and a few bones. The initial police report stated that he had been killed and eaten by a lion and other predators, and clearly some part of this sequence had happened. But rumors began to circulate of a more complex explanation of his death, and a few weeks later an ex-porter for the King's African Rifles testified that he had heard a group of Samburu moran at a dance singing of their exploit that "the vultures dropped on the Pinguan to eat one loved by the people of Nairobi" (Odhiambo 1973, 148).

After a long and exhaustive inquiry, the blame finally was laid at the feet of a group of moran of the Lorogishu section of Samburu. But for complicated reasons, they were acquitted in the end by a

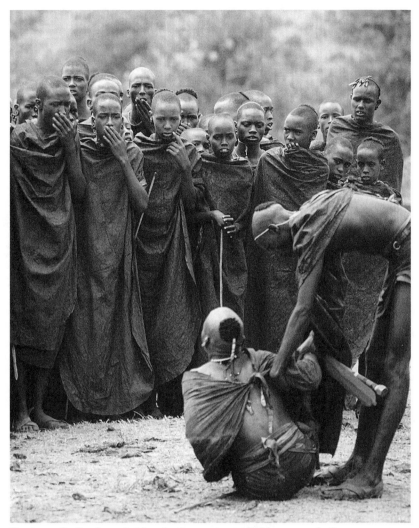

FIGURE 1.6. Samburu initiate having uncontrollable spasms before age-mates, who are singing the *lebarta* (circumcision song). *Source: Nigel Pavitt,* Samburu *(1991).*

court of appeals.[26] In retaliation, frustrated British colonial adminis-
trators, unable to stop the practice they called spear-blooding, insti-
tuted a total ban on Samburu warriors carrying spears in 1934.[27] This
ban, along with a fine that the Samburu had to pay collectively, stayed
in effect for over twenty years and radically altered the experience of
warriorhood from the mid-1930s to the mid-'50s. During this same

period, the artisanal practice of Samburu blacksmiths, the makers of these spears, also changed irrevocably.

A closer look at the narratives collected in the case reveals a good deal about British government strategies toward the Samburu, which counterbalanced the lobbying power of aristocratic white settlers in Laikipia with an official paternalism the settlers found overly permissive, since it prevented them from encroaching onto Samburu grazing lands. Although the Powys case was in many ways novel and ended in a standoff of sorts between the settlers and the Samburu, it is clear that the British were concerned from the beginning of colonial administration about their inability to control violence perpetrated by warrior nomads.

A captain in the King's African Rifles reporting from Archer's Post in the Northern Frontier District in 1921 wrote that Samburu moran were causing "considerable trouble by a series of murders . . . not for the purpose of stock [theft] but to blood their spears. They have recently been sending parties to murder the Gabra who have fled from Abyssinia for British protection. . . . If a firm hand is not taken and the Samburu made to understand they cannot blood their spears on any [defenceless person] at will they will eventually not only murder boys of settlers as has already occurred but even the children of the white settlers on their border on Laikipia."[28]

Casting spear-blooding as murder is to suggest that is it wanton and premeditated. Another, more paternalistic voice asserted that the problem was more structural and lay in the imposition of the Pax Britannica: "The existing moran system is now an anachronism which in these days can only lead to trouble, as it creates an idle class of irresponsible youth, who deprived of their former work of defending the tribe are bound to get into mischief."[29] This explanation of spear-blooding as more or less "youthful mischief" enabled the British to satisfy themselves that the morans' motive in the Powys case, as in others, was to salvage their reputations with their girlfriends. This explanation was accepted because it called into play a known aspect of warrior behavior at dances and reinforced the idea that these were adolescents out of control—but nothing more complex than that (see plate 1.).

The typical sequence of events that provided the accepted explanation went as follows: at a public gathering, warriors of the same section would cluster together to dance and sing, encouraged by groups

of girls (who were substantially younger than most of the warriors) who not only flattered when it suited them but also cajoled and even insulted the warriors with insinuations about their inadequacies—at either love or fighting. This kind of taunting is easily recognizable as a time-honored form of adolescent flirtation, but in the presence of rival groups of warriors from different sections it often took on the character of a challenge that could not be ignored (see Spencer 1965, 145–150). Following such an encounter, warriors might seek to repair their damaged reputations by spear-blooding, either in the form of raiding stock, challenging rivals, or occasionally, as in the Powys case, killing a lone individual. From the prima facie evidence presented to the court, this appeared to be what happened.[30] The following story was collected from Kushina Ole Ketachara (Leketachara), a Samburu of the Pusigishu (Lpisikishu) section:

> We fought the Lerogishu (Samburu) and we beat them and killed five of them. The Logumai (Samburu) girls told us that at a dance in a Logumai village the Lerogishu Moran came to dance and the Logumai girls said to them, "You are cowards, you ran away from the Pusigishu, why then come here and dance?" Twenty Lerogishu moran got very excited and went home. The next rains we heard that a white man had been killed at Il Pinguan. The Lerogishu said: "Do you still say that we are cowards now that we have killed a white M'sungu?"[31]

To corroborate this, several witnesses swore they had heard warriors singing the song about vultures dropping on the Pinguan. One, Kiberenge, was the ex-KAR porter who lived under the Lorogishu headman. He stated that while in the headman's village, he saw six Samburu moran arrive armed and that one was carrying something under his cloth. He also claimed that he overheard them say they had killed and mutilated a European and that the headman swore them to secrecy and arranged for the disposal of Powys's head while offering him, Kiberenge, five cows for his silence (Odhiambo 1973, 149). Kiberenge thus broke his oath and was eventually killed by the Samburu, even though he later retracted his statement under intimidation by the district commissioner in Rumuruti (150), who much preferred the simplicity of the original lion hypothesis. But despite the district commissioner's intervention, the story refused to go away. In November 1933, nearly two years after the murder, a Torrobo

FIGURE 1.7. Warriors and uninitiated girls singing near Maralal, Kenya, 1996.
Photo by author.

witness reported to another settler, Mr. G. Colville, that he had come
upon the Samburu right after the murder had taken place:

> I was looking for my lost sheep at a place called Loberik. I
> saw five Samburu and spoke to two; the other three stood by
> a tree about 300 yards away. . . . I told them I was a Dorobo
> and was looking for my lost sheep. . . . I was afraid they might
> kill me. They were not wearing their shukas [cloths] hanging
> down but rolled up round their waists [as when fighting].
> Each had two spears. One . . . had blood on it. I did not ask
> about the blood as I was very frightened. . . . It was not until
> the following day but one that I heard a white man was lost.
> As soon as I heard that he was dead, I thought to myself the
> Samburu had killed him. (151–152)

The investigation was reopened in December 1933, and the head
of the moran of the Lngwesi section, Champati Ole Lasoni, made a
statement implicating two Lpisikishu moran who were subsequently
arrested and sentenced to death, though they denied having mur-
dered Powys. The government, assuming that the *loibon* Ole Odume
(Ledume) of the Lorogishu would be busy advising the Lorogishu
behind the scenes and would therefore be an obstacle to the inves-

tigation, arrested him and deported him to Kwale on the Swahili coast.[32]

The British officials carrying out the investigation were especially angered by the defiant attitude of some of the moran, including Champati Ole Lasoni, who later freely admitted he had lied to them. The district commissioner of Isiolo complained that "they assumed an attitude of casualness, defiance and indifference," so he ordered them to be caned (Odhiambo 1973, 153), in keeping with this parental model of colonial relations. The government then weighed in with the threat of a large collective fine if the Samburu elders did not produce the real culprits.

None were immediately identified, so a hefty fine was imposed under the Collective Punishment Ordinance (1930). And in a long-reaching move, the administration also decided to create a separate Samburu District with its headquarters at Maralal beginning in 1934 in order to establish an active government presence there and discourage further acts of insubordination.[33] Finally, in September 1934, nearly three years after the incident, some Torrobo informants came forward and told the police the names of five Lorogishu moran they had seen at the time of the murder, one of whom was carrying the head. These five were subsequently tried by the High Court but in the final twist in an already convoluted narrative, they were acquitted, presumably for lack of adequate evidence.

This enraged local administrators, who (correctly) saw that the Samburu would interpret the result as meaning that the government was toothless and the court system benign. As the district commissioner in Maralal bitterly reported,

> They [the Samburu elders] were very angry about the matter and wished to fine the acquitted man heavily. They were lost in amazement at the course of British Justice. They had to pay for a Levy Force which was imposed mainly to get evidence of murders. The evidence was produced and the murderer, everybody knew he was the guilty person, was also produced. The inquiring Magistrate committed him and the Supreme Court judge found him guilty, and sentenced him to be hanged but the far-away Big White Rulers [the High Court of Appeals sitting in Nakuru] said he was not guilty: they returned him to his home unscathed, and the Levy Force, and the cost of it, went on. . . . It is easy, in Nairobi, to express

sympathy with the Local Administration in Samburu, but that in no way helps one to explain away a very embarrassing situation. (Sharpe 1936, 4–5)[34]

It equally angered the white settlers in Laikipia, who demanded a commission of enquiry and took the case all the way to the governor, Sir James Byrne. When that failed to produce results, Lady Eleanor Cole, using her personal social connections, brought it to the attention of the secretary of state for the colonies in Whitehall. The settlers, led by the Earl of Erroll, Gilbert Colville, and Lady Cole, argued that with the acquittal, the spear-blooding would surely continue and that the government's "well-known lenience" in dealing with the Samburu encouraged the morans' wild and audacious behavior (Odhiambo 1973, 154–159).

But there was an important subtext in the settlers' outrage: the colonial government had been considering since about 1926 the possibility of removing the Samburu from their high-altitude pastures on the Lorroki (Leroghi) Plateau in order to accommodate more settler ranches. Ultimately this scheme had to be abandoned because there was no adequate place to which they could be relocated.[35] But settler outrage at spear-blooding was partly a strategy to advance the cause of alienating the land on the Lorroki Plateau from the Samburu to themselves. In a memorandum to questioners in the House of Commons, they wrote:

> We are face to face with a custom of blooding spears and with a tribe which practices it. That is the tribe which is now to be rewarded by the gift of a large tract of land on the Leroghi Plateau, from which they have descended upon us to commit these murders. (Odhiambo 1973, 159)

Being "rewarded with a gift" of land that the Samburu already occupied and therefore by the laws of pastoralism possessed may seem bizarre, but this after all was a discourse about the spatialization of power. The Laikipia Plateau where European settlement was allowed was demarcated from Samburu territory to the north by the so-called Kittermaster Line.[36] This effectively divided not just grazing land but rival claimants for the same territory, each imbued with what they saw as natural rights of possession.

What was being talked about here was not only the practical issue of grazing rights but a contested cultural space. The colonial government in wielding its power had to deal with a spatial domain and

its subjects but also, at another level, with an independent cultural reality with its own laws and the possibility that those laws could be disturbed (Foucault 1984, 242). The thrust of colonial policy was to transform an open unprotected space—here, the Laikipia Plateau—into a closed and protected space for European occupation. At the same time, these policies would reserve the adjoining Lorroki Plateau and its fertile uplands for the Samburu alone. But as outsiders, colonial officials made cultural assumptions about the local rules that did not always correspond to indigenous practice.

Within this independent cultural reality, the Samburu elders and colonially appointed headmen as well as influential ritual specialists such as Ledume appeared to control the age-grade and ritual systems and thus indirectly the behavior of the moran. But in fact, in the vast spaces beyond the elders' settlements, no one controlled the *lmurran* but their own leaders, the *laigwenok*.[37] Whether or not their motives were self-consciously political in the sense of a nascent nationalism (and Odhiambo argues convincingly that they were not), the Lorogishu moran were staking out a territorial claim to a hegemony over the Pinguan that predated the British claim. It is in this light that their song should be understood: "The vultures are dropping on the Pinguan to eat one loved by the people of Nairobi." At the center of this discourse is the Pinguan, underpopulated land the colonial government alienated from pastoralists and gave to European settlers. But who are the vultures and what is it that is being eaten?

Ricoeur (1971, 557–558) has argued that "what has to be understood is not the initial situation of discourse. . . . To understand a text is to follow its movement from sense to reference, from what it says to what it talks about." What the Song of the Vultures appears to say is that a murder was committed as proof of masculine daring in the face of female skepticism. But at a more referential level it is about the claiming of power, spatialized in the form of colonial intrusion on the Pinguan. The government's explanation focused entirely on the first: the taunts of girls that caused warriors to go out and blood their spears. In this characterization, they removed the motive from the setting of the action—a contested space—and relocated it within an easily understood and essentially transparent apolitical one of adolescent delinquency.

The other missing element in the government's explanation is that it treated the triggering incident in 1929, the taunts of the Lukumai (Logumai) girls, as if it had no history in a longer discourse

of competition between the two groups of moran. Logori Lelengua, a surviving Lpisikishu member of the Lkilieko age-set, asserted that rivalries had built up between the Lorogishu and Lpisikishu moran over a number of years prior to the Powys case, including several deaths and the theft of animals on both sides, a point Spencer confirmed (1965, 117).[38] Altogether, the comparative leniency of the punishment—a collective fine and the dispatching of a levy force— reflects the "youthful mischief" rhetoric of the official reports.

The money collected was used to pay for the imposition of the levy force of "fifteen Kenya Police Rank and File under a European officer" that remained in Samburu District for nearly a year.[39] While the deployment of so few police in so vast a space may seem slightly ludicrous (the Lorroki Plateau alone occupied almost 1,000 square miles), they were there not only to collect evidence of several spear-bloodings by moran south of the Kittermaster Line but also as a reminder of the administration's power at such events as the circumcision ceremonies of 1936, which marked the passing out of moranhood of the Lkilieko age-set, the perpetrators of spear-blooding murders in the late '20s and early '30s.

Not content with policing, the colonial administration also tried to reform moranhood itself. These reforms included reducing the period of moranhood, encouraging moran to marry earlier, prohibiting meat feasts in the forest (assumed to be the occasions at which the spear-bloodings were planned), prohibiting moran from giving *somi* beads to their girlfriends (another practice defined as triggering the spear-blooding urge), and, most radically, banning the carrying of spears themselves by bachelor moran. None of these prohibitions proved to be enforceable in the long run, and all the practices were eventually reinstated by the Samburu, but they nonetheless had important repercussions for warriorhood, body arts, and blacksmithing. One obvious reason the changes did not stick was the inability of the government to enforce them. The other was the assumption on the part of the British that they could eliminate cultural practices that did not fit their model of improving the "native" without attacking deeply held Samburu ideas about manhood. In the chapters that follow, I will show that such a separation was impossible.

2

IDOMA WARRIORHOOD
AND THE PAX BRITANNICA

Ichahoho olébè òche *(Ichahoho eats [the meat of] human beings)!*

> —War cry formerly sung by the Ichahoho mask,
> Ekpari clan, Akpa District

By contrast with that of the East African pastoralists, Idoma warriorhood in central Nigeria was inscribed within a much more widespread and formulaic colonizing discourse: barbarism that had to be eradicated in order to bring civilization in Africa. David Livingstone, the nineteenth century's most popular explorer-missionary, summed up the more benign representation of this civilizing mission: "We come upon them as members of a superior race and servants of a God that desires to elevate the more degraded portions of the human family" (Jeal 1973, 382).[1] Frederick Lugard, the great architect of British colonial policy, justified colonization much more graphically fifty years later:

> The South [in Nigeria] was, for the most part, held in thrall by Fetish worship and the hideous ordeals of witchcraft, human sacrifice, and twin murder. The great Ibo race to the East of the Niger . . . and their cognate tribes [e.g., Idoma] had not developed beyond the stage of primitive savagery. In the West, the Kingdom of Benin—like its counterpart in Dahomey—had up to 1897 groaned under a despotism which revelled in holocausts of human victims for its Fetish rites. (Lugard 1919/1968, 56)

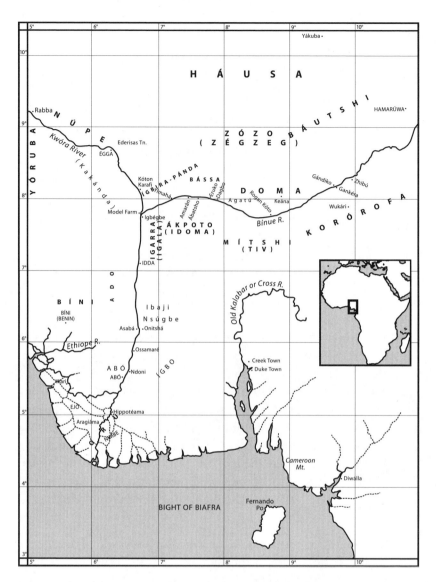

FIGURE 2.1A. Route of the Baikie Expedition up the Niger and Benue Rivers in 1854. *Source: William Balfour Baikie,* Narrative of an Exploring Voyage up the Rivers Kwóra and Bínue *(1856). Map drawn by John Arrowsmith.*

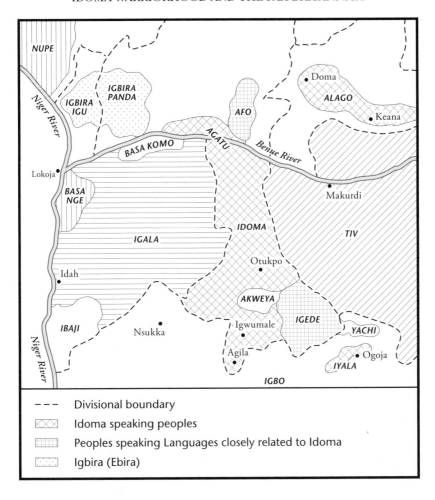

Such statements are discursive strategies in which a layer of rhetoric disguises any empirical observation. It is easier to examine and peel away these layers of supporting fiction in the Samburu case because of the extensive documentation of warriorhood in government reports and memoirs and because warriors still exist, not only as stock raiders but in the context of the age-grade system that still forms the central organizing principle of Samburu social life. In Idoma, this process is much more difficult. There were (and still are) informal age-sets in some communities but never formal age-grades, so that entry into (and exit from) warriorhood was not ritually marked as it is with the Maasai subgroups.

For this and other reasons, colonial period reports say little about Idoma warriors per se. What one finds instead is extensive documentation of the behavior of the dance guilds and masking societies, whose active membership drew most heavily on the young men's age-sets. Not all masking societies were associated with warfare, but one, the Oglinye[2] society, is well documented in this regard over a large area of eastern Nigeria. I will take Oglinye as a paradigmatic case, though it was by no means the only example of how Idoma warrior-hood operated in the period immediately preceding and following British colonization.

IDOMA AND SAMBURU ORGANIZING METAPHORS: THE LAND, AUTHORITY, SACRALITY

In the humid Benue River Valley in what is now central Nigeria, a pattern of warriorhood developed among small independent chief-doms that, despite vast differences in ecology and social organization, shared broad structural similarities with the warriorhood of East African pastoralists. While the Maasai and Samburu had no "chiefs" or titles prior to the colonial period, they were (and in many ways still are) nonetheless gerontocracies ruled by senior elders who controlled marriage alliances, cattle, and grazing rights. Warriors were called upon to defend settlements against stock theft by rivals and enemies and to carry out stock raids themselves, but they had no wives or herds of their own and were under the surveillance of elders.[3] The Idoma were also ruled by gerontocracies, but these consisted of hereditary title holders (*igabo*) under the nominal leadership of a priest-king (*oche, ocaaje*) who represented the "owners of the land," all of whom venerated the same earth shrine (*ikpaaje*). In both polities, all adult males had the right to attend open meetings and speak, though the weight of their opinions was modified by age and personal reputation. If the Samburu had no sacred chiefship in this comparison, the Idoma had no cattle.[4] The central organizing metaphor in one culture was missing in the other.

The Idoma today are still primarily yam and millet farmers who live in scattered settlements among their cultivated fields south of the Benue River, but prior to the imposition of the Pax Britannica, most of the Idoma apparently dwelled in compact villages surrounded by either protective forest or moats, with outlying farm harmlets.[5] Yams

were ritualized in the southern kingdoms, but in the central and northern polities, millet and guinea corn were at the center of the mythopoeic imagination. In a chant that is performed for the appearance of the ancestral masks (*alekwuafia*), Idoma identity is fixed as originating in Apá (Kwararafa), a historical site but also mythic place of dispersion, farther east (Amali ca. 1972, 3):

> Where did Alekwu first come from?
>
> Before the Alekwu came to the Land of Otiya, home of Odu, who digs scorpion holes and snake holes? . . .
>
> Alekwu came from Apá.
>
> Apá that originated guinea-corn,
>
> Apá that originated millet.

Idoma identity is thus ineluctably drawn into a concept of place that is closely tied to the ancestors, the Alekwu, as Owners of the Land and is materialized in the ancestral masks, *alekwuafia*. Place assumes a different importance for pastoralists such as the Samburu. They hold certain sites to be sacred, and the long initiation process for boys includes ritual treks that are carried out partly to enable them to construct memories of former homes, such as Mt. Marsabit. But while the sacrality of the land is a crucial belief for the Idoma, the Samburu express this instead through its products: grass and milk (itself the product of grass and cattle). Grass and its life-giving properties, in the form of a woven circlet for the waist, is the first covering a Samburu baby is given. When grass is proffered as a handful pulled straight from the earth, it is a declaration of peaceful intention and absolute protection against attack by another pastoralist.

In the broadest sense, warriors in both Samburu and Idomaland were protectors of the land. But whereas in Idoma the truce lines between neighboring groups were exact and uncompromising (and therefore the source of fighting whenever encroachment occurred), they were necessarily more fluid among pastoralists in northern Kenya. The El Barta plain "belonged" to the Samburu at the beginning of the colonial period, but it was often full of Turkana and their herds. In times of drought, hostilities would/do erupt over these contested spaces, but much of the time, there was/is a kind of accommodation that would not be possible with cultivated land. It would therefore be more accurate to say that Samburu warriors defended

(first) their fathers' herds and (second) their grazing rights to certain land. Idoma warriors, on the other hand, were responsible for the defense of very particular spaces and boundaries that included within them people, crops, and settlements.

In Idoma, people are buried within the family compound, with the result that the earth of that place is literally the abode of the ancestors. The Samburu do not believe in an afterlife or reincarnation or even in "ancestors" in the usual African sense of a collective elder dead who exert moral and psychological control over their descendants. Before colonialism, the corpses of all but very important Samburu were left unburied, to be consumed by wild animals.[6] And so the idea of a homologous ancestral world existing beneath the surface of all inhabited settlements, which is highly developed among the Idoma and other Nigerian people, would be inconceivable in Samburu cosmology. Furthermore, in Idoma cosmology, nonancestral spirits—those of animals, trees, streams, strangers, enemies, or even other Idoma who died of unnatural causes or without a proper funeral—may also inhabit unoccupied stretches of forest. It is through masking that spirits visit human settlements from their normal abodes elsewhere, and it is this set of beliefs that enables the Idoma to connect warfare—the defense of the Land, Aje, against encroachment—with masking. Warriors' masks embody the spirits of slain enemies. Their "home" is not the village or farm but the bush and those dangerous places beyond human control.

In Idoma, as elsewhere in the Benue Valley, the ideology of sacred kingship endured, but because of the laws of collateral succession, the king was (and still is) often a very old man who is too fragile to carry on the day-to-day business of the court.[7] He therefore relied on the *igabo* to advise him, and they in turn relied upon younger men of warrior age to defend their communities and their surrounding farms and forests against incursions by neighboring rivals. Despite the major differences in material culture, social organization, and ritual structure and practice, the warrior (*ogwu, ogbu*) occupied a place in precolonial Idoma life that was very comparable to that held by the moran in Maa-speaking groups on the opposite side of a continent.

In both cases, young men were responsible not only for the defense of their communities but also (as are soldiers in modern states) for the frequent excesses that enraged their elders and, later

on, the British colonial authorities. These excesses ranged from minor infractions such as stealing someone's goat to major excursions involving both illicit property and human lives. And in Idoma, as in Samburu, no young woman would willingly accept a husband who had not demonstrated his bravery in battle. In Idoma, however, as elsewhere between the Niger and the Cross rivers, this rule became codified: until a warrior brought home an enemy head, he was not considered ready for marriage. Head-winning became the main rite of passage to social manhood. This was so partly because circumcision, the most important maturation ritual for the Samburu and many other pastoralists, was (and still is) performed soon after birth by the Idoma and therefore had nothing to do with the passage from adolescence to adulthood.

POISONOUS VAPORS, WHITE MALAISE

The description of Idoma warriorhood in colonial texts and, eventually, colonial policy was embedded in a completely different colonizing discourse from that of the Maa-speaking pastoralists. This was despite the fact that the British formally created the administrative units known as the East Africa Protectorate[8] (1895) and Nigeria (1900) at about the same time and the men who directed policy implementation answered to the same Colonial Office back in London and were sometimes even the same people.[9] As agents of conquest themselves, the British ought to have understood the importance of the metaphors of conquest when they met them in the institutions of warriorhood in tropical Africa. But in West Africa, these institutions were clouded with a miasma that seemed to arise from every route of approach.

If the Great Rift Valley and its surrounding mountains evoked a region whose high altitude and bracing healthy climate was ideal for white settlers, large parts of British West Africa were perceived to be the opposite. Here endemic diseases and the sultry tropical climate shaped a popular nineteenth-century view of the Guinea Coast and its hinterland as the "White Man's Grave." The tropical rainforest was oppressive and humid and harbored legions of mosquitoes and tsetse fly. Not only malaria and sleeping sickness but blackwater fever and yellow fever claimed the lives of early European travelers, soldiers,

and traders in alarming numbers.[10] Europeans who traded at ports such as Bonny in the Niger Delta were thought to risk their lives by simply breathing the air (Burdo 1880, 88–89):

> When the wind, blowing from the interior, brings the ema-
> nations with which it is charged to the mouth of the river,
> an indefinable *malaise* takes possession of the most resolute
> Europeans, and if, every day at the retreat of the tide, the sea-
> breeze does not blow away the miasma they have been breath-
> ing and refresh the lungs, no one can resist the effects of the
> climate. In 1873 the sea-breeze ceased to blow for a fortnight;
> there was nothing but the pestilential air of the marshes to
> breathe and it was charged with fetid vapours; not a day passed
> without some of the whites falling ill, and one morning they
> were attacked by yellow fever. There were forty-six of them, all
> robust men. . . . Four only escaped the pestilence.

In short, there was in this region, which extended inland from the mouth of the Niger, a terrifying alterity that had to do not only with seemingly barbarous attitudes toward human life but even with the land and air itself, which seemed to emanate their own peculiar poisons. While the death rate from malaria improved dramatically after the introduction of quinine in 1854 (McLynn 1992, 56), all the other diseases to which both Africans and Europeans succumbed were still present. Furthermore, there was nothing that could be done about the enervating weather or the demanding rulers or the number of people per square kilometer, all features that were notably absent in most of East Africa.

All these limitations were eventually translated into a colonial pol-icy that recognized, in the gray prose of the official *Nigeria Handbook* (Wilson-Haffenden 1930, 21), that "except perhaps on the Plateau, the Nigerian climate is not a healthy one for Europeans, and Nigeria shares with the rest of West Africa an unenviable reputation in this respect." Accordingly there was no policy of white settlement and the settler voice did not participate in the inscription of Idoma (or any other) Nigerian warriorhood. Settlers' voices could be adversarial, as in the Powys case, when their interests were directly threatened. But they were also the twentieth century's remnant of the previous century's adventurers and therefore, at least in Kenya, the spinners of tales of the primordial Africa. In such a discourse, the warrior was

inevitably a heroic figure. In Nigeria he was seen instead as treacherous and a threat to peaceful governance.

THE RHETORIC OF KILLING AND EATING

In many of the communities inland from the unhealthy West African coastal miasma, ideas about virility and violence in fact converged in ways that were very similar to the Samburu/Maasai ideal of manhood. Yet because they were embedded in a very different context, British officialdom read these same notions and their related set of practices as an almost impenetrable challenge to the civilizing mission. Headhunting, as we have seen, stirred deeply negative feelings among the earliest colonizers of the new Nigeria and their supporters back home in England. Furthermore, the British newspaper-reading public did not distinguish between the taking of enemy heads in warfare, which was widespread in central and eastern Nigeria and the neighboring regions of Cameroon, and cannibalism, which in Idomaland and much of the Lower Benue River region actually meant the metaphorical "eating" of the body by a witch.

Even in official anthropological circles, these very different practices were subsumed into a single rhetoric. In the mid-1920s, Charles Kingsley Meek, the Nigerian colonial administration's most peripatetic anthropological and district officer in the northern provinces and the author of a major ethnography of the Jukun as well as important ethnological reports on the Idoma and Igbo, devoted a section of *The Northern Tribes of Nigeria* (1925, 2:48–58) to "Head-hunting and Cannibalism": "All the cannibal tribes were head-hunters, but many head-hunting tribes were not cannibal [at the time of pacification prior to World War I] and deny ever having been so. Some of these protest too much, as they have clearly only recently abandoned anthropophagy" (48). Meek then listed twenty-seven headhunting tribes (including both Idoma and Okpoto) and another thirty-five, the so-called hill tribes of the Jos Plateau, who had been "admittedly cannibal." The reader is left with the impression that many of the headhunters were cannibals in a state of denial, as it were. Meek was prepared to see evidence of former cannibalism even in such varied practices as masking and witchcraft beliefs (57), though apparently only in the African context.

A few years later, in 1929, allegations of Tiv ritual murder and cannibalism to the east of Idomaland created an uproar in the Benue provincial administration. Despite probing government investigations (which became known among the Tiv as the *haakaa,* "throw things away," or the *pasepase,* "confess"), no shred of physical evidence of the practice ever came to light, but there were numerous claims and counterclaims that today would be subsumed under the general rubric of witchcraft accusations (Akiga and East 1939/1965, 275–295).[11] The Tiv cannibalism debate simply lent fuel to an already undiscriminating public appetite in Britain for stories of lurid barbaric practices in the far reaches of empire.

A third practice, that of human sacrifice, had come to the public's attention with the publication of H. Ling Roth's *Great Benin: Its Customs, Art and Horrors* (1903), which included an eyewitness account immediately after human sacrifice on a large scale, committed ostensibly in the hope of preventing the siege and burning of Benin City by the British in the Punitive Expedition of 1897. This too was assimilated in the public mind with headhunting and cannibalism as one interrelated set of practices. Meek proposed a novel theory that human sacrifice, such as was found in Nigeria south of the Benue River, was a "more culturally advanced stage" that had evolved out of cannibalism (1925, 2:57). Given the collective weight of all these ideas, it is scarcely surprising that in British colonial discourse, headhunting became a scourge that had to be eradicated.

IDOLS, CURIOUSLY PAINTED

Another factor that was unrelated to these but added one more layer of ill regard was the popular reading of West African religious practice as fetishism. The Idoma, for example, owned both masks (incarnations of spirits, *ekwu,* called devil-dancers in the earliest colonial reports) and powerful protective icons and medicines (*eka,* the so-called fetishes) as a part of a complex and multilayered religious practice. To the travelers who initially reported them to the book-reading European public, this protective function was totally unfamiliar as belief or representation and appeared to be evidence of the worship of idols. While none of these writers would have had any difficulty distinguishing between an icon and an idol in representations of the Virgin Mary, they had no familiar hook on which to hang

such ideas when they encountered them in West Africa. The ideals of warriorhood and misconstrued "idolatry" converged in the Igbo and Ibaji *ikenga* figures south and west of Idoma country, one type of which depicted the warrior seated on a stool and holding in his right hand the killing knife and in his left the trophy head. The *ikenga* is often described as a shrine to a man's right hand in the sense that the right hand holding the knife (that of the shrine owner himself) metaphorically represents the ability not only to kill enemies but to cut through ambiguities and solve problems (Boston 1977; Cole and Aniakor 1984, 24–34). It is therefore an image that represents ideal manhood.

Adolphe Burdo, a member of the Belgian Geographical Society, visited a riverine Igbo ruler called Oputa during his trip up the Niger in 1878. After a repast was served, Oputa stepped upon a ledge, "near which were placed three wooden idols, curiously painted; a sort of *lares*, called *Tshi* [*Chi*], *Ikenga*, and *Ofo*." After addressing a blessing to each of his wives, he "seized a jar of palm wine, poured some of it on the heads of the three idols, while he invoked upon himself, his family and his deceased relatives, the favours of Tshuku [Chukwu]." After this there was "bacchanalian revelry before the idols, which went on all night" (1880, 186–187).

Despite the attempt at accuracy—Burdo recorded the names of each figure and asked his Onitsha traveling guide about the content of the invocation—it is impossible, given his imperial presuppositions as well as his state of complete ignorance of Igbo belief, for the narrative to move beyond the exteriority of description to any sense of the meaning of what had just happened in this small but important ritual enactment. What remained in the minds of Victorian readers was "idols, curiously painted" seen against a backdrop of "bacchanalian revelry." Though in other passages Burdo devoted his attentions to Igbo warfare, he assigned the figures he saw to a different Victorian cultural script—that of idolatry—that bore an as-yet-unexplained relation to the narrative of "headhunting and cannibalism."

By invoking the starkest contrasts across time and space, Chinua Achebe's novel *Arrow of God,* which is set during the early colonial period in an Igbo community, provides a different reading of the meaning of *ikenga*. In a violent exchange, a temperamental younger man, Akukalia, is enraged by a stinging insult and starts a fight with the older Ebo. The latter, unarmed, makes for his house to seize his

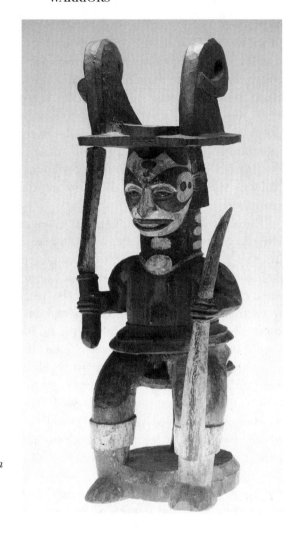

FIGURE 2.2. Igbo *ikenga*
figure. *Courtesy of
Michael C. Carlos
Museum, figure on loan
from William S. Arnett.*

matchet. Akukalia, out of control, rushes after him, enters his *obi*,
takes the *ikenga* from his shrine, and, while everyone watches in hor-
ror, splits it in two:

> Ebo rushed toward Akukalia and, seeing what he had done,
> stopped dead. . . . The two pieces of his *ikenga* lay where their
> violator had kicked them in the dust. . . . Ebo turned round
> and went into his *obi*. At his shrine he knelt down to have a
> close look. Yes, the gap where his *ikenga* of his ancestors had
> stood stared back at him . . ."Nna doh! Nna doh!" he wept,

calling on his dead father to come to his aid. Then he got up and went into his sleeping room . . . and came into the *obi* with his loaded gun. At the threshold he knelt down and aimed. Akukalia, seeing the danger, dashed forward. Although the bullet had caught him in the chest he continued running with his matchet held high until he fell at the threshold, his face hitting the low thatch before he went down. . . . When the body was brought home to Umuaro everyone was stunned. . . . But after the first shock people began to say that their clansman had done an unforgivable thing. . . ."Let us put ourselves in the place of the man he made a corpse before his own eyes," they said . . ."What propitiation or sacrifice would atone for such a sacrilege?" (1964, 26–30)

While the Idoma had no *ikenga,* there were similar types of protective figures in their repertory of images: those of *anjenu* water spirits, for example, or the famous *ekwotame,* an icon of prosperity and well-being couched in a maternal idiom. These were offered in government reports as further proof of the supposed barbarity of people such as the Ekpari clan of Akpa District, who not only possessed "juju" (the pidgin term for power emblems) but had at one time displayed the heads of enemies from a tree in the Otobi village meeting ground. They also had made occasional human sacrifices (usually slaves captured in warfare) on auspicious and rare occasions, such as the installation of a sacred king. After the onset of colonial rule, they substituted horse sacrifice for human victims, and trophy heads gradually disappeared.[12] All of these practices put them, in the eyes of the British administration, well beyond the pale of civilization.

OGLINYE: FROM TROPHY HEADS TO MASKS

Like "spear-blooding" in East Africa, "headhunting," human sacrifice, twin murder, fetishism, and cannibalism became the recurring topoi of early colonial discourse of "pacification" in Nigeria. Idoma warriorhood and its corollary, the taking of trophy heads, appear as a series of disconnected fragments in this official inscription, which I augment here with oral commentaries and details drawn from actual masquerade performances in the 1970s and '80s. Any construction of Idoma warriorhood before 1900 must be done without precolonial written accounts from eyewitnesses. The Benue region was too

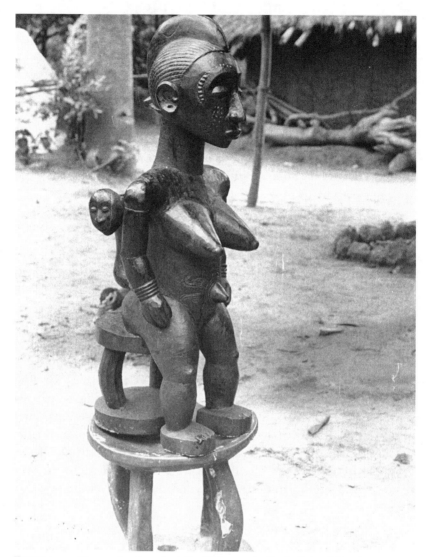

FIGURE 2.3. Idoma *ekwotame* (spirit-with-breasts), Otukp'icho, Nigeria, 1977. *Photo by author.*

far south to have been on the Saharan caravan routes and therefore documented by the Arab chroniclers who visited Bornu, Sokoto, and Kano and too far north to have been reached by European coastal exploration and trade before the mid-nineteenth century (and even then it was rarely mentioned).[13] The picture of warriorhood I sketch here is therefore a tentative one, based on regional

nineteenth-century travelers' accounts, colonial ethnography in the Benue region, and the recollections of Idoma born before the Pax Britannica that I recorded in my fieldwork of 1976–1978 and 1986. In addition to filming mask performances that thematized fighting behavior within a ritual frame, I talked at length with elderly Idoma who remembered the coming of the white man on the first British military patrols in about 1908 (e.g., Kasfir 1989) and the changes this brought.

Unlike in Samburuland, there are no young men in Idoma today who think of themselves as "warriors," though the Oglinye and Ichahoho association masquerades are still occasionally performed at second burials (commemorative funerals) of their members. It was through filming these in the late 1970s and '80s and getting to know the oldest members of these two associations that I gradually came to understand at least a part of what warriorhood had meant to the Idoma in the early part of the twentieth century.

The demise of Idoma warriorhood as a publicly sanctioned institution, while datable in a formal sense to the arrival of British military patrols in the Idoma lands between 1908 and 1914, was in fact more attenuated than that. The enforcement of the Pax Britannica and therefore the end of internal warfare did not mean a simultaneous end to taking heads. For one thing, young men were still embedded in a social system that required each of them to produce a head in order to be eligible to marry. After World War I, there was a mild boom in native rubber that brought an influx of Hausa and Igala traders into Idoma country, and it is alleged that these strangers were convenient targets for this purpose. At the time that Crocker was posted as a junior officer to Otukpo in 1933, his young Idoma messenger told him that there was scarcely an Idoma male his age who had not killed at least once (Crocker 1936, 76).

Seeing that the practice persisted beyond the suppression of warfare and having no idea of what to do about its social significance, the British took steps to outlaw the Oglinye dance in 1917 (see Kasfir 1988, 96). While dances using actual skulls may have been effectively suppressed by sometime in the late 1920s (there is a description by a district officer of a performance in 1925), Oglinye and its cognate masks, Ikpa and Ichahoho, did not disappear; instead, it "went to the bush." What this meant was an avoidance of daytime performances or performances near administrative centers. The system of masks

was too central in Idoma life to be simply legislated away through intimidation.

The concept of masking is very old in Idoma culture and occurs for multiple reasons: the ancestors (in Idoma, exemplary male elder dead with adult male descendants) are reincarnated periodically in the form of elaborate and powerful masquerades. These, the *alekwua-fia*, are embodiments of the lineages who exercise hegemony over the land and who formerly held the power of life and death in their hands as they passed judgment on accused wrongdoers. At the opposite extreme are "modern" play masks donned by male children and youths to cadge money out of passersby during Christmas holiday appearances. Somewhere between these two extremes are the young men's age-set masks, worn by members of various dance associations (*aiije*) and "secret societies" (*aiekwu*)[14] to entertain but also to discipline, since masks are spirits, not just men in costumes, and masking behavior lies outside the boundaries of everyday rules of social interaction (see plate 2).

The relationship between Nigerian masking and warfare has been little studied outside the Cross River region (Partridge 1905; Talbot 1926; Nicklin 1974, 1979; Salmons 1985). But Otobi village people say that the towering aggressive clan mask known as Akpnmobe, which today is seen only at the climax of a three-day second burial celebration, formerly was used to lead warriors of the Ekpari clan into battle. The point was to frighten and rout the enemy, and the threat of an eight-foot-high spear-wielding mask making its way toward one through the tall elephant grass was not to be taken lightly.

But it is the conjuncture between masks and trophy heads that most concerns me here. The earliest regional reports of warriors' dances (Talbot 1926, 3:788–789) among neighboring Igbo and Cross River groups describe them thus: "The Ogirinia members are the chief warriors, and always lead their town forces in battle. . . . In most of the plays, especially among the Semi-Bantu, head-dresses are worn consisting either of real skulls or of wooden imitations, sometimes covered with human skin" (see plate 3). Other early-twentieth-century sources describe the warriors dancing with either the jawbones or crania of the enemy in their hands instead of atop their heads. Enemy heads were also attached to the large war drums (*ikoro*) in northern Igbo communities (Cole and Aniakor 1984) or displayed in the village meeting grounds. An Idoma District officer saw a war

ABOVE: FIGURE 2.4.
Idoma-Akweya
children's masquerade
group, Otobi, Nigeria,
1986. *Photo by author.*

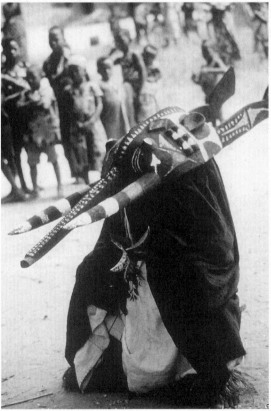

LEFT: FIGURE 2.5.
Idoma Itrokwu
masquerade, Otobi,
Nigeria, 1986. *Photo by
author.*

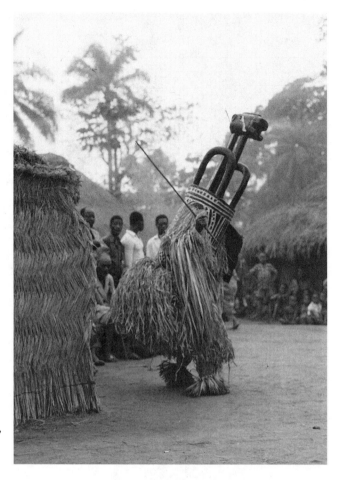

FIGURE 2.6.
Akweya
Akpnmobe
masquerade,
Otobi, Nigeria,
1978. *Photo by
author.*

dance in one of the western districts in 1925 that was performed to
celebrate the killing of an enemy:

> A masked figure appears covered from head to foot in a
> tight-fitting costume rather reminiscent of a suit of knitted
> combinations and the headwinners each bearing a machete
> dance round the figure with stiff movements. Women may
> not see this dance and only men who have actually taken a
> head may take part in it. . . . After the ceremonies the skull
> [of the victim] tied up in a cloth and [decorated] with three
> aloko feathers is hung up in the hut of the head winner and
> he henceforth can wear one aloko feather and be known as
> Ogbu. (Macleod 1925, 19–20)

Macleod recorded the name of the war dance as "chafofo," probably a misspelling of Ichahoho (pronounced Icháhòhò). What is interesting here is that both a mask and a skull are present on this occasion. Although the performance context and the audience have changed, it is broadly the same enactment, with a different mask, that I filmed in Otobi as the Oglinye dance fifty years later. Dressed in a white knitted body suit that fully covers the face and is decorated at the waist by a pelt of the civet cat, the masked figure bursts into the performance space (the compound of the family sponsoring the second burial) running at full speed, appearing to come straight from the bush, and leaps to an abrupt stop in front of the slit drum (the war drum). After a flourish of the very rapid foot-stamping technique that is the signature of warriors' dance, the mask enters into a mock battle with machete-wielding old men—nowadays the only people still entitled to wear the red *uloko* feather designating them as man-killers. After a brief and tension-filled performance, Oglinye turns and vanishes down the same bush path by which it has just entered the village.

Oglinye and Ichahoho are performatively very similar, though Oglinye wears a carved head atop the masker's own head while Ichahoho wears a face mask. Ichahoho seems to have been an indigenous masquerade in the western Idoma-speaking districts, while Oglinye, with its much wider distribution in eastern Nigeria, entered Idomaland from the south and was gradually assimilated into a local iconography and performance style.[15] Only the carved three-dimensional head, an anomaly in a culture where anthropomorphic masks are coverings for the face, betrays its probable Cross River origin.[16]

There are serious problems of interpretation with Oglinye that partly have to do with its separation from warfare early in the century and its subsequent reinvention within a different framework but perhaps equally with the attempt to research a phenomenon that, in the late-twentieth-century Idoma community, was seen as either dangerous (dredging up illegal practices) or antisocial (likely to start fights) or simply an anachronism important only to a few old men. I include here a few of these responses to illustrate the conflicting nature of local readings of Oglinye when I first saw it in 1978:

> If a man killed a person and brought the head home, Ogrinye[17] would join in congratulating the person for seven

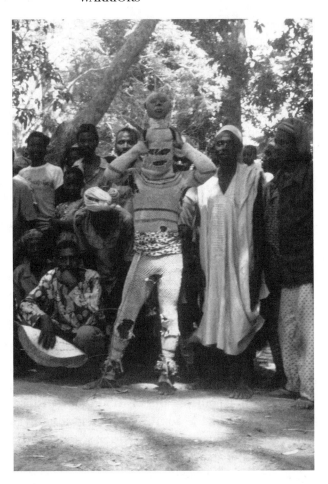

FIGURE 2.7.
Yachi Ogrinya
masquerade
performance,
Ogoja, Nigeria,
1986. *Photo by
author.*

days, dancing in his compound. (Ojiji Ojefu, member of the
oldest surviving age-set, Otobi, 4 July 1978)

The war dance is not Ogrinye. It is Ikpa. Ogrinye is not
just for warriors but for old and young alike. . . . Women may
join in the dances—it is not like other masquerades. There
is no initiation ceremony and anyone may dance who wishes.
(Omaga An'ne, head of the Ogrinye society in Otobi village,
Akpa District, 18 February 1978)

Women are limited to the afternoon dances, but there
are night plays [masking] for male members only whenever
a man dies in the community. It [Ogrinye] also comes out for
seven days annually at the beginning of the year. During this

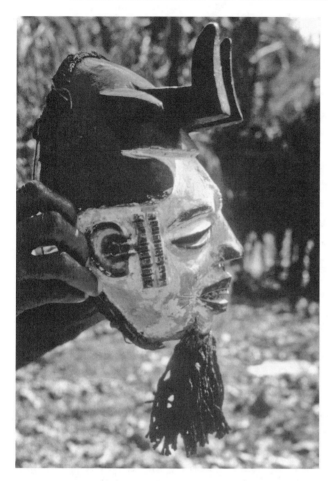

FIGURE 2.8.
Idoma Ichahoho
mask by Ochai,
Ejor, Nigeria.
Photo by author.

time the men's age-sets eat bush meat and drink millet beer
together. (Omaga An'ne, in a later conversation expanding
his initial statement)

Ogrinya is not danced in many districts today because
it is too hot. It stirs people up too much and causes trouble.
(Emeje Ogbu, primary-school headmaster and traditional
title-holder, Agila District, 9 February 1978)

The first description by Ojiji Ojefu conforms to the one Byng-
Hall (1907), the earliest British administrator on the lower Benue,
gave, which Meek (1925, 49), the government's official anthropolo-
gist later gave as well. The second (Omaga's) begins with the public
face of Oglinye in the late 1970s, one that has been neutralized by

two generations without warfare, but then in the next statement modifies this with the admission that Oglinye also has a more exclusively male and nocturnal aspect that has been retained alongside its more open public performance. The final statement comes from another Idoma district altogether where Oglinye was a war dance that did not successfully make the transition to masquerade because of a lack of a woodcarving tradition; therefore it has retained its "hot" (violent) associations there.

All of these accounts may be accurate, but each contains a different piece of truth taken from a different situation of practice. They open up distinct windows on a complex institution that has changed over both time and space and has an insider and an outsider (initiate and noninitiate) dimension and yet again a male and female dimension. To "thickly" constitute Oglinye, one has to reconnect all these strands spatially, diachronically, and through the experience of different actors. I will attempt to create a plausible version from these strands in a separate chapter; here it is only necessary to recognize that there are competing narratives.

WARRIORS AND THE CONTROL OF ELDERS

As in the Samburu case, there was considerable intergenerational friction between elders and warriors over the more visible forms of celebration that could be employed to heighten young men's reputations as fearless fighters. Dances were one such occasion when warriors worked themselves up into a state of excitement in which they—again, just as in Samburu—were out of control and might easily engage in the Idoma equivalent of spear-blooding. They also fined anyone who saw them dancing, relieved strangers of their property, and managed to steal goats, cloth, and currency rods by such strategies as tunneling into people's compounds at night (Abraham 1951/1967, 197).

Abraham recorded in the 1930s a first-person account of the coming of the Oglinye dance:[18]

> Of old, we had the Earth-chief [*ocaaje*] and the members-of-his-council (*igabo*). It was the latter who performed the reincarnation-ceremonies together with the Chief. . . . They used to perform with the Chief the religious ceremonies for war (*ɛfu^ookpo*) against others. At that time evil did not exist,

the land was peaceful (but) later on, evil began to arise (*yo*) but there was nobody to rule (*gbo*) them. Everything became muddled (and) the Chief and his council said the land was no longer good. A certain (*ee*) dance became in vogue (*tu*) called ɔgl-iñɛ [*oglinye*]. . . . The young men began to dance (*je*) that dance (*ije*)—they went to the Chief and counsellors and said to them that a new dance had arisen. . . . The Chief told them to go home that he might confer with the counsellors and that later (*ee*) they should come that he might give them his reply. (Abraham 1951/1967, 195)

What the Idoma elders did then was brilliant in its simplicity: in one move, they satisfied both the *igabo*'s desire for law and order and the warriors' youthful exuberance. They appointed an *ocuta*, or judge, and under his jurisdiction made all warriors members of the *aiuta*, literally "sons of the law"—that is, they turned them into a constabulary of policemen, effectively co-opting them. Oglinye and other warrior's dances became a performance frame for recitation of the law instead: "[If] anybody slashes with a knife, let him pay a fine of three goats! [If] anybody steals, let [him] reveal his secret" (Abraham 1951/1967, 195–196)!

Thus, the performative aspect of Oglinye was fully maintained in its new role, and the same aggressive behavior was now channeled into a kind of vigilante rough justice. When the British arrived, they had no idea of the existence of the *ocuta* system and tried to set up Native Courts to try criminals and administer justice (Abraham 1951/1967, 196–197). These were often unsuccessful because litigants preferred the traditional sanctions of the dance associations such as Oglinye and Ichahoho. In the end, a slightly uneasy coexistence evolved in which the divisional government headquarters relied on district heads and their councils to maintain law and order, and they in turn relied tacitly on the *aiuta* (Magid 1976, 167).

Despite the seemingly radical changes, the new set of attributes associated with the Oglinye institution as an instrument of social control rather than warfare celebrated the same traditional values of youthful male aggression. Both roles, that of the warrior and of the vigilante, are violent. They exist on both sides of a law/outlaw dichotomy in a manner that is largely situational. Let me conclude this discussion of Oglinye and Idoma warriorhood by returning to the connection between manliness and violence that characterized the taunting of the Samburu warriors by their girlfriends.

Not only Idoma men but also women saw male aggression as a sign of emergent manhood. Edmund Leach has argued that in fact warfare and male sexuality are activated by the same paradigm:

> In every case, both in reality and in ritual, fertility and life are the outcome of an activation of the relationship between the "I" and the "Other" which results from male aggression (which may be either sexual or combative). In a sexual context the "other" is a woman; in a headhunting context, it is "the enemy"; in a sacrificial context, it is "God." (1965, 182)

The connectedness of the first two types of aggression in precolonial Idoma thought was contained in the rule that every youth first had to have taken an enemy head before he was allowed to marry. Women served as both the premise and the proof of the successful attainment of Idoma manhood. As potential wives, they were an important reason why youths underwent the ordeal of killing (and despite the English term "hunting" for heads, it was an ordeal, not a sport; reluctance or failure meant being an outcast in the community). As actual wives, they proved their husbands' sexual manhood through the bearing of children. The Oglinye masquerade was not just an expression of youthful virility but, less directly, was an expression of behavior that sanctioned becoming a man in the face of female acceptance.

When the Pax Britannica was imposed after 1908, not only the British but also many elders were quick to see its usefulness in controlling the younger men. In the government's attempt to suppress warfare, the possession of heads was made a crime punishable by hanging and the Oglinye society was officially proscribed by the colonial administration in 1917.[19] In doing so, the colonial government attempted to end both actual fighting and the dances that celebrated it. This enforced domestication of the warrior life-style, which in many ways paralleled the spear ban imposed on Samburu warriors, had unforeseen results.

WRITING "NATIVE CUSTOMS": THE IDOMA AND THEIR NEIGHBORS

There are extensive descriptions of precolonial small-scale warfare in the region between the Atlantic Coast and the Benue's north bank

that is bounded by the Niger River in the west and the Cameroon Grassfields in the east. Idomaland sits in the center of the northern part of this region with its small states, chiefdoms, and independent village groups in a landscape ranging from the sparsely settled open savanna woodlands near the Benue River to much more densely populated stands of deep forest along watercourses as one moves farther south. For the most part, it was the outer edges of Idoma settlement and the Igbo and Igala boundary areas closer to the Niger or the Oil rivers of the south that were penetrated by the pen-wielding foreigners who gave us the first written accounts of the region.

Burdo (1880, 163), for example, described Niger Igbo warfare in 1878, a period of transition from the penetration of the Niger by geographers and early traders to the establishment of a colonial administration by the British: "The negroes of Ebo are proud and fierce, and love war for its own sake. They usually take neither prisoners nor slaves; they carry on . . . without pity and without mercy . . . and an utter contempt for death, cutting off the heads of their enemies, making trophies of them, and hanging the corpses on trees near the field of battle." With the exception of the trophy heads, this reads very like Krapf's description of Maasai fighting in the mid-nineteenth century.

Directly north of Niger Igbo country lies Igalaland and the Niger-Benue confluence. After reaching the confluence, Burdo traveled east along the Benue and was thus one of the first Europeans[20] to meet the so-called Akpoto.[21] He wrote, "The torrents of rain, the miasma from the marshes, the insects, the scanty fare, the sight of, contact with, and fear of the natives, all made it unpleasant, and often it was very hard and bitter" (Burdo 1880, 251–252). The lower Benue, which is more than a mile wide in the rainy season, was an effective barrier for the northern Fulani cavalry whose slave raids accompanied the jihad Uthman dan Fodio initiated in 1804. By the 1850s, many north bank populations had fled across the river to form refugee enclaves within Igala, Idoma, and Tiv country. There was continuous political instability and upheaval in the Middle Belt throughout the century as the Fulani conquered or converted the Nupe and northern Yoruba west of the confluence and Adamawa far to the east.

By the time of Burdo's visit in 1878, earlier English attempts at colonization near the confluence had been abandoned and the trading stations had fallen into ruins. Only Bishop Samuel Ajayi Crowther's

mission at Lokoja remained. The three English firms operating on the Niger were compelled to work with local middlemen who collected palm oil and ivory for a steamer that visited Lokoja periodically when the river was high (Burdo 1880, 207–208). Burdo, abandoned by his Kru rowers, who feared for their lives at the hands of the Fulani, found himself on foot. Barely able to walk because of a snakebite, he ended up in an Akpoto village (251–252). There he claimed to have witnessed a human sacrifice. The town of Ogberi, while nominally Idoma or eastern Igala, appears from Burdo's description and word lists (which contain mostly Hausa words) to have been a refugee enclave. "The inhabitants are Akpoto negroes, but their king has embraced Islamism, in order to gain favor with the Mussulmans, and to avert their depradations. . . . Their religion is a mixture of idolatry and Islamism" (252).[22]

In the narrative, Burdo was afraid to show openly his disapproval of the execution scene for fear that he too would be killed. At the last moment, he asked for pardon for the two victims: "But nothing came of it; at a signal from the king their heads rolled. . . . Then followed one of those scenes which is never effaced from the memory. As if they were all mad . . . men, women and children rushed round the two corpses and began to dance. . . . The moon shed her light on this odious saturnalia . . . [and] I went away as soon as possible, distracted and revolted by the monstrous spectacle I had witnessed" (1880, 263–264).

In the engraving by Yves Barret that accompanies this text passage, entitled "Human Sacrifice and Nocturnal Fête among the Akpotos" (opposite page 264), Burdo, his trusted interpreter Ben-Ali, and the local ruler watch the scene from the left background. Ranged around them in a wide circle are the "Akpoto," who are dancing, and in the right middle ground, the execution of a prisoner is about to take place. As in almost all nineteenth-century travel accounts, the illustrator was not an eyewitness so relies on a combination of textual details spelled out by the author and, where these are missing, on contemporary generic prototypes drawn from other travel books that ultimately hark back to Renaissance (i.e., Columbian) versions of classical models. While the faces are exaggeratedly bestial (and do not even minimally resemble real Idoma or Igala people), the mostly nude bodies are clumsier versions of figures that might decorate a classical Attic vase. The few "ethnographic" details—occasional feather headdresses,

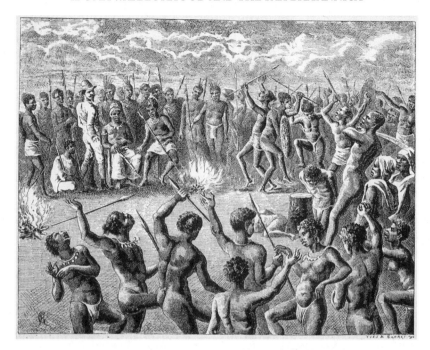

FIGURE 2.9. Human Sacrifice and Nocturnal Fête among the Akpotos (in western Idoma/eastern Igala). *Source: Adolphe Burdo*, A Journey up the Niger and Benueh *(1880).*

spears, and waist kilts—seem to be drawn from contemporary engravings of Native Americans, as are some of the dance postures.

In accounts such as Burdo's, both text and illustrations convey the relationship between explorer and native. There is first the dramatic recognition of exotic cultures, conveyed through "encounter" illustrations—Burdo or Frobenius or von Höhnel in pith helmet and somber khaki, the natives swathed in turbans or beads or elaborate body arts. But to employ Ricoeur's distinction once again between what a text appears to say and what it actually talks about (1971, 557–558), the narrative of the Akpoto encounter, presented here as the spectatorship of "odious saturnalia" and "monstrous spectacle," reveals a view of the native as not only wanton and barbarous but also as a hapless victim of that same barbarousness and therefore worthy of the European's intervention and redemption.

From this high melodrama, which attempts to distance the European from the African in thought, word, and deed, there is the intermittent shift in genre to the recording of "native custom" as part

of the responsibility of the literate foreigner. As in East Africa, narratives of exploration intended for a Victorian popular audience are first stories about personal adventure, misfortune, and discovery and second about the cultural encounter that validates that adventure. Colonial government reports and memoranda, on the other hand, are never framed as the personal experience of the writer (even when that provides the substance), nor are they meant for a public readership. But it would be a mistake to imagine that they are all couched in the same gray prose. The writer's point of view, academic training, and class position are often deducible or even transparent.

And beyond the annual reports and Blue Books, many of the officers who served on the Benue later wrote books, bridging the two genres of popular writing and official reportage. These ranged from the ethnological handbook collated from shorter reports (e.g., Meek, *The Northern Tribes of Nigeria,* 1925) to the popularized ethnography (Tremearne, *The Tailed Head-Hunters of Nigeria,* 1912; Wilson-Haffenden, *The Red Men of Nigeria,* 1930) to the occasional critique of colonial administration itself (Crocker, *Nigeria: A Critique of British Colonial Administration,* 1936).

A. J. N. Tremearne, one of the first colonial officers to serve in the Benue region and a determined optimist who tried to give cultural relativism its due, saw in head-winning the same urge as in the taking of scalps in North America or the display of war medals by European soldiers: "And just as the soldiers of a European regiment are fêted after their return from active service, so too was the warrior honoured who brought back a hot and dripping head" (1912, 178). In the pre–World War I period, Tremearne was able to write about himself in relation to "his people" and also paint West Africa with a broad brush ("feverish yet sunny, luring yet repulsive"; 23). But in the 1920s and '30s, it was to the new social science of functionalist anthropology that officers looked for their inspiration. A Department of Anthropology was founded in the Nigerian Administrative Service in 1924, a year after the publication of Lugard's *The Dual Mandate in Tropical Africa,* and C. K. Meek was one of its early appointments.

Writing a decade later than Tremearne, Meek was a good deal less effusive and more detached, but unlike most of his contemporaries who looked to headhunting in distant Borneo and Fiji for comparative examples, he was firm in locating this practice in the passage to social maturity:

The acquisition of an enemy's head is the young man's pass-
port to manhood. . . . When he has won his trophy, and can
prove that it was obtained in the manner prescribed by cus-
tom, he can take his place in the ranks of the warriors, and
his prowess is celebrated by a public feast. Among the Basange
[Basa Nge, west of Idoma in the Niger-Benue confluence].
. . . the feast lasts seven nights. . . . His temples are swathed by
his friends in a white bandage, into which feathers are stuck;
and his bow, arrows, and sword are adorned with cowry-shells.
. . . Among the Idoma . . . the claimant must prove his prowess
by cutting a ram in two at a single stroke. . . . [At the end of]
the ceremonies the Braves assemble to drink together from
the newly-won skull, the special brew being poured in from a
jar surrounded with the sacred leaves of the shea-tree. (Meek
1925, 2:49–50)[23]

Another of the department's early trainees was J. R. Wilson-
Haffenden ("FRGS, FRAI; Administrative Officer, Nigerian Service;
Late RFC, RAF & Intelligence Corps; Imperial Russian Order of Saint
Stanislas, Second Class, with Swords"). Sent off to London in 1925 to
study under Malinowski, he returned and made "detailed inquiries
into the customs of certain tribes inhabiting the Nasarawa Province"
in which he served (1930, 7), particularly the pastoral Fulani and the
Kwottos (also called Igbira Panda in colonial accounts). A major sub-
ject in his ethnography of the Kwottos was headhunting, a practice
whose origin he traced to the "Idoma-speaking Okpotos" or Igaras
(213).

Malinowski himself, in a wry comment in the book's foreword
(13), noted that despite the admirable tenets of indirect rule with its
commitment to retaining native custom, with regard to:

Headhunting, Human Sacrifice . . . and Trial by Ordeal
[chapter headings in the book] we are faced with customs
which for various reasons the European administration can-
not preserve. After all we have to consider the superstitions
and idolatries of the white man as well as those of the native.
We get up in arms when a West African sacrifices a victim
every seven years on the shrine of his fetish, though we do
not mind sacrificing some twenty million lives to our fetish of
national honour, flag and the sovereignty of the State.

While Malinowski may have exerted a certain functionalist influence on Wilson-Haffenden during his brief interlude as student of anthropology in London, *Red Men of Nigeria* owes its basic historical agenda to the ideas of H. R. (Sir Richmond) Palmer. Palmer, a respected Arabist and translator of the Bornu Chronicles and other Sudanic historical texts, saw the vector of culture pointing inexorably from the Carthaginians and the Nile Valley to the Lake Chad basin through civilizing races of "Hamites" such as the Berber and Tuareg (or in Kanem and Bornu, the Beri-beri or Kanuri) and finally to the Jukun in the Middle Benue region. Wilson-Haffenden, unlike his more skeptical fellow officer C. K. Meek, accepted uncritically Palmer's theories linking the Jukun with these "civilizing races from the East," perhaps because it gave "his" Kwottos with claims of Jukun ancestry an aristocratic pedigree that was not unlike the one Thomson claimed for the Maasai (1887, 239).

In Palmer's own words:

> By blood, therefore, and to a large extent by culture also, the Attahs [sacred kings] of Idah [the Igala capital] belong to the Kworarafa [Jukun] ruling castes, who in the sixteenth and seventeenth centuries dominated the eastern portion of the present Nigeria, and were themselves of cognate origin with the early rulers of Kanem, or were originally Hamites or Tuwareg of the Eastern Sudan and Sahara. (Quoted in Wilson-Haffenden 1930, 147)

It would be difficult to overestimate the influence of Palmer's ideas in 1920s and '30s northern Nigeria; they permeated his confident emendations written in the margins of district officers' reports when he was Resident of Bornu Province and later Secretary to the Northern Provinces. They also reached a wider readership in his *Sudanese Memoirs* (1928/1967); in his introduction to Meek's Jukun ethnography, *A Sudanese Kingdom* (1931); and in scholarly journals of the day.

Palmer consistently judged the worth of each Benue Valley culture by whether or not it could claim any historical relationship to the Jukun at Apá (Kwararafa) and had also retained the institution of sacred kingship. In these tests, the Idoma with their firmly held beliefs of an Apá origin and their sacred kings passed muster, but he also considered them to have a significant addition of inferior indige-

nous lineages (the Akpoto) mixed with their supposedly "Jukunized" immigrant aristocracy (the core Idoma) that disqualified them from the possibility of high cultural achievement. In a hierarchy of power generated from Palmer's writings and his position of authority, the Idoma were therefore inconsequential compared to the Jukun (and their non-Muslim Hausa ritual specialists and artisans, known as Abakwariga) or the Hausa-Fulani emirs.

In the period of the early military patrols (1908–1910) followed by the initial attempts at administration, what the British saw was an Idoma polity that had not yet been written into the script of civilized northernness and that appeared to them to be both hostile and inaccessible. This perception continued for many administrators throughout the colonial period, right up to 1948, when the first Och'Idoma was installed and the British could place an intermediary between themselves and the (from the British perspective) litigious old men who as clan or land heads made up the Idoma Native Authority.

J. H. Shaw, a frustrated assistant district officer assigned to Idoma Division instead of one of the emirates, complained on his first tour of duty that "the people are as difficult of approach and access as their villages. Suspicious and distrustful particularly of their own kith and kin, ever on the defensive, the ulterior motive behind word and action is always presumed until the contrary is proved. . . . [P]erhaps the most outstanding traits in the Idoma character are his instability, perversity, complete and seemingly inherent lack of discipline and disrespect for authority in any form. Failing overt opposition he falls back on silent insubordination" (1934, 3).

This classic colonizer inscription was sharpened by the fact that in the Colonial Service of northern Nigeria, promotion and career advancement during the early years of administration came via distinguishing oneself in the emirates. Posting to a pagan division such as Munchi (Tiv) or Idoma was a piece of hard luck, a kind of boot camp for inculcating the ability to endure hardship, and it was sometimes even an explicit punishment inflicted by higher-ups on junior officers who disagreed publicly with the prevailing dogmas of indirect rule. Officers relegated to the pagan divisions rarely bothered to learn the local languages and instead devoted their spare energies to trying to get posted elsewhere (Crocker 1936, 54). The problem of cultural translation, at the most literal level, was therefore a major reason for the lack of understanding between administrators and administered,

and this further complicated all attempts to inscribe "native customs" into the colonial record.

W. R. Crocker, a junior officer assigned to investigate an alleged Tiv ritual murder soon after his transfer to Katsina Ala, admitted that

> another difficulty [besides trying to understand the phenomenon of Tiv witchcraft] . . . is that I do not know Munchi [Tiv] and have to use an interpreter; every statement made to me by the witnesses has to be translated from Munchi to Hausa, and Hausa is a very inadequate medium for conveying the ghostly twilight of Munchi sorcery and animism. Hausa has been subject to Islam for too many centuries and has therefore purged itself of ideas belonging to its animistic past. (1936, 49)

Crocker neglected to mention that this "ghostly twilight" was subject to a second translation, from Hausa—a language he had acquired only recently—to that of his own conceptual apparatus, the English of the recent Oxbridge graduate, in which ideas such as witchcraft and sorcery had yet other connotations.

In northern Nigeria, then,[24] the "right sort" of Englishman (the same one who felt empathy for the Maasai in East Africa) hoped to be posted to one of the Hausa-Fulani emirates and considered pagan enclaves such as Idomaland to be difficult and unrewarding. There is no exaggeration in stating that British colonizers' understanding of Idoma culture, just as was their understanding of the Tiv, was filtered largely through a Hausa consciousness. This was guaranteed not only by the British proclivities to admire the emirates as islands of civilization in a sea of barbarity but also by the simple fact that the British used Hausa interpreters. The following tale, while perhaps an apocryphal story, was probably very close to the truth:

> In the twenties the government had become very anthropologically minded and administrators anxious to make a reputation had thrown themselves into investigation of lineage, kith and kin, marriage and burial customs of the peoples in their divisions. The man in Idoma, according to Guy Money [Captain Money, also an officer in Idoma Division], had spoken no Idoma and the Idoma were in any case not at all communicative about intimate domestic details. However,

the DO had an excellent Hausa interpreter with an inventive turn of mind. Seeing how desperately anxious his master was to record every custom, the garrulous old man filled in the many gaps left by the obstinate Idomas with his own imagination. Everyone was happy. The Idomas kept their secrets to themselves, the DO made page upon page of notes, and the interpreter was praised for his ardent help. The "customs" were thus recorded, analyzed, and finally drafted into an imposing manual entitled *The Customs of the Idoma* (Smith 1968, 59–60).

Although no one could actually locate or confirm the existence of such a volume at the time of my fieldwork some fifty years later, the story was part of local Native Authority lore. The Idoma language has continued to be little known outside central Nigeria, and a century after the beginnings of colonization and literacy there is still no published Idoma dictionary.[25] R. C. (Roy Clive) Abraham, administrative and anthropological officer to both the Idoma and the Tiv, filled the gap with his hand-typed manuscript, *The Idoma Language* (1951/1967), compiled in 1936 and published originally by the Idoma Native Authority. As a trained linguist, Abraham was acutely aware of the multilayered problems of translation the colonial administration, and more broadly the whole colonial project, faced. At the same time, he was an actor in his own script. In the introduction to his 1933 ethnography of the Tiv, he related a newspaper report concerning the Yoruba ruler, the Alake of Abeokuta, when he visited England and was presented to King Edward.

The king stretched out his hand to welcome him, so the story goes, but the Alake demurred and put his hands behind his back. The Yoruba interpreter's ingenious translation, rising to the occasion, couched the Alake's behavior in a parody of the colonizer's own rhetoric:

> Sire, I thank you for the honour you pay me by wishing to shake hands with me and there is nothing I should like better than to do so, but I am unworthy of touching, even with my fingertips, the hand that controls the fortunes of the Empire upon which the sun never sets. Please pardon my diffidence and excuse me from a distinction which I hope that I may one day merit by a lifetime of devotion to your service.

But according to an eyewitness who had spent many years in Nigeria, what the Alake actually said was,

> I trusted you and have come to this meeting unarmed, but I see that you have a large sword suspended at your waist. The game is not fair. Not contented with that, you want to catch hold of my hand, the only defence which remains to me. You seem to take me for a fool. (Abraham 1933, 5)

Aside from the rather improbable content of the story (Abeokuta was missionized very early and had known the colonizer's mannerisms for the better part of a century by King Edward's reign), what is equally interesting here is the revealing cultural construction involved in the multiple retelling (allegedly culled from a British newspaper, later repeated by the Congo Expedition ethnographer Emile Torday in *Causeries Congolaises* and reprinted again in 1933 by R. C. Abraham, officer for the Northern Provinces, in his study of the Tiv). It is, in other words, a story in triple brackets: originating in the popular press and therefore of somewhat dubious authenticity to start with but then picked up by not one, but two, famous colonial ethnographers—Abraham was not only government anthropologist to both the Tiv and the Idoma but also later the author of the standard Yoruba dictionary—who inadvertently exposed their own cultural assumptions regarding "the truth of natives." Abraham even adds sotto voce, after the florid apology by the Yoruba interpreter, "This was not bad[,] was it[,] from a savage?" Meant as a casual joke, such comments clearly expose the assumptions of colonial discourse, even when voiced by supposedly sympathetic writers.

THE BRITISH NORTHERNIZATION OF THE BENUE

The British construction of a Hausa filter to separate out the more intransigent elements of Idoma culture was not just expressed as discourse but involved constant negotiation through ritual and bodily practice. While the late Och'Idoma II, Ajene A. Okpabi, had been to England twice to have cataracts removed from his eyes, no Idoma rulers visited British royalty as the Alake had. The office of Och'Idoma, a colonial solution to the problem of administering twenty-two independent Idoma chiefdoms, was an ingenious "invented tradition" (Hobsbawm and Ranger 1984) that assimilated to itself some of the trappings of northern emirship as well as characteristics of Idoma

kingship traditions and generic colonial officialdom. By the 1980s, whenever the Och'Idoma traveled into the rural districts, the windows of his official Mercedes would be rolled down on reaching the outskirts of the village he was scheduled to visit and suitable Hausa royal music issued forth from the tape deck for his entry into the *ojira* (village meeting ground).[26] He was also accompanied by an elderly trumpeter in colonial police uniform who announced his arrival.[27]

His chiefly robes were of several styles, which were chosen for their appropriateness to different events and audiences. For "government" (as opposed to "Idoma") occasions, he wore white turbans of the gauzy Hausa strip-weave known as *turkudi* (Perani and Wolff 1999, 144) and Hausa-style gowns (*riga*).[28] Only his wrist-beads and *okwute* (ancestral staff) derived from the Idoma-Igala chiefly nexus. Each of these small strategies smoothed the stylistic transitions between the Hausa-Fulani emirates and the largely non-Muslim Idoma lands[29] with their sacred kings. In the parlance of northern Nigerian administrative protocol, the Och'Idoma is a "Second-Class Chief," ranking below the major emirs but above many others. He moves within the very mixed company and differing protocols of Idoma clan heads, other "traditional rulers" (some of them Muslim emirs, some colonially invented paramount chiefs such as the Tor Tiv, others precolonial sacred kings, such as the Attah of Igala, of Benue and neighboring states), and the rulers of contemporary Nigeria, who throughout most of the postcolonial period were military.

If one can summarize the colonial inscription of the Idoma into British colonial writing and administrative policy, it involved a slow but steady movement away from an initial judgment of barbarous and ungovernable pagans toward gradual integration of them with "civilized" northern traditions of rule, offered in the form of chiefly trappings, protocols, and status that today appear seamless and project backward a more benign picture of the Idoma past. But in the early years of the Pax Britannica, headhunting and warriorhood and their associated dance societies were proof of Idoma intransigence that had to be eradicated for successful administration to take hold.

COLONIAL POLICY:
CONTAINMENT VERSUS ERADICATION

Returning to the British colonial government's treatment of the Samburu for a moment, the question of why it saw these two rather

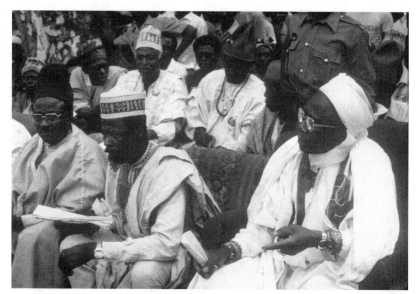

ABOVE: FIGURE 2.10.
Och'Idoma (right) in
Hausa-Fulani turban
and gown, Igede,
Nigeria, 1986. *Photo by
author.*

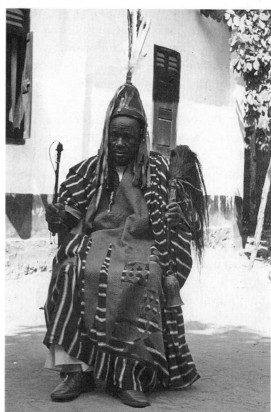

RIGHT: FIGURE 2.11.
Och'Akpa in Hausa
gown with Akweya
ceremonial headgear
and horsetail fly whisk,
Otobi, Nigeria, 1975.
Photo by author.

similar types of warrior behavior so differently bears repeating: one (Samburu) as the excesses of youth that are disapproved yet tolerated except when they threaten the welfare of the European settler; the other (Idoma) as evidence of depravity that must be wiped out at all costs. The first led to a policy of containment of Samburu spear-blooding coupled with an attempt to alter the rules of moranhood. The second led to a total ban on headhunting coupled with an attempt to suppress the secret societies and their masking practices; violation of the ban was punishable by hanging.

The crux of the difference seems to lie in the total absence of nostalgia in the British experience of colonizing the Benue region. There is no way British colonizers could look into the mirror and see themselves in anything Idoma, whereas in the values of Maa-speaking pastoralists they thought they saw, in the early colonial period, the echoes of the natural superiority of their own aristocracy. Later on, in the spear-blooding episodes of the Samburu moran, their admiration of Nilotic pastoralist-style warriorhood was tested to the limits, but the government chose to deal with warriors as irresponsible youth rather than as unreconstructable savages. This leniency had already been built into British policy through the longer period of contact with the core Maasai groups, a policy that structured a paternalistic regard for their welfare even while robbing them of their best land early in the century. The Samburu were beneficiaries of British colonizers' sympathetic attitude toward cattle pastoralists and were left alone except when settlers or settler policies were threatened. Periodically the postcolonial Kenyan government (e.g., in 1985) has tried to preach modernization to Maasai and Samburu moran and has in some cases successfully forced, cajoled, or persuaded the core Maasai to shorten the period of moranhood and do away with long hair, the most visible sign of warrior virility.[30] It has also attempted to do this with the Samburu but without much chance of its actual enforcement. Eventually President Moi instructed the police to "leave the Samburu to their customs," which is where it has stood.

Finally, the inscription of Idoma (and other small-state) warfare as a clear and present obstacle to be eradicated at the beginning of colonial occupation contrasted with the geographical remoteness of any Samburu threat. "Pacification" of sedentary cultivators living in compact villages within the densely populated savanna-forest mosaic of eastern Nigeria was a realistic possibility for military patrols;

pacification of nomadic warriors with no fixed settlements who were spread over vast open spaces was not. So the rhetoric had to be one of containment.

Each of these cases also was played out against a broader context of early colonial resistance to conquest. In Northern Nigeria between 1900 and 1903, British troops (led by Lugard himself) had to wage real war to subdue the emirs. In defeating Kano, it was necessary to breach the 40-foot-thick walls of the city as well as outmaneuver a highly trained cavalry. Meanwhile, as Lugard reported, "Primitive Pagan races held their own in the inaccessible fastnesses of the mountainous districts of the plateau or in the forests bordering the Benue River" (Lugard 1919/1968, 56). By contrast, in East Africa, the core Maasai not only did not resist but, in a mutually beneficial arrangement ("the enemy of my enemies is my friend"), actively assisted the British in subduing the Nandi and others. Although the Samburu joined a British punitive expedition against the Turkana early in the twentieth century (Pavitt 1991, 15), they were remote actors on the scene of colonial conquest. Yet in their eyes, they are the beneficiaries of this remoteness, having been largely ignored by both the colonial and postcolonial governments.

In Kenya the dialogue was more complex than in Nigeria in that there were several interlocutors: the white settler voice often carried as much weight as that of the government. At times, the two reversed positions and the government found itself defending the Samburu against the settlers, as in the contestation for land on the Lorroki Plateau. There is also a lack of unanimity in the Benue region accounts, despite the broad theme of the civilizing mission, and it would be a descent into stereotype to equate the viewpoints of scholars as different as Palmer and Meek or local spokesmen as different as Omaga An'ne and Emeji Ogbu. Yet the striking differences in Nigerian and Kenyan colonial discourse remain.

Part 2

SCULPTORS AND SMITHS

3

COLONIAL RUPTURE AND INNOVATION:
THE COLONIZER AS INADVERTENT PATRON

Narrating warriorhood in early colonial Kenya and Nigeria invoked parallel stories of what the British referred to as "spear-blooding" and "headhunting." In both situations, the British colonial administration directly intervened to contain (in Samburu) or suppress (in Idoma) a cultural practice that seemed to flagrantly undermine what the colonizers saw as their civilizing mission. I now take up the backstory, which is about the spears and the heads and their own subsequent transformations, for what they reveal about the capacity of colonialism to affect artisanal practice. Far from suppressing the inventiveness or creativity of blacksmiths and woodcarvers, colonial interventions unintentionally stimulated it. Quite simply, while literary representations and informal discourse both reflected and influenced colonial policy, those policies often misfired, and what began as an attempt to coerce or control was either impossible to implement or contained internal spaces and contradictions that allowed unintended and unforeseen results to emerge. This was the case for both the Samburu spear ban and the banning of Idoma war dances that used skulls.

In much colonial and early postcolonial writing on African art, the framing of artistic change during the twentieth century—for example, the eclipsing of old technologies or old forms of patronage—was conceptualized as a process of cultural decay that accompanied the inevitable disintegration of traditional society. In this script, most eloquently laid out in the collected writings of the distinguished scholar and connoisseur William Fagg (1965, 1970), everything that followed the colonial encounter resulted in the weakening of the social fabric that had made possible a dynamic precolonial artistic practice. To

paraphrase Achebe and Yeats, things fell apart—the center could not hold. Or to borrow a different metaphor from John Mack, writing on Azande cultural hegemony (Schildkrout and Keim 1991), the thing we call Western Culture acted as a kind of giant steamroller, slowly but inexorably flattening everything in its path. However poignant this view may be and however close to the truth in certain ways, it is cast in the same mold as Sidney and Hildegarde Hinde's elegiac *The Last of the Masai,* written in 1901, and represents an uncompromising model of art history in which purity of form and intention are a necessary precondition to the artist's integrity. It also situates the colonial imagination in a long tradition of English romanticism toward the untouched and primeval, which was associated as much with landscape as with its human inhabitants.

While prominent independence-era Africanists such as Fagg, William Bascom (1973), and Daniel Biebuyck (1969) insisted that creative innovation could and did take place (even in the midst of conservative workshop conditions oriented toward traditional patrons and practice), they treated them as acts of individual agency. In this model, inventiveness resides in the private gesture of the artist and is unrelated to the presence of a colonial government bent on a civilizing mission. While those kinds of invention were clearly there in the work of many master carvers, smiths, weavers, or potters, the colonial rupture put artisans of all kinds on their mettle by imposing radically new conditions of production and patronage and in doing so actually widening the scope for creativity in certain arenas even as it foreclosed on many others. The foreclosures have been the main theme of the study of canonical genres and are well known: the imposition of a colonial administration that undercut the authority of precolonial institutions, a shrinking patronage base as conversion to Christianity or Islam weakened the old religions, the emergence of town culture and emigrations from rural areas, the introduction of schooling, taxes, and a wage economy. But each of these changes can also be read into a new cultural script that allowed for innovation and contingency and made possible the introduction of whole new genres. In doing so, one can demonstrate how practice has the capacity to modify the earlier artisanal structures that defined precolonial production and patronage (Bourdieu 1980/1990).

INVENTION AS "IMPROVEMENT": THE CASE OF SPEARS

It is useful to consider what is actually meant by innovation in the two cases examined here because they are so different. In the case of spears, utility is the driving force in design and all change must fit within the narrow parameters this imposes upon variable factors such as weight, length, material, and the contour and thickness of the blade.[1] Concurrent with the imposition of the Samburu spear ban was a change in technology from locally smelted iron to imported mild steel. Innovation in the case of utilitarian objects, whether spears or charcoal stoves or bicycles, is tied up with the notion of improvement, of making a thing better (more perfectly functional) through changes in technology, design, or material. How does one read this in terms of aesthetics? It is not that there is no room for the blacksmith's pleasure in working with the material or the spear owner's in selecting a blade style and weight and later darkening it with fat and soot and sharpening its edges. But these sensual plea-sures of shape, patina, and surface are all held accountable to the paramount requirement of utility, that it really work as a weapon. Design innovation, when it comes, is therefore usually something incremental, taken in several stages.

But occasionally in technology there can be "breakthroughs" in which a whole process is overturned and the products with it. The most obvious example in African history would be the discovery of how to smelt and forge iron and the subsequent obsolescence of stone tools and weapons. These are paradigm shifts (Kuhn 1970, 181–191) in that they require a complete rethinking of every aspect of making a thing from conceptualization to production. The shift from the use of the trophy head to a carved mask also has this radi-cal and far-reaching quality, though the change in Samburu spear design does not; the equivalent paradigmatic shift would have been from spears to guns, a transition that began with the *shifta* incursion in the 1960s and is still in progress a half century later.

Banning Oglinye in 1917 in Idoma and spears in Samburu sev-enteen years later were policy decisions that the British justified as a necessary corollary to "pacification" in one case and intended to discipline and punish in the other. In the long run, both policies failed and were tacitly abandoned. By the end of the warriorhood of

the Lmekuri age-set (which opened in 1936 during the imposition of the levy force) and the initiation of the Lkimaniki age-set in 1948 (a period of twelve years for the Lmekuri age-set instead of the two or three years of moranhood for which the administration was pressing), many moran had learned strategies to circumvent the government policy on spears. Samburu largely ignored the government's directive for a radically shortened period of warriorhood. Elders were unable to prevent moran from stealing animals and holding meat feasts in the forest. The number of blacksmiths decreased, but many continued to make spears under a new patronage regime.

In the Idoma case, it was clear that people feared the supernatural sanctions and punishments meted out by the secret societies much more than they did the new Native Court system. So in the end, the Idoma districts were indirectly ruled by the British through the appointed district heads, who in turn relied on the secret societies (Magid 1976). In both Samburu and Idoma cases, "tradition" proved extremely resilient (though certainly not impervious) to administrative tampering, and the British eventually gave up. They managed to end internecine warfare in eastern Nigeria, but the policing of nomadic pastoralists in remote areas of Kenya proved virtually impossible until the introduction of helicopters and the anti-stock theft units of the Kenya Police much later. What follows is a detailed look at what happened when British colonial policy disrupted but also inadvertently stimulated innovations in two forms of artisanal practice situated in very different parts of the continent.

IMPLEMENTING THE SAMBURU SPEAR BAN

In October 1934, yet another Samburu spear-blooding took place in Laikipia District, right after an official visit by the governor in connection with the resolution of the Powys case. This time the colonial administration, at a loss about how to control Lkilieko moran behavior, decided to inflict a collective punishment and acted to prohibit warriors from carrying spears. Not surprisingly, voluntary handing over didn't work very effectively. Only about 1,200 spears had been surrendered by December 31st of that year, which prompted the government to dispatch two KAR patrols to assist in disarming the Samburu.[2] A district report estimated that 5,000 spears had been collected by 1936, but it is difficult to know what percentage of warrior

spears that actually represented since initially elders' spears were also taken with a promise that they would be returned later.[3]

There were three major problems with the successful implementation of the Samburu spear ban. One was the obvious inability of a single district officer, even with the help of a temporary military patrol, to enforce it effectively over the 8,000 square miles on which the Samburu grazed their livestock, especially in the days before the introduction of all-terrain vehicles.[4] The other two problems arose because the spear ban was an unacceptable incursion into pastoralist life and values. To take the simpler issue first, the government did not disarm the other pastoralists in the region, most of whom were periodic rivals of the Samburu for dry-season grazing rights. This created a situation in which Samburu-owned stock were unprotected and therefore fair targets for any Turkana or Borana who wished to confiscate them.

But beyond this lay the issues of what spears actually meant to moran and what the moran with spear (and the moran without one) meant to other Samburu and other pastoralists. The British saw spears as dangerous weapons, which they clearly were, but since each age-grade had its own type, to the Samburu they were also highly visible social markers that distinguished warriors from uncircumcised, unsocialized boys, on the one hand, and older married men, on the other. Because the elders were not prevented by the government from carrying their own spears (except at the inception of the ban in late 1934), the ban was seen specifically as a symbolic emasculation of warriors, removing the artifact that mattered most in warriors' view of themselves—the main metaphor for their virility. In this, the moran spear was second only to circumcision as the mark of a socially inscribed Samburu male. All this has begun to unravel as more and more guns have made their way into northern Kenya stock-raiding practices from neighboring civil wars and insurgencies, but in the colonial era, spears had no serious competition from other weapons.

Another way to understand this embeddedness is in the relation of a set of objects—here, weaponry—to the formal age-grade system with its ritualized transitions and the way these two systems are thereby formalized and articulated through practice (dress, body decorations, weaponry). After boys have undergone circumcision and the month-long liminal period as *laibartok*, they participate in the first of several ceremonies known as *lmugit*, the Lmugit Loolbaa

(Lmugit of the Arrows). This marks formal entry into moranhood, and at this stage initiates shed their black goatskin capes, the coiled-brass earrings (*urauri*) of their mothers, the headbands stuck with black ostrich feathers and decorated with the stuffed bodies of small iridescent birds, and their bows with resin-tipped arrows.

These are exchanged for the spear, white cloth, red ochre, and decorations of a warrior. The bow and arrows for shooting birds are symbolically the weapons/playthings of boyhood[5]; the moran spear is identified with the formal opening of the new age-set. It is not that anyone believes seriously that a fifteen-year-old moran is suddenly ready to defend his father's herds and settlement just because he is now allowed to carry a moran spear of his own (and in fact, should the need arise, these new young warriors would be led in the fighting by the senior moran who technically have just passed, or are soon to pass, out of warriorhood). Rather it is that carrying the spear associated with moranhood marshals a new set of behaviors in the same way that American boys in their mid-teens adopt a new set of behaviors when they move from riding bicycles to driving their parents' cars.

In Samburu, the new behaviors are as tied to their emergent sexuality as to their ability to fight, and because as junior moran they are still adolescents, much of the fighting is related to assertions of this sexuality in their social relationships to girls. This was laid out clearly in the Powys case. The most important point about warrior spears, however, is that they *are* the sine qua non of warriorhood and not merely an illustration of it. The Samburu conceptualization of the warrior age-grade is built up out of these distinctive practices that mark them as different from those of both boys and older married men, and these practices are in turn activated through a particular set of objects in which the spear is preeminent.

In theorizing the social significance of weaponry and personal decorations for boundary maintenance in northern Kenya, Hodder (1982, 75–86) pointed out that in cultures with rigidly maintained age-grades, the visual distinctions within groups (e.g., between Samburu warriors and elders) are as important as those between groups (e.g., between Samburu and Turkana). And in the trade-off between the power elders retain for themselves and the freedom they grant to warriors (albeit reluctantly), warriors attempt to counterbalance this inequality of power through body praxis. In this argument, "the body" is taken to include not only the physical body but also its

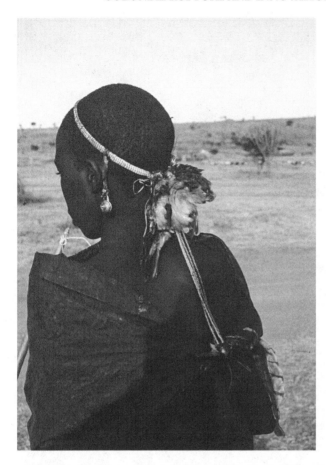

FIGURE 3.1. Newly circumcised Samburu initiate wearing brass-coiled *urauri, nchipi* beads, and the stuffed bodies of small iridescent birds, near Maralal, Kenya, 1992. *Photo by author.*

embellishments and extensions into physical, symbolic, and social space. The spear is the most significant of those extensions, though the *rungu* (the Maa *lringa,* a club and throwing stick) may be used more often in actual fighting and warriors also carry a sword strapped to the waist. In a later chapter I will elaborate body praxis in connection with the spear. Here I only wish to establish that the moran spear has a rhetorical value and conveys a panache, each of which refers to (but is quite apart from) its value as a weapon.

The ban therefore transgressed upon morans' ability to assert their identity within Samburu culture in relation to senior elders (with whom they already existed in a state of watchful intergenerational tension) and even more sharply with the junior elders of the adjacent age-set (with whom there was inevitable sexual rivalry).[6] It also undercut their relations with girls and young married women,

FIGURE 3.2.
Initiate, his
black goatskin
replaced by a
white cloth,
being ochred
for his
ceremonial
transition to
warriorhood,
near Maralal,
Kenya, 1992.
Photo by author.

which were carried on through a kind of warrior theatre scripted through comportment, body arts, and weapons. To be without one's spear was to be deprived of not only a weapon but a crucial part of the mise en scène of warriorhood, which is in no small part a performance played before various audiences of admirers, rivals, and enemies.[7] The fact that spears were so deeply enmeshed in these overlapping representations ensured that the ban would be resisted and if possible subverted.

Many warriors had spears hidden somewhere in the bush or passed them off as the property of their older brothers, fathers, or uncles, since elders eventually were allowed to keep their spears, though only

at their settlements (Lekino Lekesio, pers. comm., 1993). Or a moran would have two[8] and hand in only one to the government (Logori Lelenguya, pers. comm., 1993). Another theoretical loophole was early marriage, a piece of social engineering the British hoped would work to shorten the period of moranhood to only two or three years. If a warrior married, he supposedly could get back his spear on being issued a permit to carry one.[9] G. R. B. Brown, as district commissioner in Laikipia, a central figure in this drama and in fact the same person who had characterized the spear-blooding of the moran as adolescent mischief, suggested to the elders that "the incoming age [set] should only be allowed to remain moran for two or three years, and then made to marry and settle down." He reported that "not only did the Elders accept this idea but they expressed a willingness to go even further and insist on marriage almost immediately after initiation . . . but the Elders are much too inert and feeble to make any effective move on their own, and it will be the duty of the Administration to apply steady pressure."[10]

However, this took no account of the ritual prohibitions against marriage prior to the moran's passage through the ceremony known as Lmugit Lelaingoni, the Lmugit of the Bull, which did not take place until about ten years after the entry into moranhood and per-haps five years after the completion of Lmugit Lenkarna, the Lmugit of the Name, in which a warrior became a senior moran (Spencer 1965, 89). The existence of not one but (depending on how one counts) up to five such ritual passages during moranhood militated against the compression of its length from fourteen to three years. Even more of a problem was the fact that many of the Lkilieko moran of the previous age-set had not yet found wives and would be in direct competition with the Lmekuri moran. It is also difficult to imagine eighteen-year-olds competing successfully for wives against cattle-rich elders, though this apparently did not seem odd to British adminis-trators, perhaps because the elders adopted a stance in which they agreed sagely with everything the British suggested, knowing full well that it could never happen.

SAME SYSTEM, OTHER OBJECTS, RELATED PRACTICES

Humoring the administration involved other rhetorical promises as well. Sharpe wrote that "the elders entirely on their own initiative

issued orders forbidding the eating of meat in the bush, or the giving of beads to the maidens by the new moran. Both these practices tend most to cause the frenzy which the young warrior works himself into before going to blood his spear" (1936, 5).[11] Forbidding moran to give *somi* beads to girls, while not as radical in its effects as the spear ban, must have stung nonetheless in that it undercut the strategies warriors used to create sexual intimacy with girls and secure their loyalty.

At this time (the mid-1930s), girls wore the large white or red beads that Samburu acquired from the Rendille or from Meru or Somali traders, while married women wore the small colored glass beads that had been introduced by the ivory-trading caravans in the nineteenth century and were in the 1930s being sold by Indian traders in Nairobi such as Lalji and Sons on Biashara Street.[12] It is difficult to historicize Samburu beadwork farther back than three generations from the current time because there are very few descriptions from the nineteenth century and no illustrations from that time period, so it must be reconstructed as part of a regional pastoralist economic history. The Maasai describe the opening of the Uganda Railway in 1902 as "the year many beads fell into the land" (Donna Klumpp, pers. comm., 1991), and it is possible to trace in the Maasai literature the transition from predominantly metal ornaments in the late nineteenth century to their eclipse by beadwork a generation later. Samburu ornaments followed a parallel trajectory, though the lack of geographical contiguity of the two groups after the 1880s produced divergent styles. Gavaghan's photographs of young married Samburu women in the early 1950s show that brass arm and leg rings were still ubiquitous, but neckbeads were worn in stacks much as they are now (1999, between 160 and 161; see plates 4 and 5 in this volume).

With the intervention of the administration, girls' ornaments were made to conform more closely to those worn by married women, thereby effacing one of the visual boundaries that distinguished girls from women as unnamed (but not unacknowledged) age-grades. Needless to say, warriors did not give up presenting beads to girls; they just stopped presenting *those* particular beads, and even then they sometimes gave *somi* in secret.[13] In the end, there was no way the British could win the social engineering game, though they were perfectly serious about dislodging any custom they regarded as socially volatile and apparently went to some lengths over the bead issue.

Lekine Lekesio, an Lkilieko in his eighties when I interviewed him, described how despite the ban, four girls of his section were found to be in possession of *somi* beads and were carted off to the police post at Baragoi (pers. comm., 1993). In one sense, the absurdity of this colonial crime can be taken as indexical of British frustration at being unable to rule people in the absence of a centralized authority. But it also bespeaks an irresistible urge to tamper, as if by suppressing A and encouraging B it might be possible to whip the Samburu into shape and make of them cooperative and law-abiding colonial subjects.

The government periodically attempted virtually identical kinds of suppressions and tampering with the moran of the core Maasai (Knowles and Collett 1989, 446). Disarming them in 1919 and in 1921 prohibiting them from carrying spears and shields, wearing long braided hair, holding meat feasts, and living together in large warrior *manyattas* (something the Samburu did not do) were earlier rehearsals of what later happened to the Samburu. The bans were no more successful in curbing moran raiding than they were fifteen years later among Samburu, nor did they do anything to permanently transform Maasai moranhood, which ought to have given zealous administrators in Samburu District at least momentary pause before enacting their own regulations. As recently as 1985, the postcolonial government again "banned moranhood" and its most visible symbols, though it has concentrated efforts to enforce it only in the core Maasai districts and not in Samburu, where it has been simply ignored by both sides.

THE SMITH AS ENTREPRENEUR

This same faith in administrative decree was at work in the spear ban, though here there was another set of actors, the blacksmiths who made the spears. Unlike beadwork, which is made primarily by women during their leisure time, smithing in Samburu, as in Maasailand, is the work of an endogamous "caste" known as *lkunono* (sing.: *lkunoni*). I will return to the representations of the blacksmith as caste pariah in the nineteenth century and in colonial anthropology in a later chapter. What is salient here is that Samburu smiths acted decisively to maintain their livelihood in the face of a spear ban that remained in effect for a very long time, from the end of 1934 to 1957. Unlike smiths in agricultural societies, they produced no farming tools but specialized in an array of spears and knives and

a few ritual ornaments. First, some moved away from the centers of administration such as Maralal and resettled in the remoter parts of Samburu territory at Mt. Marsabit and near the base of the Ndoto and Matthews ranges (Larick 1984, 23). By settling at the margins of Samburu grazing lands they were able to avoid surveillance by the colonial authorities but, just as important, could find a new clientele among the Borana, Rendille, and Reshiat.[14] Second, smiths limited their spear production—there were at least eight types in the standard repertory—and expanded the production of arrows and objects that were unrelated to defense. These were characterized by one smith as "things for women," that is, things of the domestic sphere of Samburu life: *surutia* (brass coils used to decorate the ears, arms, and legs of girls and women), bells for cows and toddlers, gouges that women use in making wooden milk containers, knives, and razors. The hoe, a staple of blacksmith production among farming people, was not a part of the Samburu smith's repertory until recently.

Perhaps inevitably, some ceased smithing altogether, mainly on the Lorroki Plateau.[15] Larick (1984, 23), one of two scholars to have carried out ethnoarchaeological research on Samburu spears, estimates that twenty lineages, or almost half of all *lkunono*, gave up smithing during this period and turned to full-time herding. The extent to which *lkunono* were engaged in cattle pastoralism before the spear ban is a contested issue. Larick characterizes the nonsmith members of the blacksmith group as having been herders now for four generations,[16] though the *lkunono* I have known insist that they have "always" been pastoralists and point to the fact that they have traditionally exchanged their spears for livestock, usually goats. (The large and prestigious spear with leaf-shaped blade carried by elders is known as *mpere elashe*, "calf spear," because the payment for it is one calf.) This attempt at recuperation of a herding past is part of the smith's claim to ethnic purity—that is, to being "real Samburu," despite their endogamous status. Both claims and counterclaims about *lkunono* history are ideologically motivated and reveal a dialectic about power in which blacksmiths have used their outsider status to become mediators between Samburu and nonpastoralists in the postcolonial period.

Samburu smiths were challenged by a potentially devastating problem for any artisan—how to deal with the sudden and dramatic withdrawal of a major form of patronage. That they were able to

survive at all is remarkable when set against the widespread demise of smithing in Africa in response to the changes brought by colonialism. Yet they not only survived (though in reduced numbers) but introduced new designs into their repertory. Prior to the ban, the Samburu knew of two types of spear used in warfare and in defense against predators: the large-bladed and heavy thrusting spears used with large oval shields in hand-to-hand combat by the core Maasai and other Rift Valley and Central Highlands people (e.g., the Gikuyu) at the beginning of the colonial period and the much lighter and smaller-bladed type used mainly for throwing and in conjunction with a small narrow rectangular shield by their northern pastoralist rivals such as the Borana and Turkana.

The anomalous position of the Samburu as "Maasai" in a non-Maasai physical environment has made it necessary for Samburu smiths to be adaptive in their designs and has also accounted for their knowledge of very different practices. As Spencer (1965, xvii) points out, one reason the core Maasai were able to be so successful militarily was that they were able to subdue their mainly agricultural neighbors without fear of retaliation in kind, while the Samburu were (and still are) surrounded by other equally belligerent pastoralists.[17] The heavy Maasai spear, which could not be thrown any great distance, was more of an anachronistic symbol of cultural memory for the Samburu than a usable weapon in confrontations with other pastoralists. Not only could it not be thrown far, but because it was used singly, "if you missed you were dead [left empty-handed]" and if used to engage in combat with somebody with a lightweight spear, "by the time you got close enough to throw it, they [would] have already killed you."[18] Yet it has persisted in collective memory as a spear archetype, the *nyatum*, and could be described in detail by smiths at the time of Larick's research in the 1980s. It was used, they said, when Samburu "were Maasai" (Larick 1984, 9).

But when the smiths moved outward toward the margins of Samburu grazing lands in response to the spear ban, they found themselves courting the patronage of other pastoralist groups with no Maasai genealogy and no ideological interest in Maasai weapons. Here their patrons were not only northern Samburu but Rendille and Turkana. Rendille were not a strong force for innovation in the context of this new patronage: they have assimilated many aspects of Samburu material culture over the years (though the reverse is

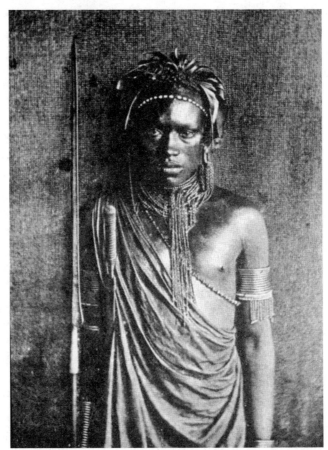

FIGURE 3.3.
Gikuyu warrior.
*Source: W. S.
Routledge and
K. Routledge,*
With a
Prehistoric
People: The
Akikuyu of
British East
Africa *(1910).*

equally true), and while they use a smaller range of spear types, these are versions of Samburu spears preferred by an earlier generation. In the 1980s these were the large *ngerani* carried by elders and large twin spears by warriors (Larick 1984a, 22). By contrast, Borana, Suk, and Turkana spears all have a very small blade in comparison to traditional Samburu "Maasai" types and are meant to be thrown rather than thrusted. It was the latter two that Samburu smiths eventually adapted and forged into the type known as *sukutaa* ("Suk") or *ngumeni* ("Turkana"; Larick 1984, 17).[19] These reflected a style of warfare and a terrain for fighting that were distinctly un-Maasai.

But just as objects (spears) were designed to implement particular practices (here, a style of fighting), practices also were continually modified by feedback from changes in the system of objects.

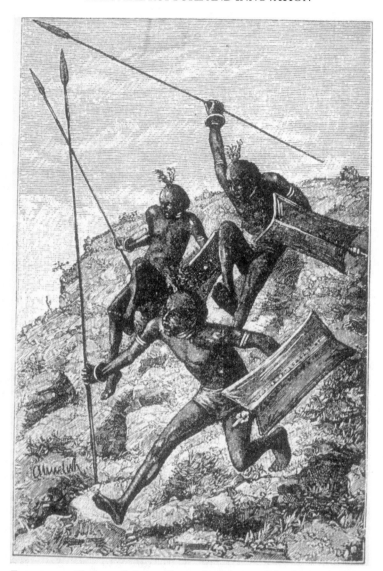

FIGURE 3.4. Turkana fighters. *Source: Ludwig von Höhnel,* Discovery of Lakes Rudolf and Stefanie *(1894)*.

As the lightweight throwing spear became an important part of the Samburu smith's repertory for Turkana patrons during the years of the spear ban, it eventually emerged as the most popular fighting instrument for Samburu moran. But in tracking changes of this kind, one quickly discovers an interdependence between the object and its disposition within a system of practices. Spears could not change in

FIGURE 3.5. Elephant hunt on Mt. Nyiru. *Source: Ludwig Von Höhnel,* Discovery of Lakes Rudolf and Stefanie *(1894).*

isolation; they could only change in relation to the ways they were used. Both the object and its use were bound up in a kinesthesis that revolved around enemy, terrain, and a style of fighting.[20] This did not alter overnight but in a series of fits and starts, and when the ban was lifted in 1957, moran were still carrying either single or twin spears with relatively large blades.[21] Two sets of circumstances combined to defeat this style and introduce the light small-bladed spear.

First, the Lkimaniki age-set, who were near the end of their warriorhood when the spear ban was finally lifted, created an unprecedented demand for new spears that could not be met by the diminished ranks of Samburu *lkunono*. They were forced to patronize Rendille, Turkana, Maasai, and Mcru smiths to procure weapons (Larick 1984, 25). This produced a mélange of spear styles circulating among Lkimaniki senior moran. When the new Lkishili age-set was initiated in 1960, the Mt. Ng'iro Lmasula cohort (who became moran before the other Samburu sections) chose to carry two large Turkana-style spears, anticipating a return to interethnic conflict with the end of colonial administration in 1963 (Larick 1985, 214). About this, they turned out to be entirely correct. During most of the following decade, both Kenya and Somalia claimed rightful owner-

ship of the Northern Frontier District. There was constant danger to northern Kenyan pastoralists from Somali *shifta* guerrillas armed with rifles and later from *ngoroko,* armed bandits with guns from Uganda operating out of the Turkana area.[22] The government armed a small number of ex-KAR Samburu elders as "Home Guards" but (for obvious reasons) was reluctant to place guns in the hands of moran. It is not possible for any throwing weapon to compete with the range of a bullet, but the discrepancy between them created a clearly perceived need for spears that could be thrown from a distance.

The Lkurorro age-set, which was initiated in 1976, was the first to adopt the small-bladed twin spears, *lmao,* as their signature. The prototypes for this developed out of a dynamic artisanal synthesis and not mere imitation. *Lkunono* of the Lkurorro age-set cite not only the Turkana model but also the Pokot; both groups had light spears before the Samburu did (Kirati Lenaronkoito 1991). Klumpp (pers. comm., 1991), Rainy (pers. comm., 1991), and Larick (1985, 209–211) have all stressed the importance among Maa-speaking pastoralists for each new age-set to set itself apart from the previous ones by changes in body arts or weaponry. Each cohort therefore has exercised strong pressure for artisanal innovation, even though each is embedded in a supposedly timeless cultural script. This same desire for innovation in connection with young men's age-sets is very common in West Africa. In Idomaland, these are typically the youth who leave the village for schooling in one of the larger towns and are eventually recruited into the wage economy. When they return, they bring with them not only cassette tapes and videos but also clothing, hairstyles, dance steps, and, more important, a catalogue of mental images drawn from electronic and print media. Because they do not have high traditional status, they have nothing to lose and much to gain from these innovations, which connect them with the powerful imaginary of life beyond the district.

Even though in Samburu it is more commonly the moran of blacksmith families and not all young men who travel in this way (and the cultural distance between pastoralist life and that of the city is still very great) the desire to differentiate themselves in some way is nonetheless strong and supports innovation in the combination of dress, weaponry, and comportment that I call warrior theatre. Each new warrior cohort finds itself in the same situation: while admired, even celebrated, by younger boys, adolescent girls, and young married

women, they exist in a state of rivalry with the age-sets that have pre-
ceded them and are ready to criticize them at every turn. The Lmooli
warrior cohort, which opened in 1990, were disparagingly referred to
as "house warriors" by the Lkurroro who preceded them. The epithet
connotes feminization, a serious insult to a warrior, not only in their
supposed lack of interest in fighting and cattle-raiding but because
they have allegedly succumbed to the physical comforts of domestic-
ity. ("Comfort" in this case means sleeping on a piece of goatskin
inside the *nkaji* instead of in a forest clearing and drinking tea and
eating their mothers' leftovers instead of stealing goats for illicit meat
feasts.)

Their most visible innovation constitutes a radical departure from
Samburu conventions: the aspiration to own a bicycle (the sturdy
black one-speed Raleigh or its Asian-manufactured equivalent), which
young men must trade between one and two dozen sheep or goats
to acquire. These are not used for transporting goods, though this is
their common role in rural Kenya, but as objects of display, much like
a sports car in the West: something to be seen with and admired by
girls for owning. The image of a warrior in full gear—ochre, feathers,
sword, and all—slowly pedaling a bicycle along a dirt track is startling
to Western eyes because of its seemingly contradictory message about
modernity. Unlike their fathers and grandfathers, who are famously
untrusting of the efficacy of such foreign trappings, the Lmooli seem
willing to mediate modernity and negotiate their way through the
outer edges of the cash economy as long as it is demonstrably on their
own terms.

Of course each new age-set is far from monolithic, composed
as it is of several thousand warriors from different sections. While
individual competitiveness is seen as a serious character flaw, peer-
group rivalry among warriors is considered inevitable and accept-
able unless it escalates into violence, as it did among Lpisikishu and
Lorogishu moran in the Powys case. If this is projected onto the issue
of inventing new forms of comportment and display, it is not difficult
to see innovation as one-upmanship—having something no one else
has—as a way of expressing age-set and sectional independence (or,
in the eyes of elders, youthful rebellion).

But if one considers this urge apart from the framework in which
it normally resides—pastoralism, adaptation, the forging of age-set
identity—it may be compared with the desire to rupture an existing

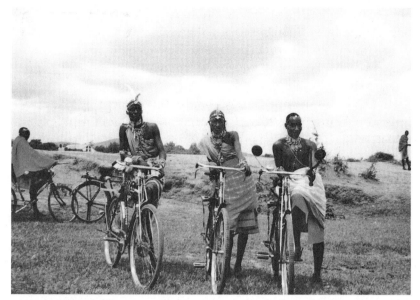

FIGURE 3.6. Samburu warriors of Lmooli age-set with their bicycles, near Maralal, Kenya, 2001. *Courtesy of Dave Turgelsky.*

aesthetic that drives youth cultures in the more urban parts of the continent. The Samburu cultural script has long recognized that there is power in display, which hovers between the practical strategy of carrying three or four weapons at once (sword, *rungu,* and a spear or two) to the sheer theatricality of waist-length ochred hair decorated with beads and feathers. Recent innovations have occurred at both the practical end, such as the substitution of a Kalashnikov rifle for a spear or crowning a *rungu* with a heavy metal nut from a Toyota truck body, and as purely aesthetic choices, such as replacing bird feathers with colored metallic Christmas decorations as hair ornaments.

Larick (1985, 210–211) has shown how this force for innovation among the smith's clients is in reality embodied in a very small number of individuals: those of the first group to become moran in the opening of a new age-set. Samburu circumcision always begins with the section that holds ritual seniority, the Lmasula living on Mt. Ng'iro (Nyiro), so it is here that the choice of spear design is actually made for the whole age-set. There are three large Samburu smithing families, one in the Lmasula section, one in the Lpisikishu section, and one in the Lukumai section. The probability therefore will be high that it will be Lmasula smiths (or at least smiths who live near

Mt. Ng'iro) who forge the new moran spears at the opening of the new age-set. In addition to this initial situation, there are intermittent pressures on smiths from senior warriors and junior elders whose spears receive heavy use and need frequent replacement (Larick 1985, 211).

One interesting question is how innovation actually takes place within the known repertory of a smith's practice and the preexisting system of objects. This repertory of forms arises from a body of artisanal knowledge and practice, but in the Samburu blacksmith's case, one that is easily permeable. It necessarily blurs at the edges because in actual practice it depends not only on the temporality of the age-grade system overlaid with the temporalities of colonial regulation but also on an artisanal geography that is created out of adaptations at its boundaries.

The pressures on Samburu smiths to adapt and reinvent the Samburu spear between 1934 and 1976, the year the Lkurorro age-set was opened, are most easily described in Kublerian terms: prime object, replication, duration, periodicity, drift (Kubler 1962, 63–77). A particular form, the invented prototype of a new sequence, gains legitimation as it is adopted by a new age-set; but since a change in spear design is not a requirement of each new age-set (they could as easily initiate a new hairstyle or bead decorations or something else) its *duration* may be long or short, but its *periodicity* is likely to be the time lapse from the opening of one age-set to the next, usually twelve to fourteen years. At times this could be superseded by events originating outside the age-grade system: the border war with Somalia, for example, which began soon after the initiation of Lkishili age-set and eventually forced the Lkishili moran to adopt the lightweight throwing spear.

Once a design is adopted, its replication is seemingly assured. But smiths are geographically scattered and unevenly clustered, so these replications are never exact. There is thus a gradual drift from the original model because of the passage of time and the spatial separations of blacksmith-patron clusters as well as improvements in the model. This occurs until a different prototype enters the system: in the case of Samburu spears, this is most likely to occur at the boundaries of the spatial distribution of the prototype, where it comes into contact with other competing designs. Invention in this context is complex, since an object is positioned within different

sets and sequences simultaneously: the age-set spear-design set, the individual blacksmith's clientele set, the spatial distribution set for this design, and the position of the design in a diachronic sequence. Given a knowledge of all the local possibilities, these can be predicted, but predictions will always fall short of actual practice by an individual smith.

THE DEMISE OF SMELTING

At the same time that Samburu smiths were adjusting to a different clientele and a new system of objects, they had also to deal with an even more radical shift in technology that occurred all over colonized Africa. This was the demise of iron smelting brought on by the introduction of European ready-made mild steel. In highly centralized societies with large populations and specialized artisans (for example, the Yoruba or Hausa), smiths and smelters were usually different people. But among the Maa-speaking pastoralists (as among the Idoma and many other rural West Africans), a substantial part of the smith's work before the 1920s was the production of iron—in the Samburu case, from the ferruginous sands of streambeds. With the cessation of smelting, the smith was drawn into an even wider system of exchange than that dictated by the spear ban. After that, not only did a portion of his patronage lie beyond Samburu spatial hegemony but so did his raw material. These new transactions occurred at a time when the colonial administration was introducing taxation payable in livestock. The idea of currencies other than livestock had not made much headway. The Samburu initially resisted the introduction of the paper florin as currency in 1921, though they had accepted the silver rupee by that year.[23] While livestock have continued to be a viable currency among Samburu smiths (a pair of moran spears are currently worth two or three goats),[24] the necessity of purchasing raw material from traders after the demise of smelting propelled the smith into a regional system of exchange and toward a cash economy. As I will argue in the next chapter, the smith was more receptive than other Samburu to these changes at least partly because of his pariah status.

Most smelting ceased across the continent in the 1920s and 1930s, not just in Samburu, so it would be a mistake to link its cessation primarily to the spear ban. Rather, the cause was largely the sudden

availability of a new source of iron alloys in the form of steel rods, rail-road tracks, and vehicle parts (the first two were frequently pilfered from construction sites, as was brass telephone wire to make *surutia*). While the railroad did not penetrate north of Laikipia, Meru traders brought its metal with them into Samburu country (Larick 1984, 23). And just as in Idoma, the Samburu smith's anvil frequently became a section of railroad track, metaphorically capturing his old and new mediatory status: at one time, between this world and the cosmos, but in the colonial encounter, a vector toward something economists would later label the "informal sector." In the colonial instance, invention and bricolage were essential elements (see plate 6).

IDOMA WARRIOR MASQUERADES: INTERNAL AND EXTERNAL RUPTURES

Running parallel to the Samburu spear ban in colonial Kenya was the earlier British suppression of warfare and its rituals in Britain's Nigerian colony. This transformation in the Idoma chiefdoms required first of all a substitute for the primary ritualized object, the cranium (or sometimes the jawbone) of the defeated enemy. As fighting ceased under the Pax Britannica, heads were no longer readily available as sacra. To cast the issue in a frame developed by Jean Comaroff (1985, 119), the resulting disjuncture between received categories (the enemy cranium) and changing everyday experience (the cessation of warfare) led to innovation (the invention of a new artifact). This took the mimetic form of a carved (in the Cross River region, also skin-covered) head that functioned as a metonymic sign for the removed enemy as well as a metaphoric representation of warriorhood. In this symbolic reformulation, Idoma warriorhood no longer meant active military engagement and the taking of heads. But it continued to signify a set of behaviors formerly associated with these practices. These were publicly acted out in the Oglinye masked dance, which in turn grew out of the earlier celebratory performances in which a warrior danced with the enemy cranium or jawbone in his hand or atop his head (see plate 7, fig. 2.7).

There were other reformulations: in the nineteenth century, it was necessary to take a human life to earn the warrior title *ogwu* ("killer" or "assassin"; in some Idoma dialects *ogbu* and in neighboring Igbo country, *ndi-ogbu,* "man-killer"). Later it became possible to

substitute a dangerous animal such as an elephant or lion, and later still, when Idoma were recruited to fight in the West African Frontier Force, killing with bullets became an acceptable substitute for killing with a spear or machete and returning veterans were allowed to wear the red *uloko* feather of the scarlet lovebird that distinguished holders of the warrior title. More recently, Idoma soldiers who fought in the Nigerian Civil War of 1967–1970 were also *ogwu*. These successive reformulations of warriorhood gradually displaced the importance of the original artifact, the enemy head, into a restructured symbolic realm of aggressive, warlike performance that characterized the Oglinye dance but that no longer had anything to do with actual fighting practice.

Out of these changes it is possible to construct at least three different phases that describe the dances associated with Idoma warriorhood. These in turn can be strung together diachronically to create a very rudimentary model of Oglinye's history. The first phase, recounted to Capt. R. C. Abraham as "reported speech" in his linguistic research with Idoma-speakers of the 1930s and 1940s, reaches back into an unspecified time in the nineteenth century and extends up to the onset of British patrols on the Niger–Cross River Expedition (1908–1910). This was the period when Oglinye first appeared as a dance for warriors, as it had earlier near the Cross River, in Ogoja District and Igede District, and later in parts of Igbo and Tivland (Talbot 1926). The accounts described the level of unruliness at the dances, which caused the *igabo* (land chief's council) to incorporate the warrior age-sets into the law enforcement process through the establishment of an *aiuta* (literally, "sons of the law") constabulary as a means of bringing them under control. From Talbot's statements about the Cross River versions, we can postulate that in the earliest phase of its entry into Idomaland, Oglinye was danced using real enemy crania. But at some point, carved heads began to appear in these dances and it remains an unresolvable issue whether it happened in this early phase, when carvers could have invented them from the models already available in the Idoma face mask repertory, or in the next phase, after the official cessation of warfare and dwindling supplies of crania made it more urgent. The Idoma had whiteface masks (facial coverings, not free-standing heads) of many types, including Ichahoho and Ikpa, but the elderly men who were their custodians in the late 1970s did not identify Oglinye with any of these.

Consul John Beecroft collected a carved skin-covered head from the Cross River region, now in the Lagos Museum, sometime between 1829 and 1854,[25] so we know that nearer the coast, where British trade contact began substantially earlier than in the Idoma hinterland, there were mimetic mask heads prior to 1900. It is there among the Ejagham and their Cross River neighbors that the earliest carved prototype for Oglinye probably developed from the original crania, because it is well documented that "warriors' associations that traditionally utilized human heads or skulls in dancing include Obam, Ogrinya, and Enyatu, which were found among the Yako, Bette, and Ekajuk respectively, and which diffused to numerous other groups in the Ejagham Ekoi area" (Nicklin 1979, 56). On the other hand, the technique of covering with skin was never used by Idoma, Igede, or Akweya sculptors, which suggests not just "drift" from a prototype but independent invention.

There is nothing novel in the idea that certain mask types evolved from trophy heads. As early as 1898, Frobenius hypothesized the derivation of masks from skull cults (1898, 126ff). However, the model proposed here is far from a general theory of masks: according to the Idoma, their different mask genres had very different origins. Raffia masks were said to have been invented originally "on the farm" as scarecrows; the elaborate basketry-framed textile masks impersonating ancestors derive from special cloths used as burial shrouds. Anthropomorphic face masks fit the model in the mimetic sense but challenge it by the fact that they are a different shape than skulls. It is also likely that this whiteface genre entered Idomaland from the south, especially from northern Igboland, since Keana and Doma, Idoma-speaking polities north of the Benue, do not have them in their mask repertoires.

The second phase of Oglinye history is the period from about 1908 to the mid-1920s, following the imposition of British administration and the proscribing of Oglinye and warfare. This was also the period of most intense production of ethnographic texts of "native customs." The first outsider descriptions of Idoma (and Okpoto) masquerades and warriors' dances are vague and date from Byng-Hall in 1907 and Kay in 1913–1914, summarized later in Temple's chapter on Idoma: "Another is a sort of ghost-dance, when the performers wear wooden masks, some of which are painted white. Another, again, is a war dance, executed by armed men bearing both dane guns and bows

and arrows" (Temple and Temple 1922, 144). Unfortunately, the districts are not mentioned, so there is little clue about which masquerades were being witnessed. Meek's description, compiled, like Temple's, from official reports for the northern provinces, contains a footnote that "headhunting . . . [has] been effectively suppressed [as of 1925]" (1925, 2:48), though an archival report from the same year describes an eyewitness account of the Ichahoho masquerade as part of a headwinner's victory celebration (Macleod 1925).

It appears that in the early years of British administration, while mimetic masks were indeed being used in performances related to warriorhood and vigilantism, crania were still being used too, though they were not being used as "masks."[26] The evidence for this period comes primarily from the colonial record, though older people (such as Ojiji Ojefu of Otobi) who were born around 1900, were able to comment independently.

Part of the reason for the lack of historical and spatial precision in summarizing this period of rupture and reinvention is that different things were happening in different Idoma districts.[27] Some districts were "old" Idoma with a high degree of cultural uniformity (e.g., Otukpo, Adoka) and others had settlements of assimilated Hausa or Igbo stranger lineages (Yangedde, Agila) or were enclaves of non-Idoma immigrants who in the early colonial period were still in the process of being assimilated (Akpa, Igede). All the non-Idoma lineages had their own masking traditions apart from the Idoma masquerades (and in Akpa this was true in the entire district). In some (Akpa most prominently), masks carved from wood were highly developed. In others (such as Agila), there were elaborate textile masquerades but virtually no wooden masks.[28] In some, again such as in Akpa District, there were well-entrenched popular dances associated with warriorhood; in others these were not as well established. What all this meant in relation to Oglinye was that it occupied different niches of varying importance from chiefdom to chiefdom at any given time in the late nineteenth century and early colonial period.

In Igede and Akpa, both of which had strong historical connections to Ogoja and the Middle Cross River region, Oglinye probably began with crania and later developed into a mimetic wooden substitute in the Cross River sculptural format of a solid three-dimensional head worn on top of the masquerader's own head. But in the western districts that Macleod wrote about and that did not have any Cross

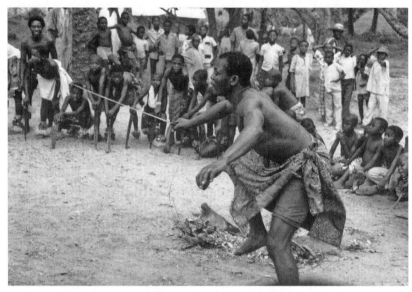

FIGURE 3.7. Young boys being instructed in "Igede," a dance with a machete, Ejor, Akpa District, Nigeria, 1978. *Photo by author.*

River immigrants, Ichahoho occupied the position held by Oglinye in Akpa and Igede. He wrote, "Ogrinia is a dance danced by young men and women at which a masked and cloaked figure appears. It seems to have no particular significance in these districts, but in Egedde [Igede], Akpa and in Ogoja Province it takes the place of the chafofo [Ichahoho]" (Macleod 1925, 19–20). Finally, in Agila, where there was no local tradition of carving masks, Oglinye remained a dance in which crania or jawbones may have been carried in the dance itself and not just displayed publicly.

The Idoma language distinguishes masquerade societies, *aiekwu*, "sons of the (mask) spirit," from dance societies, *aiije*, "sons of the dance." These have implications with regard to secrecy, since dances without masks are less hedged with ritual prohibitions. Omage An'ne stressed the point that Oglinye in the 1970s was not a "secret society" but a dance (albeit a dance with a mask, thus blurring the edges of the supposed distinction). Warriors' dances, on the other hand, were obviously different from dances that involved male and female partic- ipation. In some districts such as Agila, Oglinye retained those "hot" warfare associations into the 1970s. But in Akpa, the Oglinye heart- land within Idoma territory, it was defused and reinvented as a mask

play. Oglinye thus existed in both sides of the masquerade/dance dichotomy, depending on the district and the time frame. Not only does it occupy a liminal space between masquerade and warriors' dance, but, as a humanoid mask, it fills a different place in the spirit hierarchy than either a bush spirit or an ancestral reincarnation.

The third phase extends from Roy Sieber's visit to Akpa District in 1958 (Sieber 1961), which resulted in the first published photograph of an Oglinye head, to my field research in 1974, 1976–1978, and 1986 and 1989. By the late 1970s, Oglinye was rarely performed, but I was able to find the same mask Sieber had published twenty years earlier, kept in the compound of Otobi village's Oglinye society head Omaga An'ne, and after almost two years in the district, I was able to film one funeral performance in which Oglinye appeared. While actual performances at funerals were rare (most Oglinye members were long deceased by then) and the Oglinye society was more or less in a state of retirement, the carved heads themselves were plentiful, especially in Akpa and Igede districts, which had long been Oglinye strongholds. This third period, which was being documented as Oglinye receded into the Idoma past, is evidenced in objects much more than in events, testimony to the fact that in periods of colonial rupture, masks can outlive their active local careers and thus become positioned to end up instead as art-market commodities. By contrast, very few heads from the earlier periods can confidently be identified as Oglinye, resulting in an open-ended formal sequence that dates mainly from the middle and late colonial period (1930s through the 1950s).

To summarize the mask's history briefly, it begins in the nineteenth century with the introduction of Oglinye into Ogoja, Akpa, and Igede from the contiguous Middle Cross River region, where it was already established in cognate forms as a dance performed by warriors, using skulls or trophy heads of enemies. In some districts, decorated crania coexisted with carved masks, and in others, they were the only artifact used. To exert some level of control over the unruly performances, elders co-opted the dance societies into helping them in the enforcement of law and order. After the British pacification campaigns of 1908–1910, which introduced phase two (that of rupture and reinvention), the supply of crania dwindled, leaving sculptors with the need to make a substitute that resembled them. After the banning of warfare, the role of warrior became increasingly symbolic

and no longer reflected actual practice. Oglinye and Ichahoho continued as young men's masked dances and as part of the *aiuta* constabulary under colonially appointed district heads. Gradually this was replaced by a Native Court system, which in turn set in motion phase three, the slow decline in the Oglinye institution.

BONE, WOOD, AND SKIN

Up to now, we have discussed Oglinye heads without reference to the artists who made them. But they are the ultimate inventors in this complex algebra of transformation, not some colonial official writing decrees about headhunting. In Otobi village in 1908 or so when the first white men arrived, carvers had a repertory of at least a dozen masks associated with the ruling Ekpari, Ifu-Akpa, and Mbo clans as well as the surrounding Idoma lineages with whom they had intermarried since their arrival early in the nineteenth century.[29] The clients for these carvers were men who were active in the mask associations (*aiekwu*), women or men who were followers of the *anjenu* water spirits (a cult that arrived there from Igala at about the turn of the century), and people with requests for various shrine or guardian figures such as *enyanwu*. There were accepted conventions governing each of these genres but no real master-apprentice system to enforce them strictly, with the result that individual artists had considerable latitude to express themselves.

By contrast with the Samburu smith, there were many more degrees of freedom available to the carver whose challenge was to fashion from wood a mimetically intended substitution for the trophy head. While similarly constrained by the limits of his material, the technology of woodcarving imposes fewer conditions than the forging of iron. The spear must conform to a narrow range of weight, shape, and size; and more than that, metal is malleable for only a few seconds at a time, while it is red-hot, which discourages experimentation at that stage. The carver, by contrast, can take the time between strokes of the adze or cuts with the knife to visualize mentally the effect for which he is striving. Carvers with whom I have discussed this process say that with a new or unfamiliar form, a substantial amount of their time is taken up with thinking through what the next step should be.[30] This "thinking" is considered the most onerous part of being a carver (e.g., Gerbrands 1957/1971, 369), particularly since

African sculptors unschooled in Western methods do not work from preliminary sketches or models. Carving wood requires an ability to visualize in detail the three-dimensional result of any cut through or into the material.

There is also an important constraint in carving that is not true of forging iron: mistakes are irreparable. There is no way to put the object "back in the fire" and try again. Or to put it in terms of visualization or hand-eye coordination, every cut is decisive and final. Thus, with forging iron, the smith must work quickly but can modify the result by returning the iron to the fire, while the carver can work in a much more leisurely and reflective time frame but one in which every decision is final. If one looks only at the techniques themselves, it would be very difficult to argue that one inherently fosters a more experimental attitude than the other. Rather, experimentation must be formulated in the "thinking" stage in carving and in the doing and redoing stage in forging.

But in the case of the mask that substitutes for a trophy head, there is another level of thinking involved—how to transform the cranium complete with bone, skin, and hair into a wooden embodiment of the *idea* of the victim that not only resembles but also conceptualizes the enemy. In various parts of the Cross River region, Ogoja District, and Igede District between the mid-nineteenth and early twentieth centuries, this mimetic intention was carried out using three different strategies: by decorating and otherwise altering a real skull, by carving a wooden version of it, and, in an ultimate gesture of mimesis, by covering the wooden model with antelope (and very occasionally human) skin. In Idoma, the skin-covering technique was never adopted, though it did spread northward from the Middle Cross River region as far as Ogoja, a transition zone that includes the Idoma-related Yatyi (Yachi) and Iyala. Igede, another closely related cultural enclave appended to Idoma Division in the colonial period, was the point of entry for Oglinye into Idomaland proper.

Among the Idoma warrior mask genres, most but not all of which represent the victim, the face masks such as Ichahoho and Ikpa are more strikingly the products of an aesthetic of naturalism than is Oglinye. One explanation for this is that the face mask was a form indigenous to Idoma, while the trophy head worn atop the head was of Cross River origin (Talbot 1926, 3:788–789). It was therefore easier for an Idoma carver to translate the idea of the trophy head

into the face mask format than into a three-dimensional carved head. There is considerable variation due to individual carving styles and skills, but the most highly skilled carvers were able to capture an expression of arrest on the mask face (Napier 1986). This characterizes the moment of abrupt transition from life to death, the mouth and eyes partly open. But the range is wide, and some Oglinye heads are very antinaturalistic. The challenge of mimesis is a particularly difficult one for artists who have undergone no apprenticeship under a master carver. Whereas antinaturalism is an open-ended category, a puzzle with many solutions, naturalism is directly dependent upon the ability of the carver to replicate a lifelike model.

But another facet of the problem of mimesis is the issue of metamorphosis. The Cross River skin-covered heads are a much clearer example of this than the Idoma heads. Blier (1980, 17) suggested metamorphosis ("the changing of skin") as the underlying reason for skin covering, and Thompson (1981, 176) pointed out that the layer of skin became the new locus of the medicinal power of the former trophy head. I would suggest that the idea of metamorphosis works in the Idoma heads by a somewhat different metonymic process in which the expression of arrest comes to stand for the moment of killing. It is the instant of decapitation captured as if in the freeze frame of a camera and it fully expresses the psychic energy of both the slayer and the victim.

This interconnectedness of the slayer and victim was played out in other ways as well. One very powerful expressive act that apparently disappeared with the use of trophy heads was the ritual drinking from the skull by warriors (Temple and Temple 1922, 143; Omaga An'ne, pers. comm., 1978). This was to allow the warrior to acquire the power of the enemy—a practice that was no longer necessary with the cessation of warfare but was performed in analogic fashion not only in the region bounded by the Niger, Benue, and Cross rivers but also in the Cameroon Grassfields. Anebira ("Kwotto") warriors ingested a medicine made from the slain enemy's eyes in order to counteract the power of the deceased to see and harm them (Wilson-Haffenden 1928, 43–44). Among the Bamum, young boys licked the forehead of the crania their fathers had captured in order to acquire the qualities it contained (Geary 1981, 12). Not unlike the relics of the departed saints of Christendom, the heads of powerful enemies were thought to contain a residue of spiritual force that could be transferred, in a ritual context, to the slayer. This uniting of the slayer

and the victim through ritual performance is further complicated in the masquerade enactment, to which women are added to the equation as a third, witnessing presence.

It would be a much neater exercise in mask iconography if all post-Pax Idoma warrior masks were representations of the victim. But artistic invention, especially in a culture with no formal apprenticeship system, is no more likely to follow a single linear mode of progression than any other kind. In a transposition of the meaning of manhood from the scene of battle to the more domesticated cultural realm of becoming a man in the face of female acceptance, some Oglinye heads are said to be representations not of enemies but of women. At first this seems counterintuitive given their associations with violence, but Idoma anthropomorphic masks very frequently come out as a male-female pair that are commonly referred to as "husband" and "wife." In a homologous spirit world, conjugality is an operational metaphor, just as in the real world of the village each all-male masking society has both a male and a (postmenopausal) female head.[31] Female mask prototypes therefore existed that could be adopted in the Oglinye dance. Furthermore, women figured prominently in the social meaning of the captured head, both as nonmale, nonviolent sexual and social opposites to warriors and as rewards given by their families in marriage to the young men who succeeded in bringing back heads. In the Oglinye mask performance I witnessed, women relatives of the deceased entered the performance space individually to honor the mask by dancing briefly before it, just as they did for other masquerades performed at second burials. But unlike the Oglinye's face-to-face encounter with village warriors who were brandishing machetes, the women danced with palm fronds to symbolize their peaceful intentions.

On the basis of this knowledge of Idoma cultural practice, one might predict a pair of Oglinye masks in which one is male, the other female. But the logic of the mask system does not follow the logic of the various hierarchies it represents: there is not a mask for every important social and spiritual category in Idoma life.[32] Nor is the human social hierarchy necessarily the hierarchy of masks. While ancestors are ascendant in both, there is a certain amount of framed disorder (Kasfir 1988, 8) in the form of both inversion and reversal. It is this playfulness with everyday social categories that allows for the possibility of transvestism—male maskers representing women— hence "wife" masks that come out with their male counterparts. Yet

in the Oglinye performance I filmed in 1978, male and female were incorporated into a single masquerader with a "female" head (this was signaled by braided hair made of hemp or indigo strip-woven cotton, a women's style adopted from the Fulani that was popular in the early colonial period) and unambiguously male costume, weaponry, and aggressive warrior dance style. The male-female "pair" was accomplished in a single figure. This collapsing of male and female into a single mask figure may have been a way of compensating for the "lost" cranium that after the 1920s was no longer a part of the total representation but had been carried in earlier dances. Ideally the relationship would have been expressed as:

Warrior Is to Potential Wife as
Skull of Victim Is to Female Oglinye Head

but as the skull dropped out, maleness was left to be signified by the machete, the civet-cat fur pelt worn at the waist, and the aggressive movements of the "challenge" dance performed in front of the slit drum (see Brain and Pollock 1971, 92–94 on the Bangwa Ngkpwe, or Challenge Society).

IKPA AND OGLINYE:
THE LOCAL AND THE REGIONAL IN COMPETITION

In the Idoma region, words that relate to ritual performance often have careers of their own and can move in cognate fashion from one related object to another or from object to event to person. If the term "Oglinye" can refer to either a dance or a masquerade, then "Ikpa," which up to now has been described as a mask, has a much more formidable set of referents. Omage An'ne, the head of the Oglinye society in Otobi in 1978, insisted that the war dance was "not Ogrinye, but Ikpa." From others I finally learned that Ikpa was an inner circle, the group name of those who hold the Ogbu warrior title.[33] The same is said of the Ikpa mask in Igede (Nicholls 1984, 73). In Akpa District, this group had its own mask, a whiteface type very similar to Ichahoho that appears occasionally at the funerals of members. In the southern district of Agila there was no mask at all (just as there was no Oglinye mask) because there were no wood sculptors, but the Ikpa dance was performed as a purification ritual in which the blood of the enemy's head was symbolically removed from the Ogwu warrior titleholders.[34] In southwestern Idoma, a colonial officer reported in 1919 that a dou-

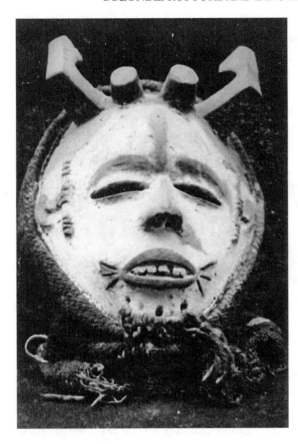

FIGURE 3.8. Ikpa mask. *Courtesy of Jos Museum, Nigeria.*

ble drum called Ikpa, composed of two hollow logs with skin-covered ends, was beaten while dancers decorated with spots of red, yellow, and white pigment carried their war trophies, skulls or jawbones of the enemy (Smith 1919, 2). Mask, dance, dancer, drum: same name, interrelated meanings and practices, different places. Ikpa not only has its own history entangled within the history of Oglinye but also its own complex artistic geography.

Therefore an alternative but hypothetical reading (since the question was never posed to the Idoma) would pair the Ikpa mask as "husband" with the Oglinye head as "wife," to fit the assertion by Omaga An'ne that the real war dance was Ikpa.[35] This reading reclaims the key position Ikpa held before the arrival of Oglinye in Akpa District, but since Ikpa was no longer performed at the time of my fieldwork and, in fact, was not in evidence anywhere except in the storage room of the Jos Museum, I can proffer this only as a hypothesis based on the complementarity of the two.

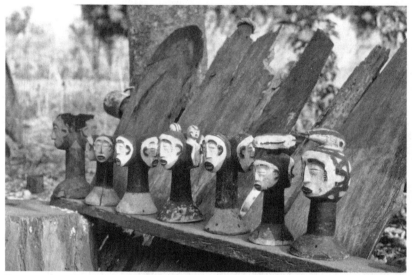

FIGURE 3.9. Ogrinye heads by Akuma, Igede, Nigeria, 1986. *Photo by author.*

Just as Ikpa could be a mask, a drum, or a dance, the same volatility of categories existed between the enemy cranium and the invention of the carved head to replace it. It could be male, in which case it simultaneously played on the idea of the slayer and the victim, or it could be female but contextualized within a male-gendered performance frame. In Igede, it could simultaneously be both, in the form of a Janus-head.

In this example of inventiveness on the part of different artists working with the same set of ideas but contrasting technical skills, local mask practices, and personal imaginations, one is able to see several solutions to the problem of representation contained in the trophy head. The problem of the spears was different both in the narrowness of the parameters in which innovation could proceed and in the fact that it was not in any direct sense a problem of representation. In fact, the ideas attached to spears were as complex, as richly symbolized, and as socially embedded as the ideas attached to Oglinye and warfare. But precisely because they were *not* a representation of the slayer or the victim but only a figurative and literal vector or instrument for those ideas, the spears themselves are unable to yield up affect in the same way as the mask heads. Does this make them "mere things" and not art? I will argue in a later chapter that to make that judgment, the spectator must see the spear not in isolation but as an extension of the ritualized body.

4

SAMBURU SMITHS, IDOMA MASKMAKERS: POWER AT A DISTANCE

There is a creative tension between *representation*[1] (a likeness called up in the mind by description) and *identity* (the condition of being something described or asserted): the first is used to construct the second. But since identity is partly self-constructed and partly fabricated by others (e.g., Waller 1993, 300), its corresponding representations may be very different. I begin with this simple observation because as a witness to the lives of Samburu blacksmith (*lkunono*) families and therefore one who is exposed daily to their representations of themselves, I continue to find it very difficult to reconcile these with the representations of *lkunono* proffered by nonsmiths, especially in the descriptions recorded by Europeans at the time of initial contact. This chapter attempts to explain these disparities and connect them directly to the power and creativity of Samburu smiths. I then apply some of the observations about cultural separation and distancing, both self-proclaimed and externally imposed, to Idoma maskmakers, some of whom are sculptors and others ritual tailors of ancestral masquerades.

I suggest here two ways to think about this problem of separation. First, at the most general level, one can think of it as the problem of how a highly specialized artisan "caste" is seen by its members and others. Second, somewhat specifically, one can examine the views of artisanship within a pastoralist-dominated social system. Pastoralists (i.e., those who raise livestock as their primary means of subsistence) constitute a tiny fraction of the African population and an even smaller share of those associated with "art-making" in the Western sense of producers of images: masks, figuration, and pictorial arts. But the concept of artisanal caste (and here I use this dated term to

position the discussion within a specific historical discourse on the African blacksmith), when viewed from within and without and from the top and bottom, has had a wide application in sahelian Africa, from the Western Sudan to the East African savanna.[2]

Using the first approach, I will briefly compare the different representations of the smith in Africa in order to uncover critical issues in interpretation. In this case, the constellation of images and beliefs about smiths is not bounded by a specifically Samburu identity but is found among all Maa-speaking cattle pastoralists in the same way that Mande-speaking smiths in West Africa have a group identity that is distinct from their ethnicity as Bamana, Maninka, and so forth (McNaughton 1988, xix). The second approach looks at the larger issue of dominant and subordinate group identity as it is localized through Maa-speaking pastoralist interactions in the Kenya Rift Valley. Spencer in his study of Samburu (1965) and Rendille (1973) and, more recently, Sobania (1991), Fratkin (1991, 1993), Galaty (1993), Waller (1993), and Kratz (1994) have documented and amply historicized this flexibility and absorptive capacity among Maa-speaking pastoralists vis-à-vis their allies, their subalterns, and even their rivals. Paradoxically, this willingness to absorb, or be absorbed by, non-Maa has held despite an ideological commitment to the superiority of "pure" pastoralism over farming and trading. If ethnic identity is often renegotiable at times of crisis or of mutual benefit (and almost all writers agree that it is), caste identity may be open to the same kind of ambiguity that is produced by "ethnic shifting" (Galaty 1982).

This is especially so because within the Samburu age-grade system, one's membership in a particular age-set crosscuts smith/non-smith group membership and is a more salient aspect of identity for everyday purposes. The same may be said of sectional (clan, phratry) identity in many contexts. When two Samburu strangers meet, the first question between them is: What is your section? For example, Lpisikishu is a section highly respected for its former success in warfare (Spencer 1973, 122) and is part of the Black Cattle moiety, which is ritually senior to the White Cattle moiety.[3] It also has an important lineage of blacksmiths, the Lelenguya family. Their Lpisikishu identity is useful to them as a leavening element in their status, both among other Samburu sections and among Lpisikishu. I will return later to this issue of multiple identities in the case of the *lkunono* of Lkurorro age-set. Here I wish only to use it to frame the

idea of caste ambiguity. None of the early-twentieth-century writers on Maasai smiths were aware of the importance of cross-cutting occupational and age-set membership, and consequently all overstated the importance of blacksmithing as a pariah caste. Once these early views were enshrined in widely used secondary sources on African metallurgy such as Cline (1937, 114–115) and Baumann (1948, 259), they were reified and repeated uncritically by other modern writers (e.g., Eliade 1956/1978, 91).

BLACKSMITH HEROES—BLACKSMITH PARIAHS

I have discussed one period of transformation in the Samburu smith's practice as a result of colonial intervention and the series of events that intervention both knowingly and inadvertently unleashed, but how does one explain this within the larger discourse on the smith in Africa? And what might this larger discourse reveal that would increase our understanding of Samburu practice? A major problem in writing about the blacksmith in Africa derives from the fact that the long-standing interest in the smith's cosmogonic status has overshadowed any potential interest in his actual practice as the maker of tools, weapons, metal ornaments, and ritual objects (Margarido and Wasserman 1972, 87–89; Kasfir 1987, 41), a point reaffirmed by Eugenia Herbert (1993, x–xi) in her monumental study of ironworking and ritual transformation in Africa. I argue, as Margarido and Wasserman have, that the first—the smith's mythic status, or his significance in ritual—cannot be understood without reference to the second—his practice.[4] In particular, it is not possible to understand the altered status of the Samburu *lkunono* today without a closer look at his role in the colonial encounter and the postcolonial economy as they have impinged upon how other Samburu represent him.

A major reason for the preoccupation with the myths and magical power of the smith has been the extreme variation in his status in African societies, an anomaly more easy to explain by recourse to myth and symbolism than by any major differences in his cultural production and practice from one place to another. At one extreme, there are the blacksmith-aristocrats in Central Africa, described by the Portuguese in the seventeenth century as *fidalghi* (nobles) among the Bakongo (Cuvelier 1953, 139–140) and fortified by numerous allusions since then to *le roi forgeron*, the blacksmith-king, as founding

hero in various Central African traditions such as the Kuba (e.g., de Maret 1985; Vansina 1972, 1978). In analyzing this vast and richly complex smith-as-hero literature, Herbert (1993, 132) isolates three themes: the identification of smith with chief; the appropriation of the tools of metalworking as insignia of chiefly office; and the role of smiths in chiefly ceremonial. She rejects, following Vansina (1969), the too-literal interpretation of the blacksmith-king tradition (132) but also notes that anywhere in Africa where the smith is symbolically ranked with the chief, even as a temporary ritual inversion, and even when he is from a caste group, it may be because he "monopolizes a primary technology" and also represents an autochthonous group (149). I will return to these questions because they are also testable in situations where the smith is explicitly *not* identified with the chief or king.

At the other extreme (though a bipolar model is actually part of the problem), there is the characterization of the smith as a member of a pariah caste and object of loathing. Here the Maasai blacksmith is frequently held up as the quintessential example (e.g., Cline 1937, 114–115; Margarido and Wasserman 1972, 105–113), though the ethnographic record from which these conclusions were drawn is both hyperbolic and historically shallow, all coming from a twenty-year "eve-of-contact" time frame from 1885 to 1905 (Thomson 1887; Hinde and Hinde 1901; Hollis 1905; Merker 1910).[5] It is based in an over-simplified understanding of Maasai social relations that Margarido and Wasserman intentionally complicate for the sake of analysis by adding the Torrobo hunter-gatherers in order to contrast the Maasai *il kunono* with a different "other."[6] The explanations typically advanced for this smith-as-pariah model are that the *il kunono* are "strangers" and that they are impure and inauspicious because the weapons they make cause blood to flow (e.g., de Heusch 1982, 56–69). That these are neither necessary nor sufficient as explanatory models can be seen in the facts that in numerous African cultures, smiths are ethnic outsiders but are not considered pariahs and that virtually all smiths everywhere made weapons that shed blood, though again, this did not necessarily make of them a despised caste. Furthermore, in the Maasai-Samburu case, they are not "strangers" at all.

In an inscription that has now achieved the status of dogma, the Dogon smith represents the opposite example of caste exclusivity: otherness without loathing. As in the Maasai and Samburu case,[7]

Dogon smiths form an endogamous subgroup and live apart from nonsmiths, though in close proximity to them. In all cases they speak the same language and are considered to be of the same ethnic origin as the nonsmiths they live among. Three major differences are at once noticeable, however. First, the smith is an important (if enigmatic) actor in several versions of the Dogon origin myths and is dramatically portrayed as culture hero (Griaule 1938, 48; Griaule and Dieterlen 1965). In the most elaborate version, the proto-ancestor of black-smiths built in heaven a granary of celestial earth divided into eight compartments into which he put the eight cultivatable grains. He descended to earth with this granary, which when dispersed became the primordial field. He also invented fire and taught people farming and the domestication of animals (Griaule 1938, 49). Second (and especially prior to the commodification of Dogon sculpture following the Griaule expeditions), the Dogon smith was a specialist woodcarver as well as a blacksmith, producing ritual masks and figures as well as agricultural and hunting tools. Third, and predicated upon both the myths and his practice in the production of ritual objects, the Dogon smith was a highly respected (even if segregated) other.

The much less elaborate Maasai origin myths (Hollis 1905, 266–267; Merker 1910) say little on the matter of blacksmiths. Hollis recorded no "smith myth," but Cline reported the following story from Merker in German East Africa: God offered three implements to the first three human beings: a herding stick, a bow, and a hammer. The one who chose the first became a pastoralist, the one who chose the second became a hunter, and the third was left with the hammer and became a smith. In a very cursory way the story suggests a God-given ranking of occupations with pastoralism at the top and smithing at the bottom (Cline 1937, 114). In further contrast to the agricultural Dogon, the pastoral ideology of the Maasai dictated that the artisanal roles outside metallurgy be filled by women or non-Maasai Torrobo. But if the most obvious ethnographic errors from early Maasai accounts are factored out (e.g., the idea that smiths were slaves or strangers) and allowance is made for the fact that things or persons that are powerful and dangerous may be either venerated or feared, admired or despised,[8] the Dogon and Maasai examples could be collapsed into a single analytic category of the smith as a powerful (hence dangerous) other, separated by caste endogamy from the rest of society. There are gains and losses in focusing only

upon this distancing of power: on the one hand, it reveals the very fine line between people and things that are thought to be dangerous to the well-being of others and those that call for distancing because they are uniquely efficacious, if handled properly. But it also tends to downplay major differences in the way smiths are thought about in diverse cultural settings. The Maasai are not the Dogon, and the relatively unambiguous position smiths enjoy in Dogon culture is very far from their lower status among Maa-speakers. Yet the reason for their distancing in both cases is a way of dealing with their acknowledged ritual power.

Until now I have used the idea of caste uncritically. In speaking of blacksmith castes in Africa, writers frequently feel impelled to qualify the term (e.g., Conrad and Frank 1995; Herbert 1993, 2; McNaughton 1988, 156–161; Vaughan 1970, 59–62) on the grounds that what they are describing may be quite different from the prototypic Hindu caste system. Fundamental to the latter are supposedly unambiguous notions of endogamy, hierarchy, and pollution (e.g., Dumont 1970). In fact, the same questions about the incorrigibility of caste are being raised by contemporary Indianist scholars themselves (e.g., Ganguly 2005; Mohanty 2004).

In the dry sahelian and sparsely wooded savanna regions of West Africa that together are known as the Western Sudan,[9] blacksmiths are typically endogamous hereditary occupational groups, but their "rank" as well as their social status is much less consistent. For example, McNaughton accepts that the Mande smiths are indeed castes in the sense of "a specialized endogamous group socially differentiated by prescribed behavior and genealogically inherited professional capacities" (1988, 159). But beyond that widely recognized definition, there is substantial ambiguity about the smith's position in society because of the ambivalent feelings nonsmiths harbor toward them (160)—an ambivalence borne partly out of the recognition of their power, which eludes everyday means of control. In the case of Mande smiths, this power extends not only to control of an essential technology but also to their ritual roles as circumcisers, diviners, and sorcerers and as sculptors for *kòmò, kore, ntomo,* and *kònò* associations (149). This multiplicity of mediating roles between nonsmiths and recognized supernatural forces allows Mande smiths to "work" the ritual structure, but it also creates for them a totalizing image of those who know how to manipulate (rules, substances, people).

The third and residual category is the unmarked (and in comparisons, largely unremarked) smith that exists in many places outside the sahelian regions of Africa.[10] Like most Guinea Coast blacksmiths, the Idoma smith falls in this group, and like the Idoma carver, his status (at least for the past two generations) has derived less from his smithing than from his overall estimation in the eyes of the community. Like his frequent counterpart the female potter, his ability to transform inert "black earth" through fire into objects basic to subsistence is a rich source of metaphoric language that often forms the stuff of ritual, yet he, like the potter (Barley 1982), is usually absent from the ritual for which he supplies the symbolism. His participation in ritual events hinges upon his status as a lineage elder and possibly as a title-holder and not exclusively as a smith.

To be sure, smithing in Idoma operates inside a power-knowledge system invested with secrecy and exclusivity, but despite that, the local status of the smith is an achieved rather than an ascribed one. To historicize this accurately, one would need to know much more about the Idoma smith in the precolonial period than is evident in either the early colonial record or through contemporary oral histories. When smelting was still regularly performed prior to the importation of metal by the British, there were rituals in which most smiths participated in connection with the smelt, but as Herbert (1993, 115–116) has aptly summarized for the continent, few of the ritual restrictions of iron smelting carry over into the smithy. Because smelting ceased in the 1920s and 1930s in most places under British colonial administration, the aura of sacrality conferred by smelting as a kind of metaphoric parturition has ceased to be a part of the cultural script for most blacksmith practice. One effect of this is to bestow on the smith a less marked status in the community, even though Idoma smithing, for reasons of craft secrecy as well as the informal father-to-son apprenticeship system, continues to run in families, even though it is theoretically open to any sentient male.[11]

The Idoma smith had a special relationship to warriors and the dangerous pollution engendered by killing: for both warriors and hunters, he performed the ritual known as èogwóonà, "washing the killing from the face" (Armstrong 1989, 32). This he did with medicinal leaves that had been dipped into the water used to quench red-hot iron or steel. The person who has killed another person or a dangerous animal (a buffalo, a leopard, or a lion) is said by Idoma to

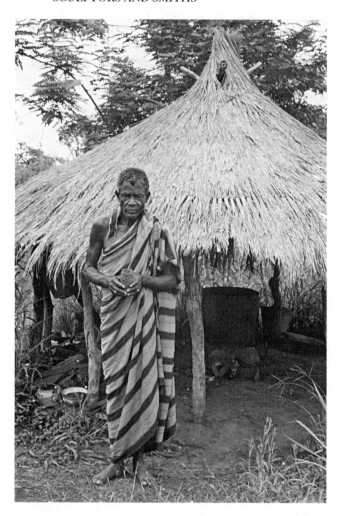

FIGURE 4.1.
Idoma
blacksmith
and bronze-
caster Audu,
Asa, Nigeria,
1977. *Photo by
author.*

behave badly just after the event: "He talks like a person who is crazy; he calls the name of the person he has killed (if he knows his name); and he regards everybody as not being as strong as he is. The Idoma people [then] say, 'That man is crazed by *ogwú*.' . . . *Ogwú* must be washed from his face so that he may begin to behave properly" (33). Into the water of the forge, the blood of a sacrificed cock is allowed to flow. The leaves are dipped in this mixture and the blacksmith washes the killer's face three times a day for up to seven days. When asked why it is the blacksmith who must perform this ritual of purification, people replied that it is the smith who forges the weapons that people use in hunting or killing a person (34).

What this custom demonstrates is the fact that, whether casted or uncasted, the idea of danger associated with iron is not limited to sahelian or pastoralist cultures; it is also seen in the widespread presence in the forest zone of West Africa of Ogún and his cognates as a culture hero sometimes deified as god of iron and war. The Idoma term *ogwú* refers not to a deified culture hero but to the warrior himself and his antisocial uncontrolled behavior after killing. The smith himself is not polluted by the warrior's behavior, as he is said to be among Maa-speaking pastoralists; rather, he plays the role of ritual specialist and intermediary, removing the stain of killing through contact with the same polluted substances used in the killing, iron and blood, but in the ritual space of the smithy.

Pierre Clément (1948, 51) correlated the variations in the status of smiths with the distinction between cattle pastoralists and agriculturalists as systematically opposite socioeconomic formations: their status is generally low among pastoralists (where the smith's main production is weapons) and high among farmers (where the smith's most important products are agricultural tools). In that case, one would expect these to be played out in parallel differences in myths. The corresponding mythic representation of the smith of high status would be the iron-bearing culture hero (in West Africa a blacksmith, hunter, or magical animal) who teaches people to till the soil in parallel myths from the Western Sudan to Guinea Coast. At first it might appear that this correlates perfectly with a pacifistic and civilizing representation of the smith in agricultural societies, but some of the most prominent non-Sudanic cultures in this myth distribution (e.g. Yoruba, Fon, and Edo) focus on a ritual weapon, the sword wielded by a warrior hero such as Gú, which collapses distinctions between aggression and civilization (Barnes and Ben-Amos 1989, 57). The idea of a clear structural opposition between a civilizing smith-hero in agricultural societies and a smith polluted by bloodletting in pastoralist societies does not correspond closely enough to actual mythic representation, to say nothing of real-life behavior, thus undercutting Clément's theory.

REPRESENTATIONS OF MAASAI LKUNONO
IN THE EARLY LITERATURE

Krapf did not mention smiths in his brief account of the Maasai (1860, 358–366), but Thomson (1887, 248), in his characteristic

mixture of sarcasm, wonder, and observation described the "El-konono" as if they were non-Maasai kept in a state of subjugation:

> This is an inferior race kept in servitude to the Masai, for whom they make spears and swords. They do not go to war, and are not allowed to intermarry with their superiors. They all speak Masai, though it is believed they have a language of their own. In response to the call [from a moran and his father] a miserable, half-starved object appeared with a selection of murderous-looking weapons.

The Torrobo are described with similar pitying condescension:

> They journeyed to a neighbouring settlement of Andorobbo—a clan who are despised heartily by their distant relatives, the aristocratic Masai, on account of their ignoble mode of gaining a livelihood by the chase. After making the Andorobbo quake in their sandals, they chose a handsome shield of buffalo hide, beautifully made, elliptical in shape, and warranted to stand a tremendous blow from a spear. . . . The unfortunate maker had to be content with a scraggy sheep—and a blow. (247–248)

The description of *lkunono* by Sidney Hinde (Hinde 1901) while he was a collector for the East Africa Protectorate is more evenhanded but is also couched in a comparison with Torrobo:

> Under Masai rule are two tribes called the Elgunonu and the Dorrobo, both of which are practically slave races. Though no individual man is a slave, any Masai warrior is entitled to give an order, which must be obeyed, to any member, or members, of either of these tribes. All work thus ordered by the Masai is paid for by them when completed. . . . The Dorrobo are hunters and carpenters, and it is their especial function to make the shields and prepare the skins required by the Maasai. They neither keep flocks nor herds. . . . In war they are not allowed to accompany the Masai or to carry shields and spears. (11–12, 15)

Hinde, however, contradicts Thomson's assertion that *lkunono* do not go to war:

> The Elgunonu—numerically much weaker than the Dorrobo —are workers in iron. They do not hunt or eat game [unlike the Dorrobo], and are a pastoral people living under the

> same conditions as the Masai. Under no circumstances do
> the men or women intermarry with Masai or Dorrobo. Their
> kraals are built in the open, in close proximity to the Maasai
> kraals, and their young men are allowed to accompany the
> Masai, with shields and spears, on the warpath. (15)

Hinde falls short of recognizing that the *lkunono* actually are
Maasai, though the assertion that *lkunono* warriors fight alongside
other Maasai and (like them) do not hunt or eat game clearly dif-
ferentiates them from Torrobo and at the same time implies their
Maasainess at some fundamental level.

Another early writer on the Maasai was A. C. Hollis, later to
become secretary for native affairs and a signer of the infamous 1911
treaty, who published a compendium of Maasai grammar, folktales,
and customs in 1905 using a Lumbwa Maasai as his main informant.
The informant, Justin ol-Omeni, was himself two stages removed
from the pastoral Maasai, first by virtue of coming from one of the
lower-status Maasai subgroups that practiced agropastoralism, and
second as a Christian convert whose education was completed at
the Church Missionary Society's station at Freretown near Mombasa
on the Swahili coast (Hollis 1905, iv–v). Ol-Omeni's views of Maasai
mythology and social relations must be filtered through this partic-
ular lens, including the statement on smiths. Nevertheless, unlike
Thomson and Hinde, as an indigene himself he knew that the *lku-
nono* were Maasai:

> All Masai do not know how to make spears and swords; this
> is the work of the smiths (*en-gias oo-'l-kunono*). It is they who
> make the weapons, and the others purchase from them.
> . . . The iron which they work with they purchase from the
> Swahili or they smelt the ore which they find in the bed of
> the Matapato river. . . . Every clan has its smiths; but there
> is one clan, the Kipuyoni, to which most men of this class
> belong. . . . The other Masai do not marry the daughters of
> the smiths, for it is not considered correct. The smiths marry
> among themselves. . . . If a Masai takes in his hand a spear or
> sword or other thing which a smith has held, he first of all
> oils his hand for it is considered improper for him to take it
> in his bare hand. (1905, 330–331)

The idea of a caste-like endogamy and social hierarchy (in accor-
dance with Thomson's and Hinde's accounts) is thus confirmed and

the additional idea of caste pollution is introduced, though the precise locus of this pollution, whether in the smith himself or in the metal or in the process of smelting or forging, is unclear. Hollis (or Ol-Olmeni) goes on to describe the relation of smiths to cattle:

> The smiths are not rich in cattle like other Masai. They have no luck with cattle. If you find one possessing forty head, it is a very large number. . . . The smiths have their own language, which, although a corruption of Masai, is not understood by the ordinary Masai. Not all of them can speak this language: it is only a certain number of them who know it. (331)

I will return to the issue of blacksmiths and cattle in the Samburu case where it constitutes an either/or condition of idealized power relations. Merker (1910, 112–113n2), a German army officer and author of the most extensive early description of the southern (later Tanganyika) Maasai,[12] asserted that Hollis was mistaken on the question of a special language and explained it by the fact that some smiths spoke a Lumbwa[13] dialect that was not understood by all Maasai.

Yet the belief in a secret language persisted, among Samburu as well as core Maasai groups. Up to a generation ago, *lkunono* were known by other Samburu as "Lkurisho," people who could do mischief because their secret language was not understood.[14] The belief in the existence of a secret language known only to members has many parallels elsewhere among subordinated groups but also among initiates to bodies of esoteric knowledge (for example, in West African "secret societies" such as Ngbe in the Cross River or Arekweeka among the southern Idoma). Knowing a secret language is therefore both a sign of otherness and a sign of power. The idea that smiths should speak a language of their own fit the representation of their alterity, whether or not it was actually true.

Merker (1910, 111) adds that the reason blacksmiths are required to locate their smithies some distance away from Maasai cattle enclosures is that their proximity brings disease and death to the livestock. I will return to this idea in discussing the Samburu forge—for now I wish only to recognize the forge as a site of danger and avoidance.

LTORROBO: THE OTHER'S OTHER

By creating a hypothetical model with three de facto "castes," Margarido and Wasserman (1972, 112) were able to isolate the

supposed distinctions among Maasai warriors, Maasai smiths, and Torrobo hunter-gatherer artisans based on these early ethnographic reports of Hinde, Hollis, and Merker. Despite this model's misrepresentation of Torrobo as farmers and the oversimplified conflation of Maasai warriors and elders, it allows them to look at power relations in an interesting way. It is Maasai cattle and weapons, they argue, that need to be made immune (protected) from the blacksmith's power claims, since he is both an owner of cattle and a maker of weapons as well as a member of the dominant group (unlike the Torrobo). This is accomplished by his social and mythic marginalization (113). Their chart, with a few changes and corrections, is reproduced in figure 4.2. Laid out in this fashion, which omits both recent dietary changes and the issue of pollution, it is easy to see that if the smith was not controlled in some way, he could easily come to dominate nonsmiths since he controls weapons technology and also keeps limited herds. Therefore limits are imposed upon his access to cattle and wives to keep him from accumulating more of these than other Maasai. In this context, ritual sanctions become instrumental and distancing is a way of controlling accumulation.

All of this must be seen against a regional background in which cattle and warriorhood play a much larger economic and symbolic role than they do in West Africa. The best-known members of the so-called cattle complex in eastern Africa were undoubtedly the cattle-owning Tutsi, who historically dominated a much more numerous Hutu peasantry and the small groups of Twa hunter-gatherers in Rwanda (Maquet 1970, 95; Bonte 1991, 64; Mafeje 1998, 55).[15] While the Maa-speakers east of the interlacustrine region brought with them the same cattle-and-warriorhood ideology that in their own eyes gave them social (and military) superiority over cultivators, their uncentralized and chiefless political system did not result in the same kind of institutionalized political domination over neighboring agricultural people and hunter-gatherers as occurred in Rwanda. Nonetheless, their attitude toward people who tilled the soil or slaughtered wild animals or made things out of these substances (e.g., iron weapons, leatherwork, ivory objects) was that they were a kind of necessary support system for warriorhood but were unworthy to associate with warriors (and their fathers, owners of cattle) as social equals. Thus it was Maasai/Samburu women (housebuilders, beadworkers and leatherworkers, calabash carvers), Torrobo women (potters), Maasai/Samburu *lkunono* (makers of iron weapons and

MAASAI WARRIORS	MAASAI BLACKSMITHS	TORROBO
Cattle keepers	Cattle keepers (#)	Hunter-gatherers
Moran who fight	Can join moran in fighting (+)	Can't join moran in fighting
Non-makers of weapons	Makers of offensive weapons	Makers of defensive weapons
Ritual killing of cattle	Ritual killing of cattle	Kill animals for consumption
Do not hunt (@)	Do not hunt (@)	Hunt wild animals
Eat meat/milk/blood	Eat milk/meat/blood/grain (*)	Eat game/agricultural products
Live in kraals in the plain	Live in kraals /forge is far from cattle	Live in the forest
Live in Maasai style houses	Live in Maasai style houses	Live in non-Maasai style houses

(#) Herd limited in size
(+) Can not fight other Maasai sections
(@) Rules differ slightly between core Maasai and Samburu but not between smith and nonsmith, e.g., all Samburu will kill and eat buffalo (= cow) in times of famine
(*) But blacksmith warriors follow same food rules as nonblacksmith warriors

FIGURE 4.2. Comparison of Maasai Warriors and Smiths with Torrobo based on Margarido and Wasserman (1972).

tools and iron and brass decorations), and Torrobo male artisans (makers of hide shields, wooden stools, and objects of ivory and bone) who supplied the material culture of pastoralist life—all of them of subordinate status to warrior-herders in the grand scheme of things.

TUAREG SMITHS AND THE AMBIGUITY OF CASTE

In a more complex (four-part) pastoralist social hierarchy, that of the Kel Ewey Tuareg in the Air Mountains of Niger, Rasmussen (1987, 5, 36; 1992) examines the relationship of nobles, marabouts (clerics), smiths, and ex-slaves to the processes of hegemony in Tuareg society.[16] She questions whether the practices of distancing (e.g., spatial location) and concealment (e.g., wrapping, veiling) are really expressions of the pollution beliefs thought to be axiomatic in a caste

society and suggests that they may instead be a strategy by those in higher castes to cover the ambiguity of actual power relations. Just as Buzu ex-slaves who grow crops may be wealthier than Tuareg nobles who do not, Maasai smiths, especially in times of drought, may be better off than ordinary herders. In this argument, caste pollution can no longer be defined as "matter [or behavior] out of place" (Douglas 1966, 40) because "the locus of the prior social order" is not clear (5). To know who or what is "out of place" presupposes an unambiguous understanding of who or what is *in* place: here Rasmussen challenges Galaty's earlier (1979, 803) analysis of smithing as one of the forms of "antipraxis, necessary to, yet structurally contrasting with, the ideal of [Maasai] pastoralism" because it assumes "that there are groups peripheral to, and groups central or internal to, the cultural identity" (36). In contrast to this, she posits that the distancing mechanism of caste status reveals a resistance toward certain conditions or states to be avoided rather than toward certain social units as fixed categories of otherness (37).

BECOMING THE OTHER

This is a kind of slippery-slope argument that actually can be traced quite readily to incidents in the Maasai-Okiek[17] literature in which Maasai in times of drought, poverty, or social disintegration sometimes "become" Okiek (i.e., Torrobo), while Okiek who have acquired sufficient cattle may move toward Maasainess (Kratz 1981; Galaty 1993, 187). The same flexibility that allowed Maaspeakers to move in and out of subsistence modes in times of crisis also allowed Torrobo with newly acquired pastoralist experience to attach themselves to Samburu and Maasai families with whom they had developed ties of marriage or economic interdependence. It is easy to oversimplify this as purely a subsistence issue, however, and despite the usefulness of including Torrobo in analyses of the Maa social hierarchy, Samburu or Maasai by definition do not ever want to "become Torrobo" (i.e., poor, without cattle), since this would be a clear inversion of the status hierarchy that places pastoralism in the socially dominant position. Nor do Torrobo (especially nowadays when schooling and the cash economy provide new combinations of subsistence choices) always want to become, or be mistaken by others for, Samburu or Maasai (see Kratz 1986; 1994, 64–70).[18]

Beyond subsistence, there are also other issues. A number of Samburu ritual specialists such as the astrologer-prophet (*lolakir*) Lesepen come from the Lmarrato clan, who are said to have absorbed Torrobo families from Mt. Nyiro sometime in the past. On the one hand, they identify themselves and are described as being Samburu and Lesepen is very highly sought after for his prophesies, but on the other, I have heard individuals of Lmarrato parentage teasingly addressed by other Samburu as "Ltorrobo." The earlier identity is like a pentimento, the shadow from an underpainted version of a picture that is still visible on the surface, but only from certain angles.

Despite these numerous and negotiable aspects of ethnic identity, Maa nonsmiths never become smiths, even though this might seem a shorter cultural distance to travel than becoming Okiek or, more generally, Torrobo. There are several reasons why this is so. First, and most obviously, they have no knowledge of metallurgy, a highly specialized (and in the eyes of nonsmiths, dangerous) cultural practice. Second, it would introduce contamination from a source within Maasai/Samburu culture, which is a more insidious concern than contamination from an outside source (i.e., from Torrobo; see Galaty 1977, 393). Third, it would not be in the economic interest of smiths to welcome others into their restricted ranks. Fourth, it would directly violate endogamous rules of marriage that, paradoxically, "becoming" Torrobo (or Torrobo "becoming" Maasai or Samburu) does not. And finally, if a prolonged drought or famine were to dictate a radical change in the pattern of subsistence, smithing would offer no solution because smiths follow the same subsistence mode as nonsmiths.

During the Laikipiak wars in the 1880s and the "triple disasters" (*emutai*) when widespread bovine pleuropneumonia (early 1880s) was followed by a smallpox epidemic (beginning in 1888) and rinderpest panzootic beginning in 1890–1891 (Sobania 1991, 119; Lonsdale 1992, 24), many Maasai and Samburu lost their herds and were virtually decimated as communities. In order to survive, some joined other groups of non-Maa pastoralists and hunter-gatherers until they could build up their herds again. A Samburu elder told Lake Turkana Basin historian Neal Sobania:

> The time of starvation people scattered everywhere, is it not
> so? Some escaped to the Turkana, some went to the Boran,
> some went to the Dassenetch and some went to the Elmolo

and some were killed by the Rendille while stealing livestock. Some went to the Rendille and [others] became thieves who lived in the bush and stole camels. Some went to the Ndorobo and took roots from the ground. . . . Most people died of starvation. (1991, 136)

After their defeat by the Purko Maasai in the 1880s, some remnants of Laikipiak Maasai "became" Turkana (Lamphear 1993, 98–99), while the equally decimated Samburu at the time of Chanler's visit in 1892 were in a state of "semi-serfdom" to the Rendille camel pastoralists (Chanler 1896, 316–317). Chanler's eyewitness accounts of the relationships between Samburu and Rendille in the 1890s and those of Maasai living among the Torrobo (374–375) contrast with the evidence from a slightly later account in which the positions of the Samburu and Rendille were reversed because of the smallpox epidemic (Arkell-Hardwick 1903, 241). The Rendille are primarily camel pastoralists, though they also have flocks of sheep and goats like the Samburu. Chanler related:

> The Samburu, or Berkenedji,[19] were originally deadly enemies of the Rendile; but since their defeat at Leikipia by the Masai many years ago, and the subsequent destruction of their flocks by the plague [rinderpest], they had been forced into semi-serfdom to the Rendile—watching their flocks, and performing other menial services for them. In return for this they were protected in their persons and possessions. *These people in no way changed their customs after joining the Rendile, and their customs are distinctly different. . . . They scorn the use of a bow and arrow until old age has deprived them of sufficient strength to use a spear.* (316–317, emphasis added)

Sobania (1991, 137) explains the alliance more fully. Although the Rendille population was spared the rinderpest and bovine pleuropneumonia, which did not affect camels, it was nonetheless decimated by smallpox. The Samburu, with few remaining animals, had a labor surplus while the Rendille had plenty of animals but a short supply of labor.[20]

Chanler (1896, 374–376) also described Maasai who had settled among Torrobo elephant hunters north of Mt. Kenya. In both the Rendille and Torrobo cases, the Maa-speakers remained more "attached" (hence detachable) than assimilated to the groups they

FIGURE 4.3.
Kirati
Lenaronkoito
(left), who
is from an
Lpisikishu
blacksmith
family, and the
lolakir Lesepen,
his Lmarrato
relative by
marriage, near
Maralal, Kenya,
1996. *Photo by
author.*

joined, yet there were some marriages of Maa-speaking men with
Torrobo women that Chanler saw as a way of "improving" the Torrobo:
"The true Wanderobbo has nothing to commend him; but owing to
the fact that some Masai and Berkenedji [Samburu] have mixed with
them, a cross has been produced, which is much more vigorous and
better developed physically than the pure strain of Wanderobbo"
(373).[21] Whether by absorption or interdigitation (both powerfully
evocative relational metaphors) or some other means, it is clear
that in times of crisis, both Samburu and Rendille pastoralists and
Torrobo hunter-gatherers moved in and out of supposedly stable cul-
tural identities; this knowledge has raised serious questions about the
permanence and immutability of those identities. More recent stud-
ies of Samburu-Rendille relations (Spencer 1973) and the forma-

tion of a third group, the Ariaal, out of Samburu-Rendille reciprocity (Fratkin 1991) confirm both the negotiability of ethnic identity and the limits imposed on it by cultural practice.

It also appears that the same debates that have forced a rethinking of the idea of ethnicity in Africa may pertain in important ways to hereditary endogamous groups as well. Galaty has likened this element of contingency in Maasai identity to a series of complex rules that are applied differently by different individuals within as well as between the groups:

> Herding and hunting practices are easily interchanged when warranted, and aspects of assimilation or separation can be highlighted as the contexts of unity or difference demand. The negotiation of such conceptual boundaries, while involving subtle gradations of attribution, are not "fluid" but rather are complex in very specific ways. . . . Complex and open for "play," full of diverse forms of meaning, yes; but if ethnic signs were fluid or obscure, they would not work. (1993, 187)

This description of ethnic identity both attempts to complicate a now-widely-accepted model of ethnicity as fluid and situational but also contrasts with Galaty's earlier, more formally structuralist characterization of pastoralism as praxis and artisanship as one form of antipraxis (1979),[22] in that it abandons any strict and unchanging notion of what constitutes accepted (as opposed to aspiring) Maasai identity. While Galaty's "open for play" argument (1993) refers to Maasai pastoralists in relationship to Torrobo hunters and he applied the praxis/antipraxis argument (1979) more comprehensively to both Maasai blacksmiths and diviners and Torrobo hunters, in his social theorization of the Maasai, both the Maasai blacksmiths and diviners and the Torrobo occupy an ambiguous position. In his more recent argument, which recognizes that these positions are open to contestation whenever circumstances demand, positionality rather than praxis (the place you occupy in a social hierarchy rather than your occupational specialization) subtly determines "real Maasai" behavior.

To return to Rasmussen's point that among the Kel Ewey Tuareg, certain conditions or states are to be avoided rather than certain fixed social units to which those conditions are usually attributed, a different sense of "caste" hegemony begins to emerge in both the Maasai and Tuareg situations. It is based only partly on who you are, in the gene-pool sense, and not very significantly on what you actually do

or even ascribe to. Much more important is the degree to which you are able to convince others that your condition is the one to which *they* should aspire. In the Maasai case, this is reinforced by the self-certainty of the pastoralist that he is superior, which contrasts with the social ambiguity both blacksmiths and Torrobo feel. Translated into comportment, it might be termed self-assurance or even panache, a quality early travelers and the colonial aristocracy highlighted in their descriptions of Maa-speakers.

What point could be drawn from this decentering of either praxis in the social positioning of smiths relative to Tuareg nobles or to "pure" Maasai pastoralists? The low occupational status of artisans is usually thought of as predetermined by two things: their inability to distinguish themselves as either successful farmers (in the Western Sudanic model) or pastoralists wealthy in stock (in the Maasai model) and the ritual contamination engendered by their persons, tools, and substances. Even though the changes in subsistence patterns wrought by colonialism modified the first in substantial ways, the belief that the ability of artisans to farm or herd is inferior has persisted long after the facts have changed. As to their ritual pollution, by adopting a more decentered view of smiths, by viewing positionality from below as well as from above and exclusivity from both within and without as having equal claim to our attention, it is possible to see artisanship as a condition in which the smith's "pollution" is another name for a transformative power that is feared and euphemized by the dominant group.

One group's center is another's periphery (e.g., Kasfir 1984b; Klumpp and Kratz 1993), and this in itself is sufficient to create both spatial and social ambiguity. Indeed, Rasmussen describes Kel Ewey Tuareg smiths as the "anthropologists" of their own social system, a position made possible by ambiguity as to where they stand:

> Tuareg smiths approach a local counterpart to Western anthropologists in their position with respect to distance and secrecy, as mediators between the nomadic noble colonizer-invader and the sedentary servile Buzu. These figures, like professional anthropologists, doubt the absoluteness of their own culture: blacksmiths pronounce what other Tuareg are "ashamed" to pronounce. (1987, 41)

If this passage were recast to describe the three-part social milieu of Maa-speaking pastoralists and smiths and Torrobo hunter-gatherers

at the beginning of colonial administration it would lose the strict parallelism of pastoralist/smith/slave that we see among the Tuareg. While all three identities are "open for play," in Galaty's terms, it is the Torrobo whose status is most ambiguous but the smith's that is most contradictory; therefore one could say that Torrobo occupy a position with respect to distance and discretion that is intermediate between the nomadic pastoralist and the more sedentary and segregated smiths. In Rasmussen's analysis, these figures, like professional anthropologists, doubt the absoluteness of their own culture, and because of this, both Torrobo and smiths do what other Maa-speakers are "ashamed" (unwilling) to do.

As different as the nomadic Tuareg are from the sedentary Mande or the Dogon in the West African savanna-sahel, all three share with the Maasai and Samburu a set of distancing mechanisms that regulate the smith's power. He is close but far, on the edge of settlements; confined to marriage within his occupational group; and unable to accumulate large quantities of traditional forms of surplus (agricultural produce, livestock). At the same time, he controls not only a primary and essential technology but also supernatural sanctions and/or powers of alchemy (over metal, but also, in certain contexts, over people) not available to the dominant group of farmers or herders. How then could one theorize the extra "loathing" visited upon Maa smiths (if indeed it is any different from that present in the Dogon and Mande cases)?

One is forced to consider the strong Maa ideology of the social distinctiveness of pastoralism and pastoralists: if those who tilled the soil (*lmeek*) were "barbarians" in the word lists collected at the turn of the century, why should it be very different for those who panned and smelted iron ores from stream beds? In this sense, smelting was a kind of transformative process similar to planting and growing crops: both are commonly described using the vocabulary of sexual fertilization, gestation, and parturition. Smiths "farmed iron" for centuries before colonialism made half of their work obsolete. Just as important, the smith's work is hard and dirty in supposed contrast to the leisurely pace of animal husbandry (another reason the aristocratic white settlers admired the Maasai).

Here is an essential difference between the ideology of pastoralism and that of West African farming castes: in the latter, the cultural ideal is a person who toils hard and long to achieve success at farming. It is not difficult to see that such toil would be held in contempt

by pastoralists, who equate labor with intrinsic inferiority and instead value expertise at herd management. In fact, during times of severe drought, the management of herds is extremely arduous work, but I am speaking here of an ideal cultural script and not of the numerous ways it is sometimes modified.

SAMBURU SMITHS AND THE MAASAI MODEL

If I now try to knit together the strands of these representations of the smith, they can be subsumed under four categories: a dialectic of pollution in opposition to hegemonic power, the ambiguity of social status, mythic smiths versus actual artisanal practice, and the ways in which all this began to change under colonialism.

First there is the issue of power. It requires an act of cultural translation to think about the Samburu smith in relation to chiefly power, since the Maa-speaking pastoralists had no chiefly institutions prior to the onset of British administration[23] and even now important issues are still decided in open meetings of elders in which every man present has the same opportunity to influence the outcome. Herbert equates the chief or king and the smith as symbolic surrogates—*le roi forgeron*—in many highly centralized equatorial African states, pointing to the role of smiths in chiefly ceremonial and the tools of metalworking as insignia of chiefly office. In Samburu society it is warriorhood, not chiefship, that is the focus of ritual life, and its principal symbol, the spear, embodies the parallel importance of the products of metalworking and the smith himself. During the circumcision ceremonies that initiate the opening of a new warrior age-set, it is always the sons of blacksmiths who are circumcised first—a ritual inversion of their everyday status.[24] The knife of circumcision itself is of course made by the blacksmith, though the operation is not performed by him but by a Torrobo, Rendille, or, occasionally, a Samburu from a different *sigilat* (clan), whose stranger status is not only useful but essential to this dangerous and polluting ritual.[25] And beyond this, the spear, the central symbol of warriorhood, is of course also the product of metalworking. At the first *lmugit* ceremony, the Lmugit of the Arrows, the initiate discards his bow and resin-tipped arrows, symbols of boyhood, for the metal spear of the warrior. The sharp and dangerous blades from the hand of the smith first transform boys, beginning with the smith's son, into young men and then, a month

later, provide them with powerful weapons with which to defend their fathers' herds and their status as warriors.

Vansina (1969, 62–67) sees the smith's place in kingship symbolism as a recognition of the superior character of metallurgical techniques at the origins of political power—a point whose validity extends to uncentralized societies or to any social formation in which warfare is the means to territorial aggrandizement. Conversely, it is the recognition of the smith's power to control metal technology that has made of him the object of control by nonsmiths. This seems the most plausible reason for his lowered status and social isolation.

In fact, the concepts of power and pollution are intimately linked in the case of the Samburu or Maasai smith. Unlike the Torrobo artisan, he is both a pastoralist and a member of the same age-sets, sections, and moieties as the dominant group as well as the practitioner of an exclusive technology not understood (yet needed) by the non-smithing pastoralist. Without pollution rules to control his power, he would be in the position of the mythic *roi forgeron* in Bantu-speaking Africa—more powerful than other members of the dominant group. His Maasainess or Samburuness is not questioned, even by those who despise him. Merker, a meticulous observer in German East Africa, claimed that he absolutely could not distinguish between smith and nonsmith solely on appearance (*pace* Thomson and his description of the smith as a "miserable, half-starved object") and when questioned, more than a hundred nonsmiths told him they considered *lkunono* to be "pure, unmixed Maasai" (Merker 1910, 112). The irony of this reversal of the usual purity/pollution argument is certainly not lost on Samburu *lkunono,* who rightly point out that because of an enforced endogamy rule, they are far less "mixed," in the gene-pool sense, than other Samburu who easily assimilate pastoralists and other strangers into their midst and that they are therefore the "purest" examples of the Maa physicality admired by Thomson, Hinde, and others.[26] What this clearly reveals is that the notion of the smith's pollution (Merker: *Unreinheit*) is actually quite separate from any concern with his identity, of concern that he is not "real" Maasai/Samburu. Rather, his distancing from nonsmiths is a way of limiting his accumulation of power in the form of wives and cattle.

This was accomplished in several ways: first by the rule of caste endogamy: smiths could only marry the daughters of other smiths (but following standard clan exogamy). In addition, Merker spoke

of the Maasai smith's herd being limited to forty cattle, a limitation I have not heard from Samburu. Furthermore, nonsmith warriors were supposedly "entitled" to steal the cattle of smiths (Merker 1910, 111). But even without these disadvantages, the Maasai smith was less able to accumulate stock than the nonsmith. For one thing, the warriors from Maasai smithing families were subject to the same rules of age-grade separation as nonsmiths and so lived in their own *manyattas*, which were necessarily far smaller than other warrior settlements because of the smaller number of *lkunono* families in the general population.[27] They therefore were very limited in their capacity to carry out stock raids and realized few animals in this fashion. What *lkunono* had came instead from livestock given in payment by non-smiths for their weapons. Here too Merker found an accepted barter system that normally excluded large fertile female animals.

Finally, the requirements of smelting before the 1930s made it necessary for smiths to live in a more sedentary fashion than non-smiths, within range of ferrous sands deposited by rivers and streams and near supplies of the species of wood used for making charcoal.[28] According to Larick (1986b, 168–170), Samburu smelting sites are more common in the highlands, especially near mountain bases. On the other hand, the general movement of stock is to highland forest pastures such as the Lorroki Plateau during the dry season and to lowland salt deposits when there is sufficient rain. The relative lack of mobility of smiths who smelted may have discouraged the ownership of large herds because it created the potential problem of overgrazing in the vicinity of ore deposits.

Thus, some of the limitations on the size of blacksmiths' herds were imposed by dominant-group sanctions and others by the occupation of smelting iron, both factors that underwent gradual transformation with the suppression of large-scale cattle-raiding and the demise of smelting under colonial administration. Once again, British intervention resulted in an inadvertent opening up of new possibilities for artisanal practice: smiths no longer needed to live close to the sources of iron and there were fewer restraints on their herding practices. *Lkunono* could therefore choose sites that were the most advantageous for serving their clientele (if they were practicing smiths) or sites best for livestock (if they were nonsmithing *lkunono*).

But it would be oversimplifying to maintain that pollution beliefs concerning smiths were solely an instrumental strategy to keep them from acquiring too much power through accruing wives and cattle

in addition to the crucial technology they already possessed. There is no question that the statements about smiths' pollution southern Maasai made to Merker in the late 1890s still find resonance among the Samburu now, over 100 years later, and that the oldest (e.g., Lkilieko and Lmekuri) age-sets firmly believe them even though their instrumentality has faded. Their resilience depends upon the continued centrality of both cattle and spears to Samburu pastoralist ideology. To understand the staying power of such beliefs, one must appreciate that in addition to the potential the *lkunono* have to control resources, they also have an unarticulated power that is associated with dangerous individuals—people who, like sorcerers, can introduce malevolence into the texture of Samburu life.

At the heart of this lies the power of the blacksmith's curse, which if invoked can bring about the death of the accursed person by the mere grazing of a razor, knife, or spear.[29] It is rarely invoked: *lkunono* living near Maralal could only recall two instances in the past twenty-odd years. Samburu give great weight to the power of the curse (*ldeket*) to bring misfortune or death upon those who have violated flagrantly the rules of social contract. Typically it is invoked by an elder upon another elder or by elders upon a group of moran who have committed a serious offense. Spencer (1965, 186) was told that the curse is "like the poison of a poison arrow tree"—it will prove lethal only if the skin is already cut—that is, it is not harmful to an innocent person but only to a guilty one. But the smith's curse occupies a special place among curses: it is the most feared curse in most cultures in and near the Rift Valley (Brown 1980, 172). Fratkin was told by a Samburu smith that smiths are afraid of no one, that nothing can protect anyone from their curse, and that, conversely, there is nothing stronger than their own protection against sorcery (ibid.).

It is especially significant that a member of a socially ostracized group should be thought to have this power of retaliation over a member of the dominant group. It bears comparison with the ritual inversions by which the smith ceremonially deposes the king, for example, among the Ader Hausa during the festival of Tabaski (Herbert 1993, 149). In both instances there is the ritualized acknowledgment that though of much lower status, the blacksmith's metaphysical power rivals the power of the politically dominant.[30]

The Samburu smith's curse is part of a complex of power-beliefs concerning him that justify his spatial and conjugal distancing as well as, conversely, his right to nullify that separation in certain situations

and insert himself where he is not welcome—for example, to claim his share at the distribution of meat from certain types of ceremonial slaughter. These occasions include childbirth, circumcision, marriage, and the *lmugit* ceremonies for warriors (Spencer 1973, 128–129). The mystical connection between the agency of iron as manifested in the knife and the efficacy of male and female circumcision seems clear enough, but with childbirth, this mystical agency seems to be at its most ambiguous. A pregnant Samburu woman avoids direct contact with knives and other iron or steel instruments, as they are said to represent a danger to her unborn child.[31]

On the other hand, a woman whose babies have died at birth repeatedly may be advised to have her next child in the kraal of a blacksmith, even in the smithy itself. If this strategy works, she will return to the same place for each subsequent birth (Spencer 1973, 82).[32] Yet when a blacksmith impregnates a woman from outside the *lkunono* caste, her child is aborted or killed at birth (83). The smith's power seems auspicious (controllable) in his own space but inauspicious (out of control) if it is allowed to permeate beyond this space.[33] In one case, it works for the good of the dominant community, but in the others, it either violates the endogamy that limits the smith's entry into the wider network of Samburu kinship or, worse, attacks the unborn child while still in the womb.

The metaphors and physical reality of spatial separation both protect nonsmiths from the smith's unwanted mediations within the spatial hegemony of "pure" pastoralism and serve to locate and contain his power within the smithy. As we have seen, Merker (1910, 111) was told that locating a Maasai smith's kraal near other kraals brings disease and death to both humans and livestock. I tried to pursue this line of thought nearly a century later with a Samburu elder, a frail old man rich in cattle whose herds were driven past our *nkang* every day in the valley outside Maralal where *lkunono* families are clustered. Lolkididi, an elderly Lkilieko of the Masula section, insisted that "cows don't go with blacksmiths. The charcoal is not good for the cows or for the non-blacksmith. . . . [It] is powerful and is 'against' the cows. It has the same power as the blacksmith's curse." But what is the locus of this power? Does it come from the trees that are used to make the charcoal (a species of acacia)? "No, the danger only occurs when the smith touches it. Anyone else would not have the same effect using the same tree." It is therefore not charcoal

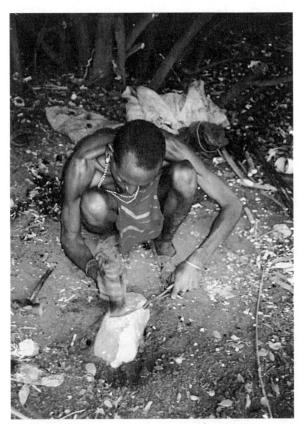

LEFT: FIGURE 4.4. Samburu smith forging circumcision knives outside a *lolora* (circumcision village), Kirisia Forest, Lorroki, 2005. *Photo by author.*

BELOW: FIGURE 4.5. Samburu smith Kariuki with calf spear and twin-spear blades, Losuk, Kenya. 1991. *Photo by author.*

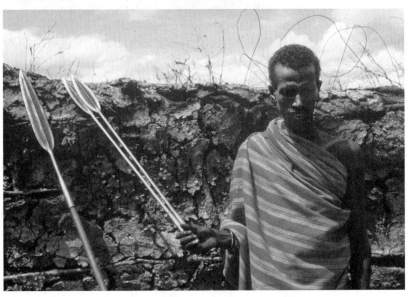

per se that is dangerous to animals, but smith's charcoal. Lolkididi explained that this was the reason blacksmiths were able to retain only a few cows compared to other Samburu. The danger was thus localized within the smithy and could be avoided through rules of physical separation.

This was not sufficient protection in itself, however: it was also crucial to prevent intermarriage and therefore sexually transmitted contamination similar to that of the charcoal. "If you [pointing to me] marry a smith, you will lose your cows. They will be cursed and die. We have tried and learned. We would rather marry another tribe than marry a blacksmith for this reason." In this logic, the charcoal of the smith's forge is like a genetic material carrying a fatal virus. It falls within the broader biological metaphor of smelting, or what Eugenia Herbert describes as the "reproductive paradigm" of iron-working (1993, 119). The smith's sexuality (his semen is treated as the equivalent of "smith's charcoal") is implicated in this paradigm even though here it is not smelting but only forging that is at issue. Charcoal, however, is crucial to the smelt as well as to forging, so it is not surprising that its qualities associated with one process would be transferable to the other—after all, in Samburu the smith was also the smelter.[34]

It is possible, Herbert argues, to see the whole process of iron production as a metaphor for human sexuality and reproduction, as Eliade (1956/1978) and de Maret (1980) have done, or to see it as the intersection of two lines of thought, one having to do with fertility, the other with danger, as Rowlands and Warnier have claimed (Rowlands and Warnier 1988, 23). In the first of these readings, the male smelter of iron is the agent through which the metaphorical impregnation and subsequent birth of the metal itself takes place, the smelting furnace being explicitly and universally female. In the second reading, danger and fertility intersect, again in the agent of the smelter. His power to transform the materials of earth, air, and fire into iron is again a metaphor for parturition, but in this case equal symbolic focus is given to the danger of such power in the hands of one who is not a god and the need to keep this fertility under control is emphasized. One effective way is to deny the smelter-smith the right to impregnate women other than daughters of smelters or smiths and to construct the idea of a strong ritual contagion around his sexuality.

Because iron smelting is a technology that widely disappeared in the early colonial period in Africa, these historical attitudes now apply almost exclusively to smiths who do not smelt. But in the case of the Maa smith as well as others, the danger he so clearly represents to non-smiths derives from his former status as a smelter (and procreator) of iron and not solely from his other occupation as a forger of dangerous weapons. The latter is a post-hoc explanation derived from colonial ethnography, and while it is not wrong, it does not reach back far enough to the central reality of making iron—a process so numinous that it provided an identity for the maker, valid for centuries, that now has outlived the actual technology in many places.

I referred in a previous chapter to the spatialization of power on the Pinguan in relation to the Powys murder and the white settlers' attempt to control grazing lands there. Here one is faced with a much more systematic instance of separation and containment as they relate to power. It occurs on two levels: the containment of the smith's reproductive powers through the refusal of nonsmiths to give their daughters in marriage and the separation of smiths from the cattle kraals (hence the settlements) of herders. We have already heard the explanation of nonsmiths for this separation. But not surprisingly, the *lkunono* see not only the facts but their interpretation quite differently.

Lkunono explanations for the endogamy rule neatly invert the suppositions of fear of contamination. Instead, blacksmiths are, as it were, irresistible. The story takes two forms, one an origin myth involving the first smith and the other situated in unspecified historic time:

> The first Samburu man was a blacksmith, who made a knife for the slaughtering of animals. Samburu women, who are strongly attracted to meat, preferred this blacksmith to other men. This was a threat to the other men so they forced [him] to move away and isolate himself. (Kingore Lenaronkoito, Lmekuri age-set, *lkunoni* of Lpisikishu section, 21 April 1991)

> Long ago, a bad drought forced the Samburu into poverty, except for the smiths, who stayed with their forges. The other Samburu [with no livestock] brought bush meat to pay for their spears, so smiths always had meat. Later the other Samburu saw that smiths had plenty of wives because of this, so

they forbade marriage to smiths. (Soroita Letekirich, Lmekuri
age-set, *lkunoni* of Lukumai section, 3 October 1993)

Thus the *lkunono* explanation is couched in terms of the control non-
smiths impose upon the smith's (and also women's) sexuality, which
in past time was made irresistible by his access to meat (a metaphor
widely used in Africa for both sex and power, but here, because it is
bush meat, it also carries the connotation of being forbidden food).[35]
This explanation of caste-type separation is couched in the domestic
idiom of marriage. In the postcolonial era, meat has been replaced by
cash—another commodity to which smiths have greater access than
nonsmiths in an expanded sphere of exchange.

On the question of the smith's cattle, the *lkunono* maintain that
they have "always" been owners of respectable-sized herds and point
to two practices that undercut the counterargument.[36] First, and most
obviously, they were paid in animals for their work. Commodities
such as milk and meat were used as payment in exceptional circum-
stances, but the usual exchange for spears was (and still is) live small
stock (usually goats) or calves. Furthermore, there is one ritually sig-
nificant object obtainable only from the smith that is very costly. This
is the *mbaririko*, a narrow, twisted torque of iron worn by smiths as a
bracelet but by infertile Samburu women as a powerful antidote—
another example of the double-coding of the smith's (and iron's)
potential to affect fertility. The *mbaririko* is paid for initially with a
female sheep and later, when conception occurs, with a fertile cow
(Soroita Letikirich, 20 April 1991). It seems clear enough that smiths
acquired stock on a regular basis in exchange for their work, even if
their opportunities to augment stock by raiding were limited.

Lkunono met with derision the other reason that is advanced for
why smiths had small herds—that they were more sedentary than
other Samburu and therefore could not seek out the best pastures.
Of course the smiths were more sedentary than the animals they
kept. Did this make them different from other Samburu elders who
were stock-owners? Did they not have warrior sons like everyone else
who could take their animals in search of water, grass, and salt?

Lkunono explain their economic advantage as simply a matter of
structural stability. They are less susceptible to the subsistence crises
of a life wholly dependent on either hunting or herding:

A long time ago there were three girls singing—a Torrobo,
a Samburu, and the daughter of an *lkunoni*. The Torrobo

girl says, "We slaughter and eat elephant." The Samburu girl supports the cow. The *lkunoni* says, "The cow can stop giving milk but the smithy never stops." (Soroita Letikirich, 20 April 1991)

Smiths explained the fact that they are avoided or disliked with equal equanimity: it was due primarily to jealousy because no one else had a marketable skill like theirs and they were subsequently rich in animals even in times of drought (e.g., Lkoine Lekimenshu 1992). This neat rejection of reasons the dominant group had proffered substitutes a plausible instrumental explanation for a cultural script centered on pollution and mystical danger. It is reminiscent of the affable interpretations Okiek ("Torrobo" living on the Mau Escarpment) gave to Corinne Kratz (1994, 67) for their subordinate status in the eyes of their Maasai neighbors. Their explanation for the fact that in their interactions Okiek must speak Maa (but never the reverse) was couched in terms of their superior linguistic adaptability and their "gracious accommodation" to other people's ways.

If both *lkunono* and Okiek explanations of their respective statuses reveal their ambivalence toward higher-status herders, the same ambivalence is revealed in herders' views of them, especially in discussions of specific individuals rather than generalized group stereotypes. Lolkididi, the same old man who opined that I had better not marry a blacksmith or I [or my father] would lose my [his] cows, announced gloomily at the end of our discussion, "We [nonsmiths and *lkunono*] are all the same now," suggesting either that the old ways of measuring status differences are less salient today or perhaps that life nowadays has become an unrelenting struggle for all Samburu alike.

The emerging *lkunono* self-representation is of a group of specialists who are a) better able to marshal their resources than other Samburu; b) more attractive to potential wives because of this ability; c) dedicated and experienced pastoralists; and d) "pure" Samburu in the sense that they are genealogically unmixed by intermarriage with non-Samburu lineages. It is a seamless depiction, difficult to contradict on its face, and has the pragmatic virtue of not resorting to the complexities of supernatural agency. It seems as plausible (if not more so) than the set of representations turn-of-the-century writers gathered in interviews with nonsmiths. For one thing, here the mythic smith of the *lkunono* coincides with the smith of artisanal

practice. The smith is indeed the "first Samburu" in terms of his perceived power to influence fertility. Women, who are prevented by nonsmiths from marrying or being impregnated by him, nonetheless may come to his enclosure to give birth, and they still ask him for the *mbaririko* to bring an end to their barrenness. By contrast, the non-smith representation of the smith as disfavored by God because he makes the weapons responsible for bloodletting (Merker 1910, 112) sounds a bit hollow coming from warriors and has little resonance in artisanal practice: real-life clients are certainly not deterred in any way by this story when they come to the smith to order their spears.

But as James Vaughan (1970, 80) pointed out in his study of Marghi smiths (*ankyagu*) in the Mandara Mountains of northeast Nigeria, there are good reasons why the smith may have a much more realistic explanation of status distinctions. Most Marghi (or, for that matter, Samburu) have relatively little contact with smiths in their daily lives and are poorly informed concerning smiths' customs. Smiths, on the other hand, live in a world surrounded by nonsmiths and must therefore know a great deal about them in order to survive and prosper. The sheer inequality of numbers ensures that smiths are far more likely to be mythologized.

There was another meaning to Lolkididi's (somewhat overstated) admission that "we are all the same now" that can be traced quite directly to colonial policy: the government's attempts to contain spear-blooding and the subsequent spear ban of 1934–1957 forced a number of *lkunono* to give up smithing as a livelihood. As we have seen, blacksmith group identity is as tied to blood (in the sense of endogamy) as it is to the handling of dangerous substances (iron and charcoal). Therefore, ceasing to smelt and forge iron does not extricate the *lkunoni* from his lower status. It does, however, make it a good deal more ambiguous. Actual practicing smiths are nowadays a very small proportion of the three large Samburu smithing lineages,[37] just as there are very few if any Torrobo today who keep no livestock, grow no food, and are strictly hunter-gatherers.

If one adds to this the dramatic shrinkage in pastoralist herd size over the past thirty years, the picture that emerges in the northern Rift Valley in 2000 is of a much less clearly differentiated mix of subsistence strategies than in 1900: herders who have many fewer cattle and who also try to grow maize or wheat in years when there is sufficient rainfall, smiths who may have as many cows as ordinary

herders, and hunter-gatherers who both farm and keep livestock. And all three groups are entering the money economy, albeit more slowly than their more educated southern neighbors.

As the nonpracticing *lkunono* moved into full-time herding in increasing numbers after 1934, they gradually came to represent a larger subset of herders within a shrinking herding economy while remaining blood relatives of blacksmiths. The rule of blacksmith endogamy still holds, but it too has begun to blur at the edges, as women from *lkunono* families are sometimes married out into Maa-speaking non-*lkunono* families such as Kisongo Maasai in Tanzania. Spencer (1973, 118) described how a nonsmithing *lkunono* family might be able to "break through the caste barrier after several generations" by marrying into other nonsmithing *lkunono* families and eventually into non-*lkunono* families in the Lmasula or Lpisikishu section "who do not show quite the same aversion for blacksmiths" (perhaps because both sections have large blacksmith lineages).

Smithing in Samburu remains a marked occupation, but with its fewer practitioners, it has become in many ways more like that of a ritual specialist (i.e., diviner [*loibon*], astrologer [*lolakir*], or one with special powers to bless and curse [*lais*]) than of an artisan group with numerous members. Like these other specialists, the smith has exclusive control of certain areas of arcane knowledge and supernatural agency around which a clientele develops. This power is contained but at the same time enhanced by separation and distancing. The nonsmithing *lkunoni,* on the other hand, while he is not a practitioner, is able to make use of this "smith's aura" through close family connections with smiths. He accomplishes this through the opposite strategy of continuing to live in smithing settlements and maintaining genealogical ties. This ideally positions him (and, in a very few cases, her) for an entrepreneurial role that will be laid out in detail in the chapter on commodification.

RECASTING THE SMITH

These status ambiguities are by no means limited to Maa-speaking *lkunono.* The same ambivalence concerning the West African smith's status has been described by Vaughan (1970, 78) for the Marghi *anky-agu,* by Richter (1980a) for the Senufo Fonombele, by Rasmussen (1992) for the Kel Ewey Tuareg smiths, and by McNaughton (1988,

7–12) for the Mande *nyamakala*. Richter, who also discusses the Kulebele, who are woodcarvers to the Senufo, captures this ambiguity by drawing a distinction between the act of avoidance and being "shunned" (51). *Fijembele* (artisans in general) are avoided by *senambele* (ordinary Senufo) because they are feared for their control over supernatural sanctions, but they are not shunned—a term that implies unacceptability as well as distancing. And while this is an "essential ingredient in *fijembele/senambele* relationships, the barriers that have resulted are manipulated by minority *fijembele* to their advantage, not by the majority *senambele,* which makes the situation very different from the Indian caste system" (52). It is not possible, she concludes, to think of *fijembele* as inferior castes if such classification is based on actual behavior.

Vaughan and McNaughton also reject the idea of a "despised" caste of smiths among the Marghi and Mande, and all three authors instead couch the dominant groups' relationship to smiths in terms of distancing and avoidance without the notion of inferiority. One needs to ask, since these are studies based in mainly postcolonial fieldwork, whether the smith's seemingly caste-like inferiority might have been more pronounced and less ambiguous prior to the social upheavals and reconfigurations colonial occupation brought. Certainly in the Maasai case (there are no detailed early descriptions of Samburu smiths), Thomson and other early writers were convinced of a marked social inferiority, though they differed considerably among themselves about both the degree and quality of social separation this engendered. The assumption that little has changed between the 1880s and the 1990s may be unwarranted. Another difficulty is the slippage that often occurs between accepted notions of hierarchy and people's actual behavior, between praxis and practice. Again, the lacuna between these may have widened considerably as a result of the political and social changes wrought by French, German, and British occupation.

The Tuareg case is more complex than the case of the Mande or Senufo because they are pastoralists. Here, as with the Maasai, the idea of the servility of "work" of any kind must be factored into the relationship between smiths and nobles. But even under the weight of this ideology, the smith is able to use his position successfully by acting as an indispensable liaison between disparate groups of nobles, marabouts, smiths, and ex-slaves. For example, on occasions

of animal sacrifice, it is the marabout who slaughters but the smith who then roasts the meat and effectively makes it suitable for human consumption by transforming it from raw to cooked (Rasmussen 1987, 39; 1992). This position of the smith as broker is very similar to that played by Samburu smiths today as they mediate between other Samburu and the cash economy in the form of safari tourism.

Another similarity lies in the fact that neither Tuareg nor Samburu smiths, despite their isolated status, are described in radically different terms from other segments of society; Rasmussen likens Tuareg nobles, smiths, and slaves to rice, corn, and millet (2). Even this degree of differentiation would be excessive in Samburu, where one's membership in an age-set both crosscuts and takes clear precedence over occupational status. In ritual symbolism, Tuareg smiths are compared to cousins and women (both categories that are "near yet far" relatives to male nobles) as well as to *djinn* spirits (thus closer to nature). Nobles and slaves in this same analogy are compared to parents and children (2–3). The symbolism surrounding Samburu smiths is very different, based in metaphors of danger and contagion. It lacks the familial imagery (smiths as women, slaves as children) that characterizes feudal caste systems. Instead, it contains the paradox of caste-like distancing because of ritual danger within the context of the egalitarian framework of the age-set, in which all members are theoretically equal.

The ability of Mande smiths to practice sorcery, of Tuareg smiths to be identified with subterranean *djinn,* and of Samburu smiths to activate a deadly curse all speak of the connectedness of smiths to forces beyond the social world. This alterity is simultaneously the reason for their spatial separation and the source of their power to manipulate that distance for their own benefit. Senufo *fijembele,* says Richter, "[husband] their supernatural resources" and "strive to maintain the ethnic identity which is associated with their occupation and thus maximize an economic advantage" (1980a, 51).

Once again, let us return to the cosmogonic representation put forward by *lkunono* (the knife = meat = wives equation), which mirrors the smith's real position as an interloper who threatens the social order but who also brings innovation to society. The mythic role of the smith in general carries the potential for innovation since the smith mediates mythic properties as well as social ones. Many West and Central African smiths in their mythic guises brought civiliza-

tion through the mastery of the techniques of agriculture. Samburu smiths are symbolic bestowers of fertility. Tuareg smiths can mediate between *djinn* and human society and between categories of individuals in an otherwise rigid status system because they are impure and therefore cannot be polluted by the wrong kind of contact. Smiths are brokers, agents, go-betweens, "anthropologists," and finally, in the postcolonial world, entrepreneurs. Invention is their métier, survival their challenge.

AFRICAN SCULPTORS: HIGH OR LOW, NEAR OR FAR?

If blacksmiths have been able to use their paradoxical status and ambiguous identity to maintain their power and influence, what about sculptors? In a spectrum of African artisanal identities, blacksmiths may represent the most highly marked specialization, yet sculptors who are engaged in traditional forms of production[38] (who in some cultures may be the blacksmiths themselves) are seen as far from neutral. Much of the unresolved ambiguity in the representation of Sudanic West and East African smiths (i.e., that they are of low social status yet unquestionably powerful relative to their social superiors) also surrounds sculptors, though for somewhat different reasons. This occurs not only where the sculptor belongs to a stratified occupational group but even where he is socially undifferentiated from the dominant occupational category—farmer, fisherman, and so forth. In the former case, Richter (1980a, 41) describes the fear that other Senufo have for the Kulebele-controlled *kafigeledjo*, a supernatural instrument more powerful than anything associated with blacksmiths. In unstratified societies, on the other hand, there is less likelihood that sculptors (or smiths) as a group will be associated with ritual pollution or powerful supernatural agency, yet they are nonetheless apt to be regarded as different from ordinary people: even among the egalitarian Dan, the carver was seen to distance himself by assisting the work of the *go*-master who was the spiritual leader of the village, a person of great authority in his role as keeper of masks (Gerbrands 1957/1971, 376).

For the very reason that the representation of a spirit world through masks or figuration is often seen as a form of divinely inspired mimesis, sculptors are frequently locked into a set of identities that separate them from the rest of the community even where

there is no occupational stratification system, no associations with sorcery, and their position in the community is respected (see Kasfir 1987, 32–34). D'Azevedo (1973, 323) described the reaction of Gola parents to a young son's display of woodcarving talent as a mixture of admiration and dismay, reflecting Gola ambivalence toward the occupation. In Gola terms, the person was either *yun edi* (a person of special mind) or *yun go gwa* (a dreamer), both psychological types that were recognizable through early signs of deviance (296, 323). At this stage attempts would be made to dissuade the youth from a carver's career through punishment or appeals to a diviner. If none of this worked, then he might have been sent to be apprenticed, though some parents would refuse to do this.

ESTABLISHING POWER AND SEPARATION
THROUGH THE WORKSHOP

Apprenticeship, especially in kin-based workshops, supports the creation of self-selecting hereditary artisanal groups—a practice that increases the social separation of the artist from the rest of the community. This representation of the sculptor as distanced from the rest of society is sometimes further exaggerated by social circumstances having nothing to do with carving. Maconde immigrant carvers from Cabo Delgado province of northern Mozambique have settled around the outskirts of Dar es Salaam in Tanzania since the late colonial period. In the early postcolonial period, they carved next to their farms along the Bagamoyo Road in kin groups of up to eight or so experienced carvers and one or two apprentices (Kasfir 1980). At that time, Mozambiquan Maconde, unlike their southern Tanzanian Makonde neighbors, still cicatrized their faces heavily and filed their teeth. Many of the women still wore small lip plugs that were no longer seen in Tanzania. Although they all spoke Kiswahili as well as Kimakonde, they remained outside the city and did not attempt to mix with the local inhabitants. To people in Dar es Salaam, they were "fierce" looking and were said to be cannibals who ate children. (Knops records the same belief about the Kulebele.)[39] A combination of perceived "primitive" cultural practices and their status as immigrants allowed for their distancing and alterity in the local community, quite apart from their workshop system with its exclusive, kin-based membership.

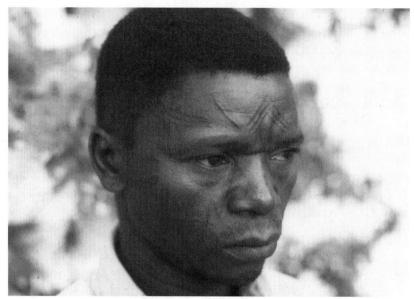

FIGURE 4.6. Maconde sculptor Sạmaki Likonkoa near Dar es Salaam, Tanzania, 1970. *Photo by author.*

But to focus only on the workshop as a way of preserving symbolic space and exclusivity is to overlook what was distinctive about sculptors in precolonial Africa: they were not just living representations of something else (say, otherworldly power), they were themselves *makers* of representations of that same otherworldly power in the form of images. The workshop therefore became a location for continuously reconstituting these images as part of a system of knowledge endowed with exclusivity and at times even secrecy. The fact that there were and still are "readable" regional, local, and family workshop styles in Yoruba carving, for example, is evidence of this exclusivity: no one experienced in looking at Yoruba sculpture would confuse the Ekiti style and repertory with the Igbomina style and repertory, and an Igbomina specialist (e.g., Pemberton 1987, 121–131) could describe the local Ila-Orangun variant of the Igbomina style and further refine it into the various Ila workshops of Inurin's, Ore's, Obajisun's, Aga's, and Oloriawo's compounds.

While each of these carving compounds represented a slightly different version of the combination of knowledge and practice that constitutes an "Ila style," none of these were fixed because over time different artists entered and left the workshops. It was thus clear at

the center with a few identifiable distinctive practices but less eas-
ily defined at the edges. Not only that, artists who were trained in
a generally practiced workshop style did not always conform to it.
Pemberton (1987, 125) describes one of the best-documented exam-
ples in Yoruba carving of an artist who crossed over from one regional
style to another: Lamidi Fakeye, son of the venerable carver Fakeye
of Ila (ca. 1870–1946), began carving in the Igbomina style of his
father and older brothers but then at about age eighteen saw for the
first time the work of the great Ekiti carvers Areogun and Bamgboye.
He was invited by Father Kevin Carroll to join Areogun's son Bandele
(George Bamidele) in the workshop Carroll ran to produce Roman
Catholic religious sculpture in the Ekiti carving idiom. In this some-
what unconventional way he learned the Ekiti style from Bandele
and eventually became its most widely known practitioner. Lamidi
thus acquired two stylistic and two iconographic repertories, each a
knowledge system in its own right but with connections to the other.
Another carver in the Ekiti style, the late Lawrence Alaye, kept a pho-
tograph album in his workshop in Ile-Ife so that clients could see for
themselves the complete repertory of objects the workshop was able
to produce. Like Lamidi Fakeye, he learned from Bandele how to
carve Christian church subjects, though he acquired his knowledge
of the conventional Ekiti carving repertory from his father and uncle
(Kasfir 1987, 31). The photograph album, as a representation of the
workshop's output but also of what Alaye knew how to make, linked
the two knowledge systems in a single practice.

The ability of Yoruba carvers such as Lamidi Fakeye or Lawrence
Alaye to work simultaneously in two knowledge systems had its coun-
terpart in the Maconde carvers of Dar es Salaam who learned back in
Mozambique in the early colonial period to make animal and genre
sculptures on demand for colonial administrators while continuing to
produce *mapico* masks and figures and other objects for their own use.
Later, in Tanzania, the greater opportunity for new kinds of patron-
age caused a florescence of the colonial genres into several subrep-
ertories, but the branching into a second knowledge system actually
occurred as early as 1910, when the first Portuguese administrators
began to appear. Moving from one knowledge-practice repertory to
another is itself a form of innovation, of "breaking out" of the conven-
tional workshop mold, though the new system can eventually become
as convention-dominated as the old one. Working for different types

FIGURE 4.7. Yoruba workshop of Lawrence Alaye with photograph album used for clients' reference, Ile-Ife, Nigeria, 1977. *Photo by author.*

of patrons is another aspect of this breakout, as Strother (1999, 29, 31) has demonstrated through Pende sculptors' very early embracing of the international art market in addition to the local one. And most obviously, it is one more way of cultivating ambiguity (or call it lack of purity) of status, for which both Maconde and Pende artists have been criticized by Western art-world institutions.

The workshop as model (as opposed to its more messy reality), with the authority of its master carver over his apprentices, operates not only as an exclusive guild but also as a force for stability rather than innovation. In Alaye's photo album, the Christian subjects differed from those of orisha worship only in the iconographic details. And although new "things" appear in the album, such as a set of freestanding Nativity figures, there is no new style, even though the work encompasses a totally different knowledge system. Without the intervention of church patronage through Father Kevin Carroll or a hypothetical Christian Yoruba counterpart, it is unclear whether the Christian repertory would have ever become part of Ekiti carving practice. One returns once again to the fact or the possibility of new patronage as a primary stimulus for invention, while the workshop, with its investment in a known repertory of forms, is counterpoised as a guardian of artisanal tradition and a guarantor that sculptors occupy a specialized status within the community.[40]

IDOMA SCULPTORS AS FREE AGENTS

But not all artists belong to workshops, and this independence radically changes how artists embed themselves in a system of knowledge and practice and, equally, how they are perceived. It also has important consequences for the systemization and stability of knowledge and practice. In Idoma, Ebira (Igbira), Kalabari, and Tiv communities in Nigeria, carvers are free agents who have picked up their knowledge in piecemeal fashion since boyhood. They do not receive any direct instruction in the correct way to carve an eye or an ear and must rely on the examples of completed work they see around them. While they are liberated from the conventions of the workshop, ultimately they learn the equivalent skills by trial and error. Theoretically at least, there is greater tolerance for individual idiosyncrasy, yet most Idoma masks and figures exhibit sufficient style uniformity to be recognizable to a skilled observer.

Nonetheless, there is a kind of freewheeling inventiveness in the work of quite a few Idoma carvers that would be out of place in a workshop devoted to canonical genres.[41] An example is the Idoma mask I saw in the mid-1970s that had been named Fok-No-Pay ("free sex") by the exuberant young men's age-set that had commissioned it. Onu Agbo, the Idoma artist who carved this, was over seventy himself, a respected *anjenu* priest and blacksmith who nevertheless was known for constantly trying out new ideas in his carvings. Other people's *anjenu* shrines used conventional mother-and-child figures or sacred animals such as hornbills, lions, or leopards. Onu's *anjenu* shrine figures included a "lady doctor" and a colonial policeman, "Sgt. Augustine Idoma," reading a letter, as well as a somewhat more enigmatic but colonially inspired "information officer." The simultaneous reputation of Onu Agbo as the embodiment of local tradition in his roles as blacksmith and priest but also as amusingly inventive in his treatment of genre forms inevitably destabilized all attempts to bequeath upon him a uniform designated status. This ambiguity was an important aspect of his identity, which he found very satisfying.

Tiv carvers were equally iconoclastic and ever ready to aggrandize other carvers' styles and even identities: one elderly Tiv that I knew, Aba of Agagbe, had perfected an imitation of the style of the locally famous Idoma carver, Okati of Ojakpama.[42] Although they lived on different sides of the Tiv-Idoma borderland, their settlements were

FIGURE 4.8. Two Idoma-Akweya boys with masks they carved, Ejor, Nigeria, 1974. *Photo by author.*

only about fifteen kilometers apart through the bush. Okati's patronage radius extended well beyond his district of Adoka. An innovator like Onu Agbo in Okwoga District, he had even designed a whimsical throne with moving parts for the Och'Idoma's palace in Otukpo, and his "Ije Honda" mask of a man riding a motorcycle was in the collection of the Jos Museum. All this was belied by his dignified bearing and status as an important elder in his village.

Aba, by contrast, was an assiduous collector of other people's carving, or at least their styles and repertories. It was never certain whether his *kwaghir* Mami Wata was a perfect copy or an actual product of the Annang Ibibio carving cooperative at Ikot-Ekpene in the Cross River region. The same ambiguity hovered around "Gowon," the Janus-faced platform mask of soldiers and horsemen that was intended to represent the (locally popular) former Gowon regime of the military government. The faces were identical to those on the Ije Honda mask Okati had carved, yet Aba claimed it as his own creation, spinning out a complex iconography with ramifications from Tiv popular culture. When I showed him a photograph of it a few months later, Okati had no recollection of carving the Gowan mask or even having heard of the Tiv sculptor Aba, but with characteristic restraint he acknowledged that it "resembled" his work rather closely.

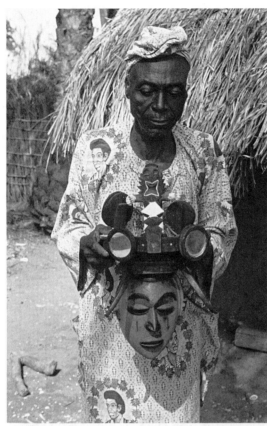

LEFT: FIGURE 4.9.
Idoma Alewu mask
and its carver Onu Agbo,
Okpudu, Nigeria, 1976.
Photo by author.

BELOW: FIGURE 4.10.
Idoma masks and
Anjenu figures by
Onu Agbo. "Sgt.
Augustine Idoma
and his beautiful
wife Elizabeth" are
on the right, Okpudu,
Nigeria, 1976. *Photo
by author.*

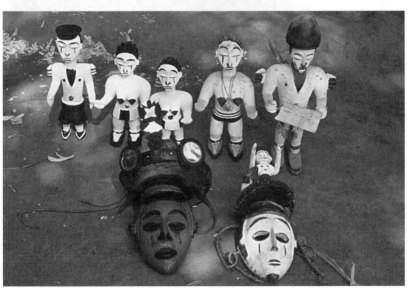

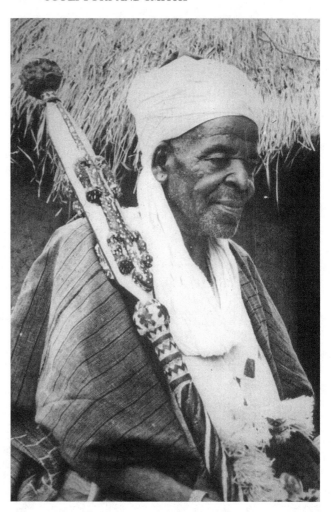

FIGURE 4.11.
Idoma sculptor
Okati of
Ojakpama,
Adoka District,
Nigeria, 1977.
Photo by author.

The matter of Aba and his skill at copying and/or hoodwinking researchers is evidence of the way distancing and ambiguity are intentionally cultivated as a way of keeping the public from knowing too much about what artists do. Outside the constraints and supports of the workshop, artists essentially invent themselves in ways that society will accept, or at least believe. There are such people as Onu, Okati, and Aba in workshops (and nowadays even in cooperatives), but they don't sit well or happily with workshop rules and if they belong to cooperatives, they often do much of their work on the side. Through appropriation of both Idoma and Annang models, Aba acquired two explicitly non-Tiv styles, iconographies, and genres. But without any

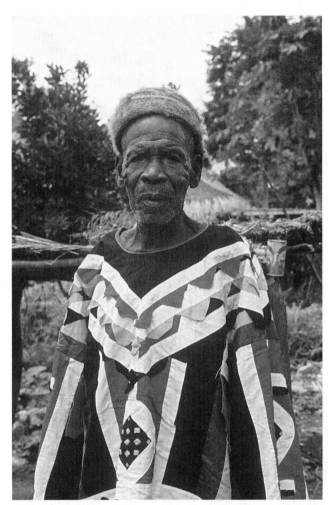

FIGURE 4.12.
Tiv sculptor
Aba of Agagbe,
Nigeria, 1977.
Photo by author.

contact with their originators, he could only use his own knowledge system to explain them.

Lone artists in Idoma and Tivland are mavericks: they create their own knowledge and practices out of networks of actual contact, stealth, imitation, even dreaming, as opposed to the more orderly and limited chains of transmission of knowledge and practice that come through training and intimate daily familiarity with the work of a selected cohort of other artists. Although they are far less wedded to a particular repertory, they are like workshop artists in their ability to materialize what are for other people just ideas. It is this ability that brings the distancing mechanisms into play.

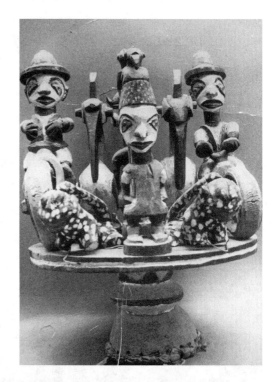

RIGHT: FIGURE 4.13. "Ije Honda" mask by Okati. *Courtesy of Jos Museum, Nigeria.*

BELOW LEFT: FIGURE 4.14. Tiv "Gowon" mask self-attributed by Aba but in Okati's style, Tiv-Adoka borderland. *Photo by author.*

BELOW RIGHT: FIGURE 4.15. Tiv *kwaghir* "Mammy Wata" self-attributed by Aba, but in Annang style, 1977. *Photo by author.*

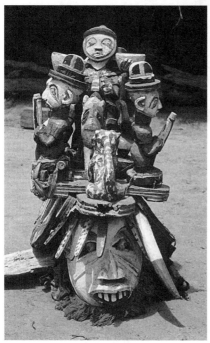

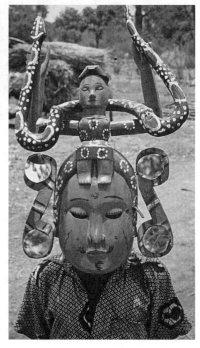

BEYOND HUMAN AGENCY: POWER BY REVELATION

These are in one sense loaded examples: not all Tiv carvers are as sly as Aba or as enamored with imitation. Workshop carvers dream too (for the Maconde and many others it is the normal way one gets new ideas). And I have left aside until now the very different Idoma ideas and beliefs concerning the creation of ancestral masks, which are not carved from wood except in the Akweya-speaking clans. All of the secrecy and supernatural agency and general sense of portentousness that is missing from Idoma carving is found in the production of *alekwuafia* and *unaaloko,* both of which are elaborate textile masquerade ensembles. *Unaaloko,* a royal masquerade of Agila and Igwumale, is claimed to be made by *och'aba* (literally, "chief of masquerades"), a mask spirit, and not by human hands at all (see plate 8).[43]

Alekwuafia are fashioned by a ritual tailor (*abakpa,* literally but not actually a "Hausa") said to be chosen through revelation in a dream. In one account, the dreamer learns he must locate in the bark of a certain tree the sacred needle for sewing the costume, after which he is declared to be *abakpa* (Bassing 1973, 8). In this version of Idoma mask-making, the artist-tailor is very far from the free agency that characterizes the woodcarver: he is chosen by revelation, works in secret, and is under numerous ritual prohibitions that included in the past the threat of death for noncompliance.

His is the other, concealed, side of Idoma image-making, though once again, he is untrained and unapprenticed, despite the great complexity of the ensemble (see Kasfir 1985).[44] What do the Idoma intend by this representation of how the ancestral masquerade comes into being? Is it a story made up to protect the *abakpa* from too much scrutiny? Or does his revelation act to ratchet up by several notches the mask's already numinous presence? Whichever way we choose to interpret it, the representation is useful. His identity as *abakpa,* for example, opens up a set of clues, some of them false, concerning the historical origin of the masquerade and its possible northern connections to the non-Muslim Hausa (Kasfir 1985). Self-representation in this case is intended to be a path of blind alleys, deflecting inquiry and masking the maker's identity in order to preserve the illusion that the *alekwuafia* is literally the incarnated ancestor, bidden from his home beneath the earth to save his descendants from error and wrongdoing. The result of this contradictory Hausa (*abakpa*) versus

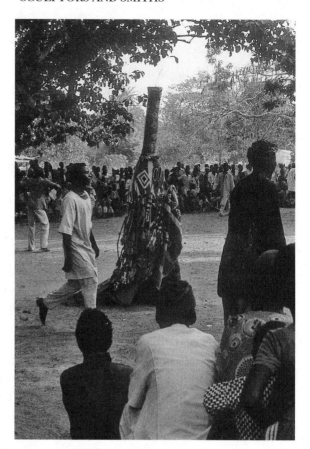

FIGURE 4.16. Enkpe masquerade from Ogbodo-Aba (Igbo borderland), Igwumale, Nigeria, 1986. *Photo by author.*

not-Hausa representation is contested identity, an outcome that serves to maintain secrecy, ambiguity, and distance (see plate 9).

The point is that all of this is strategic in distancing the production of the mask ensemble from the eyes of the community. The ensemble instead appears to materialize in a space somewhere between family obligation (the patrons who are resurrecting their ancestor) and secretly mediated knowledge and practice (the tailor who makes it). Patrons clearly are essential to artists and vice versa, but it is often easier to celebrate and remember the patrons who may be important kings, chiefs, or lineage heads.[45] Artists, by contrast, are rarely the wielders of political influence and may not possess the luster and status of those they immortalize. As with the Sudanic blacksmiths, many sculptors (and in Idoma, ritual tailors of masquerades) are instead agents, go-betweens, and "anthropologists" of their own communities. This ambiguous insider/outsider status is an essential condition to their inventiveness and creativity.

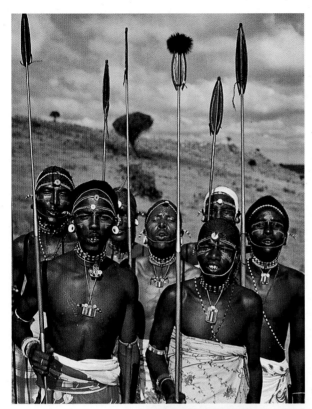

PLATE 1. Warriors
of Lkurroro age-set
initiated in 1976,
near Maralal,
Kenya. *Source: Nigel
Pavitt,* Samburu
(1991).

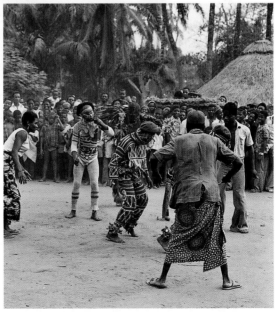

PLATE 2. Idoma Ekpe
masquerade, Otobi,
Nigeria, 1976. *Photo
by author.*

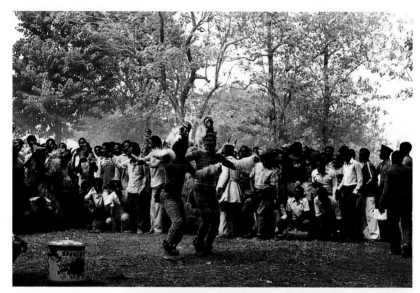

PLATE 3. Igede
Ogrinye-type
masquerade (right),
Uwokwu, Nigeria,
1986. *Photo by author.*

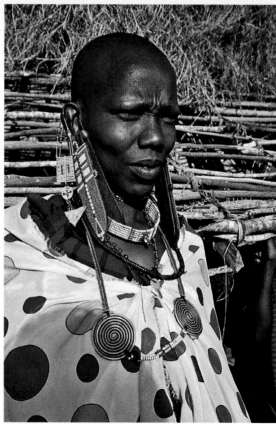

PLATE 4. Married
Kisongo Maasai
woman with brass-coil
surutia necklace and
beaded leather
earflaps, Tanzania,
1999. *Photo by author.*

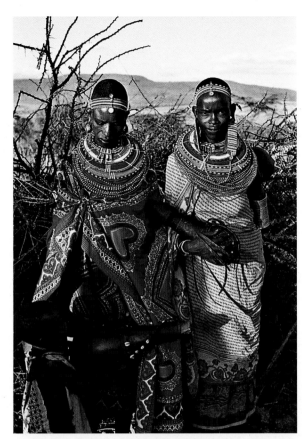

PLATE 5. Married highland Samburu women (left) wearing brass-coil *surutia* as earrings and (right) the less-common beaded leather earflaps, near Naibor Keju, Kenya, 1987. *Photo by author.*

PLATE 6. Ltibikon Lepile forging spears near Mt. Nyiro, Kenya, 1991. *Photo by author.*

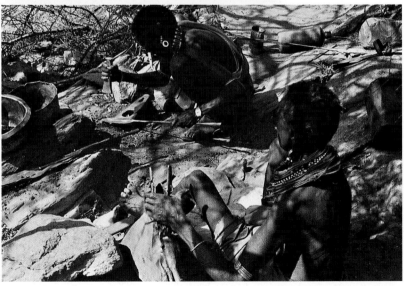

PLATE 7. Omaga An'ne, head of the Oglinye Society, with two Oglinye heads "by Ochai" (left) and Ojiji (right), Otobi, Nigeria, 1978. *Photo by author.*

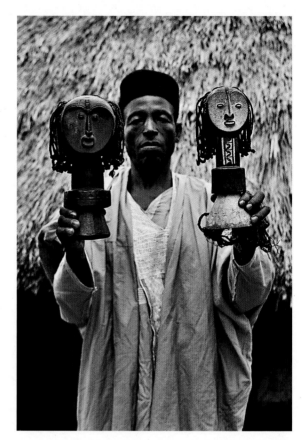

PLATE 8. Idoma Unaaloko masquerade, Igwumale, Nigeria, 1989. *Photo by author.*

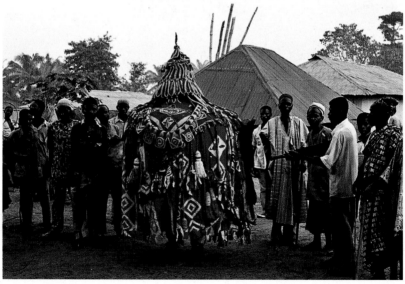

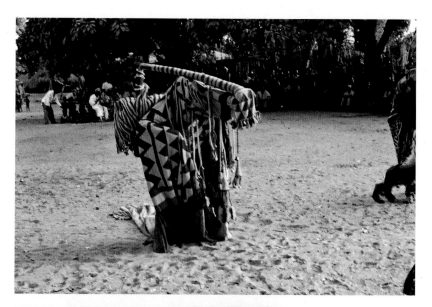

PLATE 9. Idoma
Ekwila masquerade,
Agila, Nigeria, 1986.
Photo by author.

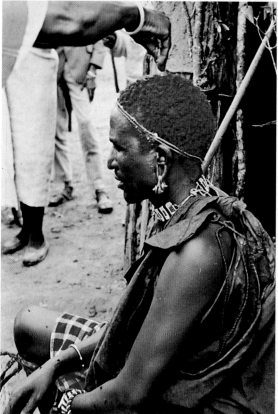

PLATE 10. Samburu
father at circumcision
wearing ochre,
women's *urauri*, green
birth beads, lionskin
leglets, and a woman's
goatskin apron over
his shoulder, near
Maralal, Kenya, 1996.
Photo by author.

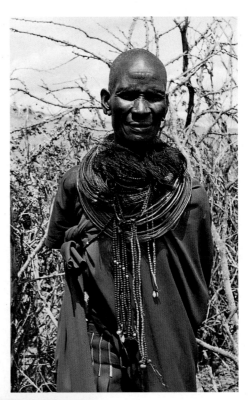

PLATE 11. Samburu
mother wearing her
son's *nchipi* following
his initiation, near
Maralal, Kenya, 1992.
Photo by author.

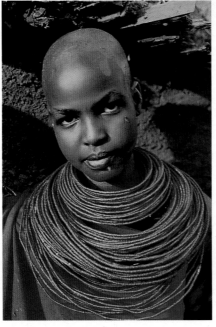

PLATE 12. Samburu girl
at her circumcision
ceremony, Maralal,
Kenya, 1996.
Photo by author.

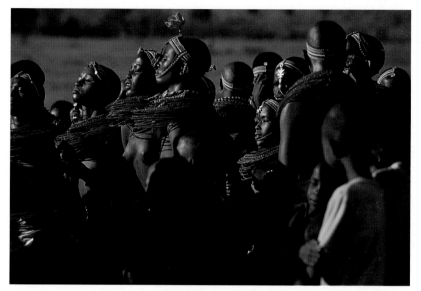

PLATE 13. Uninitiated Samburu girls dancing for warriors at a wedding near Maralal, Kenya, 1999. *Photo by author.*

PLATE 14. The Osana of Keana on horseback at the annual salt festival, Keana, Nigeria, 1989. *Photo by author.*

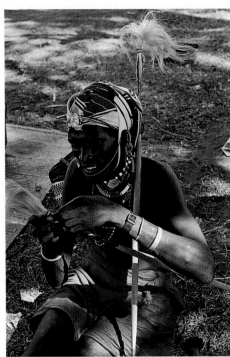

PLATE 15. Mondo, a Samburu moran, decorating the spear-blade cover of a tourist spear, Kikambala, Kenya, 1991. *Photo by author.*

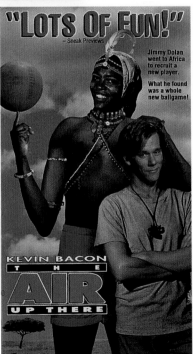

PLATE 16. Movie-theatre poster for *The Air Up There,* 1992.

Part 3

MASKS, SPEARS, THE BODY

5

MASK AND SPEAR: ART, THING, COMMODITY

Material objects are chains along which social relationships run.
—E. E. Evans-Pritchard, *The Nuer* (1940)

Every material object is constituted as an object of discourse.
—Christopher Tilley, "Michel Foucault: Towards an
Archaeology of Archaeology" (1990)

OBJECTS AS TEXTS

In this chapter I reach the core of the book's second and more aesthetically focused set of arguments, which concern the interpretations, both indigenous and exogenous, of the masks and spears of my historical narrative. In earlier chapters (1 and 2), I argued that missionaries' and explorers' accounts, novels, the popular press, and colonial government reports created a discursive field around the institutions and practices of warriorhood in what became the British colonies of Nigeria and Kenya. The inscriptions were very different in the two locales and resulted in markedly dissimilar governing policies. And because these policies had a direct effect upon artisanal practice related to warriorhood, I have argued that they inadvertently set the conditions for artistic and technical innovation. Because the Idoma and Samburu cultural scripts were very divergent, innovation meant something different in each case: the transformation of a mask genre for the Idoma and the opening up of the smith's previously limited spear repertory for the Samburu. In the next section (chapters 3 and 4), I turned to a closer scrutiny of the power and limitations of the Idoma sculptor and the Samburu smith within a

larger cultural script of African practice. But the argument cannot end there, because although I have traced the innovations in certain kinds of objects as they relate to a repertory and practice, I have not looked at them as visual texts. To understand the place these objects have come to inhabit in an externally structured art-world or material-culture concept, one has to trace the variations in ways they have been talked and written about in the colonial and postcolonial spaces they have inhabited.

Idoma warriors' masks and Samburu spears, the two types of objects most central to this book, were not just the material inventions of specific artists but also were generators of important ideas and values expressed by their users, their makers, and society as a whole. Later, when they entered a more globalized art world and culture of collecting, a whole new set of inscriptions and representations emerged that would have been completely unrecognizable in their respective localities prior to the early years of colonization. After initially being classified, along with flora and fauna, as scientific specimens by late-nineteenth- and early-twentieth-century European and American collecting expeditions, masks entered a new discourse as objects of romantic delectation, while spears lost ground from an originally symbol-laden artifact to an example of primitive technology. Tilley (1990, 333) has argued that material objects in the most typical sense—a painting, a pot, a building—are nondiscursive themselves (they do not literally speak or write), but at the same time, they "frame and constitute significative systems of meaning." In other words, they produce and are partly constituted through discourse and in this particular way they resemble texts.

Expanding this approach, it matters not only what the faraway collector/scholar/museum does to textualize an object (and in doing so, to constitute it as it will be known in distant places) but also what the close-at-hand makers and users do. By this logic, their discourses—especially their self-representations—matter as much as ours. This is one point on which postcolonial strategies of textual analysis differ markedly from poststructural and postmodern strategies: the latter have tended to devalue or dismiss the artist's intentionality as a kind of misplaced authorial privilege and to insist that the text must be viewed as independent of its maker. But such intellectual strategies were formulated in situations far removed from the theatre of colonialism that initially gave rise to Western scholarly

discourse on African art and material culture. They unfortunately play into a discursive model that has become very familiar to African and Africanist scholars, in which the meanings of African art objects are largely inscribed through the texts surrounding their introduction into Western collections. Here they are either recontextualized as aesthetic objects existing outside history or channeled narrowly into parameters constructed out of what is typically an idealized and ahistorical reading of African cultural practice. These readings, in turn, originated in a nineteenth-century social-evolutionary rhetoric in which the European colonies provided the ideal laboratory for specimen-collecting.

One way to offset the distancing of these objects from their local histories has been through the plurality of thick description, the "piled-up structures of inference and implication" that are the precondition for good ethnography (Geertz 1973, 6). This has not been just a matter of "letting the _____ speak for themselves" but also one of trying to comprehend the polysemic through multiple readings. In the previous chapter, the issue of artisanal segregation and its associated pollution and distancing was approached in this manner. It goes without saying that at a single point in time the connections between warriorhood and spears and their cultural content are seen very differently by isolated Samburu smiths, by the dominant Samburu culture, and, at a greater distance, by the tourists, travelers, and nonpastoralist Kenyans who cross their paths.

Geertz, following Ricoeur (1971), employed the culture-as-a-text metaphor in which meanings are both public (i.e., dissociated from authors and their intentions) and external to interlocutors, but unlike the later poststructuralists, he argued that texts, like symbols, contain durable meaning (Silverman 1990, 128). Whether we accept this stance or that of poststructuralism, which argues that cultures (and by extension, their objects) are inherently unstable because they are constantly reinvented through action, it should be clear that multiple readings of the same action bring us closer to understanding what a text or action "talks about" (i.e., reveals), as opposed to what it literally "says."

Thus, archival reports of the maneuvers of colonial settlers to dislodge the Samburu from the Laikipia Plateau are an essential ingredient in understanding the reasons why Samburu warriors engaged in the practice of what the British called spear-blooding in the 1920s

and 1930s, even though the surviving members of the Lkilieko age-set remembered it in terms of a feud between warriors of two rival Samburu sections. Equally, Idoma sculptors and their warrior patrons saw the substitution of the carved mask head for the enemy cranium as a necessary strategy for maintaining the Oglinye institution and the idea of warriorhood, while colonial administrators read it as a signal that the campaign to eradicate headhunting was working. It seems clear that objects do speak but that their messages depend heavily on who their interlocutors happen to be.

THE PROBLEM WITH OBJECTS . . .

Another challenge arises because objects usually outlast the events for which they were originally intended, even in the tropics, so that there is rarely a perfect fit between sequences of events and sequences of objects. Many of the Oglinye heads I saw in Idoma and Igede villages in the 1970s and 1980s were made between the 1930s and 1950s. Those now in British and Nigerian museums, which were collected mainly in the late '20s and '30s by district officers, were probably made early in the century close to the time of military pacification. One of the consequences of this difference between the date of origin and the continued use and visibility of an object long afterward is a trajectory of changes in meaning and appearance over time. Idoma masks are periodically refurbished and modernized (with everything from paint store enamels to soda cans). Both Kopytoff (1986) and Vogel (1991) have written of the multiple careers an object may experience over time. Whereas an event, which is here today and gone tomorrow, can be multivocal by virtue of having multiple witnesses or spectators, an object possesses an added degree of complexity because it continues to exist after its initial appearance in time and space.

This "problem with objects" can be quite dramatic when pieces made of wood that has been particularly well cared for or anything of ceramic, metal, or stone can easily predate photographic documentation or collection by a century or more. What this means in essence is that important objects have histories that are much more complex than the wars, rituals, or other enactments for which they were originally made. If they are portable, they may be exchanged, stolen, bought, sold, borrowed, or given away. They gain new mean-

ings through accretion, with new ownership, or over time. And they always possess a dual character; they are evidence of the past but have a separate existence in the present.

The assertion that objects are constituted as texts has gained some level of acceptance in art history and archaeology as well as ethnography. Ethnoarchaeologists and cultural historians (particularly those engaged in the history of commodities such as textiles) take this to mean that they are an especially valuable form of historical evidence because, unlike many other kinds of texts, they are both stable and difficult to falsify. Unlike oral texts, things also exist in ways that are easily separable from the interpretations attached to them. And unlike events, which begin, unfold, and eventually end, things are continually open to observation for generations, centuries, and even millennia. This paradoxical quality of existing both then and now has also made certain types of artifacts, such as photographs of human subjects, a burgeoning field of study for historians and ethnographers working within the visual culture paradigm. Their status as social documents can be continually revisited and redeployed without eroding their integrity as material culture.

In a study of ceramics and other materials in the precolonial pastoral economy of South Africa, Wilmsen (1994, 1) argues that "material objects have the same ontological status as words" and therefore can be read as texts and that furthermore (unlike many other kinds of texts), they are unchanging in themselves ("inert"), however subject they may be to competing interpretations. But the fact that objects— masks, spears, pots, textiles, photographs—also have a nondiscursive quality, as inert things, allows them to act in material ways: masks are disguises for the body, spears are to be thrown or thrusted, pots are containers. At the same time, this objecthood attracts a constant flow of explanatory or descriptive elaboration. And while objects are deeply implicated by these attached meanings at any given time, the meanings are volatile in a way that the objects themselves are not. In that sense, artifacts are imbued with both geographies and histories, both of which are sites of contestation and continual revision. This is one obvious reason why visuality is so powerful, both as affect and as analytical tool.

This paradoxical quality an object has of being stable yet volatile was underestimated in early studies of African art, in which meanings attached to objects were treated as if they were more or less

transparent. William Fagg argued in his classic study *Tribes and Forms in African Art* (1965) that for the plastic arts, unlike the sometimes unreliable observations drawn from human behavior, the data are "concrete and incontrovertible" evidence. But as I have argued elsewhere (Kasfir 1984), it is their interpretation, and sometimes even their identification, that is subject to the same contestations and revisions as are applied to other aspects of the past.

LOCAL INTERPRETATION AS HEURISTIC THEORY

One important approach in poststructuralist thought has treated all objects as if they were discursive (Tilley 1990), but this approach has very different ramifications in discussions of, say, twentieth-century avant-garde or modernist art (e.g., Duchamp, Mondrian, Warhol) than it does in discussions of the cultural production of artists who work outside the Western modernist paradigm, such as those African artists trained in a local regime of knowledge and practice. Both groups of artists have developed a consciousness about what it is they are doing, and some are able to talk about it within an interpretive framework. But whereas one who lives and breathes the rarified air of the avant-garde has by definition moved beyond any mainstream everyday understanding of art-making, the majority of African artists trained in local patronage-driven systems of practice do not position themselves in an oppositional role to the ideas of the dominant society that surrounds them.

Segregated artisanal "castes" such as the Samburu smith seem at first to contradict this difference because, like avant-garde artists in the West, they are culturally separated from the mainstream. But in contrast, the distancing of the smith results from the imposition of the dominant society's sociocultural structures and habitus rather than by their own choosing. Therefore the ways in which they see their own position mirrors (but often inverts) the way the dominant society explains their presence and power. For the avant-garde Western artist it is instead a matter of engaging current intellectual debates self-consciously on a track that runs parallel to that of the art critic or art historian, of bringing, in the case of poststructuralist art, Baudrillard and the simulacrum right into the gallery and our living spaces (see Herwitz 1993, 283–298).

This quite obviously is not how an Idoma sculptor in a village of the West African savanna or a Samburu smith from the mountains of

northern Kenya theorizes what he is doing. The distinction is between two levels of cognitive engagement: to "theorize," in the Idoma or Samburu case, is to speculate upon the reasons why things are the way they are in the context of their own observations; in the case of an intellectual avant-garde (which could easily include African artists trained in universities), to "theorize" is to construct or test theory itself. In fact, the theorizing of an Idoma or Samburu artist ultimately concerns the same broad issues as those of his or her Western-trained counterpart—practice and clientage and their place in a changing cultural script and social order—but clearly it is not conceived with reference to Western-derived discourse about theory.

The fact that any local African artist or patron, however unself-consciously, does create a discursive framework for the objects he or she fashions or acquires made it possible for Danto (1988, 23–26) to explore the paradox of localized meanings in a fable for critics concerning the Pot People and the Basket Folk. In the fable, which is about the difficulty of assigning value to things, there are two "tribes" who, for the sake of the argument, make essentially identical pots and baskets that to a museum curator would be indistinguishable. But the Pot People's pots and the Basket Folk's baskets are imbued with deep cosmological significance and are linguistically richly nuanced, while the Pot People's baskets and the Basket Folk's pots, although seemingly identical to the others' baskets and pots by every physical measure, are considered to be merely utilitarian baskets and pots by their makers and users. When transposed into a Western art museum setting, these differences become invisible because they relate not to formal or technical qualities but to multiple layers of referential meaning that are known only to the Pot People or the Basket Folk. The "correct" disposition might be to place the highly valued objects in a fine arts museum and their utilitarian counterparts in a museum of ethnology or cultural history, but since they all look the same, who could tell which was which?

Since the reader knows nothing else about these two hypothetical cases, Danto presents her with a philosophical impasse. But in fact it is mainly an elegant intellectual construct without an empirical underpinning. I therefore offer a bridge to examining the issue in relation to African real-life situations. If one accepts that African artisans include "artists" by Western designation such as carvers and casters who make sculpture and weavers, potters, and smiths and so forth, then one can speak of artisanship with reference to any of these

specializations. Leaving aside university-trained artist-intellectuals who, unlike artisans, typically subject their work to the high-art criteria of uniqueness and significance (and like intellectuals anywhere, do this with a high degree of self-awareness), it is possible to think of the impact of colonialism and commodification as affecting all artisanship in similar ways.

The other essential step is to adopt Maquet's (1982) useful observation that the aesthetic locus of a culture, the area in which aesthetic activity is most noticeably concentrated, may lie outside the types of production we are accustomed to categorizing as "art." An example of this would be the care and inventiveness lavished upon self-decoration by nomadic pastoralists. This elaboration of the body can be seen as extending to weaponry in the case of the Samburu and makes it possible to draw a set of obviously useful yet also symbolically powerful artifacts into a general consideration of aesthetic transformation.

"THE PRIVILEGED SPHERE OF ART, WHICH STANDS IN CONTRAST TO ALL UTILITARIAN GOODS"[1]

Despite these useful elisions, there is still the problem of fitting African artisanal practice into the larger discursive framework used by museums and universities and other places where people talk and write about art. Here discussions of value in studies of art and material culture are usually framed in one of two ways: 1) how well the object compares with other examples of its genre or type or 2) whether it should be classified as art or craft, fashionable deception, or commodity. In relation to modernists such as Warhol and Duchamp, Danto (1982) postulates an equivalent condition to that of the Pot People's pots: to *be* art, it must be conceptualized as art and its formal qualities are irrelevant to such a task. Thus, it is theory (or the fact that it is theorized) alone that makes art different from artifact or, in Danto's words, "mere things" (Herwitz 1993)There are problems with this argument when it is made for twentieth-century modernism, primarily because it tends to displace significance away from the physicality of the object and project it onto the object's referential meanings instead, which might produce a sliding scale of value with, say, conceptualist art at the top and experiments in pure color or form at the bottom. Danto's claim actually works much

more easily for objects that have ritual meaning and/or the status of sacra, whether it is Samburu spears, Idoma enemy heads, or medieval European saintly relics. It works precisely because these meanings are strongly held, public, and collective and not the private beliefs of an individual creator.

But one can also use Danto's fable to explore the question of value in relation to objects, since both the Samburu and the Idoma sub-scribe to a consciousness of the object's value rather than its formal complexity as a representation or even its capacity to create emotional affect, a consciousness that values a Samburu spear in the same way as an Idoma warrior mask when each is properly contextualized (that is, while being used for its intended purpose). However, the selection criteria for the entry of both masks and spears into Victorian and Edwardian collections were adopted not from those local zones of value but from hierarchies based first on evolutionary schemata used by natural history museums (where both masks and spears initially resided as cultural specimens) and, later on, from avant-garde and modernist assumptions adopted by art museums and collectors. By the early decades of the twentieth century, masks had ceased to be just specimens and had become high art as well, while spears remained mere "ethnographica" outside this privileged sphere.

And while it is true that both mask and spear fit within the broader purview of what is now called visual culture, that is not the way major museums collect and display them. While art history scholarship and teaching have changed over the past decade through the introduc-tion of more democratic visual culture approaches, that is not how "temples of culture" must operate. Museums practices are harder to change, since they are not just about words and images of real things, as university teaching is, but about the display of the things themselves.

The other point I want to expand from Danto's fable is that the various analytical frameworks that underlie Western museum clas-sification are often incommensurable with the ideas that are held by the original makers and owners of the objects these museums display. One then has to ask what losses occur between how the Samburu may have conceptualized the meaning of the spear and how it is perceived relative to other kinds of African material culture in collecting typolo-gies. Implicit in most Western discourse on art is the distinction, at once ontological and epistemological, that Danto drew between art

and artifact and that guides the contents of textbooks, educational curricula, and museum display. His essay appeared in the catalogue of an important New York exhibition, *ART/artifact* (Danto 1988), which thoroughly explored this distinction in relation to collecting practices. Here I am trying to bring it all the way back to the circumstances of actual cultural production and compare objects before they are collected and enter Western systems of classification.

While the difference between these two classifications[2] has most frequently focused on an object's utilitarian nature or its lack of it, there have been numerous attempts to use aesthetic (e.g., Langer 1957) and epistemological criteria (e.g., Danto 1982) as well. The question is whether any of them have the capaciousness to encompass the objects at issue here, both in their initial meanings and those they later come to acquire in their trajectories through time and space.

1. *Art requires a significant degree of creativity or invention (sometimes defined as "risk-taking") in its production, while the non-art object requires only technical skill.*

This is one aspect of the traditional European distinction between art and craft—in this case, an attempt to separate the mask from the spear—that is predicated on the Renaissance-inspired Western notion of creativity as an attribute that requires originality as its sine qua non. But how does one actually apply it here? An Idoma sculptor might know how to carve from three or four to a dozen mask genres, depending on his patrilineage and in which chiefdom he lived. A Samburu smith who was fully conversant with his patrons' needs could (and still can) make eight different spear types. The Idoma sculptor carried in his head a template of what an Oglinye or Ichahoho or Itrokwu mask should look like. There were no carving workshops or apprenticeships, so he possessed a certain latitude in working out the stylistic details, but there was an accepted range of innovation outside of which it would no longer be recognizable as an example of that genre. Because of the necessity of its possessing perfect functionality, the limits of innovation were much stricter in the case of the Samburu spear.

The most radical innovation came around 1960 with the adoption of smaller lighter twin throwing spears to replace the older and

much heavier Maasai thrusting type. The Idoma sculptor's singular innovation, which is of uncertain date, was to replace an enemy cranium with a carved simulacrum. Both of these innovations were radical changes, requiring an ability to see beyond current practice. But neither happened because of a simple creative urge to make something new. Each had a proximate cause: the new Lkishili age-set's demand for change in the case of the spear, the British colonial ban on headhunting in the case of the mask. Where they diverge is in the replication of the prototype, because the spears will require much greater conformity to type than subsequent Oglinye heads will. Therefore the original versions of each genre, mask and spear, could have both been considered "art" in this risk-taking sense, but the spear replications would not involve the same level of reinvention, since there are so many more degrees of freedom involved in carving a face than in fashioning an efficient cutting blade that is also a widely recognized social symbol.

This raises a corollary to the old art/craft distinction, one that took a nosedive with the rise of mechanical reproducibility, which is that a work of art is a singular thing, the only one of its kind, while craft is constantly replicated. In post-Benjamin, post-Warhol art history, this distinction evaporates or at the very least is subject to radical revision with media that are easily reproducible. Woodcarvings are not replicable in the same way as photographs or prints are, but strict workshop training methods or strong market demand can minimize the variation from a prototype. Local demand for Ogrinye (Oglinye) heads in Igede caused some carvers to stockpile them in a semi-finished state as recently as 1986, a practice that gives no credence to the Western connection between singularity and value. And while one might assume singularity to be not only impossible but irrelevant in the case of the spear, it actually is not: the Samburu owner learns the feel and balance point of a spear when hefted or carried and can therefore distinguish it from others of the same type.

2. *Art is what is found on the walls of an art museum.*

Maquet (1986) has argued that art is what experts and guardians of culture say it is at any given time and place—and therefore it is what is exhibited and written about *as* art—rather than a group of things that share certain observable properties. Sometimes this

definition is used tongue in cheek rather than seriously, but in either case it bypasses questions of how artworks may be recognized and isolated from other types of cultural production by shunting them into the realms of current elite taste and the changing exhibitionary practices of the museum.

The issue of taste (and distaste) and their relation to questions of value has not been plumbed extensively in African art studies. Most writers have introduced it as part of a broader critique of what is considered desirable and authentic within the "primitive art" collecting system (Price 1989; Appiah 1991; Errington 1998; Kasfir 1992b, 1996) Yet prevailing Western tastes, in the Kantian sense of what is judged to give pleasure, have figured importantly in what is collected and displayed as art from the vast repertory of African material culture. Whether it is by extolling patina (indexical of a taste for "finish" and long use) or the "magic" of the object, judgments of taste expressed by cognoscenti are clearly influential in deciding what goes on display in the art museum. But for insight into how taste has operated historically in defining value, one must turn primarily to studies of the Western visual or musical canon (e.g., Haskell 1981, 1987, 2000; Bourdieu 1984).

Much more has been written on institutional critique and the changing practices of the museum, often from the perspective of cultural Marxism and subaltern studies. With the recent recredentialing of material culture studies within anthropology, a specialization is burgeoning in the critical study of museum practice (e.g., Karp and Lavine 1991; Karp, Kreamer, and Lavine 1992; Duncan 1995; Noever 2001). Danto's fable is an implicit critique of the failure of art museums at the conceptual level, of the inability to account for local meanings. Unlike ethnology museums (which have struggled with their own conceptual problems), art museums have implicitly assumed that selection criteria for display ought to be universally applied, so a mask is (at least part of the time) a piece of sculpture and therefore a "major" art form, but a spear is, well, just a spear and usually finds itself outside the art museum's repertory.

Spears did have their day: the early strategies of display adopted by ethnology museums focused on weaponry, and Annie Coombes (1994) has written of the late-nineteenth and early-twentieth-century heraldic type of installation in which the fighting shield forms the centerpiece and an array of spears are arranged spokelike, emanating

from the center or crossed at the base. The spear also had its role in the exhibition style that favored evolutionary typologies based on technological ladders of advancement within a particular genre—a wall of spears of ascending size and complexity. The first of these display strategies was both aesthetically driven and emulative of European heraldry, while the second was decidedly specimen driven.

3. Art has the ability to produce affect, while artifact does not.

Like the first definition, this is grounded in Western notions of artistic sensibility. It therefore is most convincing when describing the reception of African objects in the West. To be useful in discussing reception in the communities in which the object is produced, it requires the corollary that ritual objects (sacra) apprehended as "art" by a Western sensibility must have efficacy in the case of the object's original audience. While this is in some sense an equivalent condition, it is not at all the same thing. When an object is apprehended by a viewer who does not share the same cultural assumptions and beliefs as the artist, efficacy drops away and the cultural script changes, making way for affect. This was made clear in Hoffman's analysis of the power inhering to certain Dogon sculpture. When a Westerner viewed it, she observed that true art "takes your breath away" (i.e., creates affect) while to the Dogon sculptor she interviewed, much of its power lay in the fact that "it works" (i.e., possesses efficacy; Hoffman 1995; Kasfir 1995).

Of these three statements concerning art, the third comes closest to the contrast between complex and simple representations in Danto's fable. Both artworks and sacra work as complex representations, and artifacts (in the sense of ordinary "things") typically lack that complexity. But even if they are both types of complex representations, it is not often possible to collapse artworks and sacra into one and the same type, since that requires an interdependence of affect and efficacy.

Field studies of African aesthetics have demonstrated that despite this difference in the ontological status of "affecting objects" (Armstrong 1971), there were unambiguous criteria in many historical African cultures for evaluating distinction or the lack thereof in the media of woodcarving, ceramics, weaving, and so on (Thompson 1971/1976; Borgatti 1982, 2005; Hallen 2000; Abiodun 1983; Lawal

1974). But a problem arises because technical excellence and the formal qualities that result from it were only one part of an object's value. In the case of masks and figure sculpture, the object frequently drew its greatest value from a ritual efficacy or power that might (e.g., in the case of Yoruba aesthetics) or might not be tied to its formal qualities. But in both cases, the fact that it was "for" something and that it worked was a major factor in creating value. Since in Western philosophies of art, the lack of a use function is usually basic to art's distinction from craft or artifact (e.g., Langer 1957, 91), there is no way this idea can be easily rationalized or reduced to congruence with an African system of interpretation that places efficacy above other values. The most workable bridging concept might be to allow that both affect and efficacy or power are culturally driven outcomes of the artist's attempt to give works, in Langer's terms, "expressive value."

There are numerous examples, from Kong *minkisi* to Kalabari altar screens, in which a ritual object that is not technically excellent or impressive to the eye may nevertheless be highly valued for its efficacy (MacGaffey 1993; Horton 1965). One of the most telling examples of the power that may inhere in an object is neither a mask nor a figure but a coral bead. Ben-Amos described a particularly famous bead called "One Bead Does Not Go Around the Neck," over which Esigie and his brother Arhuanran once competed to gain royal legitimacy (1999, 64). Possession of coral-bead regalia is "a defining mark of Benin kingship" in which the beads are thought to have *aṣe* (power, more specifically the ability to activate a curse), and wearing them is "a crucial component of what gives the Oba divine power" (83). In the end, there is nearly always a residue of unexplained power and feeling in ritually significant objects that prevent Western high-art values from being fully commensurate with African ones.

COMMODITIES AND THE ART/ARTIFACT QUESTION

Some kind of workable comparison of their status must be attached to various objects within a given artistic practice: not just comparisons of whether something is art or artifact but also whether it is souvenir or commodity. Remarkably, none of those terms taken alone could describe adequately the place that the Oglinye mask or the pre-1980s Samburu spear occupied in the Idoma or Samburu system of objects. This should alert anyone to the limitations of Western

scholarly discourse in describing important aspects of visual culture in non-Western contexts. Nonetheless, since these are accepted terms of Western discourse that are used throughout this and other recent work, they have to be taken into account in some way.

Appadurai's most fundamental point concerning commodities is that they are not particular kinds of things but a phase in the life of things. Might this observation be important in reconsidering the art/artifact question posed earlier? It implies, for example, that both art and artifact have commodity potential, though perhaps not equally. One could illustrate this inequality using the Oglinye mask and the type of Samburu spear that belongs to warriors. Appadurai described sacra (ritual and sacred objects) as existing in "enclaved zones of value" with limited potential for circulation. They are only commoditized (or commodified), he suggested, under conditions of massive cultural change (1986, 22). Both of the examples analyzed in this study may at first appear to lay claim to such a condition, but the Samburu spear, in addition to having symbolic and ritual value, has at the same time always had a recognized exchange value within the culture, partly due to its wide circulation as a necessity of pastoralist life. For this reason it lacks singularity, a characteristic one would expect to find in a traditional work of art or a sacred object. Therefore despite its symbolic value, it is also easily commodified, though only at the point of its manufacture and not after it has become the property of a moran. It is furthermore much more limited in its capacity as a visual representation since it is not an image or likeness of something else, while the Oglinye mask clearly is. These are not just qualities that make it easier to standardize its exchange value but also reasons why its status in Western collections is that of artifact rather than art.

In those same collections, the Oglinye mask enjoys the status of an art object, but for it to arrive there in the first place it had to pass through a commodity phase. It existed first as an inalienable possession with only a use value for its Idoma owners, and the conditions of colonization created the large-scale changes necessary for it to be desired and collected by outsiders first as a specimen of the material culture of a "primitive society" and later as "primitive art," thus creating an exchange value for it. Paradoxically, once it is ensconced in a museum collection, it undergoes a resacralization in the shrine of culture the museum represents. But its commodity potential has

been established, and it may later be deaccessioned and reenter a commodity phase.

This commodity potential is now recognized back in the Idoma village as well, which creates blurred boundaries around the enclaved zones of value that Appadurai talks about. Any disaffected youth or economically distressed farmer who has access to a shrine or storage house can cross that boundary by selling a mask or figure surreptitiously. The opposite is also true: the sometimes newly recognized commodity potential of sacra can cause their concerned caretakers to hide, bury, or lock them away, after which they are brought out and displayed only rarely. On the other hand, masks belonging to dance groups travel easily and can now be copied in one of the non-Idoma carving cooperatives in southeastern Nigeria, such as the Annang one at Ikot-Ekpene, from which it can be purchased by a Hausa or Igbo trader and, depending on the technical quality, sold to a trader across the Cameroon border in Fumban who connects with Paris dealers; to Gambian or Djula middlemen for the tourist markets in Nairobi, Abidjan, or Johannesburg; or even to a local masquerade society. As Strother (1999) has shown with Pende mask carvers (who have had a bifurcated market for a century now), the wider patronage base supports carving as a viable form of work but does not overrun the local masking culture, which (I am speaking about Idoma but the principle is generalizable) will remain viable until every rural village has Nigerian television sitcoms to replace mask performances.

Similarly, the work of a cutting-edge artist may be understood by no one in particular but theorized in a complex way and thus qualify to be thought of as art, but when it is sold to a collector by the gallery exhibiting it, it too enters a commodity phase. To a corporate patron, for example, it may be little different from the chairs and tables in the directors' meeting room whose wall it now graces and in fact may have been chosen at least partly because its colors, textures, and composition "coordinate" well with those of the carpet, drapes, and walls, like an illustration in *Architectural Digest*. How and when does it regain its status as an artwork? Let's say the board of directors are all philistines, but once a year the corporate offices are open to stockholders. When it is made available to a wider spectatorship, the work regains its potential to create affect and be recognized by its viewers as art.

If there was any question about whether artworks could resist commodification successfully, it has been dispelled by the first-person

accounts of conceptual artists such as Mel Bochner (2002)[3] and New York conceptual art dealer Ronald Feldman, who have both explained that despite many artists' attempts to subvert the established market, dealers can sell virtually anything.[4] If the artwork consists of a diagram drawn directly on a gallery wall, the wall can be photographed and the photograph sold; if it consists of a set of written instructions for doing or making something, the piece of paper can be collected; and so on. For example, Feldman described his 1974 collaboration with German conceptual artist Joseph Beuys, who performed a series of public dialogues or "social sculptures" that involved writing on a chalkboard as he spoke. During a speech by Beuys at the New School in Manhattan, collectors passed notes to Feldman offering to buy the boards. (Feldman erased them.) The last holdout, it seems, is Internet art, but it too can be downloaded. The ultimate collecting coup will be a dead artist's brain, cryogenically preserved like baseball player Ted Williams's body.

When a traditional Samburu spear is collected, it passes from complex representation to utilitarian object, while its miniaturized version moves from tourist commodity to complex representation. The "real" spear that ended up in a museum collection as a piece of ethnographica, an artifact of utilitarian value, was depleted of its complexity because its symbolic representations existed only in the minds of its original owner and other Samburu and were not easily transferable: one could say they had no surface visibility. The tourist spear, on the other hand, was a commodity only to the blacksmith and to the moran who embellished it, but once collected, it took on all the accoutrements of a complex representation in its role as a souvenir, an object of remembrance for the traveler who had been there.

In each of these examples, it is possible to replace "sacrum," "art," and "souvenir" with "complex representation." Each of these stands in hypothetical contrast to a "simple representation," or, in Danto's words, a "mere thing." The passage through a commodity phase often causes complex representations to be lost or temporarily submerged, though they may reemerge and are then reconfigured once the object takes its place in a collection. To this problem of a changing status over time, one must add the complication of multiple spectatorship, for as the boardroom example makes clear, many things depend on who it is that is looking. An elite collector of African art, on being shown a tourist spear and one of the "improved"

versions of the Asante seated female figure sold in boutiques and hotel gift shops, is very likely to be dismissive and reject the possibility that these representations could be as complex as those in his own collection of supposedly noncommodified forms. He (collectors are usually men) is likely to assert that only ritual art (or in the African view, sacra) could be complex, though he will have to admit that they are all representations at least. But the souvenir, the object of memory, is likely to be seen as trivial, the equivalent of Bourdieu's French worker's preference for "The Blue Danube" over a selection from *The Well-Tempered Clavier* (Bourdieu 1984).

What one realizes finally is that for either the collector or the collecting institution, it is crucial to be able to justify the criteria of exclusion and inclusion as unambiguously as possible. So the art/artifact contrast is a critical piece of the cultural script, just as are the notions of singularity and distinction that mark art as different from mere thing. In similar fashion, art museums must be invested in the notion that true works of art are not themselves commodities, even though they obviously have "commodity potential" on the art market. This creates contradictions when applied to work made by African artists schooled in, say, a workshop tradition since neither the art/craft nor the art/commodity distinction is very meaningful there. Commodities, even though they are not particular kinds of things, are nevertheless particular kinds of representations. So is high art, and most often the two are represented as insoluble, like oil and water.

6

WARRIOR THEATRE
AND THE RITUALIZED BODY

The body of a warrior is both an aesthetic locus and a site of signification, bridging what often appears to be a conceptual discontinuity by blurring the structurally imposed boundary between nature (the body experienced as an anatomical fact) and culture (the body as aesthetic object and signifier). Moving from artisan back to warrior again, this chapter explores the issue of how not only certain objects (masks, spears) but also the decorated, mutilated, or sexually androgynous body as an artifact of culture acquires meaning in relationship to the institution of warriorhood. Both Idoma and Samburu warriors were deeply enmeshed in their own ritual systems and their respective systems of objects that structured cultural practice at the beginning of the twentieth century. These two systems were linked through a series of performative practices that included dancing and masquerading for the Idoma, dances and *lmugit* ceremonies for the Samburu, and of course warfare itself, also a type of performance. The most ritually marked objects were (at least so far in this reading) Samburu spears and Idoma enemy heads and mimetic carved representations of such heads.

The Idoma Oglinye masquerade and related headwinners' dances have already been described. In this chapter, I will attempt to expand that reading of the incorporation and representation of the enemy to include the male genitalia as trophy, a fighting practice equivalent to the trophy head that is found widely in northern Kenya, Ethiopia, and the Horn of Africa. I will also go further in describing the "mask" of the Samburu warrior—his hair, ochre, and decorations as well as his weaponry—in terms other than as the age-grade

markers already noted by Hodder (1982) and others. In short, I take the "ritualized body" in this warrior context to include its extensions and its disguises as well as its incorporation and display of parts of the enemy body. I have demonstrated how the Idoma warrior's role and the objects and practices associated with it were transformed and aestheticized because of the suppression of warfare under the Pax Britannica.[1] Here I show how the Samburu moran's role also contains very visible and signifying components defined through Samburu ideas of manliness, sexuality, and virility.

One of the important questions is how much and in what directions this changed with conquest and "pacification" under the British and the gradual diminishing of unrestrained stock-raiding and spear-blooding. Spencer (1973, 97) describes the Lmerisho age-set, which was initiated in 1911–1912, as the last group of Samburu moran to go on raids "in the traditional manner" and the Lkilieko (which was initiated in 1921–1922), who figured centrally in the Powys case, as the last age-set to have *miraat,* a sequence of rituals enacted by a warrior who has taken a life while fighting.[2] With the imposition of the spear ban in 1934, warriorhood increasingly became a symbolic practice, but because of the fundamental importance of the age-grade system to Samburu social organization, it did not disappear as a distinctive status, as it has in Idoma culture. But like masquerading in Idoma warriorhood, a form of warrior theatre has sprung from its aestheticized Samburu counterpart. This theatricality has continued to undergo transformation as it has become the object of Western spectatorship.

The changes that took place under British colonial policy were not a seamless progression of grand plans hatched in the Colonial Office but a constant push and pull between government and local interests. Given the structural implications of the age-grade system, it was very much in the interests of Samburu elders to perpetuate the practice of moranhood in order to retain their control of decision-making and wealth as it was defined by pastoralist ideology (i.e., the accumulation of cattle, wives, and children; see Llewelyn-Davies 1981).

Warriorhood as a representation has thus remained as important to Samburu elders as it has to warriors themselves. And feeding this proclivity since the 1970s has been the increased commodity value of the warrior representation as it appears in Ministry of Wildlife and

Tourism posters, safari-lodge brochures, postcards, and coffee-table books. Even though the government has tried to neutralize both Maasai and Samburu moranhood (or moranism, as the Maasai penchant for fighting is disapprovingly called in the Kenyan press) with periodic regularity since the 1920s, the moran has actually become a major tourist icon alongside lions, elephants, and cheetahs.

I begin with the ritual transition from boy to warrior and discuss bodily symbols and practice in relation to the rites of transition (*lmugit*), which, because they are insulated from the actual vicissitudes of warriorhood, have changed little over the past century. I follow with the idea of the moran-as-fighter in order to establish what warriorhood and the ritualized warrior body meant at the inception of colonial rule. Finally I consider blood, ochre, and hair as elements of a Samburu ideal of virility that aestheticizes the enactment of ritual but is also played out in everyday social encounters.

ANDROGYNY AND THE TRANSFORMATION OF MALE IDENTITY

The most widely accepted social explanation for adolescent circumcision or excision is as a transformative rite in the socialization of the child into adulthood. In their performance in an African context, these rituals often recapitulate the idea of death and rebirth, specifically the death of the child as precondition to the birth of the adult. But since it is adult men who manage the ritual circumcision of boys, it is they who must somehow imitate the act of giving birth to the new initiate. In many places in West and Central Africa, this duty is carried out by a masked forest spirit who visits the initiation camp, thereby eliminating any problem of asymmetry between natural and supernatural agency caused by men who seem to give birth.

But elsewhere, including among the Samburu, the birthing of male initiates by their fathers or other men is done through a ritualized emulation of the parturition process. This seems at first to be another version of the mimetic theory of circumcision as male menstruation that Victor Turner (1967) put forth for the Ndembu; however, what is being emulated is not menstruation but the act of birth. In the Samburu case, this ritual emulation is seen in the appropriation of women's ornaments or clothing in order to signify the (re)birth of the initiate as a transformation in male identity. Once

again, a set or system of objects proves to be crucial to the working of the Samburu ritual system, but this time it is not spears but the things belonging to women that is central to the ritual.

There are at least four ritual occasions when the Samburu male appears wearing ornaments or garments traditionally associated with women: after circumcision, following homicide, during marriage, and at death. These object-ritual relationships can be approached several ways. Spencer (1965, 1973) preferred to present them as social facts with a minimum of interpretation of their metaphoric meaning. I will try here to see them as representations that are socially useful and relate them to the shifting nature of identity as it is played out during important rites of passage or purification.

Initiation into moranhood is, among other things, a realignment within the family in which the boy to be circumcised breaks away from his mother and the world of women and children and joins the world of men. He will no longer eat or drink alone or in front of women (or even, according to the warrior code, eat food that married women have seen)[3] or sleep with his younger siblings. But unlike the strict before-and-after phasing of girls' coming-of-age ceremonies, those for boys involve a liminal period both before and after the actual circumcision ritual when they are *laiyiok* (sing.: *laiyoni*) *loolkilani*, "initiates in black cloaks." It is the mother of the initiate who sews his garments from three blackened sheepskins[4] and makes the *nchipi*, a multiple-strand ornament of large blue or green glass trade beads ending in the wing covers of the beetle *sterocera hildebrandti* (Pavitt 1991, 66) that is worn hanging down the back from leather thongs laced through pierced earlobes.

Boys go into the actual circumcision ritual itself naked but for a necklace of small green beads (the color of grass: metaphorical growth and life) that are equivalent to the green waistbeads they may have worn as newborn babies. Mothers ritually hand over their sons as they emerge from their houses. Each son to be circumcised walks closely behind his mother while sheltered under her cape. Boys are circumcised in front of their mothers' specially built circumcision houses, each seated on a sheepskin she has prepared. The day after the operation, they don their black cloaks and *nchipi* again, but this time they also wear women's coiled and drawn-copper or -brass earrings (*urauri*), a sign that they have entered that amorphous grey area somewhere between the female-dominated world of childhood and the male-regulated adult world.

Circumcision is also a very vulnerable time for the father of the initiate: if the boy is young or timid, male relatives are likely to become obsessed with the question of whether he will flinch when cut, thus bringing dishonor and the inexpungable taint of cowardice upon the whole family. Everyone's nerves are frazzled and it is a volatile time when tempers explode (Spencer 1965, 103–105). After the operation, the father (proud, relieved, and, in some cases, in his own state of emotional semi-collapse) also puts on *urauri* and his wife's leather apron over his shoulder, the strand of green birth beads around his forehead, and strips of lion skin around his lower legs. The metaphors here are richly mixed: green beads = newness, birth; *urauri* and leather apron = femininity; lion skin = trophy of male courage (see plate 10).[5]

Samburu moran tend to be carelessly dismissive of lions, insisting that "lions are nothing to us, they are no more than large dogs." Yet despite these protestations and the accompanying warrior hubris, the lionskin leglets are crucial at both circumcision and marriage ceremonies and have to have come from a lion speared in very narrowly prescribed circumstances.

Circumcision at its core is an all-male ritual with mothers present only on the periphery even though they have produced nearly all the necessary ritual paraphernalia other than the circumcision knife itself: the *lolora,* or encampment of circumcision houses; the necessary leather skins; the bead ornaments; and the carved ritual containers. In a significant gesture toward this immanent female presence, both father and initiate decorate themselves in forms of women's ornaments or raiment in this rite of transition. Nowadays *urauri* have been largely appropriated by males for ritual use and are seldom seen on women, but in the precolonial period before glass trade beads became plentiful, Samburu women wore *urauri* in the tops of their ears and the heavier brass rings called *surutia* hanging from the earlobes or the crown of the head.[6] Furthermore, the drawn-wire *urauri* were made by women, the wives of *lkunono,* the blacksmith caste. *Urauri* have therefore retained their female associations in the minds of Samburu even though one rarely sees them worn today outside a male ritual context (whereas *surutia* continue to be worn daily by most married women).

The woman's leather apron, carried (with *urauri*) by the father at both son's circumcision and daughter's marriage, must remain somewhat more ambiguous in its gender interpretation. Cultural practice

has changed in response to the commodities that were introduced through trade—wool or synthetic blankets and cotton cloth. But as so frequently happens in Africa, women's clothing practice has changed more slowly than men's, with the result that while leather garments still are worn today among older Samburu women and are de rigueur for brides, men (whether warriors or elders) are no longer seen in anything but cloth. Therefore, when the woman's leather apron is displayed on a man's shoulder as ritual dress, it could either signify his temporary appropriation of the mother's (nurturer's) role or, more prosaically, it may simply be a solution to the problem of needing a traditional garment for ceremonial purposes that men no longer own but women do. But even if it is only "tradition" that is being invoked by men's use of *urauri* and leather, it is plainly tradition identified with women in the minds of Samburu participants.

At one level, Samburu boys' circumcision is a ritual enactment of birth in which a patriarchal order is substituted for the biological one.[7] But the real mother also matters. Her very peripherality, which in spatial metaphor represents both gender separation and the distancing from violence (the symbolic yet also real wounding of her child), allows the newly initiated male a temporarily protected status—he is still his mother's child and not yet a moran—that is still outside the requirements of warriorhood he must fulfill in a few weeks' time at the first *lmugit*. In this state of ritual androgyny, the youthful male initiate is suspended midway between the mother's protective female world and the father's more glamorous and frightening male one, signified by the lion skin.

An equally revealing practice in which he engages during this postcircumcision period, when he must still sleep in his mother's house and avoid contact with knives, spears, fighting, or dangerous activities, is the shooting of small iridescent birds using blunt resin-tipped arrows (the black resin having been acquired beforehand from a sought-after species of conifer on a ritual journey with other members of the circumcision group).[8] The dead birds are skinned and stuffed (all without benefit of a knife) and worn in a circlet around the back of his head (fig. 3.1).

This highly ritualized and aestheticized form of killing represents the need to frame and control aggressive behavior such as bloodletting during this period in a way that parallels the wearing of women's ornaments to frame and control his incipient warrior behavior and

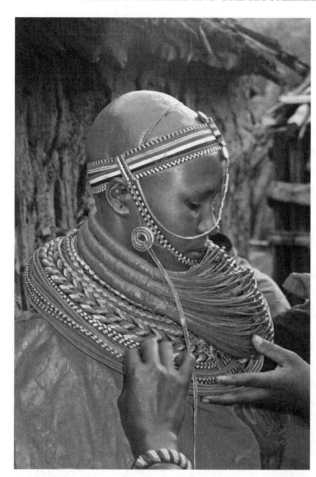

FIGURE 6.1.
Samburu bride
being dressed in
marriage necklace,
mporo, with *surutia*
and beads, ochre,
and goatskin,
Tinga, Kenya,
2004. *Photo by
author.*

sexuality. One might infer that the black resin, which is taken from
a certain conifer at a prescribed point in its productive cycle (Rainy
1996), signifies the initiates themselves, clad in their black leather
capes and about to enter a new stage in their own life cycle.

At the Lmugit of the Arrows, one lunar month after circumci-
sion, boys (*laibartak*) end their liminal status and are recognized
as fully male junior warriors. In the process they exchange their
blackened leather capes for the white cotton *shuka* and red ochre
of the new *lmurrani* (fig. 3.2) while returning the *urauri* and *nchipi*[9]
to their mothers, who wear the latter (and sometimes the circlet of
stuffed birds) on the day of the *lmugit* to mark their own new status as
mothers of warriors (see plate 11). (Some of these beads will later be
incorporated into a permanent white-and-blue bead pendant worn

by mothers of warriors, suspended from brass *surutia* earring loops.) While the *nchipi* is a strikingly beautiful ornament, it is the *urauri* and *surutia* that express the recurring theme of female identity at every major life-cycle transition. For most Samburu today, they are the only remaining copper-alloy ornaments regularly worn: brass armlets and leglets, once a central component of Samburu body decorations, have become obsolete, replaced by aluminum, which is much lighter weight, more comfortable, and cheaper.

Nowadays the moran do not wear women's ornaments again until they marry, when the bridegroom and his best man decorate their ears with pairs of *urauri* from the time they arrive at the bride's family settlement through the celebrations of the next day and the return journey to the bridegroom's *nkang*. Like the initiate's father following his circumcision, the bridegroom and best man also wear the strings of green beads along with lionskin leglets, which counterpose the association of *surutia* (brass) or *urauri* (copper) with femininity. Are these artifacts simply complementary opposites expressing male and female aspects of a pastoralist ideal, or is the bridegroom also adopting, through his decorations, the same protective stance toward the new bride as the father did toward his newly circumcised son? If so, this is an important statement about marriage and the parental role of the husband toward the new wife.

At the end of the marriage rituals, the earrings, beads, and lionskin leglets are shed and placed upon a grass-covered four-legged stool and anointed with milk, a ritual nourishment that is used to bless and neutralize conflict but that also connotes fertility. This ritual gesture seems both metaphor and metonym for the procreative role expected of the new couple.

But this is only part of a wider scenario. Is there any parallel to be drawn between these celebratory occasions when men wear women's ornaments with the old Samburu custom of a warrior wearing women's beads for a month after killing an enemy? It may be possible to see in this practice a symbolic exchange in which the intentional (but temporary) abandonment of his virility allows the warrior to shed the dangerous pollution caused by killing another person. This feminized warrior appears only in major states of transition that are always marked by the shedding of blood: he is the killer polluted by the enemy's life force that was destroyed by his spear, the initiate wounded by the knife of circumcision, the bridegroom taking

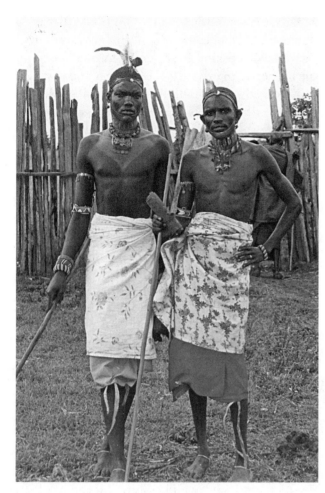

FIGURE 6.2.
Samburu
bridegroom and
best man wearing
ochre, lionskin
leglets, and
urauri, Tinga,
Kenya, 2004.
Photo by author.

the newly excised bride. In all of these situations, the use of female
raiment by initiated males seems to neutralize the dangerous state
caused by the shedding of blood.

Finally, and still maintaining the parallel, at death a man's corpse,
covered only in his wife's leather apron, was formerly taken to the
bush, where it was left to be eaten by wild animals.[10] Once more the
dangerous pollution caused by death was seemingly neutralized and
contained by the use of an artifact identified with women. But like
men's use of the women's apron at circumcision and marriage, this
too may date from the time men's leather cloaks fell into disuse.
People say that formerly old men, anticipating death, often had their
wives prepare a large sheepskin to be used as a burial shroud. If so,

the substitution of a woman's skin for what custom would dictate to be a man's skin might have been because of convenience rather than efficacy. But the fact that sheepskins are reserved for male use and goatskins for female use serves to mark the men's use of the women's goatskin apron as a gendered appropriation for ritual purposes, similar to the one that occurred after killing and mutilating an enemy.

FIGHTING AS A ZERO-SUM GAME

One of the revealing points about Samburu ideas of fighting, at least up to the 1920s, when the Lmerisho age-set passed out of moranhood, was the attitude that an enemy should not only be killed on the spot (as opposed to being taken prisoner) but physically and symbolically emasculated as well. Like the use of the throwing spear and lightweight shield, this practice located Samburu warfare within a northern Rift Valley pastoralist style of fighting. In particular, the Samburu's alliance with the Rendille, described by Chanler in 1896 and explored in more detail by Spencer (1973) as well as in recent historical (Sobania 1991) and anthropological studies (Fratkin 1991), provided much of the symbolic ballast for warrior fighting behavior.

Whereas the core Maasai farther south were organized into warrior *manyattas* as territorial units that could turn out a formidable fighting force, Samburu moran did not (and still do not) follow any residential pattern involving their concentration in large numbers except at major ceremonies (*lmugit*). They move, usually in pairs, between bush and settlements, nature and culture. Indeed it is hard to describe just where Samburu moran "live" because they are by choice and expectation nomadic and footloose.[11] In times of drought they are likely to be accompanying cattle to montane forest grazing sites, though nowadays if they are *lkunono* moran, they may also be far away selling spears for their blacksmith relatives. A few who are more affluent than the rest may be away in school, with the police, or in the army (Sperling 1987). But it has always been possible to mobilize contingents of senior moran and junior elders, men in their twenties, thirties, and forties, from the nearby settlements in response to raids by rival Turkana, Pokot, or Somali.

Their approach to fighting, which is now mainly hypothetical except during a period of heavy raiding by the Turkana in the late

1990s, would be described in modern idiom as a type of fight-and-flight guerrilla ambush more often than large organized forays into enemy territory.[12] This partly explains why early British administrators in the Northern Frontier District sometimes called the Samburu moran "cowards." Cowardice is a concept constructed upon the violation of a set of conventions about idealized (usually male) behavior in response to aggression or danger. There are major differences even within Western cultures: "kicking a man when he's down," for example, might seem cowardly to the British, but it would be a perfectly logical strategy to an Italian. Ambushing the enemy, taking no prisoners, and later mutilating the corpse went against British notions of fair play but certainly not those of the Samburu. In turn, the Samburu regarded the warring techniques of the Turkana (such as night fighting and following a defeated enemy for days) as "a very low-down game" (Stigand 1910, 86).

Spencer (1973, 51–52, 95–97) compares Samburu and Rendille warfare, arguing that the differences in ferocity between these two groups are predicated on a difference between cattle and camel pastoralism as subsistence strategies: cattle are far more easily reproducible, hence replaceable, and therefore need not be defended to the owner's death. The Rendille have gained a reputation for fierceness in fighting because, they said, a man who lost his camels in a raid might not ever be able to replace them (52). In a raid, all camels would be confined to the camp or settlement and a defensive ring of young males would form around it. Each would stand guard outside his own family gateway with a bull camel tethered between him and the entrance. He was expected to stand his ground or die trying (ibid.). Taking refuge behind the camel brought irredeemable shame, and such a person would be called a coward the rest of his life. "If he died, his body would be speared by other Rendille and his teeth smashed in with their kicks; if he lived, he would openly be scorned, made to carry out menial tasks, and others would use his loin-cloth to wipe their mouths after eating" (ibid.).

THE BODY AS A SITE OF RESPECT AND SHAME

Respect and shame are ideas with deep resonance for the Samburu moran as well. They are tied inextricably to bodily practice as it is constituted both socially (e.g., in dancing, eating, and fighting)

and ritually (in circumcision). The equating of public displays of cowardice with unspeakable shame is especially strong at circumcision ceremonies. Even the faintest sign of flinching (e.g., a slight change in facial expression or movement of the eyes) by the young initiate from the pain of the circumcisor's knife is a cause of lifelong censure and in the past gave others license to insult the family publicly and even to stampede their cattle through the thorn fence of the *lorora,* the ceremonial village (Spencer 1965, 103–104).[13]

On the other hand, the attitude of the Samburu moran toward defensive fighting was a great deal more pragmatic than that of the Rendille. They told Spencer that if they should be obviously outnumbered, it made more sense to escape with as many cattle as possible than to stand their ground. Instead, they preferred to set the conditions for their fighting in a surprise offensive attack or ambush (Spencer 1973, 95). Preparation for a raid began by consulting elders and possibly a *loiboni* (diviner), then recruiting other moran of the same section through dances at the settlements. On first sighting, the enemy the moran might call out his father's personal name (akin to calling out his bull's name at circumcision)[14] in an attempt to associate his actions with his father's honor. Here also, as in the circumcision ordeal, any sign of cowardice accrued not only to the warrior but to his family and its herd as well (Spencer 1973, 96; 1965, 106–107).

These actions have their counterparts in the colonial and postcolonial context. It is still shameful to acknowledge fear or pain, which is why the police in Maralal seldom bother to arrest Samburu moran in the hope of extracting through beatings the names of culprits in stock thefts. One refuses to talk as a point of honor. This is one source of the colonial epithet of "arrogance" often used to describe Maa-speakers.[15] The matter of honor also extends to refraining from behavior that will sully the group's reputation by placing them in the same category as non-Maa to whom they feel intrinsically superior. For example, when encamped outside their own territory, older moran put considerable pressure on younger ones to avoid unseemly behavior such as petty theft and fighting in view of outsiders.

HOMICIDE AS A FORM OF SEXUALIZED POWER

Another aspect of bodily practice concerns the actions associated with killing in warfare, which not only reward bravery and punish

cowardice, as the Rendille case so clearly attests, but also connect moranhood and ultimately the warrior body as metaphor for the properly constituted masculine social body, with a clearly sexualized notion of power as virility. Here it is difficult to pry apart Samburu from Rendille ideas, for as Spencer has made clear in his comparative study, the young men of both groups often went on raids together before the 1930s.

To summarize briefly from his account (Spencer 1973, 52), when Rendille had killed an enemy, they would slit open the right side of his stomach, castrate him, and leave the corpse with arms and legs bent together in a fetal position. If the context of fighting was defensive, the severed genitals then would be hung round the neck of the tethered bull camel (the symbolic surrogate for the victorious warrior) until they eventually rotted away. If it was an offensive raid, the enemy genitalia would be incorporated into the *miraat* observances instead.

Miraat, which Samburu moran adopted from the Rendille they accompanied on raids, is both a song sung after the killing and a series of ritualized actions carried out on returning home. For the Rendille, it involved the construction of a special shelter (*mingi miraat*) for the killers to sleep in where they also displayed the victims' genitals in view of members of their settlement (in identical fashion to the display of trophy heads in Idomaland) and allowed their hair to grow until the trophies were ritually cast away by a person from a designated clan. The killer here was in a state of ritual separation but also heightened virility, attested to by his trophy of the enemy's sexual organs and his own unshaven hair. I will pursue the question of hair in a subsequent section; here I wish only to establish that it was left unshaven—that is, in a virile state—in the ritual aftermath of killing.

Like the Rendille, the Samburu would slit the victim's stomach on the right side and lay him on that side with arms and legs bent (Spencer 1973, 96). Whether or not he also cut off the genitals and took them away with him depended on who he was with: if he was alone or with Rendille, he emasculated the victim and took the penis and testicles to prove later that he, and not someone else, had actually done the killing. If he was in the company of other Samburu, this supposedly was not necessary (97).[16]

Spencer does not discuss the significance of the right side and bent limbs other than to note elsewhere that this is the standard

mortuary position in the disposal (Samburu) or burial (Rendille) of male corpses (1973, 59, 107). But a Samburu male (assuming he is right-handed and in a traditional Samburu house) also sleeps with his weapons at his right side and his wife or girlfriend on his left. The left therefore becomes the side for sex and procreating, the right for fighting and death. After killing the victim, he would take his ornaments and then mark the right side of his own forehead and his right arm and leg with white clay (96), a practice Merker also recorded for the Maasai and Torrobo (1910, 253).

The next stage was roughly similar whether the victim was killed in a raid or in an individual case of personally motivated homicide. If a Samburu male deliberately killed another male outside the context of warfare, he entered a ritually dangerous state known as *loikop*, which, because it was of indigenous and not Rendille origin, also provided the model for the Samburu version of *miraat* (see Spencer 1973, 96, 109). After the killing, he remained in the bush alone for four days, wearing red beads and a woman's leather apron. The first step of purification was taken on the fifth day, when he sacrificed a sheep or goat, rubbed his body first with its chyme and then, after washing, with its fat. (Recall that dangerous iron objects are also rubbed with oil or fat to protect the user from the smith's contamination). Animal fat neutralizes pollution—it is also used as a poultice and to pack a severe wound. In this somewhat less dangerous state he could reenter his settlement, but he continued to avoid milk for the next several months until the period for retribution was thought to be past (109).[17]

"Having *miraat*" after killing the enemy in a raid, on the other hand, consisted initially of the returning warrior singing the Samburu version of the Rendille *miraat* song at every Samburu settlement he encountered on the way home. Women and girls would tuck grass into the top of his cloth (96), and when he reached home he would be decorated with girls' or women's beads around his neck.[18] He then entered a state of ritual separation during which he wore the beads (i.e., was ritually feminized), abstained from milk, and sang *miraat*. The temporary estrangement from his warrior identity was necessary because in his ritually contaminated state, fighting would be unpropitious. Abstention from milk could be interpreted a number of ways, but in a pastoralist ideology, it is the most fundamental, the most whole and purest substance associated with life and well-being

and therefore forms a symbolic opposition to death, particularly homicide.

At the end of a month, his reincorporation into the age-set (and by extension, society) was accomplished by the sacrifice of a he-goat as surrogate for his polluted self and the return of the beads and the reclaiming of a masculine identity. A part of the skin of the sacrificed goat would then be tied round the killer's wooden milk container, and only others who had killed in warfare would be allowed to drink from it. The overall similarity of *miraat* to the seven days of dancing in the Idoma headwinner's compound followed by the ritual drinking from the trophy head by other warriors is striking: the warrior-killer is celebrated but must also avoid the contamination of others with the blood of the enemy. The Samburu warrior's drinking of milk prior to his ritual purification and reincorporation would be symbolically equivalent to the mixing of milk with the blood of the victim; engaging in fighting would be equally unpropitious and was averted by the adoption of women's ornaments and becoming ritually female.[19]

Should the trophy be read as an extension of the warrior's virility? Is there any real difference between taking the head and taking the sexual organs? Earlier, I described the trophy head as a site of transformation but also as a locus of power in itself. In order to imbibe, absorb, or acquire the qualities it held, Idoma warriors drank from the skull, thus making evident its recognition as both metonymic and metaphoric container. Displaying it was also of major importance whether it hung from a tree in the meeting ground, as in Otobi, or was worn atop the head or carried while dancing.

But it is clear that despite the similar way they were displayed, Samburu and Rendille did not regard enemy genitalia in the same way as the Idoma and other Benue–Cross River cultures understood trophy heads. Like trophy heads, they were evidence presented to the public of fearlessness and success as fighters, powerful counters to any hint of cowardice in a male's reputation. But their symbolic associations were with masculinity and most explicitly with sexual virility rather than with the ideas of personhood, character, and supernatural agency associated with a person's head in Idoma society. It is as if depriving the enemy of his sexuality would further augment the virility and the reputation of the moran. What this suggests is that the idea of sexual virility, which elders usually represented (and British administrators interpreted) as proof of the moran's irresponsible

youthful behavior or wrong priorities, was nonetheless very basic to a Samburu ideal of warrior comportment.

An inevitable question is how to understand the practice of emasculation in a culture where circumcision is by all accounts the most important male ritual. And when the circumcised warrior did the emasculating? Was the mutilation of the enemy corpse in some way a reenactment of the symbolic wounds inflicted on the boy about to become a warrior? Both involve cutting of the genitals and subsequent bleeding (and in the Samburu cultural script, both therefore occur in the shadow of the blacksmith's knife and his dangerous pollution). One is a symbolic wound intended to transform boys into men, the other a symbolic theft to demasculinize the male enemy. One bestows virility, the other destroys it utterly in the victim but heightens it for the killer. Both are inflicted by knives and sanctioned by culture. If we accept that circumcision is a form of bodily transformation required in the taking on of new identity, it is difficult to avoid the conclusion that it is, in the process, the symbolic killing of the child. But a major difference between this and spear-blooding is that in circumcision, the beneficiary and victim are one and the same.

BLOOD AND THE SEXUALIZED WEAPON

Furthermore, the act of emasculation and the details of how it was carried out relate to two additional spheres of signification: blood and the spear. When Samburu warriors took the penis and testicles after killing an enemy, they carried them on the spear blade. In one version, they would be shown to comrades (and undoubtedly to girls they wanted to impress) as proof of one's prowess but were not kept for prolonged display, as in Rendille custom; in Spencer's version (1973, 97) they were actually hidden (at least from Rendille who might take them) and not displayed at all. Not only are the testicles the seat of virility, which when taken from the enemy in this zero-sum game is added to one's own potency, the penis is also the weapon for thrusting, the metaphoric spear, and the link between sexuality and violence, thus between fighting and sexual prowess, between killing enemies and seducing women. The Samburu term for warrior, lmurrani, is a reference to the male organ, literally, "one who is circumcised." Conversely, warriors half-jokingly refer to the penis as "my spear."

The English phrase "spear-blooding," a staple of early colonial district reports, is also apt: the blood of warfare is both potent and

dangerous. The spear carrying the enemy's severed genitals is liter-
ally a sexualized weapon and at the same time an extension of the
warrior's ritual body. In this sense, the spear is both the ultimate sym-
bolic expression of manhood and the Samburu artifact most heav-
ily imbued with meaning. This richly complex spear symbolism is a
well-known aspect of Nilotic pastoralist ideology and is certainly not
unique to the Samburu. As Evans-Pritchard said of the fighting-spear
given to a young Nuer by his father at initiation,

> It is not the acquisition of a weapon, whatever its economic
> value may have been in the past, nor even its utility, great
> though that may be, that gives a crucial significance to the gift
> of a spear at initiation. Its significance is moral, not merely
> utilitarian. It is not the spear itself . . . which is stressed but
> the activities associated with it: war and raiding, dancing and
> display, and herding. . . . The spear is not just a weapon but
> also something which stands for a very complex set of social
> relations. . . . It is a projection of the self and stands for the
> self. (1956, 239)

Among Samburu weapons, it is not just the spear that is explicitly
sexualized: the *rungu* (*lringa*), or throwing club, is often carved in the
shape of a circumcised penis and is closely identified with the warrior
himself. It is a more intimate weapon than the spear; it is used in face-
to-face encounters, especially with other Samburu of rival sections,
or thrown at a short distance. Each of the moran's weapons—spear,
sword, *rungu*—is associated with his body and bodily praxis. This
praxis derives from both sexual activity and fighting, which are seen
as complementary and equally dependent on a warrior's virility.

Like the Idoma trophy head, trophy genitalia became a part,
however transient, of the system of objects that reflect and support
the ritualization of Samburu warriorhood. Unlike the trophy head,
however, they were not preserved but were soon cast away, reflecting
not only practical considerations but a much greater ambivalence
as to their value. In part at least, this had to do with the genitals
being seen as a source of bodily pollution, especially those of their
frequent enemies, the uncircumcised Turkana. The uncircumcised
male organ is considered by moran to be not only unclean but an
object of ridicule (and responsible for much of the scorn that moran
heap upon uncircumcised boys). Whether circumcised or not, the
organs of the enemy were unclean because they were located outside

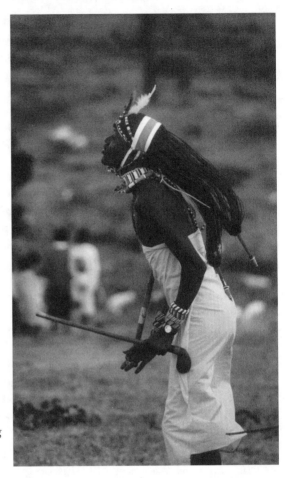

FIGURE 6.3. Samburu
warrior jumping during
wedding dance, carrying
rungu, Maralal, Kenya,
1999. *Photo by author.*

the Samburu domain of culture. They were potent trophies but also
objects of revulsion to be distanced from and avoided.

THE SHEDDING OF BLOOD

Leach equated sexuality and violence in the context of head-
hunting: here one can extend the same point to Samburu rituals of
warfare. In both the headwinners' dances and spear-blooding, female
approbation and concurrently the recognition of manhood socially
validates the taking of an enemy life. One possible way of exploring
these connections among women and warriors and victims is in rela-
tion to their symbolic potential, another is with regard to actual prac-

tice. That of practice, the behavior of a group of warriors in relation to their elders, rivals, and girlfriends as well as white settlers and the colonial government, has been described and historicized in detail for the Powys case.

Since ideas about blood are heavily marked by gender, I begin with some rules of Samburu cultural practice, first in relation to female bleeding. There are two types, the blood of excision and the blood of menstruation. Ideally, the unexcised girlfriends of younger moran are premenstrual in order to avoid the dangerous form of pollution that occurs when an unexcised girl becomes pregnant. Again ideally, a girl is sexually free until she begins to menstruate,[20] after which her excision and marriage will occur as soon as possible, followed by pregnancy and childbearing (see plate 12).

Excision and marriage were until recently completed on succeeding days and were essentially two parts of a single ritual sequence, despite the physical discomfort this typically engenders, for although she is not expected to be sexually active until her surgery has healed, the girl must nonetheless walk on the ritual trek from her father's to her new husband's settlement, which may be far. One therefore has to ask at least two questions: Why is it so inauspicious for an unexcised girl to become pregnant and why is there ideally no hiatus between excision and marriage?

In the culturally prescribed sequence, a Samburu female moves from the social status of girlhood to womanhood through marriage. The marriage ritual is preceded by the surgical excision of the clitoris by a mature Samburu woman well known to the family and is typically undertaken when menarche signals her physical maturation.[21] If her older brothers have been circumcised and a suitor is in the offing, her father then negotiates her marriage in consultation with other males of his lineage.[22] Pregnancy prior to excision may be inauspicious because it disrupts the parallel process whereby menstruation accompanies her change of state from girlhood to adulthood.

More obviously though, it blurs the social boundary that Samburu carefully maintain between erotic pleasure and procreative sex, which marriage marks. Conjoining excision with marriage in a single cluster of ritual events conforms to a clearly bounded idea of girlhood and womanhood in which one is either an unexcised (not fully socialized) child or an excised (socialized) married woman. It avoids any period of liminality, hence danger, in which the initiate/bride is neither

girl nor fully woman. This stands in contrast to both the protracted initiation into full moranhood and the now somewhat negotiable personal boundary between moranhood and elderhood that all males experience.[23]

To an outsider, the sharp distinction the Samburu draw between premarital sex (which is accepted as natural and inevitable) and premarital pregnancy (which is highly inauspicious) seems counterintuitive at first. In the past it placed clear limits on the sexual role of the unmarried warrior by forbidding him to father children, which was the prerogative of the married elder.[24] Furthermore, it emphasizes the importance, in Samburu thinking, of the distinction between youthful romantic attachment, a condition encouraged between warriors and their girlfriends, and childbearing, which belongs in the sphere of marriage.

This is not just a way of equating romantic feelings with immaturity and defining womanhood through the bearing of children. In a situation of patriarchy, for which Samburu culture provided a nearly flawless model, it can be explained as a strategy by which elders control women's reproduction in such a way that they alone are the "owners" of children (see Llewelyn-Davies 1981). Furthermore, the Samburu up to a generation ago maintained that, rules of exogamy aside, lovers were unlikely to succeed in marriage because while girls and warriors were bound together through feelings of mutual equality, the wife in a successful marriage must be obedient and be willing to place herself under her husband's authority in the same way that she lived under her father's authority before marriage (Spencer 1965, 216).

The answer to the question of why excision and marriage were performed with no interval between them is usually a practical one. There are actually two requirements for any marriage to take place: first, the girl must be excised and therefore in a state of ritual readiness, then the husband-to-be must sacrifice an ox inside her parents' *nkang*. People say that if there was an interval, a rival such as a boyfriend moran might be able to infiltrate the settlement and kill his ox before the husband her father had chosen had a chance to kill his and she would have to marry him instead (see Spencer 1965, 44–45). With many more girls going to school and deferring marriage, a space that was formerly closed has opened up and arranged marriages are no longer universal.

Because of the skewing effect of the male age-grade system, the stages of a female's life trajectory are not synchronous with those that represent the movement from boyhood to manhood. While boys become warriors following their circumcision, their long period of sexual freedom occurs after, not before, this initiation. For girls, on the other hand, the sequence of menarche—excision—marriage marks the *end* of this brief freedom.

Despite this inequality, warriors are constrained in their actual behavior by the belief that too-frequent intercourse saps the physical strength of the moran, which is regenerated only by a return to life in the bush or cattle camps with other males and far from women. If he continues to exhibit signs of malaise, he will treat his condition with the ingestion of potent wild medicines. Furthermore, although girls frequently enter the bush while herding sheep and goats or collecting firewood, those who are menstruating are kept strictly away from the deep wells from which Samburu moran extract water for their animals during the dry season for fear that they will dry up due to contagion. Menstruating females of all ages are forbidden contact with the blacksmith's tools; in the past this extended to contact with the iron-smelting furnace as well.

The warrior in his role as fighter is therefore ideally paired with the prepubescent girl and the excised menstruating woman with the mature male who has left warriorhood. In the reality that often intervenes between these two extremes, warriors do of course enter into relationships of mutual attraction with older unmarried girls whether they are excised or not and simply learn to avoid their menses and, to the extent possible, their periods of ovulation.[25]

OCHRE: READING REDNESS

Even more fundamental to the ritualized body than its ornaments and raiment is the wearing of ochre, the reddish pigment mixed with fat to form a body cosmetic (*njasula*) that is spread over the hair, face, neck, and chest of Samburu warriors. The use of ochre as a colorant is widespread and ancient: cave floors of the Aurignacian period in Europe (32,000 to 40,000 years ago) are often covered with it to a depth of several inches, suggesting that it was used as a ubiquitous dye for bodies, animal skins, weapons, and dwellings. So common is its later occurrence in the Upper Paleolithic that graves and entire

caves were painted with ochre, causing inevitable speculations about its symbolic associations with blood, fertility, menstruation, and so forth (Knight 1991, 436–439). These have been elaborated most fully by the paleontologist Ernst Wreschner (1980, 632) who returns to the Ndembu and Victor Turner (1967, 172) to draw twentieth-century Central African parallels between ochre, blood, and "the mother," citing the belief that ores grow in the earth "like an embryo in the womb."

A set of counterproposals by other paleontologists argues that in the primordial past ochre was mainly medicinal and only second-arily used in ritual (Knight 1991, 438). I begin with these theories not to lend support to the dubious scholarly practice of using con-temporary ethnographies of "tribal" people to explain prehistoric societies, as if the Ndembu or Samburu were only a heartbeat away from Paleolithic cave dwellers, but to locate the use of ochre by the Samburu in a much broader spatial and deeper historical pattern. Like blood, ochre is essentially red, though it varies in chromatic value with its chemical content, and the term is used to describe "a wide variety of ferruginised shales or sandstones, haematitic or limonic concretions and pastes made from sesquioxide-rich clayey or sandy soils" (Knight 1991, 439). Nonetheless the idea is firmly embedded in ethnographic inscriptions that ochre, because of its color, is a symbolic equivalent for blood and blood's potency. And finally, the same structural anthropology that has plumbed the sig-nificance of blood has located ochre within a color triad of earth substances: red/ochre, white/clay, black/carbon (e.g., Jacobson-Widding 1979). I will try to examine how these ideas might be rel-evant to the Samburu and, more specifically, how they relate to the ritualized body of the moran.

Samburu elders say that in former times, they obtained ochre from Torrobo groups in the Aberdare Mountains and mixed it with fat from the cow. Contemporary moran are more likely to buy the powder in Maralal, Wamba, or Baragoi markets from Turkana women selling medicines (or perhaps Arab or Indian traders in Nairobi or Mombasa) and mix it with Kimbo, a commercially manufactured vegetable fat. But the visual effect is the same. It is worn not only by warriors but by younger girls who are their partners, which pro-vides important clues to its significance. In certain ceremonies, such as weddings, nearly all the participants, both genders and all ages,

adorn themselves with ochre, but I focus here on the most intensive use by warriors.

In the most general terms, red is a transitory color state that is intermediate between white and black. As such, Michael Rainy argues, it is worn to indicate a person who is still being educated in pastoral values (Rainy 1989, 803), a person in transition—hence both warriors and unmarried girls. This essentially social reading of the significance of red for the Samburu, and, by extension, their unwavering attachment to red ochre, red beads, and red cloth, both complements and derives from the more conventional symbolic association of ochre with blood. In that formulation, red ochre signifies the blood of circumcision in males—Luc de Heusch's "wounded warrior"—or refers to menstrual blood in females (see fig. 3.2 and plate 12).

Despite the structural elegance of symbolic anthropology, it reflects an everyday reality that is both less elegant and less clearly structured: the blood interpretation for wearing ochre fits in the case of Samburu warriors for all of the reasons discussed in the earlier part of the chapter, but there is a problem in applying it to girls because some of the morans' sexual partners are still premenstrual. They therefore do not fit the paradigm paleontologists or Turner invoke for the Ndembu: there are in fact no embryos yet growing in their wombs, so they can not readily be identified with the symbolism of an archetypal womb/tomb/cave.

Yet there are numerous enough ritual occasions when ochre is applied that it requires us to examine the idea that ochre is conceptually identifiable with blood in Samburu thinking. It is worn by warriors when another of their hair-sharing group dies; at the Lmugit of the Arrows when the recently circumcised boys become moran; at marriage rituals by both bride and bridegroom.[26] All of these involve blood symbolism (associated with death, rebirth, or fertility, respectively). Nonetheless, each of these occasions is also a significant social transformation in Samburu life, making Rainy's explanation equally plausible. In this primarily social reading, beginning in prepubescence, girls start to form romantic relationships with warriors and receive red neckbeads from them as gifts.

Rainy suggests that red ochre works as a code to signal the onlooker that the painted young female is not yet an excised married woman, even though she may be the same age and stage of physical development as someone who is. A warrior must address his young

mistress and any girls of ochred status as *nkerai ai,* "my child," but if he meets a female of the same biological age who is married to a man not of his age-set, he must address her respectfully as *yeiyo,* "mother," and she must reply *nkerai ai,* "my child." Among other things, this confirms that ochre is an important element in boundary maintenance (Rainy 1989, 804).

There is another aspect to the wearing of ochre that is almost too obvious to mention: its aesthetic, sensory appeal, which figures prominently in Samburu explanations of why it is worn. As in Western aesthetic systems, the color red itself, apart from how it is deployed, is perceived as boldly attractive, drawing the attention of the eye almost involuntarily. Moran spend a considerable amount of their time applying body ochre[27] and facial designs (which are applied with a different pigment, usually a lighter-colored orange)[28] and braiding each other's hair. They are very direct and forthcoming about the effects of using the body as a canvas; their avowed intention is to make themselves as handsome as possible to attract sexual attention from females and thereby accrue prestige among their fellow warriors. No less than *miraat* or circumcision, this is an aspect of warrior theatre.

For Samburu, redness therefore plays into three different conceptual domains: the purely social (enculturation to the values of pastoralism), the hidden and symbolic (wounds of circumcision), and the transparently sensual (attracting the opposite sex). Each of these in turn reinforces the other two in a kind of escalating effect, yet there is also a fourth meaning. Ochre is used medicinally by the Samburu, particularly in the treatment of head lice and scalp infections in children. It is unproductive to see these as competing or exclusive explanations of why ochre is used. They are all true, but in specific yet overlapping contexts.

Finally, it is productive to integrate the use of ochre into the black-white-red symbolic domain as it applies to the ritualized body. Because the Samburu divide themselves into two moieties for ceremonial purposes and refer to one as Ngishu Narok (Black Cattle) and the other as Ngishu Naibor (White Cattle), it is clear that black and white, when used in a ritual context, have meanings that are self-referential. In the case of the moran, the use of red ochre completes a black-white-red triad that is driven by both symbolism and aesthetics. The combination of black skin, white ivory earplugs, and red ochre/red cloth/red beads not only dazzles the eye, it suggests

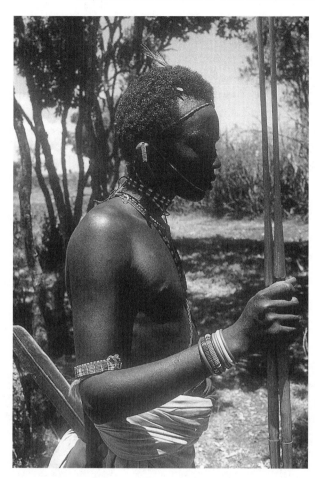

FIGURE 6.4.
Samburu moran
with short ochred
hair, twin spears,
and sword, near
Naibor Keju,
Kenya, 1987.
Photo by author.

the warrior's identification with the bush (the source of ivory and ochre) rather than the settlement and places him at the center of a system of signification that is mapped onto the ritualized body.[29]

HAIR AND WARRIORHOOD:
EFFACING THE BOUNDARIES OF THE RITUAL BODY

Genital cutting and bleeding (the nonviolent woundings of circumcision and excision, the violent ones of emasculation), the removal of incisors, scarification, allowing the hair to grow long, and shaving the head and body are each Samburu practices that modify the body's surface in some way. These intentional effacements or enhancements of the contours and boundaries of the body are an

important part of the Samburu logic of ritual transformation and are grounded in the larger logic of everyday custom that Bourdieu, following Mauss, labels habitus (1980/1990, 52–53). Their communicative value rests in their ability to be read by other initiated members of Samburu society. As with the wearing of ochre, the codes for male and female are different yet related, so it rewards us to look beyond warriors. The other caveat is that hair practices, in particular, need to be seen as symbols within a larger set (see Obeyesekere 1981, 45): in this case, the hair symbolism "set" includes both the use of ochre and cutting of the body since the former heightens the effects and the latter establishes the periodicity of hair-shaving and growth. Hair, or its absence, is also part of another set constructed out of formal preferences. In this parallel configuration, hair aesthetics are interwoven with the aesthetics of beads and ochre as an arrangement of color, texture, and shape and not just as a set of symbols.

In his classic essay on "magical hair," Leach (1958, 148) compared two kinds of explanations for cultural attitudes toward hair, the psychoanalytic and the anthropological. The first laid stress on the unconscious and on the assumption that the strictures that society imposes on social behavior cause certain feelings to be repressed (e.g., in the socialization of the child). These repressed feelings then emerge in various kinds of symbolic behavior such as circumcision or growing and cutting the hair. Furthermore, the psychoanalytic explanation assumed these feelings, though manifested by individuals, to be universal and not driven by culture.

The second or anthropological explanation, on the other hand, is much more likely to see the treatment of the hair as a collective, culturally specified practice that often has ritual significance. Ritual in this context is understood to mean a public enactment that changes the social state of the performer—most commonly, a rite of passage (157). In structuralist or functionalist discourse, this change typically was characterized as moving from a "sacred" to a "profane" state or vice versa. In the normative categories from which such states are conceptualized, "sacred" is equated with abnormal, special, marked, otherworldly, prohibited, "sick," polluted, or dangerous, while "profane" denotes normal, everyday, unmarked, of this world, permitted, "healthy," or safe.

The shaving of the head in a ritual of transformation such as circumcision (and where the everyday practice is *not* being shaven),

would be interpreted in a structural reading as a symbol of the body's transition from a profane (everyday) to a sacred (marked) state. In a less dualistic interpretation, it signifies movement up a ladder to a more advanced stage of social maturation (e.g., in Kratz's description of Okiek female excision ceremonies; 1994, 109–110, 124, 142 and photo essay). But in Freudian psychoanalytic explanation, both the head-shaving and the excision or circumcision are forms of symbolic castration. For example, in Obeyesekere's analysis of the religious significance of hair among Indian priests and adepts, the shaven head is interpreted as a psychogenetic symbol (1981, 45) drawn from dreams and the unconscious. But in the resulting interpretation, in which Obeyesekere combines both psychoanalytic and anthropological insights, it no longer has any unconscious personal meaning. Along with Leach, he maintains that any symbol originating in the remote past eventually comes to have "interpersonal, intercommunicative value" but may no longer mean anything personally (46).

To a Western spectator, Samburu hair practice would seem in direct opposition to familiar principles: girls and women in their everyday state have shaved heads, while warriors in their everyday state grow their hair as long as possible (for up to fourteen years) and arrange it in elaborate ochred styles requiring up to eighteen hours of preparation. Nor does this in any way correspond to "generic" East African hair practice. Leaving aside urban elites who have their own subcultures of hairstyles, most nonpastoralist Kenyan women and men keep their hair short and unelaborated.[30] Nonpastoralist women also wear headscarves and their hair is effectively invisible most of the time.

Samburu and Maasai practice differs even from that of many other pastoralists: the Rendille, Pokot, and Turkana women with whom Samburu have the most contact have distinctive and readily recognizable styles that involve both shaving and braiding sections of the hair. Therefore, the fully shaven female head as an everyday custom separate from ritual transitions is a regionally atypical practice. Cole (1979, 95) has given this an essentially aesthetic reading, the small, smooth head silhouette contrasting with the massive bead accumulations around the neck—an explanation the Samburu themselves also voiced to me. The aesthetic argument is compelling on its own terms, but the shaven head can also be understood as part of a larger symbolic set of hair practices.

Boys about to be circumcised wear their hair shaved except for a cap of curls at the crown. At circumcision the head is shaved clean, as it is again for the first *lmugit* a month later when the formal transition to moranhood occurs. After the *lmugit* ox sacrifices have taken place and the meat consumed, the mother of each initiate shaves her son's head, mixing the hair with milk in the cavity of a four-legged stool. Later it will be hidden under a skin used for sleeping in the mother's house.

If this shaven hair is read as powerful, hence dangerous (a reading consistent with other Samburu hair practices), its immersion in milk can be understood as a way of neutralizing and containing that danger. Alternately, it may be read psychoanalytically as a gesture of reincorporation of the last remnants of boyhood (the discarded hair) into the domain of the mother (represented by the milk and the bed skin) or even as an act of extending the mystical protection of milk, the ultimate life-giving substance, over the new warrior.

All of these have salience as explanations: the last closely parallels another African example, the Yoruba treatment of Dada, the believed-to-be-magical hair of children born with a full head of growth (Houlberg 1979, 375–378).Their eventual head-shaving, which is carried out by a priestess of Yemoja or a Dada priest, is said to incorporate the sacred child into the profane world of the living and also into the cult of Dada. The hair is saved and is mixed with river water to form a sacred medicine that ensures the well-being of the child. In both Samburu and Yoruba cases, sacred water (the "milk" of Yemoja) or milk from the cow (God's gift to Maa-speakers) is used to effect an alchemy of transformation of dangerous hair to a substance with either a neutral or positive valence.

For warriors, there are at present three major hair treatments, each subject to embellishments or modifications. These are virtually identical to the styles Cole saw in the late 1970s (Cole 1979, 90–93) in Wamba and Barsaloi, and all three are also illustrated in Spencer (1965, plate II) at an Lmugit of the Bull ceremony in the late 1950s. The first, which is the easiest to care for and requires only a few months to grow, is a curly cap style that is slightly fuller than "normal" (nonpastoralist Kenyan) men's or boys' hair. It is ochred all over to a dark burnt-orange shade and embellished with one or two isolated feathers strategically inserted at the front or in a ridge over the crown (see fig. 6.4).

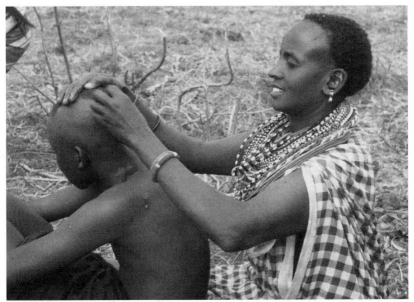

FIGURE 6.5. Shaving the head of a Samburu initiate before Lmugit of the Arrows, near Maralal, 1992. *Photo by author.*

In recent years, the natural feathers have sometimes been replaced by inventive white plastic ornaments that can be cut from yogurt or cooking-fat containers. These embellishments are inspired by the profusion of manufactured plastic items, from flowers to beads, that African markets provide. Plastic roses, which are sold in the larger towns in Kenya, are paired with feathers by the Lkurorro and Lmooli age-sets, both of whom have traveled extensively outside Samburu District. This short style is worn by both younger warriors and older ones who are in the process of regrowing their hair after a ritual shaving (for example, after the death of another warrior). It is also adopted by those who can't be bothered with the complicated upkeep of longer hair (an option that in the past would have had greater negative ramifications for their personal prestige than it does now).

The second and third styles are much more elaborate and therefore have become the stuff of postcard and coffee-table-book images of the paradigmatic moran.[31] Both involve very time-consuming braiding, a willingness to sleep on a wooden neckrest, and substantially longer hair. The visor style, in which the hair is parted from ear to ear, requires that the shorter front hair be minutely twisted in parallel

segments and these be pulled forward and plastered onto a visor (formerly leather but nowadays made from the same recycled plastic that is used to cut out feather shapes). The remaining hair is then also divided into tiny twisted strands and, depending on its length, pulled together into a few (if longer) or many (if shorter) bundles (see Spencer 1965, plate I, for a very short version). If long enough, it is allowed to hang free down the back; nowadays, it can be swept up fashionably with a clip. Rendille also wear this visor style, and it is a contested issue whether they adopted it from their Samburu cohorts or vice versa. The visor is not a style worn by the core Maasai groups further south, which differentiates it from the third hairstyle. All of the hair is ochred, both for the reasons already discussed and, as a practical matter, to stabilize and control an otherwise unmanageable mass.

The third style is a version of one first documented among the Samburu, Maasai, and Nandi in the early exploration literature that was still common among Maasai into the 1980s. It also begins with an ear-to-ear part and minute braiding of the shorter front hair. As in the visor style, the numerous small strands are pulled forward, but in this version, they are gathered at a point in the center of the forehead and held by a white button (formerly a shell obtained through the coastal trade) and bead strand. The long thin braided strands from the back and crown are either gathered into a single cluster and bound at the bottom in the shape of one large braid or are allowed to swing free like a curtain. This latter is currently the most popular look moran strive for, though it requires several years, persistence, and a huge amount of inconvenience to achieve.[32] As I will show, it is part of a complex of hair behavior that requires that it be seen in social situations in order to fully understand its significance.

Whatever its visual and theatrical potential, the cultural meaning of hair-growing by the Samburu is totally different from the meaning for the Indian religious disciples Obeyesekere described, and it does not resemble the uncombed matted locks of Mami Wata or other African spirit discipleship (Jell-Bahlsen 1993) or, closer to home in Kenya, the dreadlocks of oathed Mau Mau resistance fighters of the 1950s or today's urban youth gangs, or "Gikuyu Rastas," which have resurrected the Mau Mau practice filtered through contemporary reggae culture.

All of these require a relinquishing of control over the hair's natural tendencies that is very different from the care and elaboration

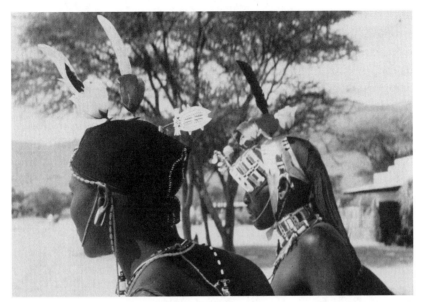

FIGURE 6.6. Two *lmurran* of Lmooli age-set with current visor-style hair treatment (left) with feathers and plastic flowers, Wamba, Kenya, 2004. *Photo by author.*

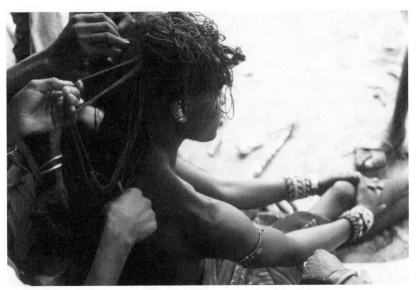

FIGURE 6.7. Tangas having his hair dressed by friends, Swahili Coast north of Mombasa, Kenya, 1999. *Photo by author.*

tendered by *lmurran*. But what Obeyesekere calls the psychogenetic content may be similar: if the shaven head of the Buddhist priest is an unconscious symbol that Obeyesekere translates as chastity, we find its counterpart in the propriety of the shaven head among married Samburu women. The long braided hair of the warrior is the opposite. Rather than chastity or self-contained sexuality, the aesthetic system at work projects a very strident but tightly controlled notion of young male sexuality. This control, which is expressed in elaborately braided and ochred hair (turning inchoate adolescent virility into a thing of "culture" and Samburuness), is what clearly distinguishes the moran from, say, the Indian or African religious disciple with uncombed matted locks and supports instead the characterization of restrained sexual energy.

Hair in turn forms part of a larger Samburu cultural script in which warriors are certainly the star players. The hair is clearly an important focal point for the accumulation of meaning, revealing two aspects of warriorhood that are held in counterbalance: on the one hand, exuberant ochred spear-wielding virility, and on the other, the controlled restraint that is seen as a mark of maturation of the warrior (beginning with the refusal to acknowledge pain or any other emotion during the circumcision ceremony).

Several observations might help support this view historically. First, warriorhood epitomizes the Samburu ideal of manliness and virility. Prior to the mid-1930s and sporadically since then, this was activated through stock-raiding, spear-blooding, and sexual liaisons with adolescent girls and young married women. Spear-blooding gradually ceased under British and later independent Kenyan administrative control and stock-raiding changed from being a regular seasonal practice undertaken to exert spatial hegemony and augment herds to a more occasional ad hoc strategy for settling affrays caused by unwanted incursions into pasturage or water points, but sex is no less in evidence, and therefore notions of virility have come to cluster even more around the sexual, as fighting becomes less about sport and, with the introduction of guns, more dangerous.

Second, Samburu *lmurran*, like a number of other male pastoralists and agropastoralists in Eastern Africa, continue to display these elaborate head-dressings as a matter of everyday routine. This is not just "ritual dress" and therefore subject to special rules; it is the way moran aspire to represent themselves every day over an extended period of many years. The implications of that are important: it

becomes considerably less persuasive to describe something that is a matter of routine self-representation as a "rite of transition." Since the long period of warriorhood has several distinct *lmugit* ceremonies that subdivide it and that themselves are rites of transition, it would make more sense to see warriorhood as the canvas on which those transitions are painted. On that canvas sexuality is nowadays the architectonic around which everything else is composed.

Third, a definite cultural style is associated with the theme of hair and virility. The best place to observe this is at dances, where moran gather to meet and, they hope, impress girls of the same section. For both, flirtatiously suggestive behavior is articulated not only with body movement and song lyrics but with the help of ochre, beads, and, for the warriors, hair.

At a dance, a girl may flick her ochred neckbeads at a warrior by raising her chin, arching her back and thrusting her chest and breasts forward and shoulders back rhythmically. This movement (especially exposing her throat, which is normally buried in neckbeads) is taken as a sexual challenge, to which a warrior may respond in various ways: one is by tossing his long hair forward to brush the face of the girl opposite (Spencer 1985, 149). The gesture can carry overtones of invitation, challenge, or sexual domination. In all of these gestures, the connection between long hair and virility is explicit: for example, in the bound variant of the longest hairstyle (*suroro or sieror*), the binding terminates in a wooden clasp carved in the shape of a circumcised penis (see Cole 1979, plate 2).[33] Cole describes a dance movement he witnessed in which the moran tossed his pigtail forward so that this clasp touched the girl facing him (92), an gesture with an obvious erotic parallel (see plate 13).

There can also be "hair death" (Spencer 1973, 115–116). If one warrior dies, the others in his hair-sharing group (*kong'ar lpapit*) must also shave their heads. This is done not only to remove the ritual pollution of his death but because their own hair is also, through metonymic association, now dead. Like smith's charcoal, the taint of untimely or violent death is conceptualized as a kind of virus spreading its ritual contagion, but unlike the charcoal, it spreads not by physical proximity but genetically, since the hair-sharing group consists of a number (up to sixty) of age-mates who define themselves as having a common lineage ancestry (Spencer 1965, 74).

The spatial location where this hair-shaving occurs also matters. Just as a moran should die in the bush and not inside a settlement—an

indication of his strong association with the wild, danger, bravery, and his outsider status (however heroic) in Samburu domestic spaces—the other moran of his hair group must shave their hair in the bush and cast it away while still there. In Spencer's interpretation, this is because it is already "dead" and to continue to wear it might bring misfortune to the wearer (1973, 116). It might also be seen as an enactment of ritual solidarity with the dead age-mate—their own metaphorical death. Finally, there is the paradox that since this "shared" hair is already dead, it is not susceptible to sorcery, while normal hair, when cut, is mystically vulnerable and therefore is either hidden or dispersed in a flowing stream of water rather than simply abandoned in the bush where some ill-disposed person might find it (ibid.).

The norm, however, is for a male's hair to grow from the first *lmugit* throughout his fourteen or so years as a moran, cutting it off only after he has married, been blessed by the elders, and settled into his new role as a junior elder. It would be thought immature of him to continue to wear long hair after the opening of the new warrior age-set, even though he and the other senior moran do not completely leave behind their warrior status until the new age-set become senior moran at the Lmugit of the Name, about five years after their initiation. During this first five years, a new age-set includes both senior moran of the previous age-set and juniors of the new one—a practical necessity in the past when warriors were required to raid. It creates a blurred boundary around senior moran identity, since, unlike what happens in core Maasai groups, there is no single ceremony or point in time at which all members of the age-set move from moranhood to elderhood.

Today this transition is even more indistinct than in the past, since moran now tend to marry at a younger age and it is difficult to fully maintain the warrior lifestyle and have a wife with whom one spends little time and in front of whom one is not allowed to eat. When I came to Lorroki in February 1991, many circumcisions had taken place in the previous August and again (for schoolboys) in December. In those first months of fieldwork in 1991, I came to know several Lkurorro, the outgoing warrior age-set, who still wore long hair and ivory earplugs, another important signifier of warrior status, despite the fact that they were already married by then and were sometimes fathers of young children.

But by my 1992 visit, all of my Lkurorro acquaintances had cut their hair and had left off their ochre and ivory and most of their

bead decorations. Some had even abandoned their spears for herd-
ing sticks (though in fact spears are a lifelong necessity, so they are
kept at home to be used when needed). Both junior and senior elders
wear their hair short like other Kenyan men, a further step in putting
aside the seductiveness of warriorhood and the socially irresponsible
behavior that comes with it.

While marriage requires a shaven head for women, it requires of
men only a token of hair from the temple to mix with the bride's hair.
In this act, the bride is transferred from her father's to her husband's
family and will in future shave her head if her husband dies (Spencer
1965, 243). However, older Samburu women are the main ones who
make an effort to keep their heads fully shaved nowadays. Younger
women sometimes observe this meticulousness as well, but most of
those I know tend to wear their hair very short, somewhat shorter
than most men, rather than constantly shaved. It is stylishly trimmed
at the edges with geometric precision in order not to overlap the
beaded headband that all women wear when fully attired. About once
a month, it is shaved and then allowed to grow back slowly.

A Samburu girl with braided or copious hair is probably in school
(where many of her classmates are not pastoralists). If she is older, she
is either educated or pregnant. Spencer (1973, 82–83) also reports
a custom of allowing the mother's and baby's hair to grow for several
months after birth in situations where the mother has had past dif-
ficulty with infant mortality—the same mother who was advised to
have her baby in the house of the blacksmith. With both pregnancy
and lactation, there is the same association between hair and fertil-
ity as there was between hair and virility for the warrior. Hair in this
context is like smith's charcoal—powerful and efficacious as long as
it is kept under control, dangerous if displaced.

School authorities strictly forbid the ever-growing number of
Samburu schoolgirls and schoolboys to wear any kind of ochre or
beads with school uniforms. The modern Kenyan cultural script calls
for neatly braided or very short hair for girls in primary school and
slightly longer but still modest styles for those in secondary school.
Hair therefore becomes a very important status marker for formally
educated girls and women in the same way that beads are among
the much larger number of Samburu girls and women who have
not been to school. In this new script, hair signifies not fertility but
literacy and with it, a new degree of autonomy and connectedness to
life outside the *nkang*.

MASKS AND THE RITUALIZED BODY

I would like to return to warrior theatre and the idea of masked performance in Idoma warriorhood. Do any of these Samburu embellishments, mutilations, and disguises of the body constitute a "mask" that is comparable to Idoma warrior masquerades? African masks, in the narrow sense, are defined as a discrete type of artifact, usually made from cloth, wood, or vegetable fiber, that disguises the wearer and transforms his (or, very rarely, her) identity from mere person to some classificatory opposite. But in actual situations, masks include almost anything that disguises and transforms: for example, acoustic "masks," which are sound patterns identified with spirits and have no visible embodiment. In this broader conception, the question of body-painting or modification is often raised, particularly with reference to rites of passage.

Do they constitute a mask? Body-painting transforms the body through the dissolution of its everyday image and the substitution of something conceived with more conscious artifice (see Kasfir 1988, 5). But except in extreme cases, it does not fully disguise the wearer. One sees the person transformed, but the elements of secrecy and deception (in not knowing his/her identity or not knowing that it is only a person in a costume) are not present as they are with masking in the stricter sense. The question then becomes Can a person be "masked" if he or she is visibly transformed but not fully disguised? For example, is a possessed person who is wearing the clothes and trappings of and is obeying the dispositions of the god but whose face is uncovered "masked"?

Part of this question of disguise indeed centers on the face, which is so often taken to be the ultimate locus of personal identity. But Pernet (1992, 12) points out that among the Dan, it is the headdress and not the face of the mask that is most important in identifying its type and importance. Faceless masquerades include the "stocking-head" tricksters and runners of the Cross River region and eastern Nigeria.[34] The much-more-powerful ancestral mask ensembles of the Benue Valley and Niger-Benue confluence are also faceless, since they are fashioned as elaborate burial shrouds (Kasfir 1985b). These examples suggest that the face as focal point of the mask is less than universal in the African context.

In turn, this facelessness opens up an analytic space to consider disguise as something besides a cover for the face. In fact, it resides equally, and sometimes even more than the mask, in dressing and performance. The most diffident person in the village, if he or she is dancing as an attendant of Oglinye, must act boldly aggressive. All over the continent, women are possessed by male spirits (as well as men by female spirits) and facilitate transformation through disguising their everyday selves with clothing, props, body movement, and speech. One might then ask what the real differences were between the performance of *miraat* and a dance like Oglinye prior to the imposition of British rule. Were dressing in women's beads and leather apron and singing a song about killing an enemy and/or displaying the trophy essentially the same kind of ritual enactments as dancing with the Idoma enemy's head or later its mask substitute?

I would argue strongly that they were, in the sense that they conveyed a very similar idea of warrior theatre, the ritualized display of power that connects young men's virility to both fighting and sexuality. There are some differences; in the case of *miraat,* the transformation effected by wearing women's clothing is not complete, while with Oglinye and other warrior masquerades, covering the body and face with a knitted costume not only transforms but fully disguises the wearer. Yet the point of both rituals—to celebrate male aggression and prove that manhood has been achieved through taking an enemy's life—is the same.

Like representation and identity, disguise and transformation are deeply interdependent variables that are not fully separable from each other. Transformation is visually signified through disguises of the body, while disguises of any kind inevitably transform, from the point of view of the spectator. The transformation effected by the disguise of a mask is commonly said in the Benue region to "turn a person into a spirit": in the case of the headwinner's trophy or its carved equivalent, this "spirit" has nothing to do with "the gods" but is essentially the power of the dead enemy encapsulated in the metonymic symbol for him, the decorated cranium. Its equivalent for the Rendille or Samburu was the enemy's genitalia, hung from the neck of a bull camel or carried home on the point of a spear.

That one form of ritual display and performance involved a permanently preserved artifact that was integrated into the wearer's disguise and the other treated the equivalent artifact as ephemeral

and not a part of that disguise has led us to place them in different categories of thinking and behavior. Art historians have been trained to recognize masks in particular kinds of societies in Africa, and pastoralists are not among them. Looking instead for vehicles of transformation and at the process rather than the artifact of masking has become an accepted practice in discussions of puberty rituals such as Sande initiation in West Africa (Kasfir 1988, 5). I would argue that it is time to incorporate warriorhood and warrior theatre into this masking scenario.

It remains to answer the question of what if anything this has to do with "art" in the museum or textbook sense. At one level, the logic is inexorable: if masks (such as Oglinye) are, by current Western definitions, art and if the ritual body in its disguises, modifications, and extensions also constitutes a mask (and one that is very similar to Oglinye in its precolonial manifestations), then the ritual body when in that state is clearly an art form. It will also meet Danto's test of significant meaning, as long as one grants that the body can be construed as an artifact. And yet it seems obvious that because the body is also much more than an artifact, it is usually only represented (e.g., as a photographic image or as a mannequin) and not literally displayed in an art or ethnology context such as a museum or private collection.[35]

Conversely, in Samburu contexts where it is actually displayed, the decorated and ritualized body is apprehended first as a site of significant meaning and second as an aesthetic locus but not as an artifact or "thing," since it is also a living individual with specific attributes of personhood. There is an insider-outsider problem here that is not easily bridged. But by returning to the importance of efficacy as a privileged form of utility in African approaches to objecthood, the problem can be restated. The ritualized body, while it is not art or artifact from the Samburu perspective, is nonetheless clearly marked as efficacious. It is also a site of complex meaning that is as highly valued in Samburu ideas of representation as "the privileged sphere of art" is in Western aesthetics.

Part 4

COMMODITIES

7

IDOMA SCULPTURE: COLONIALISM
AND THE MARKET FOR AFRICAN ART

The next two chapters describe the bridging from the colonial to the postcolonial phase in the trajectories of certain objects as they became collectible commodities. But first I clarify what I mean here by "the postcolonial" as a historical phase versus an experiential condition, how clearly it can be distinguished from the late colonial, and whether this is even a right way to characterize the changes I am describing in the African art world. There is a qualitative difference between using "postcolonial" as a temporal marker meaning "after formal colonialism ended" and using "postcolonial" as an intellectual construct involving a broad new kind of consciousness, a stepping away from one's old identity as colonial subject and adoption of a critical stance toward the colonial experience. Today this second sense of postcoloniality is fading into abstraction as the colonial experience has become less personal and more remote in time and is morphing, often due to migration (Papastergiadis 2000), into the African artist's experience of an expanded horizon in a global cultural field (Liep 2001, 46). For the Samburu pastoralists, these migrations are a new form of seasonal transhumance without cattle and, like the experiences of more urban Africans, they involve encounters with strangers and their ideas. But Idoma artisanal practice has remained largely local and rural so that the second sense of the postcolonial as a form of changed subjectivity is a mantle to be worn lightly, if at all.

The other question is whether the colonial/postcolonial divide as a kind of historical periodization reflects real changes in policies or practices that affected Idoma and Samburu. The corresponding disjuncture in Samburu artisanal practice, which was caused by allowing safari tourists into the North Rift, appeared in the late 1970s, while

colonialism formally ended in 1964. Policies could not change practice overnight: first the border issue with Somalia had to be formally resolved and the Kenyan government's development plans for the opening of tourist-oriented game reserves in that part of the country had to be implemented. The changes happened, but it is more accurate to think of the early independence period of the 1960s in Kenya as a decade of transition, not as a before-and-after dividing point.

In Nigeria, the experience of this transition for rural peasant farmers such as the Idoma was blunted by their distance from the seats of power and they were insulated from change by their long experience of subsisting independently. This insularity was shattered in 1966 by the military coups and pogroms in the north and during the Nigerian Civil War that followed from 1967 to 1970. The elderly king of Igwumale, a strong patron of artists, refused to flee with his subjects when Biafran soldiers overran the town. Instead he sat in his house and waited for them, and in doing so became a rallying point for Idoma self-assertion. It was events such as this that stuck in local memories, not the handing over of government in faraway Lagos almost a decade earlier. But during the chaos brought on by the war, substantial looting of shrines by combatants took place and many objects were moved by middlemen across the border into Cameroon, from where they were bought by traders and shipped to Europe as art-market commodities. It was the political and economic chaos of the independence decade that introduced the Idoma to the fact that their masks and shrine figures were desirable commodities.

Throughout the colonial period, both the Idoma and the Samburu were too remote from major population and administrative centers to experience the brunt of new market forces. With the introduction of colonial taxation, both were forced to enter the money economy as marginal participants: the Idoma grew their share of cash crops such as cotton, rubber, and beniseed for the British, and the Samburu participated very reluctantly in government marketing schemes designed to reduce the size of their herds to fit the smaller carrying capacity of lands allocated to them in competition with white settlers and to supply the demand for beef in Nairobi.

But the parallel impact of colonial rule and incipient modernity in both places (especially the Northern Frontier District of Kenya) was minimized by the dearth of roads, schools, and missions.[1] Even now, almost a half-century after formal colonialism has ended, most

Idoma are still small-scale subsistence farmers at the nexus of the yam and millet zones and most Samburu are still cattle pastoralists, though with dramatically reduced herds since the droughts of the 1970s, 1980s, and 2000 and a subsequent increase in sedentary crop cultivation to augment seasonal movements with animals. This remoteness has been interpreted as proof of their authenticity and their right to be seen as uncontaminated by modernity. In Idoma, this status has been conferred largely by art dealers, in Samburu by the safari tourism industry, filmmakers, and professional photographers.

IDOMA CULTURE, THE FULANI-BRITISH INCURSIONS, AND THE COLLECTING REGIMEN

When the accoutrements of Samburu and Idoma warriorhood were filtered through an externally imposed colonial philosophy and practice, they emerged as commodities in a globalizing art and souvenir market. But since collecting institutions eventually conferred a high-art status on African sculpture made for indigenous use, Idoma masks have followed a different commodity trajectory from anything the Samburu produced. An important part of the commodification process has involved the repositioning of the Oglinye and other masks and shrine sculpture within a corpus of sculptural objects that scholars and collectors refer to as "Idoma art." Therefore, I will configure these objects as a group and not refer to Oglinye heads alone.

Appadurai (1986, 24) describes ritual objects as a kind of enclaved commodity—that is, objects whose commodity potential is hedged about with restrictions. Like gifts, they are supposedly insensitive to supply and demand,[2] are "highly coded" in terms of etiquette and appropriateness, and tend to follow socially set paths (24). Idoma masks, by this definition, are (especially in the precolonial period) enclaved commodities. Like medieval relics, their most desirable mode of acquisition outside local spheres of exchange is not by sale but as gifts (or even thefts) since these modes are "more emblematic of their value and efficacy" (ibid.). Certainly in the twentieth-century international art market, theft (the more spectacular the heist, the better) has served to validate the worth of African objects as "cultural treasures."

The clients for Oglinye in 1900 consisted solely of the warrior associations that had adopted the Oglinye dance from Igede and

farther south. In Akpa District, these would have been linked to young men's age-sets that in turn were village based.[3] There would have been at least one warrior association for each village and perhaps more. Commissions from outside the village were common and were a response both to the carver's reputation and to the fact that carvers were not evenly distributed across the population: one village of several hundred people might have two or three, another none at all. In a survey of carvers in several Idoma districts in the late 1970s, I found, on average, one recognized carver per 1,000 population, so that a large lineage village such as Otobi could easily support a carver while a small hamlet probably could not. Akpa District was particularly well known for its carvers, and though strictly speaking it was an Akweya-speaking immigrant enclave from north of the Middle Cross River, it became emblematic of Idoma sculpture in the African art literature, thanks to a brief but informative 1958 field-collecting trip by Roy Sieber to Otobi (Sieber 1961b) and the subsequent attentions of William Fagg in the exhibition catalogues of the 1960s and '70s.

Colonial district lines were drawn by the British from precolonial truce lines. These were boundaries around areas controlled by a particular set of related lineages who venerated the same earth shrine or of alliances of related lineages in neighboring territory within which it was safe to travel. Not surprisingly, these boundaries also demarcated zones of precolonial mask patronage. Later, as internal warfare ceased due to the imposition of British control, it became possible for carvers to receive commissions from a wider clientele, and exceptionally well-known artists such as Ochai of Otobi (Sieber 1961b; Kasfir 1979), who was active from the 1920s to the 1950s, received clients from several neighboring districts as well as his own.

If Idomaland had not been so far into the hinterland from the coastal trading stations, there would have been the added prospect of European patronage and the linkage with foreign markets, though in the colonial reports of Northern Nigerian officialdom, the Idoma were depicted as having no culture (in comparison to the emirates) and certainly no "art." Objects that were collected were thought of as ethnographic specimens.

In the early phase of colonization, objects that "came out" (a phrase dealers and collectors still use, effectively divorcing the arrival of art in the West from any visible agency) at first came through the colonial pipeline of trading networks, so that masks and statuary from

French West Africa were first known in Paris, Cameroon pieces went to Germany, and those from Nigeria ended up in England.[4] Idoma sculpture was first exhibited as fine art in London in 1949,[5] though it had been acquired considerably earlier by ethnology museums as part of the cultural underpinning of British rule.

From the beginning of these collecting practices, it has been important to those financially involved to deny any commodity status to precolonial and early-colonial African sculpture and to focus instead on its singularity. This has been accomplished through a collecting discourse that treats the appearance of such objects in a Western commercial gallery or auction house as a happy accident of chance rather than as an intentional commercial practice.

It has been possible to maintain this view because, as Appadurai has noted, "a commodity is not one kind of thing rather than another, but one phase in the life of some things" (1986, 17). It is therefore possible to focus attention on an object's noncommodified phases—for example, its original usage context as a ritual object and its final resting place in a prestigious public or private collection—and to minimize its commodity phase in between. In the village shrine and later in the museum vitrine, it is both singular and sacralized by its context of display (e.g., Kopytoff 1986, 74). In the period between these two statuses, which could be weeks, months, or years, it exists as a commodity, a fact that makes everyone (except Africans themselves) uneasy because it undermines a conventional assumption about authenticity, namely that it is a property associated with objects confined to local spheres of exchange. Idoma masks and figures share these same phases and problems.

The sculpture of the Idoma is far less well known than that of their much more populous neighbors to the south, the Igbo. It is sometimes even relegated in museum displays to a kind of Igbo substyle or offshoot due to the whiteface mask repertory and the ancestral textile masquerade ensembles it shares with southern Idoma, Igala, and Onitsha. It is best represented in the Nigerian National Museums in Jos and Lagos, the British Museum in London, and the Pitt Rivers Museum at Oxford. There are also significant clusters of objects in public and private collections in London, Paris, New York, Los Angeles, Washington, Atlanta, New Orleans, and, until 1997 when its Nigerian collection was sold to the French government, in the Barbier-Mueller Museum in Geneva.

The first pieces were acquired in England in a quite straightforward fashion as ethnological specimens. In the 1920s in Nigeria, when the colonial government set up a Department of Anthropology within the Administrative Service and instructed district officers to record local beliefs and customs, many objects became part of that larger project and found their way eventually to the British Museum or the Pitt Rivers Museum. Sometimes these artifacts were collected as part of a government inquiry, as, for example, during the Tiv "cannibalism" investigation in 1929, and at other times they were collected simply as specimens illustrating native custom. Thus, the Pitt Rivers Museum contains a small group of Idoma masks and figures, which were commissioned by one district officer from a single artist, Ochai, of the Akweya subgroup. In this way the production of a single artist sometimes comes to represent that of a whole culture, and in this case one that was not (strictly speaking) his own.

But there was also a subtext to official collecting: at times the colonial administrator took a personal interest in the work of a carver and commissioned him to make souvenirs to bring back to England along with collectible examples of masks and figures and other objects suitable for museum preservation. Thinking about the souvenirs that district officers commissioned for themselves and their friends and families is useful because these were in many instances the first wholly commodified transactions in which Idoma carvers participated. An artist who was asked to make something outside the boundaries of his own repertory had to step into the role of the bricoleur, modeling the requested forms after parallel ones in the existing repertory but also inventing whatever was missing.

To use a hypothetical example, had an Otobi carver been asked by Captain Downes or R. C. Abraham or Guy Money to make an elephant footstool in the 1920s or '30s, the carver would have looked to his formal repertory for the elephant and perhaps would have found it there in the Itrokwu mask. But the idea of the footstool, which presumes a comfortably upholstered chair for the body to recline upon with legs extended parallel to the ground, would likely have been a new and imperfectly understood idea, like Kamba napkin rings or salad servers, because of the lack of an existing model in the artist's culture.

He would have to have been made to understand by the patron, who probably didn't speak Akweya, that the elephant's load is the patron's feet and from there improvise a link to the known formal

category of "elephant" that in the Akweya-Idoma carving repertory existed only as the Itrokwu mask. The mask has a head, trunk, and tusks but not a body, which is to say, not the load-bearing part. It was at this point that the "traditional" artist would be called upon to innovate. I would expect that a similar process accompanied the first nonrepertorial objects sculptors were asked to carve in the early contact period with European patrons. As with the Samburu blacksmith, commodification brings with it new opportunities for invention.

OTHER ROUTES FOR COMMODITIES

Objects in private collections usually materialized through another route than those in well-established colonial museums. In the Lower Benue region during and after the Nigerian Civil War (1967–1970), local Igbo or Hausa traders who supply regional dealers outside Nigeria extracted pieces from their usage contexts in exchange for cash. While this is usually represented as "art theft" or "antiquity theft" in later accounts, it is rarely so bald as an actual robbery, though the practice contravenes Nigeria's antiquities law.[6] Given the impoverishment of the typical Idoma farmer, it is not so difficult as one might imagine to find someone—usually young and not deeply involved in the elders' traditions but with access through kinship connections to storage places for sacra—who needs the money more than he values the sanctity of the objects. In other instances, it may be someone in authority who makes the transaction and it may not be secret at all.

These sacra are then recontextualized in a wider system of exchange as art objects. (Up until that point, no one would have used that word to describe them.) The larger dealer, located across the Cameroon border in Foumban in the case of many eastern Nigerian objects, sorts them through a kind of quality sieve that determines whether they ultimately will be offered to a reputable European dealer or whether they become "souvenirs" in boutiques in international hotels and in craft markets scattered across Africa. This division is based on apparent age and the level of technical sophistication of the carving and only incidentally on the initial significance of the piece in its local context. Newspaper accounts of spectacular thefts of African art objects, such as the removal of the Afo-a-Kom ("Kom thing") from Laikom in the Cameroon Grassfields in the mid-1970s

and its subsequent repatriation by the U.S. State Department, usually stress the cultural significance of such objects. But for most pieces, what it may mean to a local mask association or group of lineage elders is essentially lost once it has left its storage place in a shrine house. Objects that are important sacra may be part of the anecdotal knowledge of the initial collector (the "runner," or local trader) but this knowledge is seldom passed along in any detailed or systematic way when the object enters a wider system of exchange. This loss constructs for an object a kind of tabula rasa that allows other narratives to be created around it later.

An unusual example of commodification that obeyed a different set of rules happened in the mid-1970s just prior to the time I began my Idoma fieldwork, when two art dealers, one from London and the other from Paris, made a clandestine field-collecting trip together to Idomaland. This in itself was very unusual, but the French dealer was also a trained anthropologist and his British counterpart an artist as well as a dealer. (Most Western dealers who claim to "field-collect" actually install themselves in hotel rooms in African capitals where they are visited by their local runners.)

As the Parisian dealer later explained to me, they presented themselves as visiting researchers who also wanted to collect. In fact, they did do "fieldwork," in the sense of filling notebooks with helpful "data," while they were there. They stayed several weeks as guests of the local people and attempted to buy old pieces through arranging for a local carver to make new replacements for them as part of the bargain. They alone knew the vast difference in market value between the two and managed to turn a large profit, though not every transaction on those grounds was considered acceptable by the caretakers of the various masks and shrine figures. In those instances, they acceded to local wishes and left the old pieces intact in the village, exercising what the French dealer told me he considered to be fair "rules of the game." Here the attitudes of the two dealers toward the wishes of the local people was mediated by the fact that one was an anthropologist before becoming a dealer. But with the price differentials in the late 1970s between what he paid for a piece (which was typically about $5) and what he sold it for in Europe to collectors and museums (up to $5,000), he could afford a certain largesse.

COLLECTING AT GROUND ZERO: THE SCHOLAR'S UNEASE, THE ARTIST'S OPPORTUNITIES

Anthropologists and art historians have in fact field-collected all along and in the colonial period provided another scenario for the observation of how local objects circulate in a wider system. Frobenius's diary *Und Afrika Sprach* documented the acrimoniousness that could sometimes enter such transactions; he described a situation when he was accused by the British colonial administration of illegally taking away sculpture from Ile-Ife. Eventually, this act of taking away became an important ethical issue for American- and British-trained graduate students, with the result that many of us who carried out our dissertation research in the decade after the Nigerian Civil War ended felt constrained to collect nothing but photographs and cine films or videos.[7]

But Igor Kopytoff (1986, 78–79), a veteran of those earlier years when anthropologists were expected to bring things home with them, describes the elaborate set of working rules that denied that collected objects were being commodified in any way by their removal. First, they had to have come from an authentic usage context and not from an African trader or art dealer. Second, they could only be given as gifts, traded for "like" objects with similar people (i.e., fellow scholars), or sold at cost to a museum. Under no circumstance was one to make a profit. The professional culture decreed that all such objects were to be collected only for scientific (i.e., as specimens) or sentimental reasons (i.e., as souvenirs). All these strategies supposedly kept such collecting free from the taint of commercialism.

Idoma artifacts rarely left the Benue in this way, if only because they have been subject to very little attention by outsiders. Roy Sieber collected some important pieces for the Nigerian Department of Antiquities in 1958, as did Anita Glaze a decade later when she was attached to the Jos Museum. But foreign researchers in Idomaland can be counted on the fingers of one hand. But the trader/runner route into Cameroon has been much more popular and accounts for most Idoma pieces that have become art-market commodities.

As for tourism, it barely exists in Nigeria outside a few well-traveled cultural epicenters (Ife and Oshogbo) and cities (Lagos and Ibadan) in Yorubaland in the south and in Kano in the north, the final stop on

the overlanders' route across the Sahara. It would be hard to imagine a place less compelling to foreign visitors than Otukpo, the noisy, sprawling main commercial town of Idomaland at the intersection of the railroad and the north-south road from Kano to Enugu. Idoma culture exists in lively form in the villages, which are often beautifully situated in stands of shady high forest along watercourses, but since these are scattered throughout the bush and many are beyond the reach of all-weather roads, no tourist would be likely to find them without a guide.

And because there are no regular tourists, there is no Idoma tourist art. It is important to realize that this stems not from some reluctance to commodify forms but from the absence of any visible market for them. If given the opportunity, most Idoma carvers would be eager to expand their repertory to include export art, as Igbo and Ibibio and Yoruba carvers already have. But the lack of accessibility means it is difficult to get any kind of goods to distant markets. It makes little difference in this context whether one is speaking of yams or carvings.

But it would be wrong to assume that the Idoma see no difference between sacred objects in shrine houses and the carvings they would make to sell if they could. I learned from trying repeatedly to purchase certain pieces for the Department of Antiquities or for the Och'Idoma's Museum in Otukpo that very few Idoma were willing to sell their sacred objects for cash back in the 1970s. But a new carving has none of that value: it is a mere thing—perhaps well made but still a thing that is not imbued with any spiritual attributes. The difference is similar to the difference between the spears Samburu make for tourists and those they make for themselves, a variant of Danto's story of the Pot People versus the Basket Folk.

There are Oglinye heads in many public and private collections, though, not surprisingly, no fearsome overmodeled skulls of the type that preceded the introduction of the carved substitute.[8] While the rejection of these by collectors on aesthetic grounds might be understood, it is unlikely that any have ever gone the route of the art commodity. (The one exception I heard about, but never saw, was a skull said to have been used as a paperweight in the divisional headquarters by one of the more flamboyant early district officers.) What is salient about this lack of interest is that it exposes so clearly the connections between the idea of authenticity and taste. In a strictly

historical reading of Oglinye, the decorated cranium is surely the older and more "authentic" cultural expression, while carved (and, in the Cross-River, skin-covered) heads bespeak accommodation to a European presence. But the fact is, very few Western collectors would pay large sums of money for and later display in their homes a decorated skull with its gaping eye sockets and open jaws. Its negative connotations in Western popular iconography would outweigh its historical authenticity.

HISTORICIZING IDOMA COMMODIFICATION:
THE NINETEENTH CENTURY

Discussions of commodification of African sculpture usually focus on European interventions in the precolonial and colonial period or African entrepreneurship since that time. But if one takes commodification to be the creation of an exchange value for an object, it has been happening to African sculpture for a much longer period—it has happened every time an artifact has been circulated beyond its immediate community. Sieber made this same point in a different context in the late 1960s (Sieber and Rubin 1968, 12) when he deplored the "hermetically-sealed" approach to the boundaries of African style that ignored the movement of objects through wars, migration, and trade routes.

The most important and protracted war in the Benue region was the nineteenth-century Fulani jihad of Uthman dan Fodio, a reformist movement that began with the Hausa states and slowly moved southward, using as it gained momentum a horse cavalry recruited from the peripheries of the movement, finally coming to a stop at the Benue River and in northern Yorubaland. At the Niger-Benue confluence, the jihad immediately preceded European penetration from the coast. Both Crowther (1855/1970, 152–159) and Baikie (1856/1966, 83–84) described the smoldering ruins of towns on the north bank, including the Ebira (Igbira) capital of Panda, which had fallen only nine months before their arrival. Enormous pressure was placed upon north bank populations, many of whom fled in canoes to the south bank of the Benue and into Idomaland or other Lower Benue regions.

The subsequent intermingling of riverine populations in Idoma, Igala, Tiv, and Jukun communities was a primary reason for the

diffusion of ritual objects such as shrine figures from their original villages to new, often foreign, settlements. This has caused confusion in the attributions of these figures when they have been collected for museums, often far from their place of origin (Kasfir 1981, 1997, 2002). It has also added to the already-complex scenario of the distribution of masks, which are highly portable and easily commodified even during peaceful conditions, quite apart from the forced migrations that happened here.

This dispersion of sacred objects happened just before the British arrived to set up trading companies on the Niger and the Benue rivers in the mid-nineteenth century and was followed by the British Punitive Expedition in 1897, military conquest soon after 1900, and the onset of countrywide British administration.[9] The Fulani jihadists obviously did not wish to collect and preserve heathen sacra, but to the new colonial administration such activity was a natural outgrowth of the specimen-collecting for British natural history museums that had begun in the later years of the nineteenth century with major expeditions to such places as the Torres Strait.

In the Benue region, since this collecting occurred at a time immediately after major social and political upheavals—first at the hands of the Fulani, then the British, it has to be seen in retrospect as affected by this culturally very discontinuous serious of ruptures. The Idoma are adamant that they have always moved with their shrines when settling in a new location, but those shrines are then exposed to a new, reconfigured set of competing allegiances, often from the local "owners of the land."

In the peacetime equivalent of this disenclaving process, established sacra originating elsewhere were brought back to Idoma lands from stranger communities, where they were exchanged for valuable goods. The best example of such movement known to me is one of borderland trading, that of the *ekwotame* figure (Sieber 1961b; Kasfir 1979, 1997) that until a few years ago resided in the Idoma village of Otukp'icho between Otukpo and the Tiv-Idoma border (fig. 2.3).[10] The story of its acquisition by the Otukp'icho owners made it clear that it was not made locally, an assertion reinforced by its largely unassignable style and iconographic details as well as its lack of association with any known Idoma ritual complex. Its hybrid character includes the Tiv mudfish scarification pattern around the navel and Tiv *abaji* scars on the face that suggest either a Tiv artist or an Idoma artist working for a Tiv client.

The *ekwotame* ("spirit-with-breasts"), first photographed by Roy Sieber in 1958 and published in 1961, has long been considered by people in Otukp'icho to be a very powerful juju, or receptacle of supernatural agency. Over the years since its acquisition in the nineteenth century by the brother of the grandfather of the most recent Idoma owner, it has by accretion added wealth, fertility, luck, and protective functions to benefit the lineage that owns it. Part of the reason for its power is perceived to be its foreignness: it was purchased (probably around 1870) in a village in the northern Tiv-Idoma borderland from a carver named Aka who, according to the account, was given in exchange one slave, one dane gun, and one brass bracelet.

This suggests that in precolonial Africa even objects considered to be "priceless" were sometimes given a price, and what are usually thought of as inalienable possessions are indeed sometimes alienated. This particular story of course may be an invention, but even if it is, its particularity bespeaks a past tradition of exchanges for valued objects. The assumption that transactions involving ritual objects were triggered and set into play for the first time by colonialism rests on the improbable idea that there was no past movement of things of ritual value within African spheres of exchange. No one would defend that position today, which makes it equally impossible to defend the idea that commodification began with the "breakdown of traditional society" under colonialism.

Sadly, the *ekwotame*'s strong market potential in the colonial and postcolonial capitalist world economy has come to outweigh its local status as a powerful sacrum. It was removed by unknown persons from its shrine in Otukp'icho in the late '80s, a likely victim of International Monetary Fund structural adjustment policies that have greatly impoverished the rural people in Nigeria. Its original home was a Tiv-Idoma borderland village, its second an unambiguously Idoma one. After more than a century of use, it has now (one assumes) moved out of a regional sphere of exchange into an international one, where it will undoubtedly surface one day in a foreign collection.

"THE SUN NEVER SETS ON THE BRITISH EMPIRE": EARLY GLOBALIZATION AND TRANSNATIONAL GENRES

It is difficult not to see British imperialism and colonialism as an earlier globalizing project, minus, of course, the time-space

compression of modern communication and other attitudes and conditions that presuppose modernism. Despite the lack of instantaneous intelligence reportage and mechanized warfare in the late-nineteenth-century military campaigns in the Benue Valley, the changes wrought were no less disruptive and hegemonic than contemporary globalization in spatial and temporal terms. Actually consolidating these changes, first by the Fulani and then the British legitimation of Fulani sovereignty in Northern Nigeria by indirect rule, took decades longer than the initial pillaging and conquest. Nonetheless, it was a time of "fast happening" in material-culture reckoning (Kubler 1962) compared with what came before and after. Braudel (1979) later expounded these differences in temporalities from a historian's perspective, and more recently Mbembe (2000) has applied Braudel's idea of the long duration versus rapid change to the African experience. This late-nineteenth-century time of rapid change, or "fast happening," was the context for the migration of numerous sacred objects and their new careers in a developing Benue Valley diaspora of ethnic heterogeneity.

Hausa elephant hunters, craftsmen, and ritual specialists resisting Islam had filtered southward toward the Benue River and lived as Abakpa stranger lineages in Idoma communities for many generations; they brought their own textile-weaving and -dyeing traditions and cloth masquerades (Kasfir 1985). But the partnership between the British and the Fulani upended this creolizing process within Idoma sovereignty by incorporating northern colonial outposts, such as the ancient Doma and Keana states north of the Benue, into newly reorganized emirates such that the Idoma/Alago kings became subordinate to a British-appointed Fulani emir. Spatially, this created a bifurcated sovereignty in which the Idoma were left to administer their own kingdoms as before but found themselves answerable to a Fulani emir, who in turn answered to the British.[11] After 1900, a successful political career as a Doma ruler meant conversion to Islam as a de facto precondition, as it also did in Igala and northern Yorubaland. Thus, both cultural geography as the Idoma had known it and temporal change, which had previously accompanied the system of collateral succession through royal lineages, were reconfigured within a British colonial–Fulani emirate frame of reference (see plate 14).

When political designs such as indirect rule are set within a climate of classifying zeal such as that fostered by the early ethnology

museums in the closing years of the nineteenth century, they become their own justification, advancing scientific knowledge while coming to the aid of the benighted native subject. But since the evolutionary suppositions basic to specimen-collecting were concerned only with archaeological durations, collectors made no attempt to factor recent and localized histories into the knowledge base. Thus, recently disenclaved Benue Valley sculpture was subject to misinterpretation in at least two ways when it was collected and classified: the first was in assuming that an object collected by an early traveler, soldier, or administrator actually originated in the host community where it was found (i.e., as if the jihad had never happened), and the second was in subjecting the collected example to the museum's own, more comprehensive program of classification and display (one thinks of the Pitt Rivers Museum). These typological schemes, which focused on differences in technology, tended to work more successfully with such things as spears and baskets than with representational forms such as sculpture.

During his tenure as keeper of African ethnography at the British Museum, distinguished Nigerianist William Fagg developed an assumption that sculptural forms for different ethnic communities were mutually incompatible—essentially a "one tribe, one style" approach that effectively denied the hybridization that actually took place in Nigeria's central region (Middle Belt) due to forced dislocations in the nineteenth century (and all the smaller ones both before and after that period that resulted from land or chieftaincy disputes).

The net effect of this dispersal of images among immigrant populations was to create a transnational (scaling down that term to fit precolonial states and chiefdoms) zone of figures that when commodified (i.e., collected as ethnographic specimens) were given overdetermined local identities. Many of these have stuck fast once they were enshrined in exhibition and auction catalogues and legitimated by the authority of William or Bernard Fagg (the latter his equally distinguished brother, archaeologist of the Nok cultural complex, director of the Jos and then the Pitt Rivers Museum).

To mention only the most famous example, the purportedly Afo maternity figures in the Horniman Museum (London) and the Berlin Ethnology Museum derive their attributions from general but not very closely read or easily explainable resemblances that the

Faggs saw in relation to Afo examples in situ (see Kasfir 1981). If placed side by side with similar genres found in Idomaland, such as the Tiv-Idoma *ekwotame* figure and other Idoma seated female figure types such as *anyanmole* and *anjenu,* it is clear that they form a closely related set that extends as far west as Igala and Igbira Panda at the Niger-Benue confluence and as far east as the Tiv and Jukun, with Idomaland roughly in the center and the Afo directly north of Idoma's Agatu District and on the other side of the Benue. Art dealers and auction catalogues aside, it is much more productive to think about these figures as a regional Lower Benue genre with individual (i.e., artist-driven) stylistic variations than as distinct ethnic styles and genres (Kasfir 1984).

But it would be wrong to conclude from this that early forms of transnationalism covered up hidden local identities. The local versions changed in response to diasporization and the formation of new refugee enclaves, not unlike a diaspora of Senegalese artists living in Paris today who may have an effect on local Parisian-African practice yet claim a distinct identity. Idoma nationalism is a perfect example of this continuous enclaving process, partly the result of shifting residence patterns (the Hausa elephant hunter who "becomes" Idoma after several generations) and partly from a desire to validate local practice within a larger nationalism.

Thus, the Akweya-speaking Idoma enclave in Akpa District has its own exclusive clan masks in addition to owning many (but not all) core Idoma masks. The powerful clan masks such as Akpnmobe form a diaspora of masquerades that originated among the Akweya and Yatye in the shatter zone of Ogoja, north of the Middle Cross River (fig. 2.6). Yet in Ogoja itself, those older masks exist mainly as memory, and current mask practice there has in turn been successfully diasporized by influx from the Cross River masquerades.[12] Each Akweya-speaking locality is now distinct insofar as its masks are concerned, though they share a language, clan membership, and other cultural markers that unite them to a receding, partly imagined and partly experienced memory of the past (see Huyssen 2001, 62–64).

This example, just as with the jihad-driven remappings of shrines and their images, makes havoc of any idealized notion of distinct ethnic (or in art dealer terms, tribal) styles in the Benue–Cross River region. But museums must aim for clarity in their display practices and so are usually committed to a simplified ahistorical presentation that leaves out all this fluidity of movement and memory. The same

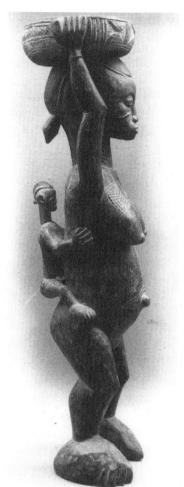

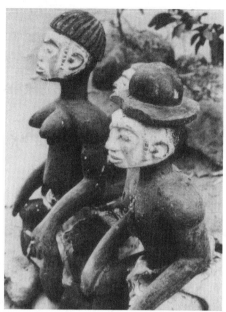

ABOVE: FIGURE 7.2. Idoma *anjenu* shrine figures by Ochai, Oko, Nigeria, 1976. *Photo by author.*

LEFT: FIGURE 7.1. Afo *okeshi* figure. *Courtesy of Jos Museum, Nigeria.*

is true of teaching and the undergraduate lecture survey, which is typically divided into distinct case studies or "style regions" (in the parlance of the previous generation of scholarship). The result is a universe parallel to the actual one that is more orderly and rational than the reality and receives a good deal more validation from dealers, collectors, and the museum-going public. A well-known American dealer once told me he could pinpoint to within a few miles the origin of a piece of African sculpture provided it was reasonably old, so confident was he in the unchanging nature of styles and genres. It goes without saying that he had not actually been in Africa, but from his point of view, this was quite irrelevant.

CREATING A DIFFERENTIATED MARKET:
THE REAL THING AND ITS VARIANTS

The other major art discourse that accompanied the commodification of African sculpture in the West is that surrounding authenticity: what is genuine, what is a deception, and what lies in the grey area between. Since increasingly large sums are paid at auction for African art every year, it continues to be a contentious matter for collectors and dealers that has legal and ethical as well as aesthetic dimensions. The quest for a return to authenticity has also been a formative issue in the project of modernism itself, in which pre-European contact African sculpture was upheld as the quintessential example of powerfully authentic plastic form.

These supposedly authentic forms of African art follow certain prescriptive conventions that are finite and well known to specialists. The formation of the canon in the early years of the century, primarily in Paris, out of a corpus known indiscriminately as Art Nègre disposed collectors toward a range of forms that varied from an angular antinaturalism (the "Sudanic" style) to a restrained and more organic quasi-naturalism (the "Guinea Coast" and "Equatorial" styles).

Ben-Amos (1977, 130–132) has suggested that by contrast "tourist art" would be found unacceptable because it was either too naturalistic or too exaggerated (but in ways that are different from canonical styles). I would add that these new genres often lack what Picasso and others saw as the *raissonables,* or logical, quality of older forms. These formal qualities as they were embodied by masks and figures in wood posited what were to become an accepted canon over the course of the twentieth century. Objects that deviate from it in an obvious way are, by inference, not authentic cultural products and therefore not what is usually meant by the term "African art" in a collecting context.

It was a short step from this bracketing of what was thought to be quintessentially primitive (in the French sense of primordial) artistic expression to its transformation into principles of taste. Because it is a sensibility, taste plays heavily into the requirements of class (Bourdieu 1984, 40), and lays claim to high-art expectations when associated with a collecting elite. However tautologous, high art is partly defined by what elite patrons admire and acquire at a given moment.

Objects such as African sculpture produced under an unfamiliar formal rubric or works that deviate in scale or material from what is canonical usually fall outside the parameters of elite collectors' tastes (which is why the collecting publics for canonical and noncanonical forms do not usually overlap). This is true whether or not the excluded objects are made by younger or more entrepreneurial members of artisanal workshops that in the past have produced canonical work. The exclusion therefore is based not on the identity of the ethnic group or artist or workshop but on the divergence of their production from the accepted canon. Thus the gaudy, recently invented "Asante" masks[13] that are found alongside (but in no way resemble) colonial-period Asante wood-carving and metallurgy in East and West African boutiques and souvenir shops are collected only by those unaware of the canon's parameters.

If "the real thing" both defines and is validated by elite tastes and discernment, what about the nonelite market? The topic of post–World War II tourism is most often located in discussions of the effects of mass culture, which have taken as axiomatic that the tourist is typically uninformed and his or her encounter with foreign cultures is superficial or (especially in poor countries) that tourism is predatory and destructive.[14] More recently this position has been aligned with the antiglobalization and ecology movements. Objects made for tourists have fallen under a similarly dismissive rubric. Long associated with the notion of kitsch (itself a high modernist concept), artifacts made to be sold to strangers outside local networks of exchange in Africa have, until recently, been assumed to be unworthy of serious attention by art historians.[15]

It is necessary to make a distinction at this point between two kinds of export art. Paradigmatic "tourist art" is usually thought to be easily distinguishable in style from canonical art: it either involves totally new inventions at the level of both style and iconic content, such as the Maconde *jini* and *shetani* figures, or parodic interpretations of older genres in which facial features or body proportions are noticeably exaggerated or embellished. An example would be seated female figures in an Asante carving style that are "improved" with the addition of inset colored beads in the form of non-Asante motifs such as butterflies. These are not in any way "fakes" or attempts to deceive. They are new inventions, some of which are based in older (now-canonized) folk models and others of which are not. Their buyers are

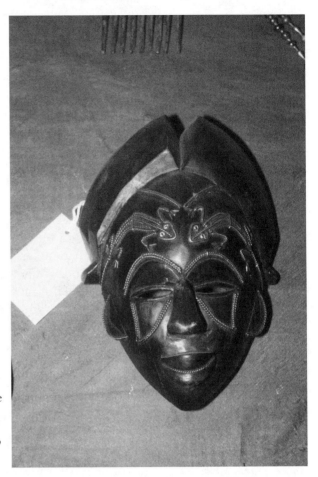

FIGURE 7.3. New hybrid Nigeria-Cameroon style mask with bronze chameleons on the forehead, tourist art shop, Nairobi, Kenya, 1994. *Photo by author.*

tourists seeking souvenirs rather than collectors who are knowledge-able about the styles and genres of historical African sculpture.

The other kind of export art, however, is more difficult to discuss (or to reject, in the case of collectors) because of its liminal-ity. It consists of recent versions of canonical genres and styles. The best-documented examples are again Asante (e.g., Ross and Reichert 1983) and Senufo (Richter 1980b), while Steiner (1994) has described the circulation of such pieces in the context of the Côte d'Ivoire art market. In the shorthand of African traders, there are "originals," or, in Nigeria, "antiquities" (old and used objects); there are "copies" (faithful and frequently artificially aged versions of old pieces); and, under many names, souvenirs, which are neither.[16] In Abidjan, this third category is known either as *nyam-nyam* or *masques*

et poupeés Kenya to denote its generic, rather than identifiably ethnic, style and iconography (Steiner 1994).

ORIGINALS, COPIES, SOUVENIRS AND THEIR COLLECTORS

In addition to the obviously wealthy collecting elite, who rely on the judgment of experts as well as their own judgment to avoid buying "export pieces," there is a class of collector with a decided taste for canonical forms but without either the inclination or the financial liquidity to pay huge sums for a mask or figure. It is members of this latter group, who collect not as an investment or an obsession but for the "beauty of the thing" (Bourdieu 1984, 274), who may acquire exceptionally well-carved export art (made perhaps in the 1960s or '70s) because it is aesthetically compelling and not because it is certifiably old or used. Disdained by traditional elite collectors, these buyers often put together very interesting collections (from the perspective of the scholar) but also sometimes try to elide distinctions between these objects and older, more strictly canonical art, especially when such collections reside in more provincial cities where there may be little opportunity for comparison with actual canonical collections.

With the passage of time, such collections acquire the legitimacy of age that further obscures their resemblance to or diversion from older art in the same style. A parallel process occurs with traders and dealers who sell it, all of which creates a cloud of ambiguity that art museums, as the guardians of the cultural gates, feel impelled to resist by drawing boundaries determined by age and use around an increasingly rare corpus of legitimated objects.

Souvenirs suffer the same low regard as replications in the eyes of both the orthodox elite collector and the less-monied buyer seeking "distinction." Bourdieu's (1984, 276) grand bourgeois prototype "detests travel souvenirs" and never brings any back. Both the aristocratic and the grand bourgeois collector in Bourdieu's interviews (which were conducted in Paris in the mid-1970s) were wedded to an implicit high-art notion of cultural authenticity that would exclude anything like the souvenir that emanated from the realm of "popular culture" (a category Bourdieu himself dismisses; 395). This exclusion by elites of what was perceived to be essentially an uncultured sensibility of the masses with an appetite for "degraded" forms extended also to a distancing from the nonwealthy but well educated with a

conservative penchant for "'truly classical, restrained things'" (289).
These judgments of taste relegate both prosaic copies and souvenirs
to a cultural Siberia populated exclusively by the ill-educated worker
and the upwardly striving petite bourgeoisie.

Translating this into the proclivities of those who travel to Africa
from abroad is far from straightforward because the configuration
of French tastes and attitudes contained in Bourdieu's study only
approximates those of, say, Americans or British or Germans or
Japanese and because Africa presents several distinctly different types
of travel scenarios. There are tourists and there are travelers, and
each of these categories breaks down further into widely different
social types. Nonetheless, the distinctions based in class and educa-
tion form remarkably consistent strata of taste within broad cultural
formations. Therefore what is acceptable as a souvenir will vary with
class-based tastes in quite predictable ways from the truly rare to the
mass-produced and from the artifact made and used in a foreign
culture (if possible, in an arcane context) to one that is specifically
produced as a ready-made object for the traveler to take home.

The conventions of scale and material also matter when elite
collectors or art museums determine the acceptability of objects.
Both miniaturization and gigantism are characteristic of souvenirs
worldwide (Stewart 1984, 43, 52–53) and are part of the nineteenth-
century taste for "marvels" encountered by the traveler. In East Asia,
small-scale carved ivory souvenirs demonstrated artisanal virtuosity:
the Asian collection of Robert Ripley (of "Ripley's Believe It or Not!"
fame) is distinguished by its intricately carved Chinese ivory puzzles:
boxes within boxes, spheres within spheres.[17] By contrast, carving
workshops within non-mask-using cultures in Africa, such as the
Asante in Ghana or the Kamba in Kenya, are predisposed to produc-
ing export masks of exaggerated size, which are freed from specific
cultural conventions regarding masquerade performance. This is not
to suggest that gigantism and miniaturization per se are evidence of
souvenir status or entry into wider systems of exchange: the Igbo use
several very large "fierce" mask types in their masquerades as well as
extremely small whiteface "beautiful" masks (Cole and Aniakor 1985),
and the Dan and Mano used, along with face masks of human scale,
very small maskettes meant to be carried in initiation baskets. Rather,
exaggerations in scale free objects from their everyday strictures and
thereby facilitate their reinvention for a different clientele.

Similar distancing from the canonical comes with the use of non-traditional materials. Ebony (Swahili: *mpingi*, African blackwood) has been exported from Africa since biblical times, but in the late nineteenth and early twentieth centuries, during the formation of the canon, it rarely if ever appeared in the West African masks and figures that made their way to Europe. These two facts have translated into an association of ebony wood with commercial exports rather than with "genuine" African sculpture in the minds of collectors.

This suspicion is seemingly confirmed by the use of ebony for Maconde and Zaramo sculpture made for export, though in fact the plentiful supplies of *mpingi* in the Ruvuma River region of southern Tanzania and northern Mozambique influence the choice of materials as much as the destination of the final product. In fact, precolonial Maconde figures and snuffboxes documented by Karl Weule (1909) as well as precolonial examples in the National Museum of Tanzania were also carved from ebony. In Benin, on the other hand, using ebony for export carvings seemingly was a conscious strategy to appeal to the European patron and is a clear departure from earlier materials used in court art. Since tourists and resident expatriates are the main buyers of ebony carvings in both East Africa and Nigeria, ebony has become a questionable substance to the connoisseur that is freighted with an ingratiating commercialism. It therefore suffers a demotion in status, associated not with genuine high art but with middlebrow yearnings for an authentic piece of exotica.

Besides style, scale, and material, other objections are leveled by the collecting elite against tourist or export art. With the distancing of the patron (both culturally and geographically) and the uncertainty this generates for the artist concerning the object's use-value, there is frequently a decline in technical quality. But where the export market is large and patronage differentiated into distinctive segments (as in Kulebele Senufo carving in Côte d'Ivoire), artisanal practice becomes similarly differentiated, with "hack" carvers turning out masks for casual tourists at one end of the spectrum and master carvers working only on commission for a traditional clientele and for European dealers at the other end (Richter 1980b, 61–72). To judge solely from the large quantity of mediocre Yoruba and Lega sculpture for sale nowadays in Nairobi, the same differentiation in technical quality may be occurring within or among Yoruba and Lega workshops.[18]

At the same time as the niches distinguished by quality appear, embellishments may be added in response to either actual or perceived patron preferences. For example, traders in both East and West Africa have long noted that Europeans apparently prefer figures embellished with small beads or cowries or fragments of cloth. Collectors read this as a sign of actual use, therefore authentication. In the 1970s, Maconde artists obligingly added small scraps of *kitenge* cloth to some of their figures. In like fashion, the Samburu have added an elaborate beaded and plumed spear-blade cover to the tourist spear in response to the perceived tastes of their foreign (mainly European) patrons. Because of the cultural distance, Samburu often assume that these patrons harbor preferences diametrically opposed to their own; furthermore, they deem such differences to be appropriate. A Samburu elder once complimented me on my bracelet (which was in a prevalent Samburu style but was composed almost entirely of black beads) by noting that while no Samburu person would choose that color, it looked good on my wrist because Europeans have "bright" skin.

Finally, and more important than all else, there is the perception that export art is highly commodified and "all the same" while genuine African art is not. Here the elite collector is on slippery ground because one mark of an "authentic" object is its predictability concerning its formal, scalar, material, and iconic values. These are articulated through the notion of distinct "tribal styles" (Fagg 1965; Kasfir 1984) that supposedly preclude an artist's individual flights of fancy. because this is the understood norm, elite collectors are often wary of pieces that depart radically from it, and such pieces never have the art-market value of an object that is well within the parameters of a recognized style, genre, and period.[19] So, ironically, a healthy measure of replication is thought to be a sign of the authentic in the context of "tradition" but symptomatic of the counterfeit in the context of objects openly made to be sold. The collector would respond to this observation with the point that even within the limited parameters imposed by "tribal style" conventions, every "traditional" artist's work is unique. But this is also true of most export art, given the rather similar conditions under which both kinds of objects are produced. What is actually an important resemblance between older and more recent African art usually goes unrecognized because the two rubrics are never compared on these grounds.

For example, the similarities between one Yoruba *ibeji figure* and another from the same workshop and time period are explainable as an inevitable result of the workshop as an institution and the training it provides through the apprenticeship system, but instead of realizing that this is also the reason for the close resemblances among, say, Kamba carvings, elite collectors often assume there is some kind of assembly line that turns out export art with a machine precision. The Kamba once again provide an instructive example as a paradigmatic case of export art, since their carvings have no grounding in any precolonial patronage system and have from the beginning been highly commodified. The only division of *tasks*, even in the large cooperatives at Wamunyu and Changamwe, is between carvers and the finishers who lacquer and polish the carvings. Carvers are even responsible for procuring their own logs, though the cooperative gives them the opportunity to work out sharing arrangements with other members. But every piece is carved by one sculptor from start to finish.

There is nonetheless a sharp and clear division of *talent*, just as there is among the Kulebele carvers in Korhogo (Richter 1980b). Young apprentices and less-accomplished older carvers therefore make simple things: paddles for stirring maize porridge, walking sticks, salad spoons and napkin rings for foreigners, small animal figures for children to play with. At the other extreme, the best carvers work only on commission, spend weeks on a single figure, and exhibit the same combination of inventiveness and adherence to accepted practice in what they make as, for example, an accomplished master carver in the Igbomina Yoruba workshops that Pemberton (1987) studied.

Conversely, the division-of-labor principle is often found in supposedly traditional workshops. Here again, aspects of the Yoruba system are well documented (e.g., Carroll 1967; Willett 1978, 28–33). In the cases of Bandele and his pupil Lamidi Fakeye, there were four distinct stages in the Ekiti carving technique: *ona lile* (blocking out with axe or adze), *aletunle* (dividing up the masses into smaller forms with adze or chisel), *didan* (smoothing the forms with knife or chisel), and *fifin* (cutting sharp detail with the knife; Carroll 1967, 94). Willett (1978, 30), who closely studied Lamidi Fakeye's working methods, stated that in a workshop context the master would keep close control over the first two stages while the last two would be done by apprentices. By contrast, in the workshop of Ekiti sculptor Lawrence Alaye

(who was also trained by Bandele), Alaye executed the first and last stages and apprentices completed the two intermediate stages (Kasfir 1987, 42). But in both cases there was a clear division of tasks based on the level of competence of the carver. What seem initially to be differences between an older and localized versus a more recent and export-driven artisanal practice turn out, under scrutiny, to be evidence instead of a widespread continuity over time and space.

LINKS BETWEEN PRACTICE, REPRESENTATION, AND AUDIENCE

It has fallen to a handful of prescient anthropologists and sociologists to incorporate tourist arts into the broader study of African popular culture (Jules-Rosette 1979, 1984) or foreign patronage and the art market in Africa (Ben-Amos 1977; Richter 1980b; Steiner 1994). In a seminal article comparing art and language, Ben-Amos not only examined the differences in style between canonical and tourist art but compared tourist art in Benin city with West African pidgin, arguing that (compared to work produced by Benin artists for precolonial royal patronage) both were predicated on a shorthand form of communication necessitated by lack of shared cultural grounding between artist (the speaker) and tourist (the audience). Building on the earlier studies of popular art in Zaïre by Szombati-Fabian (1976) and Fabian (1976, 1978), Jules-Rosette (1984), in an equally important work, constructed a semiotic approach to tourist paintings that treated them as texts bearing embedded cultural messages. But compared with the popular street paintings bought by Zairians, these tourist versions depended on a limited repertory that was intelligible to patrons who had no collective memory of colonialism, no past that needed replaying. While based in very different artisanal practices (tourist sculpture in ebony wood copied from earlier Benin royal portraiture executed in brass or ivory versus painting on flour sacks for a Lubumbashi street clientele) and different theoretical perspectives, both studies examined tourist production as based in a kind of rudimentary artistic language in which iconography had to be simplified and form altered due to the lack of common ground between artist and audience.

While there is no doubt that this condition is emblematic of tourist art, I shall try to move the discussion in a different direction in

the next chapter by examining the tourist souvenir as an instrument of recollection not for the maker but for the traveler. This is a shift away from the issue of the level on which tourist objects actually communicate to the issue of the power of such objects to represent. It is also centered on the consumer as one who "reads" the object in order to constitute its meaning, whether this is a simplified version of its meaning to a local audience or something quite different. To do this effectively, one must apprehend the whole situation of cultural practice and look beyond its end product. Jules-Rosette already has done this very innovatively in relation to a producer-consumer model. Here I have examined the problem as an issue of representation by self and by others.

In the early chapters I considered the ways early writers, filmmakers, and spectators have represented the Idoma or Samburu and their systems of objects and practices relating to warriorhood. The second half of the book has focused thus far on Samburu representations of themselves and others: the representation of blacksmiths by nonsmiths in contrast to the way they represent themselves, their representation by non-Maa speakers generally, and, in the postcolonial period, by tourists and tour guides. Some of these are verbal, others are written inscriptions, still others are the product of artisanal practice. I have avoided wherever possible the separation of objects (masks, spears) from the larger representations through which they are constituted by both Western spectators and the Idoma and Samburu themselves. This follows from the point that while objects are at one level revealed only through their physical form, they are more thoroughly decoded by the texts that surround them. While formalist art historians feel this is an unjustified demotion of the importance of the concrete representation, it is really only an attempt to understand it more fully as a conflation of signs. If a painting is at the most basic level a certain arrangement of pigments on a flat surface, the Oglinye mask would be a dynamic combination of solids and voids that emulates at some level of abstraction a human cranium. These qualities, however, offer no clue to its meaning beyond the purely physical, and in order to plumb that meaning, one must complicate the description by locating its concrete objecthood within a larger frame of representation.

Visual representations are constituted through practice, but in most of Africa, twentieth-century aesthetic practice was continually

modified as a result of colonial and postcolonial interventions. Changes in political and economic structure introduced competing cultural scripts as blueprints for various representations—those of the British, the Samburu, and, in the past twenty years, the Kenyan government. Both the British-imposed spear ban from 1934 to 1956 and, since about 1980, the opening up of the tourism market to blacksmiths have reconfigured the way Samburu smiths conduct their practice and have expanded their production of spears as commodities, first for neighboring pastoralists with different spear preferences from the Samburu and now for tourists with even more elaborate expectations of what a souvenir spear ought to be. And given these new forms of patronage from outside the Samburu community, the smith has responded with an expanded repertory of sizes, styles, and technical specifications.

For the Samburu, a spear may be an inalienable possession with complex symbolism or a straightforward commodity depending on the particular script being called into play. But in either case it is an object constituted through practice, whether the practice is artisanal or takes place in the context of use, where it becomes part of the larger representation of warriorhood. For the tourist, it is a souvenir: this makes it a commodity but also part of the discourse of memory, thus a very complex representation. It is clear that just as a given object can move in and out of commodity status over time and space, it also moves through a series of representations that correspond to its changing status. I commissioned a blacksmith acquaintance to make me one of each Samburu spear type, thinking that I would have a complete, documented set. But since these were left idle in my house within a Samburu settlement, one by one they have all been appropriated for use by herd boys, moran, elders, the night watchman, and so on. What was briefly a collection is now dispersed among several people for purely practical use, altering the status of each object as well as that of the aggregate, which no longer constitutes a set. While I may still technically have a claim to their ownership, as a female and someone who does not use spears, my ownership is mainly hypothetical.

THE COLLECTOR AND THE TOURIST

The types of commodities discussed here and in the following chapter, high art and souvenirs, occupy very different niches in a

global market, though both draw their referential meaning from African cultures at the point of their origin. I will say much more about the souvenir and its relation to a different kind of representation of memory, the photograph, in the next chapter. Here I would like only to lodge a contrast in the two varieties of consumers of these commodities, art collectors and tourists. In a Bourdieuian analysis, the differences in them would be explained by their respective class positions in relation to educational and cultural capital that in turn lead them to adopt rather different tastes for objects.

But these are far from parallel consumption niches, because while collectors of highly priced and valued objects are necessarily few, tourists are many and varied. They diverge widely in their educational capital, their travel experience, and their notions of what counts as an authentic representation of their encounters with alien cultural landscapes. Furthermore, the discourses of cultural tourism differ dramatically from those of ecology or wildlife: in Nigeria, for example, the mountains of the southeast borderland with Cameroon are home to the rare mountain gorilla, but with the exception of one crumbling colonial-era mountaintop hotel, there is no place from which tourists can seek them out, no advertisements or tour groups. (If you want the gorilla experience, you go to western Uganda, Rwanda, and eastern Congo.) Instead, Nigeria's tourists (who are very few relative to Kenya's) are more often on the trail of culture, such as African Americans looking for their West African historical roots, and tend to focus their itineraries on the well-known Yoruba towns, especially Ile-Ife (the place where Oduduwa established civilization) and Oshogbo (with its annual festival for Oshun, the river goddess).

Tourism discourse can differ markedly even in a single country. In Kenya, the wildlife safari tourists tend to be earnest and educated seekers of species, armed with binoculars, expensive cameras, and checklists, while those who buy inclusive packages to the beach hotels on the Swahili Coast are usually there for a tan and in some cases a possible sexual adventure, as if they were at a Caribbean Club Med instead of in Africa, surrounded by the archaeological ruins of Swahili Coast culture. Student backpackers form a third category, traveling alone or in the Saharan overlander trucks, never on the package tours their parents might take. Each of these types of tourist tries assiduously to avoid encounters with the other two since it is emblematic of tourist discourse that there is a strong desire to

dissociate oneself from other tourists, to be the sole traveler in an alien landscape. It is also obvious that each group will look for different souvenirs, reflecting their degree of engagement with the local African culture.

Collectors, on the other hand, are a much smaller group and have fewer discourses to choose from, though they are not all, as Baudrillard (1968) would have us believe, middle-aged white males with a Type A personality. The dominant discourse among collectors of African sculpture, derived from the writings of William Fagg and others, is that of "tradition," which assumes that all African cultures were strong and coherent before colonialism destroyed their moral underpinnings. In this view, the twentieth century and after has been a period of long slow cultural decline, so in collecting, old is generally good, new is highly suspect. In the Francophone version of this discourse, the broad outline is the same but it places greater emphasis on the heroic anonymity of the tribal artist, who apparently never engaged in acts of cultural brokerage or entrepreneurship (strategies that were introduced by foreign colonizers).

Mainstream collectors most closely resemble my first category of safari tourist in that they tend to be well read in the "classic" literature of the field (though not the literature of the present postcolonial period) and are armed with mental checklists of what it is important to look for. I speak in the next chapter of the collector's passion for completeness—owning every mutation of a series or set—but this seems less true of collectors of African sculpture, since unlike rare editions of books, what would constitute a "complete set" is often unknowable. The passion for completeness is often replaced instead by a passion for acquisition (Baudrillard again), in which a newly acquired object works like a "fix" until its newness wears off.

There is also the maverick collector, often an intellectual with more time than money, the functional equivalent of the backpacker traveler, who prides himself (once again, a male preoccupation) on finding "the real thing" in a flea market or out-of-the-way place for "next to nothing." Suffice it to say that he and the elite collector, like different kinds of tourist, hold each other in mutual disregard, each feeling superior to the other. But unless they happen to go on safari or on a roots journey of their own, both are unlikely to acquire their African sculpture in Africa, which is the privilege of the tourist.

8

SAMBURU ENCOUNTERS WITH MODERNITY:
SPEARS AS TOURIST SOUVENIRS

This chapter concerns the interplay between commodified and noncommodified forms and the situating of Samburu cultural practice within the creative tension between representation and identity. The souvenir, an object that both represents and identifies, operates at the intersection of memory and experience. More specifically, souvenirs commodify a particular type of memory associated with the tourist experience, which in Kenya is centered on the safari.[1]

SAFARI TOURISM AND THE SAMBURU

The way the process of cultural commodification took hold was very different in British-held East and West African colonies. While West Africa, and especially Nigeria after the Benin Punitive Expedition of 1897, became a major site of specimen-collecting by museums of ethnology, East Africa instead became a safari destination. Beginning with Teddy Roosevelt's legendary elephant-hunting safari early in the century, affluent foreigners journeyed to Kenya, Uganda, and Tanganyika to hunt among the vast herds of wild game and the spectacular landscape of snow-capped mountains (Mt. Kenya, Mt. Kilimanjaro, the Rwenzoris) that frame the two branches of the Great Rift Valley.

Out of the big-game-hunting tradition of the colonial period, modern varieties of safari tourism, centered on the camera instead of the gun, developed as the new East African governments set aside wildlife reserves and national parks. In Kenya these were located mainly in undeveloped regions peopled only by pastoralists, so it was

FIGURE 8.1. Photograph of a sacrifice stored in a Samburu house, Maralal, Kenya, 1996. *Photo by author.*

inevitable that a few of the more intrepid safari tourists would eventually find the Samburu, though they are too hard to reach to be on the "standard circuit" organized from Nairobi.

What is surprising is that a sizeable number of tourists have encountered Samburu not in the former Northern Frontier District (which is still a punishing drive on rough tracks) but far away at the Swahili Coast on the beaches of the Indian Ocean. The reasons why this happened and the subsequent commodification of the Samburu spear and even moranhood itself could be summed up in the wry title of a panel on Kenyan pastoralism at the 1993 African Studies Association meeting: "No More at Home on the Range."

Kenya is a predominantly dry country[2] with a burgeoning land crisis, in which the roughly 25 percent of land considered to have a high potential for agricultural production in the central highlands is occupied mainly by farming smallholders who until recently had one of the world's highest birthrates. This has produced a steady incursion of Gikuyu and other farmers into pastoralist lands that were previously considered marginal for agriculture, causing ongoing conflict and competition over land use. At the same time, safari tourism, which until recently was second only to coffee production as

an earner of foreign exchange, has also eaten up substantial portions of pastoralist land that is now set aside as game reserves.

So far these conditions have most affected the core Maasai who live on more fertile grasslands closer to the central highlands, though commercial wheat farms and fenced ranches are also a familiar sight in Laikipia, in the Rift Valley District south of Samburu, and even in the fertile uplands of Samburu District. There, a combination of frequent droughts, ongoing desertification, raiding by Somali *shifta* (Samburu: *ljipita*) and Turkana *ngoroko,* and allocation of scarce fertile land to private ranches have reduced dramatically the size of Samburu herds and the rangeland that was available to them at the beginning of the colonial period. In the 1920s, there were ten domestic animals for every person on the Lorroki Plateau (the Samburu highlands). Now, thanks to population growth and stock depletion, that ratio has been reversed: there are ten people for every domestic animal. For Kenya as a whole, the result has been farmers without enough land to grow food and pastoralists without sufficient stock for milk production or enough land for grazing.

With this impoverishment has come pastoral sedenterization in the vicinity of towns and trading centers that has created conditions that forced pastoralists to enter into wage labor (Hjort 1981) and various forms of entrepreneurship. These conditions have affected the Turkana most, since their district has the most inhospitable terrain for cattle-raising and many have been resettled as drought refugees by the Catholic missions and aid agencies farther south in Samburu District. These sedentarized Turkana, with few or no cattle, are accommodating themselves to the dominant culture, for example in accepting circumcision as a sine qua non for living among the Samburu. Conversely, Samburu women have learned from more-entrepreneurial Turkana women how to trade in traditional goods—cloth, beads, ochre, local medicines—and to carve and stitch beaded dolls and other commodifiable objects.

While Samburu are less willing than Turkana to take menial informal sector jobs (for example, making charcoal in the forest and selling it in town), one Samburu group, the *lkunono* smiths, are actually predisposed to an entrepreneurial stance as cultural brokers. The contact with tourism, while it is limited to a few sites and involves very few Samburu, has provided an opportunity to participate in the money economy without the loss of status that comes with menial

labor or the capital necessary to undertake livestock trading. Both entrepreneurship and brokerage characterize the new breed of *lku-nono* moranhood.

Two interrelated issues emerge from this situation: first, the commodification of the Samburu spear (and beadwork) beyond local circles of exchange, and second, the warrior's representation and changing identity in this new social context where he himself has become a kind of commodity. This in turn plays into Samburu subjectivity, most particularly into the self-representations of the blacksmith caste, who are more likely to have contact with outsiders. At the other end of the lens is the problem of spectatorship and the gaze of the safari tourist. To what degree is he (the pronoun intentional) just a modern Joseph Thomson or Ludwig von Höhnel with a backpack or camcorder?[3] To what degree the patron who sets the terms of a patron-client relationship?

THE SOUVENIR: COMMODITY AND OBJECT OF MEMORY

Discussions of so-called tourist art usually focus on its commodity status. Appadurai's often-quoted essay in *The Social Life of Things* succinctly addresses the question of tourist art as an example of "the very complex relationship between authenticity, taste and the politics of consumer-producer relations" (1986, 47). He sees at the producer end "traditions of fabrication . . . changing in response to commercial and aesthetic impositions or temptations from larger-scale and sometimes far-away consumers." At the consumer end there are "souvenirs, mementoes, curios, collections, exhibits and status contests, expertise, and the commerce on which they rest." In his analysis, tourist art exemplifies a situation in which "group identities of producers are tokens for the status politics of consumers" (47).

While it is essential when situating such objects against an art-historical discourse whose premises lie in notions of uniqueness and authenticity, the category of commodification tends to resist analysis of the patron or spectator as anything but a consumer and the artist as anything but a producer. Thinking about aesthetic objects as goods is productive for locating and contextualizing them within systems of exchange, yet the language of commodity forms works less successfully in dealing with the highly contingent and often somewhat blurred realities of cultural practice and cannot do full justice to the

ethnographic complexity of the encounter between artist and specta-
tor. But if not goods, or not only goods, then what? I will suggest that
if we are to understand what is happening to Samburu artisanal prac-
tice, we must look at the tourist encounter as well as the objects.

Therefore I will examine two related sets of artifacts—photographs
of and spears made by the Samburu pastoralists—in the context and
language of the souvenir and theories of collecting. I will contrast
this with the use Samburu themselves make of their photographs and
their attitudes, both artisanal and sociological, toward making spears
for foreigners. Although they are neither rigorous nor codified, these
attitudes constitute an aspect of Samburu thinking that underlies
their notions of identity and self-representation. The pairing of pho-
tograph and spear is not arbitrary: the most common postcard and
coffee-table-book image is precisely the spear-carrying warrior, and
this in turn defines the spear as the perfect souvenir of the hoped-for
(if seldom realized) "authentic" encounter between the traveler and
the pastoralist.[4]

For the returned traveler (who in this context is also the collector
and was once the spectator), the spear and the postcard are alike in
the sense that they exist as fragments of something else, metonymic
references to a larger cultural experience that is being remembered
and objectified. By contrast, the meaning Samburu attach to spears is
mediated not by time and distance but by social context. Spears have
multivalent properties as weapons, social markers, and metaphors
for virility, and for members of the blacksmith group, they have the
additional property of being an object with exchange value.

To Samburu, photographs are essentially mnemonic devices used
to recall specific occasions and events.[5] It can be seen that Samburu
and foreigners' ideas about the same artifacts are not "parallel" con-
cepts (as in "producer" and "consumer"). There is an inclination on
the part of both anthropologists and art historians to see the world
in terms of key dualisms: center/periphery, self/other, artist/patron,
producer/consumer. But from an on-the-ground perspective, one is
just as often working with ideas generated by encounters that are in
conflict but not necessarily in opposition.

A souvenir (from the Latin *subvenire*, to come into the mind) is an
object of memory; a token of remembrance of a person, a place, or
an event; an object that comes to stand for something that is remem-
bered. In that sense, its meaning is private and individual to its owner

rather than public and collective. Yet certain kinds of objects become accepted repositories of such recollections in particular cultures and time periods—the Victorian locket, the family photograph album, the stolen street sign displayed in a college student's room—suggesting that there is also a social meaning to the souvenir, something that affirms and legitimates the memory for other viewers as well as for its collector. It is also clear that these "memory-objects" function as signs that recall for their owners and other knowing viewers a complex set of associated meanings. I will suggest that the Samburu spear is one such sign when it is introduced into a collecting context, since it is not only an important social marker in the Samburu age-grade system but also a weapon used against both animal and human predators.

FROM EXPLORERS' ACCOUNT TO WEBSITE JPG: ONE HUNDRED YEARS OF REPRESENTING WARRIORHOOD

It is possible to describe the Samburu solely in terms of the environmental determinism ecologists favor or the age-grade system that has traditionally been the focus of anthropological study. What the Samburu (and, more broadly, the Maa-speaking pastoralists) represent to the typical traveler in the East African savanna is neither of these, yet their representation has been remarkably consistent in the popular imagination for more than a century: they are aestheticized and reinvented as proud nonconformists rejecting modernity, who therefore appear as a last living sign of a primordial Africa. This representation can be broken apart into three aspects: comportment, body decoration, and the accoutrements of warriorhood—particularly weaponry, since it is in these three areas that the aesthetic locus of the culture is highly visible.

In the nineteenth century, before the big game safari and tourism developed, the aesthetics of Maa warriorhood was already being inscribed through popular travel-writing. In May 1883, Thomson's caravan reached Maasailand while trying to establish a route inland to Lake Victoria. Expecting fierce and uncouth savages, the Scottish geologist was astonished by the grace and ease of these young men:

> Passing through the forest, we soon set our eyes upon the dreaded warriors that had been so long the subject of my waking dreams, and I could not but involuntarily exclaim,

> 'What splendid fellows!' . . . After a most ceremonious greet-
> ing performed with much gravity and aristocratic dignity . . .
> the oil-and-clay-bedaubed warriors assumed a sitting posture.
> . . . A spokesman arose, leisurely took a spear in his left hand
> to lean upon, and then with knobkerry as an orator's baton,
> he proceeded to deliver his message with all the ease of a
> professional speaker. With profound astonishment I watched
> this son of the desert . . . speaking with a natural fluency and
> grace . . . and a dignity of attitude beyond all praise. . . . Till
> the formal speech-making was over, each one had sat with
> unmoved countenance, betraying by neither word nor sign
> that the second white man they had ever seen in their lives
> was sitting before them. (Thomson 1887, 90)

While Thomson's encounter was that of explorer wary of meeting
a potential enemy, the colonial settler's reaction was more compli-
cated. The Maasai refused to work for Europeans and they refused to
recognize through their behavior the colonial social hierarchy with
Europeans on top, Indian or Arab traders in the middle, and Africans
at the bottom. This, along with their aloof comportment, helped
earn them the reputation for "arrogance" that had a double edge: to
European settlers it was a continuing cause for both annoyance and
admiration.

But here too, it was the warrior's embodiment, his ease of move-
ment and confidence in his superiority, that impressed itself on
Europeans. Karen Blixen, like Elspeth Huxley and other colonial
writers, betrays both of these reactions to the Maasai in different pas-
sages of her 1937 memoir. But when she couches her description in
terms of a total personal style, encompassing dress, cosmetics, and
weaponry as well as behavior, it is fulsome and frankly admiring:

> A Masai warrior is a fine sight. Those young men have, to the
> utmost extent, that particular form of intelligence that we call
> chic:—daring, and wildly fantastical as they seem, they are still
> unswervingly true to their own nature, and to an immanent
> ideal. Their style is not an assumed manner, nor an imitation
> of a foreign perfection; it has grown from the inside, and is
> an expression of the race and its history, *and their weapons
> and finery are as much a part of their being as are a stag's antlers.*
> (Dinesen 1937/1966, 145, emphasis added)

This analogy of the moran to a wild yet beautiful animal appears frequently in colonial and postcolonial discourse. Joyce Cary (1944, 44) described the Maasai as "a brave, proud, handsome race" and lamented the idea of their being "settled, *tamed* and commercialized" (emphasis added). Samburu and Maasai elders also speak of the "wildness" of moran and their refusal to obey elders' injunctions or show proper respect for authority, but such statements express disapproval, not admiration.

The alleged panache of the moran is seen by Europeans to reside equally in attitude and appearance and combines physical elegance with a sense of social superiority. How does this translate from literary trope to lived social reality? The Samburu and their core Maasai brothers claim important status distinctions between themselves and all non-Maa. This is because they believe pastoralism to be an intrinsically preferable way of life and a devotion to animals to be the most reliable sign of a person's character. But it is no longer the case (if it ever was) that they are unwilling and unable to adapt to changing environmental and political pressures. I will illustrate this with the behavior of the Lkurorro age-set of the Samburu—middle-aged men who are now elders entering the second stage of postwarriorhood—in their entrepreneurial activities at the Swahili Coast during their warrior days.

But to update these outsider representations of the Maasai and Samburu to the postcolonial era and to demonstrate how they play into the importance of the souvenir, one need only look at that most ubiquitous of all genres, the postcards sold in safari lodges and hotels throughout Kenya. Here, as in the plethora of coffee-table books with names like *The Last of the Maasai* (a title first used by Hinde and Hinde in 1901 and most recently by Amin and Willetts in 1987) and *Vanishing Africa* (Ricciardi 1977), the focus is squarely on pastoralists as a "disappearing" beautiful people who exist in a remote and exotic environment among the elephant, lion, buffalo, and zebra in the spectacular natural landscape of the Great Rift Valley. A recurrent image is that of the warrior with his spear who is embodying a set of behaviors, an elaborate aesthetic system of body arts, and the inclusion of weaponry as an essential social marker. It should not surprise anyone that spears should become, at least for male travelers, a highly desirable souvenir.

This persistent image as an object of memory functions on two levels: as a mnemonic and, at a more elegiac level, as a repository

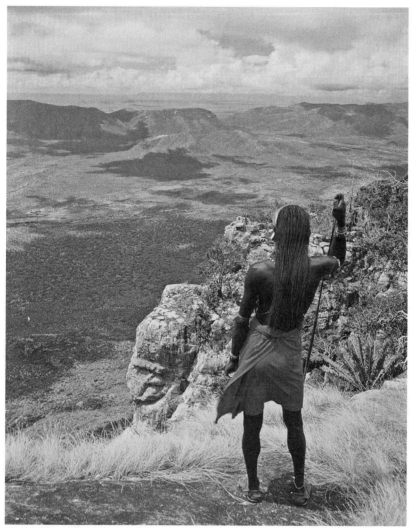

FIGURE 8.2. Samburu moran atop Mt. Sabachi, Kenya. *Source: Nigel Pavitt, Samburu (1991).*

of nostalgia. At the first level it instantly recalls for the traveler his safari and its highly encapsulated encounter with an exotic culture in a remote place. At the second level, it allows the traveler to identify himself—and one speaks here of male-to-male encounters—at some deep level of consciousness with someone who seems to exemplify a perfect manhood that no longer exists in European culture. The *lmurrani* appears to be effortlessly at one with nature, able to subsist independently in a harsh environment, and uninterested in

the trappings of Western civilization. Further, these pastoralists are "natural aristocrats," not only in preferring the spear to the hoe but also in their physical attributes. Meanwhile, the postcolonial Kenya Ministry of Wildlife and Tourism, while of two minds about promoting Kenya as "primitive," understands the efficacy of such imagery as a marketing strategy. So there is the seemingly endless production of postcards, travel posters, game-park brochures with Maasai and Samburu as generic cultural symbols of an "authentic" Africa, and even carved representations of them by Kamba artists—an interesting subject in itself that calls into play Kenyan ideas of otherness. Finally there is the Internet, where sites such as www.tourismkenya. com employ the same spear-carrying Samburu warrior as a jpg image. It is consistent with British colonial admiration for the pastoralist life that many of the upscale safari camps and cottages are located on private ranches and reserves owned by white Kenyans in the Laikipia region bordering Samburu District.[6]

Moving through this field of objects, it seems inevitable that the male traveler with a nostalgic propensity to identify with "vanishing worlds" should want to acquire a Samburu spear—an artifact heavy with these multivalent associations of manhood. He will also, if possible, collect images of Maasai and Samburu moranhood—postcards, snapshots, and perhaps one of the beautifully illustrated books sold in Nairobi shops or upcountry safari lodges (e.g., Pavitt 1991; Saitoti and Beckwith 1980; Amin and Willetts 1981, 1987).

THEORIES OF COLLECTING AND LOOKING

Theories of collecting, both Marxian (Benjamin 1968a) and psychoanalytic (Baudrillard 1968), intersect with those of the souvenir (MacCannell 1976; Stewart 1984), the latter often situated within the phenomenon of tourism. Collections of stamps, butterflies, or rare editions of books have a different reason for existing than collections of souvenirs. In the former, it is the passion for completeness that motivates the collector; in the latter it is, as we have seen, something else—nostalgia, longing, memory, the proof of an authenticating experience. Both may involve competition with other collectors and both are important sources of validation for their owners, whether or not the actual artifacts are rare or costly.

The souvenir is entirely self-referential, while the object collected as part of a set derives its significance from its relation to others in

the same set (Schor 1992, 200; MacCannell 1976, 79). Postcards are peculiar in that they bridge these two types of collection—the series and the souvenir. One initially may collect postcards as evidence that one has "been there," but this may mutate into collecting them in order to augment or complete a particular iconic category (as in my own collecting of Maasai and Samburu postcards). Or in Naomi Schor's parallel formulation concerning her collection of Paris postcards, "the metonymy of origin is displaced . . . by a secondary metonymy, the artificial metonymy of the collection" (1992, 200).

Photography, and therefore the postcard photograph, has its own internal social history and theories of representation apart from its role as collectible artifact, but what interests me here is its power of evocation as an object of memory. (In this sense the spear and the postcard are equivalent, though they are at two different degrees of removal as representations). There are two other approaches to the interpretation of these types of photographs that are well known but that I have chosen not to pursue here beyond brief mention: first, the notion that tourism is a form of cultural appropriation and that taking photographs is an obsessive type of capitalist consumption (MacCannell 1976). In this interpretation, images of the Samburu and Maasai become material commodities that circulate and are consumed in a world system of exchange. While I think this is obviously true at the level of social fact, it is one of those useful observations that does not get us closer to the actual encounter itself.

The second is the interpretation of the subject in terms of the photographer's gaze. Implicit in the gaze discourse is an assumption about power, of dominance and subordination, that translates very roughly here into the dominance of the colonizer over the colonized or, more accurately in this instance, the camera- and money-wielding foreigner over the spear-carrying native. While this inequality is indeed axiomatic, the tourist is not quite as powerful as the colonizer once was because the "native" has the right of refusal and, in the Samburu case, does not hesitate to exercise it. In fact, it is the Samburu and Maasai's seeming imperviousness to the gaze that has earned them the approbation of Europeans—in Dinesen's words, "an object for contemplation . . . which is to be seen . . . but which itself sees nothing" (146).[7] For the most part, Samburu ideas of self-representation do not allow for their interpretation as "victims" or unwilling subjects. For this reason, I avoid some of the assumptions of the gaze discourse but will embrace many of its conclusions.

The one exception to this seeming imperviousness concerns photographs of women—a very different kind of representation and one that more obviously reflects the deep inequalities of power between colonizer/male spectator and colonized/female subject. There is a type that Malek Alloula (1986, 105), in his study of the erotic postcard images of colonized Algerian women, described as "The lucky bastard!" postcard, sent home by French soldiers to elicit envy from their comrades with the intended message that this smoldering oriental eroticism was theirs simply for the asking.

This has its counterpart in the postcards for sale in Nairobi hotels depicting young bare-breasted pastoralist women and girls—Samburu, Maasai, Turkana, and others. These are usually posed by the photographer to occupy the full frame of the camera and thus blot out any contextual background while at the same time focusing on the upper torso. The woman is smiling and dressed in her beads and perhaps a leather skirt. In one recent example, she stands in a pool of water that reaches her ribcage and droplets cling suggestively to her face, shoulders, and breasts, as if she has been submerged.

Alloula (1986, 130–131) argues that the colonial postcard is the perfect expression of the violence of the gaze, in which "the colonizer looks, and looks at himself looking." In a radical social critique, tourism is also a form of spatial colonization and tourist postcards as criminal as colonial ones. This kind of explanatory model, while it has been accepted by many critics, situates the colonized in a helpless passivity—a state that does not fit Samburu ideas of either social worth or prescribed behavior. Even Samburu women, subordinate to men as they very clearly are and with very limited access to strategies of protest, sometimes manage to subvert this "tourist gaze." When a woman of my acquaintance discovered that her photograph, which had been taken without her knowledge by an Italian priest at her marriage ceremony, had been made into a postcard and was being sold in Nairobi, she complained to her husband, who took legal action on her behalf and successfully sued the postcard makers. The resulting litigation was carried as a feature story in the *Daily Nation* in Nairobi.

Sexual themes in the representation of both women and warriors form a recurrent topos in Western photographs of pastoralists, just as in other representations of the "savage" throughout history. They play heavily into the spectator's fantasies of possession, but to assume that they are merely a more exotic version of the Western

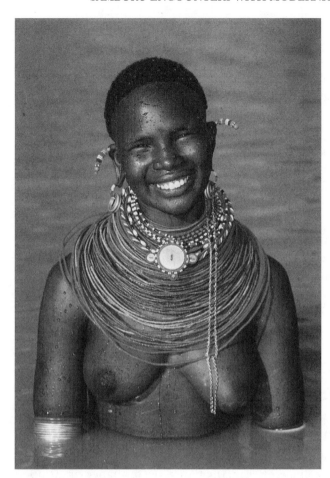

FIGURE 8.3.
Young
Samburu
woman
submerged.
*Courtesy of Sapra
Postcard Studios,
Nairobi.*

magazine pinup would be to miss part of their significance. There is
also a nostalgia being voiced for physical perfection itself—that same
ephebism seen in the Attic kouroi of classical antiquity.

Maasai warriors are admired for their "breeding"—another
approving term of the European settler aristocracy that conjures up
associations with rarity and distinction but in the idiom of the ani-
mal world: "Physically, they are extraordinarily beautiful, with slender
bones and narrow hips, and the most wonderful rounded muscles
and limbs. So delicately built are they that they look more effeminate
than the women. But their beauty is entirely masculine. Their breed-
ing shows in their finely cut nostrils and the precise chiselling of their
lips" (Cameron 1955, 45).

In some photographs for the art-book souvenir trade, notably those of Samburu and Maasai circumcision rituals, nostalgia is colored by something closer to voyeurism, legitimated as a form of ethnographic documentation. There is a fascination at the very idea of semipublic genital cutting that makes these group ceremonies a magnet for outsiders—tourists, missionaries, and professional photographers.[8] Detailed photographs, somewhat more discreetly contained within coffee-table books instead of on postcards, may show the nude initiate, the moment of cutting, and the aftermath. Other instances of young male nudity are also caught by the camera, in states of ritual undress or in the performance of tasks such as taking water from deep wells (Pavitt 1991, 88–90, 158).

Because published photographs and postcards[9] always raise the issue of multiple spectatorship, their readings will vary depending on whether the subjects are aestheticized, treated as "data," or viewed as a disguised form of pornography. But within this "multitude of gazes" (see Lutz and Collins 1993, 192–197) there is a discernible element of the erotic underlying both nostalgia and voyeurism.[10]

PERFORMING WITH THE BODY

If the photograph can project several kinds of representation to its readers, how do the Samburu and Maasai subjects visualize themselves?[11] While the postcard is a static representation of male or female sexuality keyed specifically to Western ideas of what constitutes ethnographic eroticism, the dance performance draws upon comportment as much as the decorated body itself and is therefore a more promising framework for understanding local meanings.

A major distinction must be made between men and women in that warriorhood, a prolonged period in which there is a strong emphasis on elaborate body arts and weaponry, happens only to males. The period in which a female makes elaborate use of ochre and beads extends for a much briefer time from prepubescence to marriage and corresponds to her period of romantic involvement with warriors. But for both, flirtatiously suggestive behavior is incorporated into song lyrics and dance movements in ways that have already been described. What may seem erotic (because it is tabooed) to the Western spectator, her exposed breasts, is culturally neutral here except among girls who have been to school. Instead it is the baring of her throat, which

is usually hidden while stacked with beads, that carries a discreetly sensual message. Spencer recorded the response of one moran to this: "You are standing there in the dance, and a girl starts to sing. She raises her chin high and you see her throat. And then you want to steal some cattle for yourself. You start to shiver. You leave the dance and stride into the night, afraid of nothing" (1985, 149).

One reason for such strong reactions is that male and female nudity is treated very differently by pastoralists and Westerners. Normativities of dress and undress are always contained within a complicated set of rules that define the range of choices available. Conditioned by the relative lack of privacy in sleeping arrangements and aided by the total darkness inside a Samburu house at night, men and women never intentionally reveal themselves to each other in a state of full nudity. Nor do Samburu rules of behavior, even in marriage, allow them to explore in a tactile fashion those parts of the body that are not publicly visible. At the same time, elaborate body decorations, suggestive dance movements, and an ease with bared breasts might easily give an outsider the impression that Samburu sexual mores must be very liberal, when on a contemporary Western scale they actually would seem quaintly old-fashioned.

Certainly their self-awareness is much more subtle than simply the bare expanses of flesh accentuated by ochre and beads that are the focus of Western spectatorship. Little boys (who are considered asexual) and old men (who as patriarchs don't care what people think) are often careless about the exposure of the body, but warriors and middle-aged men are very mindful of propriety and always adopt postures of sitting, reclining, and squatting that reflect a strong sense of body awareness. It is also a regime that maps the body and its adornments onto a set of power relationships within a group.

If one has spent any time with moran, one has no doubt that they care greatly about their appearance and actively cultivate a view of themselves as devil-may-care seducers of girls or women and fearless fighters. The use of ochre mixed with fat as a body cosmetic is well understood to have sensual as well as symbolic meanings that complement each other. The long hours spent plaiting each others' hair into intricate coiffures and drawing designs with makeup on the face would be read by the Western spectator as "effeminate" behavior unless it was contextualized against their readiness to fight and prowess in using weapons. The models of male comportment most readily

available in Anglophile cultures do not easily fit the pastoralist, yet warriors are obviously comfortable with these pieces of their identity and to see a preoccupation with personal adornment and a love of fighting as somehow in conflict is simply the result of an attempt to accommodate them within a Western cultural script.

REPRESENTING AND REMEMBERING
WARRIORHOOD AND THE SPEAR

While the photograph is a container of memories for both outsiders and the Samburu themselves, no such parallel exists for the spear, which has emerged as a specifically intended souvenir only over the past twenty-five years.

The blacksmiths who ply their trade in Samburu District sell most of their spears to other Samburu and sometimes to their rivals the Turkana. But Maralal is also a stop on the northern game-park circuit, and the relatively few tourists who get as far north as this, disgorged for an hour or so from microbuses or the big-wheeled Saharan overlander trucks, provide a small supplementary form of patronage for them. Another large portion of the local spear production is reserved for carrying to Mombasa, which will be the other locale of this story.

The Lkurorro age-set, which was initiated in 1976, became warriors at a time of great difficulty in the pastoralist economy of northern Kenya. Many of their fathers and older brothers lost massive numbers of cattle in the 1974 drought and subsequent spread of East Coast Fever. To the older generations of Samburu, cattle are the only recognized form of wealth, but these young moran were the first age-set to realize fully that money can be a safer investment than cattle.

While a few Lkishili, who were circumcised in 1959–1960, were the first to make the long journey to the Swahili Coast, the Lkurorro were the first Samburu age-set to migrate there seasonally in numbers. From about 1981, when most of them reached their early twenties, pairs or small groups of Lkurroro from both blacksmith and nonsmith families made the seasonal migration all the way to the Coast, where they congregated up to fifty at a time in one small enclave between Mtwapa and Kikambala a few miles north of Mombasa among the beach hotels that hold German, Swiss, Italian, British, and American tourists. On the beaches, they sell the spears

they have carried on the long journey from upcountry Maralal to coastal Mombasa.[12] Since the initiation of the Lmooli age-set beginning in 1990, these warriors have largely replaced Lkurorros, who are now stock-owners and fathers with young families.

Everything about this new style of migration appears to be a departure from older patterns of transhumance by Samburu: first, there are no cattle; second, instead of walking, they ride in an upcountry bus; third, they abandon the everyday dress of the warrior (*shuka,* sandals, beads) and his sword and twin spears in favor of the generic town dress of blue jeans, jacket, and sneakers. Like the liminal period between circumcision and the *lmugit* ceremony that confers warrior status, this journey to the Coast is another time-out-of-time requiring different visible signs of identity. In this guise, the Samburu is almost indistinguishable from other young Kenyan males in the overcrowded *matatus* carrying passengers from upcountry stations to Nairobi. He seeks anonymity, though two things inevitably draw peoples' attention: his pierced and enlarged earlobes in which ivory plugs normally are set and the presence of his *rungu* (*lringa*), the throwing stick thought to be necessary for self-defense in dangerous places like Nairobi. Yet in other ways, this trip is not very different from the far-flung wanderings of warriors in Samburu District but for the fact that the distances are greater and the cultures encountered are more foreign to pastoralist norms. Warriors are beholden to no one but themselves, and this is a logical extension of that freedom.

Warriors do not use Nairobi, halfway to the coast, as a place to break the journey for long, partly because most moran travel with little or no money but also because they perceive it to be a hostile place where police hassle "primitive" pastoralists (the most frequent reason moran give for not wearing the *shuka* while traveling). Most go directly from the *matatu* to wait for the Malindi bus of a popular coach line that plies back and forth daily at perilous speeds between Nairobi and the Coast.

Once they reach the Samburu enclave at the Coast, they change back into their *shukas* and beads, since Samburu ideas of self-representation dictate that they identify themselves as moran, not merely generic Kenyan youth. This is a manifestation of warrior hubris and Samburu/Maasai claims to social distinctiveness, but it is also a conscious strategy to attract attention—a variation of the warrior theatre that is performed for a female Samburu audience back home. Moran

FIGURE 8.4. Selling tourist spears on Bamburi Beach, north of Mombasa, Kenya, 1991. *Photo by author.*

are perfectly aware that dressed in a pair of jeans, they stand far less chance of marketing their spears. Thus, there is a highly instrumental convergence of traditional norms of dress with an understanding of how to deal with tourists as a new clientele for Samburu artisanship —these moran seemingly can have it both ways.

INNOVATION FAR FROM HOME

What happens at Mtwapa could best be described as a closely cir- cumscribed set of artistic innovations that relate not only to a new and different kind of patronage but also to the Samburu/Maasai sense of age-set competition. This competitiveness is especially felt toward the age-set immediately senior—that felt by the Lkurorro toward the Lkishili and more recently by the Lmooli toward the Lkurorro.

While many of the bachelor warriors who come to the Coast are of the *lkunono* blacksmith caste, none of the actual smithing is carried out there.[13] The coast-bound spear blades and tails are all made by smiths in the southern part of Samburu District and are a miniatur- ized version of the small-bladed Samburu spear type known as *nkuch-uru,* or "youth's spear." At Mtwapa, the smiths embellish the middle of the wooden shaft by the burning in geometric designs and make a

highly elaborated spear-blade cover. These are innovations that have developed out of a known and shared artisanal tradition as it came into contact with a new set of patrons.

One important crossover is that of warrior to craftsman and another is the blurring of traditional distinctions between spear production as a male occupation and the beading of leather by women. In Samburu District, the spear-blade cover is a simple but expertly fitted piece of leather that may or may not be embellished with a black ostrich feather. At the Coast, it more closely resembles a piece of women's beadwork to which has been added a plume of goat hair rather than an ostrich feather. The Samburu perception is that male tourists, especially the Germans and Italians who are the main buyers of spears, want brightly colored (e.g., red and yellow) beads on whatever they buy (see plate 15).

The Samburu use black (male) ostrich feathers as a sign of themselves, "the people of the black and white cattle." The word *gesidai*, something that is beautiful or good, is applied to certain black-and-white savanna animals such as the male ostrich and the zebra, neither of which are ever killed or eaten and both of which are self-referential to males because of their color (Michael Rainy, pers. comm.). Although both types of spear-blade decoration are part of the Samburu grammar of representation, one is a Samburu interpolation of a Western aesthetic preference and the other is driven by a structured indigenous precept that implies both efficacy and aesthetic value (see plate 1).

The other major departure from the "authentic" working model is the miniaturization of the tourist spear. The Samburu explain the difference in scale between an actual warrior-spear, which should be substantially taller than the warrior himself, and the much smaller versions made for tourists as a practical matter: foreigners will not buy a large spear both because they don't want to pay what it should cost (the equivalent of up to two she-goats) and because they cannot transport it back to Europe on an airplane.

But in the language of signification, something else has also happened: the relation between the abstract and material nature of the sign has altered (Stewart 1984, 43, 52–53). The object has become smaller, with the net effect that its meaning has become compressed—a process similar to the one that creates bumper stickers ("I love Samburu") and "Karibuni Kenya" T-shirts with Maasai warrior logos printed on the front—and, indeed, postcards. Both

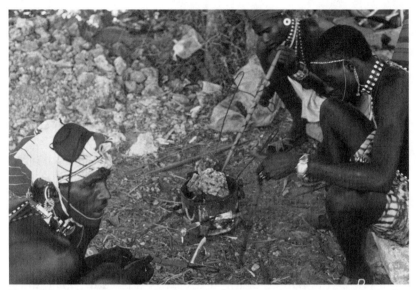

FIGURE 8.5. Samburu moran burning in designs on the wooden midshaft of tourist spears, Kikambala, Kenya, 1991. *Photo by author.*

miniaturized spear and postcard are intensified repositories of messages and memories.

This intentional aesthetic separation—simple versus elaborate, large versus small—is symptomatic of the approach the Samburu have to both making objects for strangers and sojourning far from home. One the one hand, they have learned everything they need to know (including, in many cases, a speaking knowledge of rudimentary German) about tourists and tourist hotel operators. Yet they know almost nothing about the food, customs, religion, or community structure of the Swahili people of Mombasa among whom they move daily. The reverse is also true, and they are known (and identify themselves) as generic "Maasai" to tourists, hotel owners, and Swahili alike. There are in fact a few Maasai moran among them, and away from their respective homelands they are comfortable with this common ethnic identity, which is reinforced by language, custom, and body arts and the studied aloofness toward non-Maa-speakers both Maasai and Samburu cultivate. Their habit of dressing exactly as warriors do at home reinforces the view of them by both tourists and locals as exotic others.

They live together in a concrete-block enclave of rented rooms, the functional equivalent of an all-male cattle camp without the

cattle. They eat together at the small canteen across the road owned by a Maasai whose mother is Samburu. Their decision not to mix with locals is not imposed by language skills, since they are almost all conversant in Kiswahili. Rather, it is shaped by their view of the Coast as a place that is physically as well as culturally inhospitable to Samburu and Maasai. The sea-level climate is unremittingly humid and usually hot (whereas the Samburu highlands at 7,000 feet are "cold," meaning healthy, bracing); here there are mosquitoes and malaria. Even worse, people eat fish and other seafood, which violates Samburu and Maasai food prohibitions. There are also unclean people about: prostitutes, both male and female, with whom it would be dangerous to associate because of the risk of contracting AIDS and venereal diseases. Finally there is the attitude of the Samburu back home to be concerned about. The older age-sets regard the younger ones as wastrels and adventurers who are lacking in discipline and are ready to criticize them at any public meeting.[14]

It is important therefore to prove that one is a "real Samburu" despite these trips to the Coast. The Lkurorro cannot make the trips too often or for too long because they have left warrior status for elderhood. To do otherwise will leave them open to serious community criticism. For most Lmooli, who have recently left formal warriorhood, the Coast is no longer so attractive either.

It remains to discuss how Samburu encounters with tourists fit into a more general discourse on commodification within what used to be called "traditional societies." First, tourism is not the only source of money. Lkurorro typically refer to any exchange that results in the acquisition of shillings, whether trading livestock or selling spears, by the English term "making business," just as they also use the English term "town" for a non-Samburu settlement.[15] What you do in a "town" is "make business." But loading a bundle of spears onto the back of a donkey and walking into Turkana country to sell them is also "making business," so it need not carry the association of selling to foreigners at all.

What is striking is the ease with which the business of selling spears and beadwork and perhaps working as a "traditional dancer" at beach hotels can be incorporated into pastoralist life with only minimal changes—in most cases a few weeks a year away from Samburu District. Ownership of livestock remains the most visible index of wealth, with the result that trips to the coast are not all-or-nothing

changes in lifestyle but periodic attempts to augment resources. For the younger moran, they are mainly adventure, a kind of *Wanderjahr* far from the control of elders. For the older ones, it is a chance to build up capital for the purchase of animals. While this could change in the future, the young men who travel to the Coast are at present still imbued with the values of livestock ownership. This situation contrasts sharply with that of Melanesian societies such as the Iatmul (Silverman 1999), in which many see the continuation of village life as economically viable only because of the presence of the tourist trade.

Silverman's other major point is that the ethnographic encounter with tourists is actually a source of innovation that then plays back into "traditional" noncommodified forms. Now that warriors have become skilled at certain kinds of beadwork while they are at the Coast and away from the women of the family in whose province it normally resides, these designs—modified by tourist encounters and by the presence of nonpastoralist beadwork for sale in the same places—find their way back to the *manyattas*.[16] The town itself is also a source of innovation, and the tinsel Christmas ornaments and plastic flowers sold in markets there have now found their way into warrior headgear in the same way that zippers and buttons became ornaments in the early colonial period (see fig. 6.6).

What I want to problematize is the idea that souvenirs necessarily have, from the point of view of their makers, some kind of marked status that puts them outside the rules of accepted cultural practice. The fact that they are firmly client-centered—making what people are perceived to want or need—can be recognized as a way of embedding new forms of patronage in a much older set of ideas about artisanship in Africa.

In the tendency to see the meaning of the souvenir for its recipient as if that were its only meaning, it is easy to lose sight of its rather different place within Samburu (or any indigenous) social theory and aesthetic practice. Once an artifact has been separated from its customary social and ritual roles, it is free to be newly invented and theorized for a different clientele and a different purpose. In a more conventional Western context, we might refer to this invention as "art." But however much we may prefer to disarm, deconstruct, or neutralize it, it remains for the Samburu a very significant locus of aesthetic practice.

9

SAMBURU WARRIORS IN HOLLYWOOD FILMS: CINEMATIC COMMODITIES

Prior to the 1970s, the Samburu living in the closed Northern Frontier District of Kenya were known only to their fellow pastoralists and a few district administrators and traders. Like Papua New Guinea highlanders, their entry into the global flow is recent, so their exoticism quotient is still high. The way they have been represented in commercial feature films and some of the ways the Samburu have learned through this experience to trade on their own commodification form two aspects of a complex story. In addition, Samburu perceptions of the films and their making were markedly different from those of the filmmakers, and I examine these contrasts in interpretation for what they reveal about cultural identity and its volatility.

DREAMS AND GHOSTS, MAU MAU, AND BASKETBALL

In Justin Cartwright's 1993 novel *Masai Dreaming*, the protagonist-author is in East Africa researching and writing a film script about the incommensurate lives of Claudia, an ill-fated young French Jewish anthropologist in the early 1940s and her equally ill-fated Maasai lover, Tepilit. The writer discovers that Claudia's legitimacy among the Maasai with whom she lived was undermined by an accident involving an American film crew and a staged lion hunt that went tragically wrong and resulted in the death of two warriors and a major fight between two Maasai sections.

In the 1996 film *The Ghost and the Darkness*, a staged Maasai lion hunt occurs once again. This time there was no accident, but since the Maasai warriors in the scene were played by certain Maa-speaking Samburu I know well, I have been struck, over the course of many conversations, with the vastly different understanding they had of the whole undertaking and of the matter of their representation as

293

film subjects from that of the filmmakers and the Western audience. I therefore describe not just the film representations of Samburu, which play upon the usual stereotypes of primordial masculinity and glorious blood-drinking savagery that have been a constant theme in Victorian travelogues and modern coffee-table books but also some of the differences in perception from the standpoint of the subjects. I will also try to frame this within Kenyan public discourse regarding the Maa-speaking pastoralists, because film representations such as these also raise critical questions about national self-fashioning and negotiated issues of ethnic identity.

Several commercial feature films (in addition to numerous staged and unstaged documentaries beginning in the 1920s) have involved groups of Samburu as actors. By far the most extravagant in its staging was the 1953 Hollywood safari film *Mogambo*, starring Clark Gable, Ava Gardner, and Grace Kelly as well as about 1,000 moran, but since there is no record of what the Samburu participants thought about it, I will limit my comparison to three more recent examples whose participants I have known personally. The earliest I will consider here, *Kitchen Toto*, was made in 1987 in Kenya with no Hollywood stars. As a meditation on the 1950s Mau Mau anticolonial insurgency and colonialism's ability to destroy lives on both sides, it is the only film of the three that can lay claim to a serious intention.

By contrast, *The Air Up There* was a 1992 basketball movie with echoes of *The Gods Must Be Crazy* in which star Kevin Bacon tried to recruit one of the exotic Winnabi (Samburu) to play on an American college team desperate for a high-scoring star. *The Ghost and the Darkness*, starring Val Kilmer and Michael Douglas and filmed in late 1995 and early 1996, was a rather terrifying dramatization based on the true story of man-eating lions near Tsavo, Kenya, that almost prevented the building of the Uganda Railway in 1895 by devouring the Indian and Swahili laborers who had been brought in to construct it.[1] Samburu appear strategically in each film, and a few have appeared in all three.

I will first deal briefly with how the Samburu were recruited for these commercial films. The discussion then takes up one aspect of the film representations, the on-screen male bonding that takes place between the white film hero (Kevin Bacon in *The Air Up There* and Michael Douglas in *The Ghost and the Darkness*) and the Samburu warriors. I will then turn to the off-screen realities of the relationship of

the Samburu to everybody clsc during thc filming and will end with
a few observations about pastoralist identities in Kenyan public dis-
course and the commodification of those identities.

MERGING OF IDENTITIES:
FROM SAMBURU TO MAASAI IN AN IMAGINED SPACE

The merging of Maasai and Samburu identities in two of the films
reflects both historical reality and current cultural politics. Since the
British relocation of the other northern Maasai sections from the
Laikipia Plateau to a reserve south of Nairobi and the Athi River in
1911, Samburu no longer have direct contiguity with them and for
most of the twentieth century were the only historical Maa-speakers
in the old Northern Frontier District.[2] This has reinforced a separate
ethnic identity for census purposes and in other relations with the gov-
ernment since the early colonial period. However, the "Maasai-ness" of
the Samburu is a useful connection that is brought into play in many
situations. One of these is in marriage arrangements: some Maasai
men marry Samburu women as second or third wives. Another is in
relation to tourists, who before coming to Kenya have invariably heard
of the Maasai but not the Samburu. Young Samburu *lmurran* therefore
are accustomed to identifying themselves as Maasai to the German and
Israeli and Italian safari clients who cross their paths. At the coastal
beaches, they are all "Maasai." A third is in national politics: one of
the most outspoken "Maasai" politicians under Kenyatta and then Moi
was John Keen, son of a Samburu mother and British father, who was
raised in Maasailand and was elected to Parliament from there but
whenever needed was also a supporter of Samburu causes.

In two of the three feature films considered here (*Kitchen Toto* and
The Ghost and the Darkness), the script is based loosely on events that
actually happened, and Samburu warriors (*lmurran*) played the parts
of Maasai or Samburu historical participants in those events. In the
third film, *The Air Up There*, the Samburu were cast as the "Winnabi,"
a mythical tribe who happen to look and dress like Samburu, in an
unnamed African country. As a casting decision, the reasons for the
merged identities were originally political. *Kitchen Toto*, made in
1987, is about the 1950s Gikuyu-led resistance movement popularly
known as Mau Mau,[3] and since former members of the movement are
still alive, the Kenyan government wanted the film to be shot outside

Central Province where Mau Mau occurred, using actors who were mainly from other ethnic groups.[4] During the Mau Mau resistance, trading on the usefulness of traditional rivalries between the Gikuyu and Maasai, the British colonial government brought in Maasai and Samburu warriors as irregular troops, taught them to use rifles, and used them to help fight Mau Mau insurgents. The Samburu were cast to represent themselves but also the Maasai in a merged identity.

The other casting reason for using Samburu as Maasai, I was told by a producer of *The Air Up There,* is that they are "more traditional," hence more attractive to filmmakers. "More traditional" to a Hollywood producer translates partly into Western correlations of tradition with greater geographical remoteness from urban centers, but it also refers to a relative lack of experience with the cash economy, for example not knowing about contracts or how much to ask for in wages. It was therefore cheaper to hire them.

By contrast, some of the Maasai who live around Ngong just a few miles outside Nairobi come into frequent contact with tourists and professional photographers. Their representation has become highly commodified, from the ubiquitous safari-lodge postcard to advertisements for Visa cards on network television and the 1998 *Sports Illustrated* swimsuit issue. However, the merged identities occur here too: at least a third of the postcards sold in Kenya and labeled "Maasai" are actually pictures of Samburu, the Visa ad on television used footage of both mixed together, and the photograph on the contents page in *Sports Illustrated* is of a group of Samburu warriors dancing, even though Maasai are the subjects in the swimsuit spread that follows.[5] "Being Maasai" is therefore one aspect of being Samburu, and both groups seem at ease with this shared identity when away from their respective districts. This is one of several kinds of cultural elision that occur in all three films.

This merging of cinematic identities is not limited to the Samburu and Maasai. It also occurs in the imagined geography of each film. While the geographic displacement for the filming of *Kitchen Toto* was only from Nyeri in the central highlands to the politically more neutral ground of Kakamega in western Kenya, the other two films were made thousands of miles from the Maasai and Samburu homelands, in South Africa's Kruger National Park and Drakensberg Mountains. Since Kenya has its own spectacular scenery of snow-capped mountains and vast plains in addition to the singular Great Rift Valley, why

would the filmmakers want to shoot in South Africa? Apparently, it was easier and cheaper, even when for *The Air Up There* about 100 Samburu had to be given passports and Western-style clothes to travel in and had to be transported several thousand miles on a charter flight.[6] Film production companies are already in place in South Africa, and there is little or no bureaucratic interference with the filmmaking process there. The Samburu were flown to a rural airstrip and in fact never saw Johannesburg or any other part of South Africa aside from the shooting location. But to lend a touch of credibility, *Air* features one street scene actually shot in Karatina, a small town in Kenya, and *Ghost* has footage shot around Taveta, the southern end of Tsavo Game Park where the man-eating lion episodes actually occurred 100 years earlier. Making films in South Africa's imaginary Kenya has continued with the more recently released *I Dreamed of Africa,* adapted from Kuki Gallmann's memoir of her ranch in Laikipia at the southern border of Samburu country but actually filmed in a remote corner of the Zulu homeland in South Africa's KwaZulu-Natal Province. Director Hugh Hudson (who also made *Greystoke: The Legend of Tarzan* in 1984) told the New York Times, "It's considered more secure, and certainly has a better infrastructure for making movies. . . . And the day we started shooting [August 7, 1998], there was the explosion at the US Embassy in Nairobi."[7]

DRINKING BLOOD TOGETHER

There are several possible approaches to understanding the contradictions and mediations between representation and subject these films raise. One of them requires looking at how the Samburu as subjects are inscribed as elements in the completed film project. Another avenue is by examining the social framework of the filmmaking itself: what happened off screen but on location. The most revealing of the on-screen inscriptions is the consistent way in which both *Air* and *Ghost* construct masculinity as something cross-cultural, even universal, and built upon a kind of primordial "warrior within" who is never far from the surface, despite the trappings of civilization. In *The Air Up There,* the American hero Kevin Bacon proves his manhood to the Samburu by submitting to an ordeal of passage: a ceremonial cutting of the lower abdomen with a knife that is meant to suggest the real Samburu circumcision ceremony, followed by his scaling of

a dangerously high rocky outcrop, alone and in a rainstorm. This, in the film's logic, makes him a Winnabi—one of them—and no longer just a faded basketball star on a recruitment mission.

In *The Ghost and the Darkness*, the parallel moment of truth occurs when a maverick white hunter, Michael Douglas, is brought in to dispatch the man-eating lions that no one else has been able to kill. He brings with him a band of Maasai/Samburu warriors, and that night they dance themselves into a state of heightened anticipation over the next day's lion hunt. Douglas joins them (indicating to the audience his insider status) and at the climactic moment, lifts a vessel of blood drawn from a cow's jugular vein as if it were a chalice and drinks from it. Thus, a gesture taken from Christian liturgy is welded onto a Maasai-Samburu practice in a moment of high theatre.

In actual practice, the blood would be whisked with meat broth or milk to make a fortifying drink, or if the animal had been ritually sacrificed, the blood would be tasted by each warrior kneeling over the carcass. The first is undramatic and the second difficult to photograph, but the chalice is a representation that is easily decodable by the film audience. Douglas and the Samburu were communicants in a quest to conquer the forces of darkness. Both films carry the suggestion that by participating in the ritual behavior of warriorhood, the Western hero can transcend cultural boundaries and become the "warrior within." But in real life, no one quite knew what to do with the Samburu.

THE NON-SPEAKING SUBJECT

While Samburu straightforwardly played themselves or Maasai in the two quasi-historical films, the basketball movie was constructed around a specifically American fantasy of spear-carrying warriors who could be taught to dribble and slam-dunk. It also was not connected to a historical context or any real geography so was a sheer construction in every sense. The Samburu were not central to the other scripts, but in *Air* they—or more precisely, the Winnabi—really were the true subjects of the film.

Despite this, all but one of the speaking parts for Winnabi were played by English-speaking South African actors, who are typically much shorter and stockier than the Samburu and distinctly different looking. One kept wondering if the American theatre audience noticed this, especially the renowned actor Winston Ntshona's pasted-

FIGURE 9.1.
Extracting
blood from
sacrificed
marriage ox
to make a
fortifying drink,
Tinga, Kenya,
2004. *Photo by
author.*

on elongated earlobes—a technique also used for Kilmer's faithful
retainer in *The Ghost and the Darkness*. The one "speaking" Kenyan
was the slam-dunker named Saleh that basketball coach Kevin Bacon
had come to recruit: he was played by an unusually tall Gikuyu from
Nairobi, who later assured the New York Times in an interview that
the real Samburu were, to him, much stranger than New York City
was (see plate 16).

It is also reasonable to ask, since there were plenty of tall good-
looking Samburu to choose from, why this part was played by some-
one else. The answer remains slightly ambiguous but primarily comes
down to a language issue. A substantial number of Samburu speak
only Maa and others speak Maa and Kiswahili (which is taught in all
Kenyan primary schools), but few speak and understand English with
fluency. This was especially the case with *The Air Up There*, which used

about 100 Samburu men and women ranging in age from twenty to eighty. But none of the American or South African film crew for *Air* spoke either Kiswahili or Maa, so there was a clear communication problem.

By the time the third film, *Ghost and the Darkness,* went into production in late 1995, it was recognized that something needed to be done about this, so an American graduate student in anthropology who was fluent in Kiswahili was hired to relay instructions from the director and camera crew to the Samburu and to relay Samburu questions and requests to the filmmakers. Unfortunately, she happened to be both young and female and was also confronting Samburu culture, language, and gender relations for the first time. Most of the group of thirty Samburu were even younger than she was and were on an adventure far from home and full of warrior hubris, so despite her efforts to mediate the language gap, many *lmurran* resisted, and some refused to take orders in this fashion.[8]

This failure of communication was endemic to both of the South Africa–made films and is the lens through which the off-screen cultural inscriptions need to be read. None of the Samburu, aside from their group leader, could tell me the story line of either film or even the title. One reason is that they were never given the opportunity to mix with the rest of the cast and crew away from the set until the filming was completed. For *The Air Up There,* there were three tented camps in separate locations connected by shuttle bus, one for the Samburu, one for the South Africans, and one for the American film crew. But because the South Africans all spoke English, even those who were not professional actors had some idea of what was going on from day to day. Not so the Samburu, who moved through the three months of filmmaking encapsulated in their own set of routines and with only a heuristic understanding of what was actually happening.

MONEY

One has to ask, then, what motivated the Samburu to leave their settlements and disrupt their lives for this. When the filmmakers initially wanted to recruit actors to play their splendidly ochred, beaded, spear-toting Winnabi, they approached Wilfred Thesiger, the elderly British photographer-adventurer who from the early 1960s to the mid-1990s lived outside Maralal in the Samburu highlands. He in turn put the project of finding local recruits from the warrior age-

grade in the hands of his adoptive Samburu son Lawi, who was then the elected mayor of Maralal town and a successful entrepreneur.

Lawi subsequently accompanied the first group to South Africa, where the film producers naively agreed to pay all the salaries for the Samburu extras to him so that he, a person with more money experience, could hold them in safekeeping until they returned home. This plan misfired and the full salaries were handed over only when a group of Samburu complained to the filmmakers and the mayor was threatened with jail. This meant, among other things, that there were no written contracts for Samburu and that none of them except Lawi had any idea what they were being paid for this adventure. Nor did it occur to them to ask, unaccustomed as most of them are to wage labor.[9]

It is worth remembering the much more inventive and (literally) colorful working arrangements the district commissioner in Samburu, Terence Gavaghan, was able to negotiate with director John Ford and MGM for Samburu participation in *Mogambo* in 1953. The problem with *The Air Up There* forty years later was that there was no Gavaghan figure playing the role of honest broker, only a group of unpaid Samburu extras who had to struggle against their "leader" to be heard. After the first South African scenario unfolded in 1993, I suggested to my Samburu friends that they obtain contracts and prearranged agreements about salaries in any future film project. This did occur a few years later for the third film, though all of them would have gone ahead without a contract if it had not been offered.

But despite this lack of experience with "making business," they saw their participation in *The Air Up There* as a rare opportunity to make money and devised strategies to do so. The main strategy was to bring with them, or make while there, the artifacts they knew to be popular with foreigners: beadwork and spears. They rightly assumed that actors and members of the film production crew would want Samburu souvenirs to bring home with them, and in fact they ended by selling every item of clothing, decoration, and weaponry they wore or used in the film. On the last weekend before departure, they were taken to the nearest town so that they could spend their per diem allowances and fill their gym bags with store-bought goods.

But nearly everyone, including the women, bought a cow or calves with the salary payments eventually given to them back in Maralal. When I protested to them that they were paid very little (about $450 each) for three full months of work, most people I spoke with said

that they did not feel exploited, because in Samburu District, they would have no chance to earn this much money.

Furthermore, they were able to sell things such as their spears to the film directors and crew for far more than they would normally be worth in Kenya. Assuming that their opening price was just a bargaining strategy, as it would be in a livestock exchange back home, the Samburu were astonished to see it uncritically accepted by the Americans. The Samburu are relentless bargainers and think nothing of spending most of the day working the price down on a transaction over a cow. Rather than assuming that Americans were too rich to care about spear prices, they supposed them to be deficient in this particular skill, when actually both were true.

For *The Ghost and the Darkness,* the monetary arrangements were different. The much smaller group of thirty Samburu (who were nearly all warriors of the Lmooli age-set) were paid their contractual amount in cash on their return when they arrived at Nairobi Airport and had half a day to shop before a chartered bus took them back to Samburu District. I had arranged to meet them, so I got to see just what everyone bought with their $500. Despite the youthful age of many of the warriors, no one bought Nikes or jeans or cassette recorders. We went to River Road and everyone purchased the same thing—large quantities of red cloth and glass beads from Indian wholesalers, which would be traded in the lowlands on their return in exchange for sheep or goats.

I don't wish to suggest that young Samburu males today have no interest in Western gadgets or stylish clothing, since they quite often do, but that their priorities of what to do with assets are still firmly focused on the acquisition of livestock. Later several of them had to be retrieved from the Central Police Station, where they had been taken on suspicion of possessing stolen property after being seen in the Nairobi streets hefting large bundles of cloth.

The most important part of the film experience for Samburu themselves was participating in the money economy and, however briefly, learning how the commodification of the warrior image could be advantageous. There was also a mild degree of curiosity invoked by riding in an airplane (an adventure a few of the elder Samburu had flatly refused when they arrived in Nairobi and saw their mode of conveyance) and being together in another country in what was effectively a cattle camp without the cattle.

By contrast, they were completely unimpressed by the fact that they were rubbing shoulders with Hollywood stars, and my questions about it were politely fended off as inevitable female curiosity about men's affairs.[10] The only individual singled out unequivocally as someone who impressed them was the Hollywood lion trainer on the set for *The Ghost and the Darkness.*

THE POLITICS OF REPRESENTATION IN KENYA

While films such as these are seen by Western audiences long before they ever reach the movie theatres in Nairobi, commodifed images of Maasai and Samburu on postcards and T-shirts and in coffee-table books are highly visible in Kenya itself. They therefore form a part of public discourse in Parliament and in the press whose broad subject is an imperfect modernity. In the British colonial discourse, pastoralists were a problem because they possessed large herds that supposedly overgrazed and degraded the environment. Furthermore, they showed little interest in the advantages that colonialism bestowed—Western-style schooling, material possessions, participation in a cash economy. Paradoxically, they were also admired by the British for these very reasons, for their devotion to a Spartan life and confidence in the superiority of their own values.

In the postcolonial nation-state they are still seen as a problem, but the problem is now couched in terms of the land issue. Pastoralist grazing land has been continually encroached upon by the government and by Gikuyu and other farming people who have been forced off their own land by their rapid population growth and continual subdivision of inherited family plots. This resulted in frequent violent clashes over land between Maasai and Gikuyu throughout much of the 1980s and 1990s, giving rise to Kenyan media portrayals of what has come to be called "moranism," meaning the behavior that results from the use of moran by Maasai politicians to intimidate their opponents.[11] At the same time it is recognized in government circles that tourists have been promised that they will see not only wild game but spear-carrying warriors, which requires that warriors not be hidden away in jails.

It is also widely believed among Kenyan farmers that KANU, the ruling party from independence until December 2002, was sympathetic to pastoralists, which in their minds has contributed to the

fact that the land issue is still unresolved. Samburu firmly reject such characterizations and typically see themselves as existing on the far periphery of any kind of government policy, citing as evidence their two most pressing issues, large-scale cattle-raiding across the Somali and Uganda borders and catastrophic periods of drought, both of which seldom are alleviated through governmental intervention.

The Maasai's most outspoken politician, William Ole Ntimama, has attempted to link the land issue, about which the majority of Kenyans harbor little sympathy for pastoralists, to the tourist issue.

> The traditions of the pastoralists have been destroyed and "junk culture" imported. . . . We have been dehumanised and perceived as mere artifacts. Our culture continues to be abused and commercialised. We appear on postcards standing on one leg, on covers of glossy books, logos of safari companies and in batiks and T-shirts which are on sale in posh hotels and lodges.[12]

Ntimama sees this commodification process as not merely an outcome of the promotion of tourism but as part of a larger process by which Maa-speaking pastoralists are exploited by anybody who stands to profit by it. It is part of an opportunistic view whereby "Maasailand has been regarded as frontier country, wild and unoccupied and ready for conquest and plunder." In this argument, safari tourism and encroachment by farmers, though they are very different processes, are justified by the view of pastoralists as "disappearing people."

Ntimama argues that in the case of tourists, the "disappearing people" dogma is activated by romantic nostalgia and spectatorship, while in the case of agricultural settlers such as the Gikuyu from the overpopulated central regions, pastoralists have been "persuaded, coaxed, cajoled, induced, threatened and even forced to part with their land totally unaware of the social hazards and abject poverty which has befallen them through the myth of willing seller, willing buyer."[13]

In parliamentary debates, a second set of issues revolves around Kenya's self-image as a modern state that exists in constant tension with the spectatorship of tourism. Laws against photographing nudity are aimed at off-road tourists who encounter pastoralists while on camel safaris; for a while in the late 1980s, there was a blanket law against photographing the Maasai at all (which was universally ignored by both Maasai and tourists). Political theorists have usu-

ally associated this kind of legislated puritanism with fundamentalist Islamic or socialist states in Africa, and while Kenya is neither, lawmakers who are the products of a modernizing ideology do not want Kenya to be known as primitive and backward. This translated into elaborate requirements when the Samburu had to travel to South Africa. They were forbidden by the government to wear their everyday *shukas* and beads while in transit and the film company had to issue them track suits (for the men) or a clothing allowance (for women) to purchase Western dresses. On their return from filming *The Ghost and the Darkness,* the group of tall, lanky moran in identical track suits carrying gym bags resembled a traveling basketball team arriving at Nairobi Airport. At the same time, the moviemakers wanted them to look precisely the opposite way in the films, so they had to pack everything from ochre and beads to *shukas* and spears, and one of the blacksmiths even manufactured full-size spears while on location in the South African bush for *The Air Up There.*

To summarize the relationship of the Samburu to the two South African episodes, their interactions with the nonpastoralist world were closely supervised from start to finish by either the Kenyan government or the film company. The fact that they were both residentially separated from the other members of the cast and crew and enclaved within their own language pocket replicated the conditions of pastoralist life back in Kenya, so they viewed it as unremarkable. At home in Samburu District, men are attuned to land and livestock issues, but what is happening in the capital seems remote and irrelevant except when politicians visit to campaign prior to a national and district election. Over and above this, they are aware that as pastoralists, they are politically and socially marginal and a numerically insignificant minority.[14] The film experience simply reproduced these kinds of social relations in a larger world.

One effect this has is to reinforce Samburu notions of cultural distance. Highland Samburu (who come into more frequent contact with outsiders than their lowland cousins) often refer to Gikuyu and other Rift Valley farming peoples as "Kenyans" or "Africans," as if they are not Kenyans and Africans themselves.[15] They see their relationship as one of mutual distrust but also as one of natural superiority. By contrast, they view whites in Kenya instrumentally, whether they are tourists or residents, just as they viewed the American filmmakers. But categorically, most Samburu consider neither whites nor nonpastoralists to be models worthy of emulation.

The film experience simply reinforced this view for them and extended it beyond the boundaries of strictly Kenyan discourse. In turn, this strongly focused view of the world is given further legitimation by the attention they receive from safari companies and film-makers as well as the photographers for *National Geographic, Sports Illustrated,* and a multitude of photographic essays, all of which seems to confirm their superiority over their more "modern" fellow Kenyans, who are photographed far less often. This distinctiveness in their eyes is translated as panache by the Western spectator, and their own visual code for masculinity—hair, ochre, beads, the spear—comes to mean glamour to Western fashion magazines or to the safari tourist and the back-packing trekker, the last vestige of authenticity in an aggressively present-oriented world.

THE CINEMATIC WARRIOR

But aside from these outcomes, another important result of Samburu forays into the cinematic world has been the creation of a new avenue for the commodification of the warrior image. As Ntimama has shown, the primary means by which this occurs in the postcolonial era has been through print-related media—the postcard and the coffee-table book, the bumper sticker and the T-shirt logo. There is also a steady business in carved hardwood representations of Maasai warriors made by Kamba sculptors in Kenya and Zaramo in Tanzania. But it is also worth considering how these contemporary inscriptions compare to the much older ones found in the nineteenth-century travel accounts, both in their "reality quotient" and in their ability to reach and influence a broad audience.

The early written accounts—popular Victorian travel books such as Joseph Thomson's *Through Masai Land*—probably have had much more influence than recent feature films, for several reasons. First, they have had a much longer duration of circulation: films spend only a few months in theatres before being relegated to an unpredictable status in the video or DVD library, while books are still available a century or more after their publication in large university and public libraries. Second, the early books (which typically combine text with engraved illustrations) contain much more detailed inscriptions, which gives them greater force and durability. Third, there is much greater likelihood of feedback into the subject community in the case of books, especially if they attain the status of "classics" of early

ethnography or history. This can occur either by their use as sources for locally produced amateur histories or by their appearance on a school examination syllabus. Films, in contrast, are rarely seen by the pastoralists who appear in them.

Nonetheless, films now enter a much wider postmodern global discourse than nineteenth-century or colonial printed media. However fleeting the images may be, they can crop up anywhere and cut across both cultures and socioeconomic classes of spectatorship much more than books do. *The Air Up There* could appear on the syllabus of a film course on alterity in New York or Bombay, but it could also be a popular hit with American basketball fans. This multivalence happens only rarely with books.

These representations are also mediated by the subjects themselves. In both literary and cinematic media, the subject is inscribed far from the authors' moment of encounter—the film script in advance, the book following it. While these encounters may seem equivalent in the sense of being equidistant from the event, they really are not, in that a script change will require revision of an already-existing text while the book author (or a print journalist) fashions the inscription at least partly out of the encounter with the subject, which provides greater opportunity for the subject to intervene. The place where the encounter with or intervention by the pastoralist subject is most powerful, however, is not in either of these situations but within the framework of tourism.

Here it is real warriors interacting with the gaze of strangers, both the encounter itself and the snapshot or videotape that captures it as memory and souvenir. For Samburu, these encounters can occur either somewhere on the periphery of the Samburu Reserve, on the less-traveled northern game-park circuit, or on the coastal beaches around Mombasa.

The difference between the two kinds of "exposure" through tourism is crucial. The first (the postcard and the curio) is wholly outside pastoralist control, but the second requires Samburu to participate at the level of engagement with the photographer. The commercial film experience is one more such strategy, more labile than the ready-made souvenir, more structured than the tourist snapshot or videotape.

Although it involves the direct participation of very few *lmurran* (perhaps two or three hundred out of a warrior cohort of at least 10,000), for these few the commodification of the warrior image

(for tourists or filmmakers) becomes an alternative mode of production to pastoralism. Maa-speaking pastoralists in East Africa, their Fulani and Tuareg counterparts in francophone West Africa, and Nharo San Bushmen in Botswana have each discovered that their media representations have exchange value as their old patterns of subsistence become undermined by demographic changes, political marginalization, and environmental disasters. In the most practical terms, this alternative mode of production must be temporary in the life of any Maasai or Samburu because it is focused on the glamorous but transitory condition of warriorhood. Western spectators and filmmakers are not usually interested in the unexotic representation of middle-aged men who are married and sedentary.

A crucial point, however, is that it is the *representation* that is sold and consumed and not pastoralist culture itself, as is sometimes claimed. Culture is more than a collection of signs. The confusion about just what is being commodified arises because within the spectator's imagination, the boundaries are blurred between a largely romanticized and misunderstood notion such as moranhood, its visual and performative manifestation as a set of embodied practices (hair, ochre, beads, spears, fighting, dancing, and so forth), and the cinematic and postcard representation of those practices.

Further mystification also results from the anachronistic character of what is being seen: travelers are shocked the first time they see flesh-and-blood *lmurran* walking about with spears in the northern Kenya landscape, interrupting their linear notions of progress and inserting what logically belongs in the past into the present. This apparent temporal displacement has the effect of making real *lmurran* into walking signs of themselves, as if they had stepped out of the pages of an illustrated nineteenth-century exploration account. In a parallel way, cinematic elisions of time and space enforce the folding of present into past and a mythic geography into the real one. The actual drama that is unfolding in northern Kenya now, the trading of spears for Kalashnikovs against a backdrop of escalating violence from cattle-raiding, seems destined to go unnoticed by both filmmakers and tourists, who will be headed for the safer and better-organized venues in South Africa instead.

Reprise

THE THREE C'S: COLONIALISM, COMMODITIES, AND COMPLEX REPRESENTATIONS

It remains to summarize these changing representations and practices within the particular historical circumstances the book describes. There were many colonialisms operating simultaneously in sub-Saharan Africa following its partition among the European powers at the Berlin Conference of 1884–1885. British colonial policy, following the implementation of Lord Lugard's mandate for indirect rule after World War I, was less intrusive than most. Throughout most of the colonial period, the whole of Nigeria was administered by a corps of about 200 district officers (Smith 1968). Local rulers were expected to continue to govern their subjects as they had before and at the same time recognize the overarching authority of the British administration. Kenya, which had few towns or precolonial governing structures, had to be administered by direct rule implemented by about the same number of officers (Gavaghan 1999). "Native custom" was to be respected as long as it did not interfere seriously with what the British saw as their civilizing mission. Unlike French colonial policy, which assumed that Africans, when properly educated and enculturated, could become black Frenchmen, British policy was based on the racial assumptions that the African was too different from the European to ever assimilate European culture beyond formal changes and that any attempts in that direction could only result in a cruel parody (see Joyce Carey's *Mr. Johnson*). This had very important implications for the rate at which change took place, since it left the institutions intact that directed and regulated life at the local levels.

The ruling scenario, however, played out rather differently in Nigeria and Kenya. One major difference in the scripts had to do with the early assessment of Nigeria, along with other parts of coastal

West Africa, as dangerous and inimical to Europeans. This was an inscription based on the combination of an unhealthy climate and the prevalence of disease on the one hand and native barbarism on the other. Kenya by contrast was seen as healthy and bracing (except at the coast), with highlands suitable for European settlement. Kenya also had a low population density as a result of the semi-arid conditions that made much of the land outside the fertile central highlands unsuitable for farming. This contributed further to its inscription as a tabula rasa in which semi-nomadic pastoralists such as the Maasai and Samburu were not seen to "occupy" land but only to "use" it seasonally (thus making it available for European ranches in the Rift Valley).

Beyond this, and very unlike Nigeria with its Hausa-Fulani emirates, Yoruba and Edo city-states, and innumerable small chiefdoms, including those of the Idoma, Kenya lacked centralized political authority except along the Swahili coast. Governing policies in these instances could be implemented only by the creation of a local leadership structure of "white men's chiefs." In Samburu country, this amounted to largely unsuccessful attempts to establish among the elders the occasional chief and "headmen" who were paid a few rupees a month to supposedly control the behavior of intransigent moran and implement government directives. It was, in short, a situation of very minimal control on the part of the British that allowed Samburu cultural schema, in particular the age-grade system with warriorhood as its centerpiece, to remain relatively unaltered throughout the colonial period. The spear ban of 1934 would not have been imposed without the strong pressure on the government from white settlers following the Powys murder, and while it had important ramifications for Samburu smiths and their practice, it did almost nothing to undercut the warrior institution.

By contrast, Nigeria was densely populated and more politically centralized and, in the estimation of Lugard and his colleagues, its south was deeply in the thrall of "fetishism, human sacrifice and other forms of degradation." In the Benue region, Idoma villages were compact permanent settlements scattered at short intervals throughout the bush, and most could be visited on a regular basis by the district officer in charge. District boundaries demarcated precolonial truce lines within which it was safe to travel. No permanent settlements or comparable opportunity for regular face-to-face contact existed for the administrator in Samburu. Even when a *baraza* (public meeting) was called in some centrally designated location, there were no

guarantees that the elders who showed up could effectively enforce government directives. This ultimately meant a greater opportunity for colonial officials to intervene in Idoma affairs than in Samburu affairs.

This relative ease of intervention, coupled with the conviction that Idoma cultural practice was in need of suppression insofar as the issue of local warfare was concerned, led to the banning of the Oglinye dance in 1917 following the imposition of the Pax Britannica. The taking of enemy heads became a crime punishable by hanging. Despite these measures, the burning administrative issue throughout the colonial period continued to be the perceived threat to law and order posed by young men's dance societies and (at all age levels) the men's secret societies. The British vacillated over this, taking a very hard line in the early years of colonial occupation and pacification that secret societies were a serious threat to order because they frequently took the law into their own hands. On the other hand, they were institutions that enjoyed both fear and respect, so they were potentially valuable in enforcing government directives as well as those of local governing councils. As the colonial period wore on, the British fell back on their time-honored principle of muddling through, leaving the implementation of law and order to the district heads (most of whom were traditional rulers in their own right), while the district heads in turn relied on the secret societies and dance groups (see Magid 1976). Oglinye was officially banned very early in the colonial period, prior to the implementation of indirect rule, which left room for the rise of Ichahoho, a parallel masking association of local instead of imported origin.

What happened to Oglinye in particular, to warriors' masquerades generally, and, by extension, to Idoma warriorhood as an institution has been described in detail. Here I review it only as it relates to the issues of representation, practice, commodification, and audience. In both Idoma and Samburu districts, it became clear that changes in structure (the cultural script) bring corresponding changes in practice, one of which may be commodification. But this was just as true in 1917 as in 1977 or 1987. The banning of warfare and (soon afterward) Oglinye by the British created just such a structural change that was then reconfigured through artisanal innovation as a change in practice: a warriors' dance with enemy heads or jawbones became a masquerade whose centerpiece was a carved effigy. Moreover, it required the radical rethinking of the problem of representation, in

this case of the enemy head that had been the main object of display in the Oglinye dance when it entered Idomaland from the Ogoja–Cross River direction. And as the supply of enemy crania dwindled and disappeared, so (necessarily) did the requirement that every man must take a head to be eligible for marriage. Thus, a major change in the social system was not only reflected in but also initiated by a parallel change in the prevailing system of objects.

The Oglinye mask that materialized was not a real substitute in the sense of one for every cranium: the mask instead belonged to the Oglinye society as a corporate dance group. Here an alteration in practice, both social and artisanal, forced a change in the cultural script. As the mask came to stand for the cranium, it stood for all crania as a collective representation. The effect of this was to create a new psychic distance between audience and artifact, removing the latter from the realm of direct experience and changing it from a comparatively simple metonymic representation of the slain enemy to a much more complex representation not only of the enemy cranium but, more metaphorically, of the celebrity of warriorhood itself. Conjoined with the fact that warfare was no longer a viable occupation for unmarried Idoma males, both the institution and its representation were displaced into the aestheticized realm of mask performance.

Following Lugard's dual mandate, the Nigerian Administrative Service initiated in 1924 a Department of Anthropology to record "native custom" in order to aid in the implementation of indirect rule. "Headhunting," as it came to be labeled, was invariably a major topic in these reports. In 1926, Talbot was the first European to publish an account of "Ogirinia" and its cognate warrior dances in southern Nigeria. These reports and descriptions served to turn Oglinye and other similar masks into objects of ethnography. From here it was a short distance to collecting them in the following decade, first as museum specimens for the Pitt Rivers and British museums and finally as souvenir for the returning colonial officer. In this way commodification seeped into the formerly enclaved zones of value that predated the colonial encounter. The audience now was no longer simply Idoma women (who still come out to honor the mask's occasional appearances today) but Western museum visitors and retired colonial servants.

Perhaps the most complicated and problem-filled of all the representations and inscriptions concerning African artistic practice in

the colonial period were those laid down by scholars. In the formative years of African art studies prior to the 1980s, the colonial experience was typically represented as a source of contamination in which a formerly pure cultural product was polluted, diluted, or diminished through contact with Western ideas, losing its cultural integrity in the process. While scholars have gradually accepted that this biological model of growth, flowering, decay, and death is just that, a model, it is still the operating assumption upon which elite collectors and collecting institutions base their estimations of an object's value. I have argued elsewhere (Kasfir 1992) that if this standard were to be applied in a consistent manner, many highly valued objects in the "traditional" repertory would have to be rejected as very impure indeed. The example closest to hand is the carved Oglinye mask headdress, since it evolved specifically in response to an early colonial rupture. Its "pure" counterpart was the overmodeled skull that it replaced.

But there are many such instances. The field of African textiles is replete with examples that often involve the introduction of imported materials or techniques. Some of the most elaborate and highly valued Yoruba *adire* cloths were made in Abeokuta, which by the mid-nineteenth century was a heavily missionized town, where finer-textured imported cotton cloth could be substituted for the soft, bulky homespun in use elsewhere, enabling *adire*-makers to stitch the minutely complex patterns for which they became famous. Elsewhere, in the Niger Delta, Madras cloth imported from India became the raw material from which a major cloth aesthetic with important status implications was developed. But the vision of a pristine traditional society dies hard: I have heard of museums refusing to collect African sculpture that has been carved using imported knife blades, as if this is a reliable measure of their degree of deviation from tradition, when in fact some of the most highly commodified workshop sculpture in Africa (e.g., Kamba) is made using very traditional tools, while carvers such as the Idoma, who work only for a local clientele and therefore pass every test of supposed cultural integrity, are ready to augment their tool kits with anything that works, imported or not. My point is that colonial interventions in technology, practice, or patronage have to be read on a case-by-case basis. They are neither inherently good nor inherently bad.

Two valuable lessons emerged from the Idoma and Samburu cases when subjected to close reading. First, far from suppressing

creativity on the part of blacksmiths and carvers, British colonial policies in many cases unintentionally stimulated it. In Nigeria, one reason had to do with indirect rule, which prevented direct interventions in the artist's practice. In Kenya, this level of policing was impossible because of the remoteness of a largely nomadic Samburu population. Another major factor was the inability of the colonial administration to predict accurately the effects and outcomes of every government directive. How could the British have predicted that Samburu smiths would respond to the spear ban by moving to the margins of Samburu grazing lands where they could make spears for the Turkana and Rendille instead? Or by changing their repertory to making "things for women"? Even less could they have imagined the effect that banning warfare would have on Idoma masking practice. In altering the cultural script, the colonizer sometimes played the part of inadvertent patron to the artist.

The second lesson, which is closely intertwined with the first, is that the colonial encounter, by its imposition of new structures, put artists and artisans of all kinds on their mettle. In doing so, it ruptured existing practice and actually widened the scope for creativity in certain arenas even as it narrowed the possibilities on many others. The foreclosures (which turned out to be opportunities at the same time) are well known: Christianity, Islam, urban migration, Western education, wage labor. But again and again, each of these changes could also be read back into a changed cultural script that made possible the introduction of new readings on old forms and sometimes the invention of wholly new ones.

The other inscription that has had important consequences in the way African art is evaluated, collected, and displayed is the privileging of one class of artifact—sculpture—over all others, opening up a distinction in the museum world that has little meaning in an African context. The classificatory model for this was already in place with the division of Western art collections into "major" (painting and sculpture) and "minor" (everything else) art categories and, to further complicate the picture, the growth of natural history museums alongside art museums in the late nineteenth century. Natural history collections, which were formed initially to further the Victorian passion for classification that was stimulated by evolutionary theory, greatly expanded their holdings as the opening of colonies in Africa provided a major opportunity for the collection of specimens of all types.

Since African sculpture was not yet "art" in the 1880s and '90s, it was exhibited alongside spears, baskets, textiles, and other material culture as evidence of "primitive technology" (Clifford 1988). But in the early twentieth century, masks and figures from Africa and a few Oceanic cultures began to be privately collected (significantly, by artists and dealers) as art rather than technology. Gradually, from the 1920s onward, these masks and figures began to appear in art museums, where, as sculpture, they were admissible as novel additions to the established high-art canon. Spears, pots, baskets, and the like stayed behind in the natural history collections, where for the most part they still reside. Pottery is an interesting crossover in this scheme of classification, since it is on the one hand functional but on the other capable of being a sculptural medium. One therefore sees pots, especially highly elaborate or figurated ones, in some of the most venerable African art collections as well as in the material culture displays of natural history museums. Spears, as I have argued, are often complex representations, but those complexities are part of its extension of the ritualized body and are not readable in the form itself, so they cannot accompany the spear into its commodity phase or later in its second career as a collected object. This limited legibility requires it to remain outside the privileged sphere of art insofar as museums are concerned.

However useful Danto's distinction may be between art and "mere things" in thinking through the problem of complex representations, it is unlikely to affect collecting practice. Institutions such as natural history museums that are committed to the collection and display of systems, series, sets, and sequences of objects, whether or not they are laden with affect, will continue to do so. Art-museum boards will continue to rehearse the importance of singularity and distinction in their collecting policies, though the increasingly arcane and hard-to-meet authenticity criteria currently applied to African and other "tribal" and "folk" art are likely to give way to more informed selection processes as scholarship on commodified forms accumulates and is taken seriously. Hopefully this reading—of mask and carver, spear and smith, of ritualized warrior body and of the warrior body commodified—will go some way toward effacing the boundaries between what is comprehended as African art and what is not. Even more hopefully, it makes a claim for the full inclusion of the colonial encounter in the history of African art, not as a pretext for its decline but as the occasion of its reinvention.

Coda

FROM SPEARS TO GUNS IN THE NORTH RIFT

This book has asked: What happens to a complex representation when the cultural script undergoes a major change? The original context was British colonialism, but just such a thing has occurred again during the decade in which this book was researched and written. In this last section, I attempt an updated reading on the fighting spear in Samburu culture, the evidence for which comes from reports on the radio, on the Internet, and in newspapers and from first-hand accounts within Samburu District.

In Idomaland, it took the Pax Britannica and the banning of headhunting in 1917 to aestheticize and memorialize warriorhood and turn a disappearing supply of enemy crania into carved representations and a war dance into a masquerade. Nearly a century later, Samburu warriorhood is still a recognized and clearly marked stage of life, but in the past decade its main symbol, the spear, has begun to undergo a similar kind of transformation.

This time, however, it is not pacification or government control, but their opposite, increasing levels of violence for which the government has no effective antidote, that are responsible. Cattle-raiding has been a traditional form of warfare, the staging ground for much warrior theatre, and the means for the redistribution of wealth for centuries among the pastoralists of the Northern Rift Valley—Samburu, Turkana, Borana, Pokot, Somali, and others. Not only has it been an essential part of the economy of pastoralism but it also has remained the measure of successful warriorhood.

For the North Rift pastoralists, who live in a remote region with few roads and little active policing, national boundaries have always been easily permeable. Therefore raiding has taken place across these borders for as long as they have existed, by and in retaliation

against Ugandan, Sudanese, Ethiopian, and Somali rustlers. What has changed in the past twenty years has been the introduction of illegal arms in large numbers, which circulate because of the destabilized political regimes in each of these countries that border northern Kenya.

Beginning with the Somali *shifta* fighters in the 1960s, who tried to liberate the Northern Frontier District so it could be annexed to Somalia, guns have presented a serious challenge to spear-carrying warriors there. While the conflicts of the Northern Frontier District were far from the center stage of colonialism, the history of European conquest in Africa illustrates how crucial a technological edge has been in subduing local populations everywhere, whether the British with late-nineteenth-century Asante, Benin, or Zululand or the French with the Tuareg. Then it was the Maxim gun, today it is the Kalashnikov.

The first big influx of illegal arms into the hands of Kenyan pastoralists occurred in 1979 when a large military armory in Moroto, northern Uganda, was broken into and the guns acquired by the Karamojong, cattle pastoralists who are traditional rivals of (and cousins of) the Turkana across the border. As Turkana seized these weapons in counter-raids and Pokot and Samburu acquired them in a similar fashion from Turkana, all Northern Rift cattle raiders armed with guns came to be known as *ngoroko*.

More than a decade later, the political collapse of Somalia into warring factions created a second easy source of guns for Somali pastoralists making incursions into northern Kenya. Concurrently there was also the long-standing civil war in the southern Sudan, the third source of illicit guns circulating in the region. One important point of entry for these arms into Kenya has been Lokichoggio, where, until the Sudanese civil war ended in 2005, deserting members of the Southern Sudanese Army (SPLA) reputedly sold their guns.

A study conducted from July 2001 to December 2002 by the Security Research and Information Centre in Kenya has found a direct link between cattle-rustling and arms-trafficking in Turkana, Samburu, West Pokot, Trans-Nzoia, Uasin Gishu, Marakwet, and Baringo districts (Kamanju, Singo, and Wairagu 2003). One of the researchers told the *Sunday Standard,* "You [need] not struggle to get arms in the region, they are just like walking sticks. There the [herding stick] is a fully-loaded AK-47 rifle."[1]

The Kenyan government originally responded to the *shifta* threat by creating a "Home Guard," carefully screened pastoralist ex-warriors they armed with rifles. But in today's climate of arms proliferation, the Home Guard, now officially called the Kenya Police Reserve (KPR) are inadequate because of their small numbers and the random weapons they use, many of which are nonautomatic rifles. Even worse, the study claims, in some districts, members of the KPR use their government-issued weapons to participate in cattle raids. The KPR presence and the burgeoning number of illegal guns has created an escalating cycle in which pastoralists without guns feel strong pressure to acquire them for use in self-defense, thus further ratcheting up the level of endemic violence.[2]

Where is the spear in all this? It is still the first line of defense against predators such as hyenas, lions, and leopards that threaten livestock. It is also still the major symbol of Samburu warriorhood, since however glamorous the gun (and it has an unassailable cachet), it is a generic and not a Samburu symbol of masculine prowess and is carried by one's enemies in an identical shape and form as one's own. And finally, the spear is still preferable for certain types of fighting at close range. For all these reasons, the spear is not about to fade into oblivion, but at the same time, it will never again enjoy the unchallenged superiority it held before the colonial scenario was set in motion a century ago.

Since this study is about the aesthetics as well as the artifacts of warriorhood, it is also worth considering how the acquisition of the assault rifle changes the way in which the warrior is visualized. The moran with his customary weaponry—spear, *rungu,* and sword—and his numerous embellishments—ochre, beads, feathers, elaborately braided hair—presents himself to the spectator as a romantic anachronism, detached from the temporal frame of the present and instead part of a "dying world" that predates, and ultimately must succumb to, modernity. But a gun changes all that: he is instead thrust forward, beads, ochre, and all, into the postmodern condition, which is quintessentially one of hybridity.[3]

In the warrior theatre that I have argued is an essential part of moranhood's performance, this disjuncture between his embodied personal aesthetic and a lethal weapon associated with modern (especially guerilla) warfare sharply increases both the level of theatricality and the level of danger. He is at mortal risk, but at the same time he

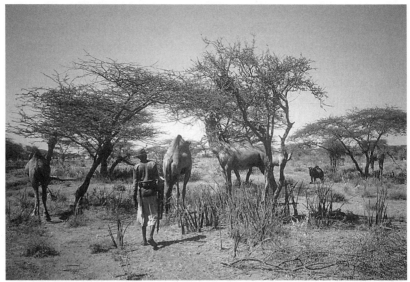

FIGURE CODA.1. Samburu "Home Guard" with camels on the lowlands, near Wamba, Kenya, 1987. *Photo by author.*

is still an artifact of masculinity on display. Like the cinematic warrior-hero, another of his roles, he is perpetually about to experience a lethal encounter, except here it is real and there are no cinematographers to film it and no CNN on-the-spot coverage. These raids are reported in the newspapers in Kenya and Uganda only if something unusual happens, for example when in December 1996 Turkana rustlers shot down a government helicopter near Baragoi, killing the district commissioner and other government officers.

Another that caught the attention of the national and international press happened in July 2005, when Borana raiders attacked a Gabra settlement near Marsabit and killed over seventy people, including many women and children. This was only one of many fights in the preceding six months between Gabra and Borana, who are kinsmen and normally allies, over the control of scarce water points and pasturage in the desert-like region near the porous Kenya-Ethiopia border.[4] Occasionally these performances carry overtones of humor at their sheer daring in the face of officialdom: in June 2003, the Ugandan army was sent into Karamoja District to protect local villages from incessant cattle raids by Karamojong warriors. The latter responded by breaking into the government *boma* during the night and stealing the army's own cattle.

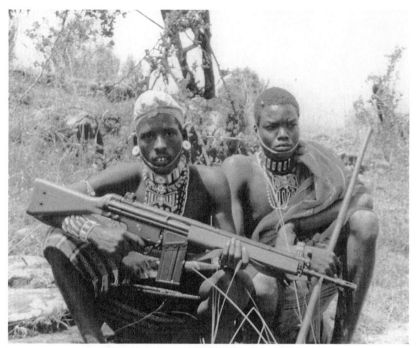

FIGURE CODA.2. Samburu moran with rifle, Tinga, Kenya, 2001.
Photo by author.

But the most daring feats rarely reach the news media, since the
Kenyan government's Anti-Stock Theft Unit intervenes only after
the worst raids have already taken place and such interventions are
staged very far from the beats of Nairobi reporters. They are nar-
rated instead by word of mouth and become part of the grapevine of
rumor and gossip and, ultimately, oral tradition. An example was the
account of how the protracted Turkana incursions against Samburu
and Pokot in 1996–1997 finally came to a halt when the Pokot were
able to find the Turkana leader's hidden camp and kill him in an
ambush. In a piece of grisly but spectacular warrior theatre, the tri-
umphant Pokot led the Turkana leader's favorite ox into the Pokot
camp with his rifle tied across the ox's horns along with his severed
head. Narratives such as this confirm that raiding is a high-stakes
performance where bravery, triumphal revenge, and humiliation are
still the currencies that activate warrior aesthetics, whether in Nigeria
in 1900 or Kenya's North Rift a century later.

NOTES

INTRODUCTION

1. Masquerades are "plays" in Nigerian pidgin, so to play is to mask, and the open clearing at the center of a village is called the "playground."

2. Mauss memorably described the power of habitus in the liberation of Paris, where the troops from different Allied countries could not march en masse down the Champs Elysées because their marching styles were incompatible.

3. While Baudrillard's study is especially valuable for deconstructing notions of the anachronic and the authentic (Kasfir 1992b), I use his term "system of objects" here simply as a convenient way of juxtaposing discrete and culturally distinct sets of artifacts against equally distinct ways in which they are used or ideas in which they are embedded. In a series or sequence, objects are related morphologically and occupy assigned positions. In a set, they may be related in other ways. For example, the contents of a shrine constitute a set in the same way that a fork, knife, and spoon do. A system contains both sets and sequences. This is made more clear in chapter 4 in the discussion of innovation.

4. Two important exceptions are Christopher Tilley (1990), an archaeologist, and Kris Hardin (1993), an anthropologist.

5. Erim (1981) divides the Idoma polities into kingdoms, chiefdoms, and chieflets depending on their size, complexity, and heterogeneity, but all are politically centralized with some form of priest/king and council of titled elders. The Agila and Igwumale kingdoms also have a prime minister.

6. This was done symbolically by creating beads of office made up of one bead from each of the rulers of an Idoma polity.

7. Non-anthropologists tend to mistakenly conflate the terms age-grade and age-set. The Samburu male population is divided into three fixed age-grades: uncircumcised boys, warriors, and elders. A new age-set is formed every twelve to fourteen years by circumcising boys (who may be as young as twelve or as old as twenty) and making them warriors. The age-set is given a name,

and as its members pass through warriorhood and elderhood, it gains a distinctive social identity.

The passage into moranhood and formation of a new age-set, ceremonially marked by circumcision and the *lmugit* that follows, is precisely defined for each group of boys who undergo it together. But for the age-set as a whole, it takes place over several months. Ideally, the senior moran pass out of moranhood at the same time that the new age-set joins, but since this takes time, there is a transition period in which there are two moran age-sets (Spencer 1965, 81).

8. My Idoma fieldwork (1976–1978, 1986, 1989) preceded my work in Samburu (1987, 1991 to the present) and involved a different set of issues focused on sacred kingship, masking, and metallurgy. The topic of blacksmiths is the only common one from that period with my later Samburu research, though representations of warriorhood also figure prominently in both.

9. In *The Short Century: Independence and Liberation Movements in Africa 1945–1994* (2001), Okwui Enwezor argues that this new art grew out of the political consciousness created by the late-colonial independence movements. It is more difficult to demonstrate that artists were not simply caught up in the flow of late-colonial events but were actually responsible for creating an alternative modernism that reflected in visual terms the precepts of Negritude or Pan-Africanism.

10. Paula Girshick Ben-Amos's early work in Benin on British-engineered art training and its results is the most important exception to this lacuna (1976).

11. Ukelle, Iyala, Boki, and Yatye (Yachi) groups.

12. See world-systems theorists such as Immanuel Wallerstein (1974).

13. There are well-known exceptions such as urban masking (e.g., Yoruba) and rurally produced souvenirs (e.g., in Kenya and South Africa), but the generalization holds.

1. MAA WARRIORHOOD AND BRITISH COLONIAL DISCOURSE

1. *Lokop* as a Samburu self-designation means simply "people of the land" in the same sense that Krapf (1860, 358) understood *loikop* for core Maasai as "possessors of the land," which should not be confused with its modern (and pejorative) core-Maasai usage as "Maa-speakers who cultivate," hence not "true" Maasai. See Galaty 1993, 179–180, for a discussion of *loikop* as an identity marker. Samburu point out that *loikop* also refers to homicide, which they say is another reason Maasai do not like to use it as a self-designation.

2. Throughout this chapter, I use the nineteenth-century and colonial-period texts whose subject is "the Masai" generally in order to historicize the more recent inscriptions of the Maa-speaking Samburu. The scattered early references to the Samburu proper (Höhnel 1894; Chanler 1896; Wellby 1901; Arkell-Hardwick 1903; Stigand 1910) contain little descriptive detail and the two discursive streams do not begin to converge until the 1970s with the opening up of the Northern Frontier District to travel and the simultaneous growth of tourism and the market for books about and postcards of Maasai and Samburu. I justify the relevance of the earlier Maasai discourse on two

grounds: first, in the shifting construction of Maasai identity (by Samburu, by core Maasai, and by non-Maa outsiders), the Samburu are one of twenty-odd autonomous subgroups subsumed within Maasai-ness broadly construed, even though they are not a part of the core group of Maasai who occupy the colonially demarcated Maasailand of today. Second, using empirical criteria, Samburu share with core Maasai a language, material culture, the values of pastoralism, an age-grade system, and many of the key rituals. Most important, they share the sense of social distinctiveness that sets them apart from all non-Maa. For a detailed discussion of Maasai identity, see Galaty 1993, Spencer 1993, Sommer and Vossen 1993, and Waller 1993a.

3. As the focus of the warrior life stage has moved further from actual fighting toward a more strictly social identity, marriage during warriorhood has become increasingly common, though it is still hedged with awkward prohibitions such as that against eating alone or in front of women.

4. The Samburu term for warrior is *lmurrani* (literally: one who is circumcised; pl. *lmurran*). The Anglicized "moran" (both singular and plural) is in common usage in Kenya and will be used here as synonymous with "warrior(s)."

5. "Laikipia–Samburu District Annual Reports, 1935–1937," DC/ SAM/3/2.

6. For example, a Maasai woman's hair is like "an old shoe brush clotted up with blacking" and he said of the incessant prayers offered by the elders to Ngai (God), "nothing could be done without hours of howling" (Thomson 1887, 258, 260).

7. They acquired grains and vegetables from agricultural neighbors and buffalo-hide shields and honey (necessary for brewing beer) from the hunter-gatherer "Il Torrobo," the Maa designation for "poor people without cattle" (see Thomson 1887, 247–248, 259).

8. John Galaty's seminal essay, "'The Eye That Wants a Person, Where Can It Not See?'" (1993) reveals the complexity of this ideology and the shifting nature of its claims.

9. For example, between 1904 and 1911, the Purko Maasai increased their herds from 45,000 to 200,000 cattle and from 750,000 to 2,000,000 sheep (Sorrenson 1968, 277).

10. Both the 1904 and the 1911 treaties between the British administration and the Maasai were intended to establish European rights of occupation to what had been Maasai grazing lands. The first treaty, signed by the Maasai *laibon* Lenana, was amicable, but the second was signed under strong government pressure and was resisted, since it effectively banished the Maasai from all the best pasturage north of the Athi River.

11. On 15 August 2004, the 100th anniversary of the signing of the 1904 treaty, Maasai demonstrators rallied in Nairobi carrying signs proclaiming "We want our land back" and tried to march on the British High Commission. They were turned back by Kenyan police officers firing teargas canisters (Marc Lacey, "Tribe, Claiming Whites' Land, Confronts Kenya's Government," *New York Times,* 25 August 2004, A1, A6).

12. In a turn-of-the-century Maasai vocabulary, Hollis (1905, 272–273) glosses the Maa term for Bantu, *ol meeki,* as "barbarian." In more charitable terms, it denotes one who tills the soil (Spear 1993, 4).

13. Karen Blixen's view of the Maasai is not based on any intimacy in her relations with them. There was no Maasai Kimante or Farah (her Kikuyu and Somali servants) in her life, since the Maasai refused to work for Europeans. Her comments are a reflection of an ideology strengthened by casual encounters rather than any deep personal experience.

14. African receptivity to Western ideas was frequently caricatured by British writers, as in Joyce Cary's *Mister Johnson* (1939/1952). But by the late colonial period in Kenya this receptivity was transformed into political activism, and the Gikuyu were at the forefront in the nationalist movement as well as the Mau Mau resistance.

15. See Waller 1993a and Galaty 1993a.

16. Ehrhardt's map (Krapf 1860) depicting Dr. Krapf's travels in East Africa between 1837 and 1855 show present-day Lake Turkana as "Lake Zambuni or Ufole?" but Krapf himself never reached the area north of the central highlands.

17. Precise dates for these occurrences vary slightly in different scholarly accounts. I have combined Spencer's account (1973, 157), Lonsdale's summary (Berman and Lonsdale 1992, 24), and unpublished research by John Rowe on the chronology of the first rinderpest outbreak (pers. comm., 3 May 1994).

18. Gavaghan explains that "legally it remained an Outlying or Special District within the Northern Frontier District, requiring permits for entry via Isiolo or Rumuruti" (1999, 169).

19. The 1904 agreement between the government and the Maasai lists the Maasai's main signatory, Olonana, as their chief *laibon* ("Son of Mbatian, Lybon of all the Masai"). But by the time of the 1911 agreement, Segi, the son of Olonana, is listed as "son of Ol-onana (Lenana), Paramount Chief of all the Masai" (Hanley 1971, 306, 310 [appendices 2 and 3]).

20. "Northern Frontier District Annual Report, 1921," 3, 6, DC/SAM/1/1.

21. "Isiolo District Annual Report, 1933," 7, DC/ISO/1/2.

22. "Isiolo District Annual Report, 1936," 7, DC/ISO/1/2.

23. Not all were so alienated. Huxley (1948/1975, 7) described a colonial district commissioner who reportedly walked into Arusha wearing Maasai battle dress and carrying a spear and began shaking in the provincial commissioner's office.

24. As a technique of the body, it is the same set of somatic behaviors associated elsewhere in Africa with possession by spirits. In this case, however, there are no beliefs of supranatural causation.

25. "Samburu District Annual Report, 1957," DC/SAM/4/1. All of the annual district reports cited in this volume are in Kenya National Archives, Nairobi.

26. The version recounted here combines elements of Atieno Odhiambo's historical account (based on the Francis Scott Papers at the University of Nairobi) with others I found in Samburu and Isiolo District annual reports. I have checked these against current Samburu recollections of the story in interviews with two surviving members of the Lkilieko age-set, who were moran in the early 1930s (L. Lelengua 1993; Lekupon 2000) as well as several Lmekuri age-set members who were initiated in 1936, who were the first group to suffer

government reprisal (e.g., S. Letekirich 1993; Kingore Lenaronkoito 1991–2000; Larugumu 2000).

27. "Isiolo District Annual Report, 1931," 9, DC/ISO/1/2; "Isiolo District Annual Report, 1934," 4, DC/ISO/1/2; "Samburu District Annual Report, 1936," 3–5, DC/SAM/1/2; "Samburu District Annual Report, 1957," 2, DC/SAM/4/1.

28. "Samburu District Annual Report, 1921," 3, DC/SAM/1/1, 3.

29. "Samburu District Annual Report, 1934," 3, DC/SAM/1/2.

30. I am indebted to Ben Lenaronkoito for directing me to Odhiambo's 1973 essay (which he helped to research while a student of Odhiambo's at the University of Nairobi), long out of print. Odhiambo focused upon a seemingly different set of questions about Kenyan protonationalism, but they are nevertheless closely parallel to the questions I am asking about the same events.

31. The correct Samburu form would be "Leketachara" rather than the Maasai spelling "Ole Ketachara" found in government documents. I substitute the term "section" for Spencer's "phratry" (e.g., Spencer 1965, 72–73) in referring to the Lpisikishu ("Pusigishu") and Lorogishu ("Lerogishu") as sections and the Lukumai ("Logumai") as a clan/section, although in everyday usage, many Samburu refer to all of these groups as "clans," the term used in government reports.

32. According to local stories, he was innocent but framed by a jealous brother. Ledume was widely known in Samburuland for having prophesied the coming of the white man and was the advisor to the Lorogishu moran on how to handle the case; Kirati Lenaronkoito, interview with the author, October 1993. In another version he was wrongly accused of being involved by one Loturo Omum, a Lorogishu government-appointed chief; Lokwakwi Larugumu, interview with the author, 20 August 2000.

33. Until 1921, Samburu was administered partly from Marsabit and partly from Archer's Post. In 1921, Samburu became a separate district, with headquarters in Barsaloi. But with further provincial reorganization it was incorporated into the newly created Isiolo District in 1929. In 1934, it became a separate district once more with a substation at Maralal. But it remained a part of the larger Northern Frontier District at the same time, largely for security reasons.

34. "Isiolo District Annual Report, 1936," 4–5, DC/ISO/1/2.

35. In 1928–1929, about 6,000 Samburu, 60,000 cattle, and 50,000 smaller stock; "Isiolo District Annual Report, 1929," F110, DC/ISO/1/2.

36. "Isiolo District Annual Report, 1929," F109, DC/ISO/1/2.

37. *Laigwenok* (sing. *laigwenani*) were selected by their warrior cohorts as leaders based on their skill, eloquence, or bravery. "Laikipia-Samburu District Annual Report, 1935," 1, DC/SAM/3/2.

38. Logori Lelengua, interview with the author, 2 October 1993.

39. According to Sharpe ("Samburu District Annual Report, 1936," 4, DC/SAM/1/2), this was over £1,000.

2. IDOMA WARRIORHOOD AND THE PAX BRITANNICA

1. In a differently focused study, it would be interesting to tease apart missionary discourse into its several distinctive subtexts as Comaroff and Comaroff

have done for the Griqua and Tswana of South Africa (1992, 198–203). My main concern here is the development of the literary representation of Idoma and Samburu (in which I include early exploration accounts as fictions of a special type) that later undergirds the official discourse of the laying down of colonial government policy.

2. In the dialects of Idoma, "Oglinye" or "Ogrinye"; in Tiv, "Girnya"; in Igbo, "Ogirinya," and so forth.

3. Married women and warriors owned cattle given to them by their husbands at marriage or their fathers at the time of their entry into warriorhood, respectively, but husbands and fathers continued to hold power over the right of disposal of such animals. This is still the case.

4. There was considerable variation in both the size and the degree of political centralization in the twenty-odd precolonial Idoma chiefdoms, from small culturally homogeneous chieflets to at least one heterogeneous and highly centralized state (Agila). The literature on sacred or "divine" rulers in West Africa usually refers to them as kings. In some Idoma polities this is appropriate, in others somewhat misleading, which requires me to move between the equally imprecise English terms "chiefdom," "chiefship," "kingdom," and "kingship" for the Idoma concepts of Aje, a "Land," and Och'Aje, its ruler. See Armstrong (1955) and Erim (1977).

5. Early colonial reports describe the remnants of such moats and walls, along with the remains of iron-smelting furnaces (Ethnological Notes on the Tribes in Idoma Division 1919–1925, passim, Nigeria National Archives, Kaduna]. The stands of high forest that often surround a village in what is otherwise a wooded savanna have remained to the present.

6. Interment is now very common because of the combined influence of sedentarization and the Christian missions.

7. The office rotated through the eligible royal lineages, which chose the most senior eligible male to serve, barring a major character flaw or physical collapse. Because of arguments over eligibility, the British found many kingships vacant at the time of their arrival (Armstrong 1955, 95–96).

8. While Nigeria (so named by Lady Lugard) was known as such from 1900, the East Africa Protectorate did not become Kenya colony until 1920.

9. Sir Percy Girouard, for example, was both lieutenant-governor of Northern Nigeria (1907–1909) and governor of the East Africa Protectorate (1909–1912). Lord Lugard had worked in Uganda before becoming governor of Northern Nigeria.

10. For example, of the forty men who accompanied Mungo Park in 1805, thirty-four died of malaria or dysentery (McLynn 1972, 228). Between 1804 and 1825, 60 percent of the men sent by the Church Missionary Society succumbed. More than half the members of the Baptist Missionary Society died of disease from 1878 to 1888. For soldiers in West Africa it was even worse: in one garrison of 1,568 men, 1,298 died during 1822–1830 (ibid.).

11. Colonial authorities investigating claims of Tiv witchcraft at first failed to differentiate between accusations of metaphorical "eating" and actual consuming of flesh of the victim (see Abraham 1940, 97–105; East 1939, 289–294).

12. Ekereke Odaba, Och'Akpa (Akpa District Head), interview with the author, Otobi, Nigeria, 7 October 1976.

13. The only detailed attempt at this construction, using extensive documentation from oral evidence, is Erim O. Erim's "A Precolonial History of the Idoma of Central Nigeria" (1977), published in 1981 as *The Idoma Nationality, 1600–1900*.

14. The distinction, not always uniformly followed, is that *aiije* are entirely public in their performances while *aiekwu* also perform rituals restricted to their members.

15. The reading of the relative chronology of Oglinye and Ichahoho is different in Akpa District, the primary site of my Oglinye fieldwork, since Ichahoho arrived there after Oglinye was well established. Akpa is an ethnic enclave with strong Ogoja connections, and since Oglinye entered Idomaland from Ogoja, the people of Akpa (Akweya speakers) adopted it earlier than the surrounding Idoma-speaking districts.

16. For a detailed discussion of the path of diffusion of Oglinye, see Kasfir 1988, 91–96.

17. Oglinye and Ogrinye are Idoma dialect variations.

18. Abraham's interest was in recording the language and only secondarily in ethnography. His accounts are particularly valuable for their verbatim nature as "reported speech."

19. Och'Akpa Ekereke Odaba, interview with the author, 15 May 1976.

20. An earlier British-sponsored expedition to explore the Benue in 1854 visited Doma, one of two Idoma-speaking kingdoms north of the Benue, but never went ashore to Idomaland proper on the south bank (Baikie 1856/1966).

21. Akpoto (sometimes Okpoto), a term that has fallen into disuse but was still heard occasionally in the 1970s, was used in the nineteenth-century exploration accounts and early colonial reports to describe the indigenous population in what would become Igala and Idoma divisions in the colonial period. In this construction, the Igala and Idoma, both "people of Apá," were migrants with a culture of sacred kingship who assimilated the acephalous Akpoto, an identity that gradually shrank to encompass only what is now eastern Igalaland (closest to Idoma and furthest from Idah, the Igala capital on the Niger). For a full discussion, see Kasfir 1979.

22. This is probably a reference to the Attah of Idah, the Igala king who converted to Islam following the Fulani jihad. Because of the large number of refugees, ethnicities and belief systems were in flux and identities were negotiable in the mid to later nineteenth century.

23. Omaga An'ne, the head of the Oglinye society in Otobi village at the time of my fieldwork in 1978, affirmed that this was done in Akpa District.

24. Because of its location near the middle of the country and the renegotiation of internal colonial boundaries, Idoma has been in both Northern and Southern Nigeria (which were administered separately by the British before 1914). When I refer to it as also geographically and culturally part of "eastern" Nigeria, I mean that region bounded on the west by the Niger River and on the north by the Benue River.

25. Robert G. Armstrong spent much of his career studying the language but died before his dictionary could be completed. His Idoma collaborator, Professor S. O. O. Amali, took over the project at his death in 1988.

26. The invention was necessary because playing the traditional Idoma royal music would have required traveling with an orchestra of drums and flutes. This type of music was often performed during the welcoming ceremonies of these visits, but it would not have been appropriate for driving up and stepping out of a car.

27. I was fortunate to travel with the Och'Idoma II on a few of these visits in 1986 and 1989, which were made mainly to encourage people to obey state government directives though they were also made to listen to boundary disputes and other grievances. The description given here is taken from those occasions.

28. The more traditional Idoma men's dress would be the toga-style wrapper, which the Och'Idoma still wore in his private chambers. The Hausa *babariga* has long been the dress of choice for his public audiences.

29. The kingdom of Doma, because of its location north of the Benue and adjacent to Keffi Emirate, is an exception; about one-third of the subjects there are Muslim. Keana kingdom, also north of the Benue, has a slightly less visible Muslim component.

30. See Alastair Matheson, "Culture Shock for the Maasai," *The Standard* (Nairobi), 11 March 1985, 14.

3. COLONIAL RUPTURE AND INNOVATION

1. These all underwent further transformation in the tourist spear, a development that did not occur until about 1981, nearly fifty years after the spear ban.

2. "Samburu District Annual Report, 1934," 4, DC/SAM/1/2.

3. "Laikipia-Samburu District Annual Report, 1936," 4, DC/SAM/3/2.

4. Spencer (1965, xix) points out that the Land Rover, which was introduced after World War II, was the first step in bringing the Samburu under some level of administrative control.

5. In fact, the bow and arrow are real adult weapons too, but since little boys learn to use small versions of them at an early age, they cannot carry the symbolic weight of moranhood.

6. This rivalry was built into the structure of the age-grade system, in which warriors helplessly watched their girlfriends being given in marriage by the girls' fathers to other moran or elders.

7. My Samburu father-in-law, a member of the Lmekuri age-set that was most affected by the ban, was arrested because he defied the ban and carried a spear during his wedding.

8. The practice of carrying a pair of light, smaller-bladed spears was not adopted by warriors until well after the lifting of the spear ban, so the pair in this instance would have to have been larger-bladed and heavier spears. See Larick 1985 for a detailed discussion of these changes over time.

9. Permits were also given to ex-KAR soldiers after World War II, since evidently they had proven they were adequately socialized during their military service ("Samburu District Annual Report, 1947," 5, DC/SAM/1/2).

10. "Samburu District Annual Report, 1934," 3–4, DC/SAM/1/2.

11. "Laikipia-Samburu District Annual Report, 1936," 5, DC/SAM/3/2.

12. Logori Lelenguya, interview with the author, 2 October 1993; Lekino Lekesio, interview with the author, 6 October 1993; Lokwakwi Laruguma, interview with the author, 20 August 2000. The beads introduced by the ivory traders were said to be "black" (deep blue); Logori Lelenguya, pers. comm., 1993.

13. Lokwakwi Laruguma, interview with the author, 20 August 2000.

14. Kariuki Letikirich, interview with the author, 8 October 1993.

15. Ibid.

16. Four generations reckoned by age-set and not in the genealogical sense would encompass the Lmekuri, Lkimaniki, Lkishili, and Lkurorro age-sets who were initiated in 1936, 1948, 1960–1961, and 1976, respectively. This would translate into no more than two biological generations because a man's sons should be at least two age sets away from his.

17. The other reason had to do with their location in an environment that could support large *manyattas* of warriors (Spencer 1965, xvii). In much drier Samburu country it is only during circumcision rituals that large encampments are ever built, and even then the environmental damage from them is very considerable ("Samburu District Annual Report, 1948," 15, DC/SAM/4/1).

18. Kariuki Letikirich, interview with the author, 8 October 1993.

19. The Boran spear with its short blade and tail and very long midshaft cannot be thrown very far and is therefore imperfectly suited for the Samburu method of fighting. It was adapted for use by younger initiates and old men; Kirati Lenaronkoito, interview with the author, 1991.

20. The sequence of adaptation I recount here comes from the Samburu themselves (specifically the *lkunono* of the Lpisikishu and Lukumai sections), but it accords closely with the sequence Larick described (1985, 212–215) except in small details.

21. See plates I and II in Spencer 1965. His fieldwork was conducted between 1957 and 1960.

22. Ngoroko raids were still common in the 1990s and after a hiatus have begun again in 2005 and 2006, for example on the eastern edge of the Rift wall near Losiolo and Pura.

23. "Northern Frontier District Annual Report, 1921," 3, DC/SAM/1/1.

24. This represents a drop in value: in 1936, the price of two spears was one bullock ("Laikipia-Samburu District Annual Report, 1936," 10b, DC/SAM/3/2). Or to put it another way, with the decline in herds, cattle have become more valuable in relation to manufactured objects.

25. See Nicklin (1977, 233–237) for a description of the Beecroft mask. Sadler (1935, 54) lists the date of collection as 1843.

26. Macleod's account speaks of both a masked figure and a skull hung in the headwinner's compound.

27. The districts were formed out of the independent chiefdoms (lands, Aje) at the onset of British administration. Idoma Division contained twenty-two districts, a few of which were amalgamated lands.

28. The one exception at the time of my fieldwork was Ekwaja, an important carved mask that linked Agila with Igala through its origin myth (see Kasfir 1986).

29. The Akpa District clan masks included Okpnma, Akpnmobe, Igllo, and Itrokwu. Idoma or regionally diffused mask associations included Ikpa, Oglinye, Ichahoho, Okpekwu, Afufu, Ikpobi, Ibó, Odumu, Ekpe, and several others. These do not include the textile ancestral masquerades Alekwuafia, Ekwila, Enkpe, and Unaaloko, which are owned not by the enclaved Akweya-speaking clans of Akpa District but by the Idoma proper who surround them in other districts.

30. Kamba master carvers in Kenya who invent new forms and sculpt only for individual commissions often spend more than half of their work time on "thinking." Idoma carvers, who work within a prescribed traditional repertory, also must "think," but it occupies less of their time.

31. In Otobi, this "wife" of the mask never came into physical contact with it, but it was sometimes stored in her compound. Her main role was to organize the cooking of food for the mask performances, a practice that is both ritually and socially embedded in second burial ceremonies.

32. For example the most important deities, the Earth (Aje) and the Sky-dwelling God (Owoico), are never depicted by masks.

33. Vincent Ojiji, interview with the author, 4 July 1978.

34. Emeje Ogbu, interview with the author, 9 February 1978.

35. Omaga An'ne, interview with the author, 18 February 1978.

4. SAMBURU SMITHS, IDOMA MASKMAKERS

1. I am therefore using the term in the current sense used by art historians, not in the Durkheimian sense of a professed belief or understanding as a collective representation.

2. For a discussion of artisanal status in Mande society, see Conrad and Frank 1995.

3. The Samburu see themselves as divided into eight sections (referred to as phratries in the older literature—e.g., Spencer 1965, 71–76). Four of them form the Black Cattle moiety. Of the eight sections, which are propagated through patrilineal descent and are exogamous, only three have blacksmith lineages: Masula, Lpisikushu, and Lukumai. Each new age-set cuts across all sections, though they hold their ceremonies in different locations.

4. For a judicious and sustained analysis of this point, see McNaughton (1988) on Mande smiths.

5. Merker's data comes mainly from investigations between 1895 and 1902.

6. The Maasai and Torrobo are interdigitated groups that in the past have supplied each other with crucial goods or services. I am using the term "interdigitation" instead of symbiosis to imply (following Wilmsen 1994) a cultural process in which interactions are limited to specific contexts and both sets of participants play an equally active role.

7. As in chapter 2, I use data from the core Maasai to historicize the Maa-speaking Samburu. However the Maasai *il kunono* and Samburu *lkunono* have existed under somewhat different social and environmental conditions that have created subtle differences in their status and practice. See Galaty 1977, 348–424 for a full description of Maasai *il kunono* in the mid-1970s. Maasai *il*

kunono in both Kenya and Tanzania seek wives from Samburu *lkunono* families, but I know of no Maasai smiths who practice in Samburuland or vice versa. A comparison of early sources and contemporary representations suggest that the Maa smith's status was lowest in Tanzania and highest among the Samburu.

8. The best-known examples of this in West Africa were the practices of twin killing and twin veneration. The Yoruba did both at different times in their history. In Idoma, twins were venerated, while farther south in the Cross River region they were killed. The reasons people give for killing or veneration are essentially the same: twins are powerful and potentially dangerous.

9. Its precise boundaries are drawn somewhat differently by Herskovits, Baumann, and Murdock. For a more detailed treatment and map, see Vaughan (1970, 59–61).

10. In the Ethnographic Atlas, information on forty-five Guinea Coast ethnic groups lists caste as "absent or insignificant" for all of them (Vaughan 1970, 65).

11. The uncasted smith also exists widely in Kenya among nonpastoralist populations. For a useful summary, see Brown 1980.

12. Unlike Thomson's, Merker's book is not an explorer's account but is based on material he methodically gathered while in the Kilimanjaro region at the turn of the century. Merker buries the authorial voice, which is so plain in Thomson, beneath an avalanche of fact-gathering in an effort to prove that the Maasai are of Semitic origin.

13. Maasai today describe Lumbwa as their precursors on the Maasai Steppe in Tanzania (Galaty 1993, 65, 69) and are nowadays often associated with the ethnonym Parakuyo. The odd point about Hollis's "mistake" is that his informant ol-Omeni was Lumbwa himself and would presumably have recognized his own dialect.

14. Bernard Lenaronkoito, interview with the author, 21 February 1996. The *lkunono* refer to other Samburu as Lomet.

15. As with the Maa-speakers, it has become clear in more recent studies that relations between Tutsi and Hutu, while they involve a social, economic, and political hierarchy, were and are much more negotiable than early writers had thought.

16. Murdock assumed that caste was an Arabic influence, since it is ubiquitous in Saharan Africa but falls off as the distance from the Sahara increases (Murdock 1959, 76, 134). An alternative explanation might revolve around pastoralism, which predated Islam in the Sahara region. Some "caste" societies are neither Muslim nor pastoralist.

17. Il Torrobo (Samburu: Ltorrobo) is a blanket term of condescension in Maa for "poor people without cattle" rather than an explicit ethnonym. It is most commonly applied by Maa-speakers to neighboring hunter-gatherers, of whom the Kalenjin-speaking Okiek are the best documented (but not the only) group. Dorobo (pl. Wandorobo) is the anglicized term used in most of the early and colonial literature (see Kratz 1980; 1994, 60–64; Klumpp and Kratz 1993, 200). The Samburu-Ltorrobo relationship is essentially the same as the core Maasai-Torrobo one, though the northern Torrobo groups are not Okiek and don't speak Kalenjin.

18. Margarido and Wasserman (1972) follow conventional ethnography by

defining Torrobo and Maasai as representing two cultural entities. Galaty (1977) describes Torrobo as peripheral to Maasai identity and blacksmiths as a "submerged" group within Maasai identity. In Galaty 1979, by contrast, he does not distinguish them in this way since in order to make his argument, Torrobo have to be structurally and symbolically equivalent to *lkunono*. His later work (e.g., 1993) is clearer (and less structural) on this point. Larick (1986b, 166) argues that all pastoralist identities in northern Kenya were in a state of constant flux prior to colonialism and that therefore one can speak of Maa pastoralists as having herding, foraging, and blacksmithing "components" (cf. Galaty 1979). I follow here the approach offered by Kratz (1994) that allows the Torrobo to define themselves (and allows others to define them) independently of their higher-caste neighbors.

19. *Loibor-kineji,* "people of the white goats." Samburu at this time (1892) had very few cattle, probably due to rinderpest (which did not affect goats) and to the fact that in Rendille country they were in a much more marginal environment for cattle pastoralism.

20. Arkell-Hardwick (1903, 241) claimed that when smallpox struck, the Samburu were able to send their moran away to avoid the disease, since they did not own such large numbers of animals as the Rendille. The Rendille, unable to spare their young men, paid a high price in lives lost—apparently enough to tip the balance of power in the alliance.

21. On a visit to Laikipia in 1991 we stopped at a settlement where to my unpracticed eye and ear, the inhabitants both looked and sounded Samburu. They were tall and slender, wore Samburu-style ornaments and dress, and spoke Lokop, the Samburu dialect of Maa. I was later corrected by my Samburu companions and told that these were in fact "Samburu Torrobo." There were of course subtle differences, but I as a neophyte could not detect them.

22. Galaty (1979) lays out a classic structuralist argument for caste pollution based on the substances associated with each caste in turn. The term "praxis" in this case is understood to refer to symbolic, not actual, behavior.

23. Diviners (*iloibonok*) were influential sources of authority among core Maasai but were much less so among Samburu.

24. *Lkunono* say that this acknowledges fear of the smith's power. Non-*lkunono* say it is to ensure that there is no curse on the circumcision knife.

25. Recent concern for the spread of HIV-AIDS has affected these practices. At a circumcision I attended in 1996, a Gikuyu "little doctor" (medical assistant) from the nearest government hospital was brought in to perform the circumcisions, though this was an unusually small group of only six boys and not one of the large public ceremonies involving hundreds of initiates. In the 2005 ceremonies, the same group of families returned to the use of a traditional circumciser.

26. This purity is a bit of an exaggeration on the part of *lkunono;* they sometimes take wives from the Lmarrato clan which absorbed Torrobo families in earlier generations.

27. Samburu moran do not live in separate warrior *manyattas,* so it is unclear how this generalization about raiding applied in their case.

28. For a detailed analysis of the location of Samburu smelting sites, see Larick 1986b.

29. Brown (1980, 171–184) describes the smith's curse as ubiquitous in Kenya, suggesting that it has nothing to do with out-group status per se, though the details she relates for how the curse is used suggest that among agriculturalists it is most often used to punish thieves.

30. The Tabaski festival commemorates the sacrifice of Abraham, traditionally framed as a blood sacrifice with a knife, which may account for the ritual salience of the smith.

31. Allan Lelenguya, interview with the author, 21 October 1993.

32. The umbilical cord is cut by the smith's knife, creating the parallel to circumcision and excision.

33. This ambivalence about the boundary between auspiciousness and danger appears again in the Samburu attitude toward twins, who were dangerous and formerly killed at birth if they were first-born, but at all other times were thought to be favorable (Spencer 1973, 83).

34. Among both Samburu and Idoma, despite the wide differences in the way smithing was construed as an occupation, all smelters were smiths, though all smiths were not necessarily smelters. This appears to be a very common configuration; smelting and smithing were both limited by the proximity of ores, charcoal, and clay.

35. In times of famine, Samburu do hunt and eat a few kinds of wild game —buffalo (equivalent to cows) and certain gazelle species (equivalent to sheep and goats)—but it is not publicly acknowledged, both because it is on the margins of acceptability and because of anti-poaching laws.

36. Discussions of this question were complicated by the fact that what constitutes a respectable-sized herd in Samburu estimation has shrunk dramatically since 1958–1959 when, according to Spencer (1973), the average Samburu herd was eighty cows (though he documents many much larger ones in his case studies). The impoverishment has come as a result of *shifta* and *ngoroko* raids and several severe droughts. At the same time, the population has more than doubled, thus further shrinking the per capita herd size. Lolkididi, who is considered well off by local standards, has about sixty cows and perhaps 200 sheep and goats.

37. Researchers for the Samburu District Profile (Were 1986, 87) counted thirty blacksmith settlements in three of the four divisions. This represents a significant undercount because Lorroki Division was not reported.

38. "Traditional" here means having a local use value, whether or not the objects are sacra.

39. Knops (1959, 91) cited in Richter (1980a, 41).

40. There is not sufficient published information on how various Yoruba carving workshops have responded to colonial and postcolonial patronage and the decline in orisha worship. In 1977, about 80 percent of Alaye's commissions were nontraditional. This is due primarily to the fact that modern Ile-Ife is a university town with many educated elites as well as an ancient center of Yoruba tradition—a major reason for locating the workshop there rather than in Ekiti.

41. An interesting exception would be Yoruba Gelede masks that combine inventiveness with a range of recognized symbolic conventions.

42. Tiv are known in the Benue for their expansionism (Tiv territory now

covers a substantial area north of the Benue River as well as south of it), and with it, the acquisition of whatever seems worthwhile from neighboring cultures. A favorite Tiv song begins "Everywhere, everywhere is my country" (Martin Dent, pers. comm.).

43. Emeje Ogbu, interview with the author, 11 April 1978. A similar kind of claim is made regarding Dan masquerades, which are said to be created by the spirits they materialize, though with the help of a human carver (Fischer and Himmelheber 1984, 8)

44. Although the basic structure is a simple burial cloth, because the masked spirit is an ancestor resurrected from the grave, it has gradually become much more opulent and colorful in the same manner as the Yoruba Egungun masquerades with which it shares many similarities.

45. For contrasting views on the relative importance of African sculptors and patrons, see Walker (1998) and Vogel (1999).

5. MASK AND SPEAR

1. Bruce Lincoln, *Discourse and the Construction of Society: Comparative Studies of Myth, Ritual, and Classification* (New York: Oxford University Press, 1989), 145.

2. It is somewhat misleading to talk about them as dichotomous, in that all "art" is also a particular kind of artifact that exhibits special characteristics.

3. This took place in a public conversation between Bochner and critic James Meyer at the Carlos Museum in Atlanta, Georgia, on 17 October 2002, in which the artist acknowledged his dealer's success in selling conceptual art. See also Taub (2002).

4. Andras Szanto, "A Business Built on the Hard to Sell," *New York Times,* 20 October 2002, A35.

6. WARRIOR THEATRE AND THE RITUALIZED BODY

1. For comparable phenomena, see Jean Comaroff's (1985) discussion of Tshidi body ritual before and under colonialism and Fernandez's (e.g., 1991) treatment of Bwiti embodiment in relation to precolonial Fang practice.

2. My interviews a generation later, over a fourteen-year span from 1991 to 2005 that included massive cattle-raiding from *ngoroko* (mainly Turkana) and Somali, indicate that while *miraat* may have been shelved, it has not actually disappeared and may be resuscitated when necessity arises.

3. These food prohibitions were strictly observed until very recently but have begun to be ignored by the newest age set of junior moran, who are referred to contemptuously as "house warriors"—that is, warriors who prefer the comforts of the *manyatta* to the rigors of the bush—by the age-set immediately senior to them.

4. Goatskins in some accounts.

5. He will wear identical ornaments for his daughter's initiation and marriage.

6. Kingore Lenaronkoito, interview with the author, 19 February 1996.

7. This ritual androgyny is seen not only in the father's donning of wom-

en's ornaments at his son's rebirth as a young adult but in the very important role performed when another adult male who is close to the family holds the boy's back while he is being circumcised. In doing so, he releases (gives birth to) the new initiate into the world and takes on a lifelong godparenting role toward him.

8. The journey itself is also very important as it brings the initiates to places where their ancestors formerly lived (such as Mt. Kulal or Mt. Nyiro), thus is a kind of recapitulation of pastoralist history. It is also a test of endurance, as the trek may be very long and the initiates must rely on their own strength and inner resources. In 2005, half the initiates in my family's *lolora* were schoolboys whose exams overlapped this schedule so had to be transported part of the way by lorry.

9. Also called *lokwenyi* after the boy who wears it.

10. This is a custom in flux, and many people are now buried in graves, but as in the past, the houses in which they died are still abandoned or torn down.

11. In our *nkang* there was one house in too advanced a state of disrepair for women and young children to sleep in during the cold nights on Lorroki Plateau. Boys took it over and moran would sometimes pass the night there too, but their sleeping arrangements are always vague and noncommittal, reflecting the unconcern of late adolescence for the formalities of living as well as an ideology of nomadism. Elders with young wives do not want moran other than their sons or grandsons sleeping in their settlements for obvious reasons having to do with sexual rivalry.

12. There is, however, a widely held belief that in the past there were large-scale raids. It is difficult to know how typical this was and how much of it is part of the broader "usable past" Samburu shared with Maasai before the latter were displaced from the northern Rift Valley in 1911.

13. According to Pavitt (1991, 1), no more than five cases occurred among the 5,000 boys circumcised in 1990. On this question of honor with regard to girls' excision, the fact that it is not a public ceremony removes much of the social pressure to which boys are subjected. For example, circumcision ceremonies were held at my Samburu family's *nkang* in 1996, at which two girls and five boys were circumcised on the same day due to the strict rules about observing sibling order. The ceremonies were repeated, though in a *lolora* in the nearby forest, in 2005 when the same family initiated two boys and their intermediate sister. In both settings, they were very separate events, one outdoors and semipublic (to a Samburu male spectatorship), the other inside the circumcision house and exclusively female.

14. "My light brown bull—roar! For I will not bring dishonour (*nyileti*)" (Spencer 1965, 105).

15. Another source of this judgment was their refusal to work on settler farms, which further colored the views of Samburu moran held by Lady Eleanor Cole and others in the Powys case.

16. My own information differs somewhat from Spencer's on this point. I was told that emasculation was a common (though not universal) Samburu practice and that the genitalia were openly displayed as trophies.

17. According to Spencer, he also continued to wear the woman's apron

for this period, but I was unable to confirm this with informants a generation later.

18. Again my information that they were the beads of unmarried girls differs from Spencer's account that they were women's beads. In any case, neither of these rituals is likely to have been performed in this fashion before the end of the nineteenth century. It is fairly clear from later-nineteenth-century travelers' accounts that Samburu warriors typically wore little or no clothing before their sojourn with the Rendille, and the beads were not common before the arrival of ivory caravans beginning in the last quarter of the nineteenth century. However, Hollis recorded the custom of women and/or girls greeting returning warriors with grass (the usual gesture of peace or request for forgiveness among Rift Valley pastoralists) and milk for core Maasai: "Whenever warriors return from a raid, and it is desired to praise those who have killed some of the enemy, a girl takes a small gourd of milk, and having covered it with green grass, sprinkles it over them" (1905, 289, 351).

19. This too has its Idoma equivalent in the wearing of women's ivory bangles by sacred kings who become ritually female at their installation in order to avoid involvement in fighting among political factions.

20. Fifteen was a typical age for excision and marriage in the past, but marriage for girls is taking place at an increasingly later age due to fact that more are being enrolled in primary school (which typically ends at the eighth grade) and even secondary school. It has therefore become common for excision and marriage to occur as separate rituals a year or more apart.

21. In 2005, this was a custom in flux: still officially required but with increasing numbers of families with girls in school being influenced by their non-Samburu teachers to substitute a nonsurgical alternative.

22. It is possible to circumvent the strict sibling order of initiation if there are enough extenuating circumstances, but a blood sacrifice must first be offered.

23. Unlike the Maasai *eunoto,* a group ceremony ending warriorhood, most Samburu warriors do not cut off their hair en masse; instead, they do this individually. In the days when all moran were bachelors, marriage was the reason for ending warriorhood and short hair was the principal symbol of that new role.

24. This distinction is no longer so rigid in real life. Moran today tend to marry and often become fathers before they reach formal elderhood. Prior to the 1950s, marriage was permitted after they had passed through the Lmugit of the Bull ceremony into the last stage of warriorhood (Spencer 1965, 89), but nowadays it is frequently allowed after they have passed through the Lmugit of the Name and become senior moran (about five years earlier, at roughly twenty to twenty-five years old).

25. In the event of pregnancy, the warrior will approach the bride's male relatives for consent to marry. Although adolescent love relationships are not considered the ideal basis for marriage, abortion by traditional medicine is thought of as dangerous. In the past, if the marriage was forbidden by the rules of exogamy or incest, or was otherwise inauspicious, the baby would be aborted or killed at birth (Spencer 1965, 185). Today it may also be given away

privately for adoption or even kept, though the girl's future marriage prospects will be decreased in that case.

26. The hair-sharing group described by Spencer (1965, 74) is composed of a circle of kinsmen who are age-mates. The group is demarcated through shared hair rituals and use of ochre, but its members do not share any particular hairstyle.

27. It is applied not only to the skin but to the hair and, in the case of girls (whose heads are clean shaven), to their neck beads. The final occasion when a girl is fully ochred is when she is a bride, when even her arms, back, and leather clothing are covered.

28. Known generically as *balu* ("blue") after commercial powdered laundry bluing, despite the fact that it is a different color.

29. As noted in the preceding section, green is also a color of major signifying importance to the Samburu. For a fuller treatment of Samburu color symbolism and its relation to the surrounding environment, see Rainy 1989.

30. Prior to the 1930s, a number of other Rift Valley and Central Highlands warriors (such as the Gikuyu) had Maasai-type hairstyles, along with similar weaponry, but these disappeared under missionary and white settler influence.

31. Cole (1979, 90) relates the story told to him of a moran mauled by a lion who refused to enter hospital when told that his hair would be cut off prior to treatment.

32. There is one way around this problem nowadays: a talented old man in the Maralal area has for some time constructed ochre-colored yarn wigs in this long style, which can be worn when the occasion demands. They are detailed and carefully made and are detectable as wigs only at very close range. In recent newspaper photographs of an enterprising young Maasai moran touring the United States, it was clear that he too wore such a wig (for who would be available to carry out the elaborate braiding required?).

33. Cole (1979, 91) refers to the clasp as arrow-shaped but it is actually fully rounded, not flat like an arrow. The same shape is carved on one type of *rungu*.

34. I do not include Oglinye or other mask headdresses (also called crest masks) in this category because they do have "faces," even if they are spatially displaced from the wearer's own.

35. From time to time this actually happens as a self-conscious piece of performance art, such as when the Native American artist James Luna displayed himself in a glass case of the type used in exhibiting ethnological specimens.

7. IDOMA SCULPTURE

1. Idomaland was intersected by the railroad connecting Northern and Southern Nigeria, and the market town of Utukpo then grew around the crossing of the railroad and the trunk road from the north to Enugu. Despite the presence of this commercial outpost, the villages surrounding Otukpo remained small and deeply conservative even at the time of my fieldwork in the late 1970s and '80s.

2. I would take exception in the case of African masks because some genres are simultaneously sacra and the major form of local entertainment, for which the laws of supply and demand do apply.

3. At the time of my initial fieldwork in the late 1970s, Otobi village had forty-two age-sets. Each one was formed about every two years after its members reached the age of about five, but they were not named until the members were in their late teens. Akpa District settlements have Ogoja roots, however, and core Idoma communities do not recognize named age-sets in this fashion, though they have several shared masquerades.

4. The Benin bronzes were the exception, as they were put up for public auction in London after the 1897 Punitive Expedition and were acquired by several German, American, and Austrian museums.

5. The exhibit, which was held at the Royal Anthropological Institute, was titled Traditional Art from the British Colonies.

6. The Nigerian law defines an antiquity as anything of "surpassing cultural value"; therefore, an object need not be old to require an export license. This blanket coverage has been partly responsible for the steady business in illegal exports, often in large overlander trucks across the Sahara or the mountainous eastern border with Cameroon, which can also be breached easily by canoe in the network of creeks at the coast.

7. I did collect for several museums, though I did not collect sculpture. I collected Nigerian textiles for the University of Ibadan and Dartmouth College Museum (now the Hood Museum); Idoma pottery for the Jos Pottery Museum; Idoma cast-brass smoking pipes for the University of Ibadan; and household objects for the Och'Idoma's museum in Otukpo. The fact that I collected no masks or figures for the Department of Antiquities was due to the unwillingness of the Idoma to sell them (partly a result of the fallout over the actions of the two art dealers a few years earlier). Somewhere in a box, I have one face mask that my friend the artist Ojiji (Kasfir 1989) insisted on giving me and for which I dutifully got an export permit.

8. Cameroon scholar Pierre Hartier apparently had a collection of these overmodeled skulls at one time, though they were from Cameroon, not Idomaland.

9. The city walls of the Kano Emirate were finally breached by British forces in 1906, and the first military patrols in Idoma country began around 1908–1910.

10. Father Francois Neyt has identified a number of seated female figures as *ekwotame,* as if there were a cult or a group of disciples associated with them. This is quite misleading, and unfortunately the misidentification has found its way into the auction-house literature (e.g., McCarty-Cooper and Kosinski 1992). A piece very similar to the Otukp'icho *ekwotame* exists in a private London collection and while it is undoubtedly by the same artist, it had its own trajectory of use that need not have included any sojourn in an Idoma community.

11. The colonial document collection "Lafia Emirate—History and Organization 1933–1951" in Nigeria National Archives in Kaduna notes that the Jukun and Alago (Arago) "are remarkable for their developed idea of supernatural kingship," which was probably why they were left to deal with

their own internal affairs (as opposed to "those tribes still in a primitive state" that formed the bulk of the population in the countryside).

12. In 1986, I accompanied a small party of Ekpari clan elders from Otobi and its environs to their originating villages in Yatye (Yachi). Treated like returning heroes, we were honored with visits by several masquerades, none of which physically resembled the Otobi clan masks, though everyone "remembered" these masks vividly. The Akweya moved north into Idomaland about 150 years earlier.

13. Christopher Steiner (1994) says these are made by Senegalese traders, but a Gambian middleman who sells them in Nairobi claims they are produced in Kumase too.

14. See two special issues of the ecology journal *Cultural Survival Quarterly:* "The Tourist Trap: Who's Getting Caught?" (6, no. 3 [31 July 1982]) and "Ethnic Arts: Works in Progress" (6, no. 4, [31 October 1982]).

15. See Vogel 1991, 238–239 for a typical assessment.

16. These are terms used by West African middlemen who bring their goods to traders and dealers in Nairobi. Steiner reports similar usage in Abidjan. "Antiquity" is Nigerian pidgin for practically any artifact that is being sold illicitly.

17. Ripley's collection was a part of the old Dartmouth College Museum, where I came to know it in the early 1970s.

18. A Lega carving workshop made up of refugee carvers from the Congo in Kampala, Uganda, obeys a slightly different logic—the best carvers make souvenir furniture and the lesser ones carve copies of the small Bwami figures for initiation baskets.

19. Collectors are of course not monolithic any more than artists and traders are on these points. There are fearless and timid, intellectual and bourgeois, intensely involved and coolly detached collectors. There are also predictable differences between American and European collectors. But I am speaking here of what constitutes a norm compared with the demeanor of the tourist or traveler.

8. SAMBURU ENCOUNTERS WITH MODERNITY

An earlier version of this chapter, entitled "Samburu Souvenirs: Representations of a Land in Amber," was prepared for the 115th annual meeting of the American Ethnological Society, co-sponsored by the Council for Museum Anthropology, entitled "Arts and Goods: Possession, Commoditization, Representation," Santa Fe, New Mexico, 15–18 April 1993. It was later published in the anthology *Unpacking Culture,* edited by Ruth Phillips and Christopher Steiner (1999b).

1. As the term is used by Kenyans, a safari is any journey away from home, regardless of the purpose. I refer instead to the specialized meaning used by foreigners and tour companies, connoting an adventure far from home that usually includes wild game viewing.

2. Its ecosystem of savanna grasslands and acacia thornbush resembles those of many Sahelian countries but for the fact that it also has mountains

and borders the Indian Ocean so includes a tropical coastline as well as the fertile central highlands, both with dependable rainfall.

3. Errington and Gewertz (1989) noted a self-referential distinction between "tourist" and "traveler" in Melanesia, the latter referring to the typically youthful backpacker seeking an "authentic" experience of the exotic other who tries to distance him or herself from the less intrepid (and usually older) "tourist" on a luxury package tour. The spectators discussed here bridge both categories as well as the gray area between.

4. I have twice accompanied groups of American college students to Samburu District. Virtually every male student on those trips, where bonding with Samburu males is encouraged in an effort to help students participate in the culture, came away with some version of a spear. Like the backpackers in Melanesia, they were eager to distance themselves from tourists and to have an "authentic" encounter with the Samburu, so they rejected the spears made for tourists and sought to acquire actual warriors' spears.

5. Since most do not have cameras of their own, their photographs, carefully laid away, are usually gifts from the spectator-photographer—whether tourist, missionary, or ethnographer.

6. On a 2004 ecotourism Web site calling itself The Kenyan Portfolio (www.kenyanportfolio.com), more than half of the locations were north of Mt. Kenya in Laikipia. All were private residences of white ranchers with luxurious guest accommodations.

7. David Brown (pers. comm.) has pointed out to me that it would be misleading to suggest that the Samburu do not "incorporate and process the outer world" like everyone else. Rather, Samburu and Maasai behavioral norms for warriors place a high value on an unflinching composure in all situations, which is then interpreted by the spectator as imperviousness.

8. The presence of outsiders in the circumcision camp (*lolora*) is sometimes negotiable but at other times forbidden. If they are allowed, they may be told that they cannot take photographs.

9. The two categories overlap: some of the more expensive postcard representations of Maasai and Samburu are reproductions of art-book photographs by Carol Beckwith (*Maasai*), Angela Fisher (*Africa Adorned*), and others.

10. I do not wish to oversimplify what is really a very complex set of interactions. The professional photographer, who is as apt to be Kenyan and/or female as male and/or foreign, is also a spectator in this situation but has no control over the spectatorship of all who eventually "consume" the published photographs. Inevitably this will include everyone from students looking for research topics to nostalgic travelers to people who like to look at nudity.

11. The reader will wonder how I know this since my understanding is necessarily filtered through the consciousness of a non-Samburu (and female) researcher. It is based partly on the accumulated field investigations of others who have studied the Maasai and Samburu (especially Paul Spencer and Michael Rainy) and, since 1991, on my experience of living in the same family with Samburu who have recently left warriorhood and others who have recently entered it. The "way warriors think" is far from monolithic. But as Spencer and Rainy have both noted, there is in Samburu culture a noticeable pressure to conform to role expectations that makes a certain degree of generalization about behavior possible.

12. According to the Lkurorro, it was actually a Maasai from Narok who first thought of making and selling a small spear for tourists at Bomas of Kenya (a Nairobi tourist village), and there are a few Maasai moran mixed with the Samburu at Mtwapa. There is nowadays a second Samburu enclave farther north up the coast at Malindi, but they are there primarily to sell beadwork, the other Samburu commodity in this new tourist market (Johanna Schoss, pers. comm., 28 January 1994).

13. The reasons for this are partly cultural ecology and partly economics: in Samburu District, smiths make their own charcoal from the wood of a local species of acacia tree; at the Coast they would have no access to it and would have to buy local charcoal, which is both expensive and inferior in its ability to sustain the high temperatures needed for forging.

14. There are inevitably some assignations with female tourists, which are essentially an extension of warrior behavior at home: a string of conquests adds to a young man's prestige with his peers, though he is often counseled by the older moran present to be cautious in this matter. The purpose of being there is to earn money to bring home, not to spend it on discos, drinking, clothes, and women. The moran who habitually falls prey to such pleasures is forced to stay at the Coast for long periods, sometimes years, rather than face the humiliation and disapproval of arriving back in his father's *nkang* empty-handed. He is pitied by fellow moran rather than admired.

15. Maasai usage allows for the word *enkang*, "settlement," to be used even for a city like Nairobi while the Samburu dialect of Maa limits the idea of *nkang* to "home," the family settlement. All commercial settlements are inherently foreign and cannot be bridged semantically without resorting to Samburu English ("*ltown*") or Samburu-ized Kiswahili (*lduka*)—further suggestion of the bracketing of the conceptual spaces for the cash economy and the nonpastoralist in Samburu thinking.

16. The most popular of these in the 1990s was the beaded watchstrap cover that warriors began making for themselves to decorate the wristwatches they bought with their newly acquired cash.

9. SAMBURU WARRIORS IN HOLLYWOOD FILMS

An earlier version of this chapter was given at the 1998 Triennial Symposium in African Art in New Orleans and was later published as "Slam-Dunking and the Last Noble Savage," *Visual Anthropology* 15, nos. 3–4 (2002): 369–385.

1. To avoid possible trouble, the filmmakers used trained Hollywood lions that the warriors were warned not to spear under any circumstances (being both very expensive and hard to replace).

2. Various other pastoralists such as Rendille who have alliances with Samburu, as well as scattered Ltorrobo, sometimes speak the Samburu dialect of Maa as a second language, and Ariaal are bilingual in Rendille and Samburu.

3. The movement actually called itself the Land and Freedom Army.

4. When political independence was ushered in, former Mau Mau fighters were pushed aside by the ruling elite. Yet they continued to command the loyalty and respect of many people in Central Province.

5. It is not hard to see this if one looks carefully, since their style of dress, weapons, hairstyles, and decorations are slightly different. Most noticeably, only Samburu warriors wear ivory earplugs.

6. These were complex undertakings: to get a Kenyan passport one needs an identity card, and to get an identity card one supposedly needs a birth certificate, something very few Samburu have. Instead, the passports were issued en masse but were valid only for the duration of the filmmaking. The Kenyan government insisted on the Western clothes; it had no interest in perpetuating the Noble Savage stereotype beyond its own borders.

7. Rick Lyman, "At the Movies," *New York Times*, 28 April 2000, E26.

8. Beneath this blanket statement lie many contradictions in the accounts of the various parties. I have left these out, since I want to stress the fact of a communication problem rather than its actual scenario.

9. Aside from joining the army or police (an option only for those who have been to school) the only salaried employment open and acceptable to most Samburu is working as a night watchman in faraway places such as Nairobi. All three occupations are seen as a logical extension of the warrior age-grade.

10. Sample verbatim comment from field notes: "Michael Douglas? Michael was a good person. At the end of filming he held something called 'barbecue,' and invited all the Samburu."

11. Fred Mudhai, "The Good and Bad Side of 'Moranism,'" *The Standard* (Nairobi), 15 July 1999, 5.

12. Kenya News on the Internet, 15 November 1995.

13. Ibid.

14. In the 1990 census, the population of Samburu District was 145,000, of whom approximately 97,000 were Samburu. This translated into roughly 0.4 percent of the Kenyan population.

15. Traveling to Nairobi from Samburu District is referred to as "going to Kenya." This no-man's-land status is also affirmed by long-distance lorry drivers, who have to pass through the North Rift as they travel from Ethiopia en route to Nairobi.

CODA

1. J. Ngunjiri, "Awash with Illicit Arms: In the North Rift, the Gun Is the Weapon of Choice," *Sunday Standard* (Nairobi), 30 March 2003, 16.

2. The current black-market price for an AK-47 rifle in Kenya is 20,000 to 30,000 shillings, the cost of about two heifers.

3. Another recent change is in what to wear on a raid: the "Turks" took to wearing red *shukas* so they would look like their enemies the Samburu. As a result, the Samburu do not wear their *shukas* anymore while fighting Turkana.

4. Muchemi Wachira, "Spilling Blood Is a Way of Life in This Northern Frontier District," *Sunday Nation* (Nairobi), 10 July 2005, 12–13.

BIBLIOGRAPHY

ARCHIVAL SOURCES

Kenya National Archives, Nairobi:
 Isiolo District Annual Reports, 1929–1940, DC/ISO/1/2
 Laikipia-Samburu District Annual Reports, 1935–1937, DC/SAM/3/2
 Samburu District Annual Reports, 1921–1928, DC/SAM/1/1
 Samburu District Annual Reports, 1933–1934, 1938–1947, DC/SAM/1/2
 Samburu District Annual Reports, 1948–1959, DC/SAM/4/1
Nigeria National Archives, Kaduna:
 Ethnological Notes on the Tribes in Idoma Division, 1919–1925
 Lafia Emirate: History and Organization, 1933–1951
 Macleod, T .M. 1925. "Report on the Western Areas of Okwoga."
 Shaw, J. H. 1934. Memorandum on Idoma Traditional Council [formerly Idoma Native Authority], Otukpo, Nigeria.
 Smith, J. N. 1919. "Okpoto Dances."

FILMS

The Air Up There. 1992. Dir. Paul Michael Glaser. Los Angeles: Hollywood Pictures.

The Ghost and the Darkness. 1996. Dir. Stephen Hopkins. Los Angeles: Paramount Pictures.

The Gods Must Be Crazy. 1980. Dir. Jamie Uys. Gabarone, Botswana: CAT Films.

Greystoke: The Legend of Tarzan. 1984. Dir. Hugh Hudson. London: Edgar Rice Burroughs Inc.; Los Angeles: Warner Bros.

I Dreamed of Africa. 2000. Dir. Hugh Hudson. Los Angeles: Columbia Pictures.

In and Out of Africa. 1992. Dir. Ilisa Barbash and Lucien Taylor. 1992. Los Angeles: University of Southern California Center for Visual Anthropology.

BIBLIOGRAPHY

Kitchen Toto. 1987. Dir. Harry Hook. London: British Screen Productions.

Mogambo. 1953. Dir. John Ford. Los Angeles: MGM.

Odongo. 1956. Dir. John Gilling. UK: Warwick Film Productions Ltd; Los Angeles: Columbia Pictures.

Safari. 1956. Dir. Terence Young. UK: Warwick Film Productions Ltd; Los Angeles: Columbia Pictures.

INTERVIEWS CITED

An'ne, Omaga. 1978. 18 February.

Kitavi, Jackson. 1991. 17 January.

Klumpp, Donna. 1987. 10 April.

——. 1991. 14 January.

Larugumu, Lokwakwi. 2000. 20 August.

Lekesio, Lekine. 1993. 6 October.

Lekimenshu, Lkoine. 1992. 5 January.

Lekupon, Lembarasoroi. 2000. 20 August.

Lelenguya, Allan. 1993. 21 October.

Lelengua, Logori. 1993. 2 October.

Lenaronkoito, Bernard (Ben) Saidimu. 1996. 21 February.

Lenaronkoito, Kingore. 1991–2000. More than ten interviews.

Lenaronkoito, Kirati. 1991–2005. More than thirty interviews.

Lepile, Ltorroni. 1992. 4 January.

Lepile, Sankeyo. 1992. 3 January.

Lesepen, Ltuperset. 1992. 2 January.

——. 1992. 15 January.

——. 1997. 5 August.

——. 2003. 6 May.

Letekirich, Kariuki. 1992. 6 January.

——. 1993. 8 October.

——. 2004. 10 July.

Letikirich, Soroita. 1993. 3 October.

——. 1991. 20 April.

Lukumiair, Lolkididi. 1992. 15 August.

Odaba, Och'Akpa Ekereke. 1976. 15 May and 7 October.

——. 1986. 18 January and 3 March.

Ogbu, Emeje. 1978. 9 February and 11 April.

Ojefu, Ojiji. 1978. 4 July.

Ojiji, Vincent. 1978. 26 January.

Okpabi, Och'Idoma II Ajene. 1976–1978, 1986, 1989. More than twenty interviews.

Rainy, Michael. 1991. 3 February.

——. 1996. 7 February.

PRIMARY AND SECONDARY SOURCES

Abiodun, Rowland. 1983. "Identity, and the Artistic Process in the Yoruba Aesthetic Concept of Iwá." *Journal of Cultures and Ideas* 1, no. 1: 13–30.

Abraham, Roy Clive. 1933. *The Tiv People.* Lagos: Government Printer.

——. 1951/1967. *The Idoma Language.* London: University of London Press.

Achebe, Chinua. 1964. *Arrow of God.* London: Heinemann.

Ackerman, James S. 1963. "Western Art History." In James S. Ackerman and Rhys Carpenter, *Art and Archaeology.* Englewood Cliffs, N.J.: Prentice Hall.

Akiga [Akighirga Sai], and Rupert East. 1939/1965. *Akiga's Story: The Tiv Tribe as Seen by One of Its Members.* Trans. and ed. Rupert East. London: Oxford University Press for International African Institute.

Alloula, Malek. 1986. *The Colonial Harem.* Minneapolis: University of Minnesota Press.

Amali, S. O. [ca. 1972]."What Caused the Trouble between Alekwu and the Abakpa: Alekwu Chant, Otukpo." Unpublished paper, Institute of African Studies, University of Ibadan, Nigeria.

Amin, Mohamed. 1981. *Cradle of Mankind.* London: Chatto & Windus Ltd.

——, and Duncan Willetts. 1987. *The Last of the Maasai.* Johannesburg: Thorold's Africana Books.

Appadurai, Arjun, ed. 1986. *The Social Life of Things.* Cambridge: Cambridge University Press.

——. 2001. *Globalization.* Durham, N.C.: Duke University Press.

Appiah, Kwame Anthony. 1991. "Is the Post- in Postmodernism the Post- in Postcolonial?" *Critical Inquiry* 17, no. 2: 336–357.

Arkell-Hardwick, A. 1903. *An Ivory Trader in North Kenia.* London: Longmans, Green and Co.

Armstrong. Robert G. 1955. "The Idoma-Speaking Peoples." In *Peoples of the Niger-Benue Confluence,* ed. Daryll Forde. London: International African Institute.

——. 1989. "The Etymology of the Word 'Ògún.'" In *Africa's Ogun: Old World and New,* ed. Sandra T. Barnes. Bloomington: Indiana University Press.

Armstrong, Robert Plant. 1971. *The Affecting Presence: An Essay in Humanistic Anthropology.* Urbana: University of Illinois Press.

Baikie, William Balfour. 1856/1966. *Narrative of an Exploring Voyage up the Kwora and Binue.* London: Frank Cass & Co. Ltd.

Barley, Nigel. 1984. "Placing the West African Potter." In *Earthenware in Asia and Africa,* ed. John Picton. Percival David Foundation Colloquia no. 12. London: University of London Percival David Foundation of Chinese Art.

Barnes, Sandra T., and Paula Girshick Ben-Amos. 1989. "Ogun: The Empire

Builder." In *Africa's Ogun: Old World and New,* ed. Sandra T. Barnes, 39–64. Bloomington: Indiana University Press.

Bascom, William. 1973. *African Art in Cultural Perspective.* 1st ed. New York: Norton.

Bassing, Allen. 1973. "Masques Ancestraux chez les Idoma." *Arts d'Afrique Noire* 5: 6–11.

Baudrillard, Jean. 1968. *Le Système des Objets.* Paris: Editions Gallimard.

———. 1983. *Simulations.* New York: Semiotext(e).

Baumann, Hermann, and Diedrich Westermann. 1948/1957. *Les Peuples et les civilizations de l'Afrique.* Paris: Payot.

Bell, Catherine. 1992. *Ritual Theory, Ritual Practice.* New York: Oxford University Press.

Ben-Amos, Paula Girshick. 1976. "A la Recherche du Temps Perdu: On Being an Ebony Carver in Benin." In *Ethnic and Tourist Arts,* ed. Nelson Graburn, 320–333. Berkeley: University of California Press.

———. 1977. "Pidgin Languages and Tourist Arts." *Studies in the Anthropology of Visual Communication* 4, no. 2: 128–139.

———. 1999. *Art, Innovation, and Politics in Eighteenth-Century Benin.* Bloomington: Indiana University Press.

Benjamin, Walter. 1968a. "Unpacking My Library." In *Illuminations,* ed. Hannah Arendt. Trans. Harry Zohn. New York: Schocken Books.

———. 1968b. "The Work of Art in an Age of Mechanical Reproduction." In *Illuminations,* ed. Hannah Arendt. Trans. Harry Zohn. New York: Schocken.

Berman, Bruce, and John Lonsdale. 1992. *Unhappy Valley: Conflict in Kenya and Africa.* 2 vols. London: James Currey Ltd.; Athens: Ohio University Press.

Biebuyck, Daniel P. 1969. "Introduction." In *Tradition and Creativity in Tribal Art,* ed. Daniel P. Biebuyck, 1–23. Berkeley: University of California Press.

Blier, Suzanne Preston. 1980. *Africa's Cross River: Art of the Nigerian-Cameroon Border Redefined.* New York: L. Kahan Gallery.

———. 1987. *The Anatomy of Architecture: Ontology and Metaphor in Batammaliba Architectural Expression.* Cambridge: Cambridge University Press.

Bochner, Mel. 1999. "From *Working Drawings* to *Measurements:* 1966–1970." Lecture given at Emory University, April 22.

Bonte, Pierre. 1991. "'To Increase Cows, God Created the King': The Function of Cattle in Intralacustrine Societies." In *Herders, Warriors and Traders: Pastoralism in Africa,* ed. John G. Galaty and Pierre Bonte. Boulder, Colo.: Westview Press.

Borgatti, Jean. 1982. "Ogiriga-Okpella Masks: In Search of the Parameters of Beautiful and Grotesque." *Visual Communications* 8, no. 3: 28–40.

———. 2005. "Aesthetics and Social Change in Okpella 1979–2003." Seminar paper, World Arts Faculty Seminar Series, University of East Anglia.

Boston, John. 1977. *Ikenga Figures among the North-West Igbo and the Igala.* London: Ethnographica.

Bourdieu, Pierre. 1977. *Outline of a Theory of Practice.* Trans. Richard Nice. Cambridge: Cambridge University Press.

——. 1980/1990. *The Logic of Practice.* Trans. Richard Nice. Stanford: Stanford University Press.

——. 1984. *Distinction: A Social Critique of the Judgment of Taste.* Trans. Richard Nice. Cambridge, Mass.: Harvard University Press.

Bowden, Ross. 1992. "Art, Architecture and Collective Representations in a New Guinea Society." In *Anthropology, Art, and Aesthetics,* ed. Jeremy Coote and Anthony Shelton. Oxford: Clarendon Press.

Brain, Robert, and Adam Pollock. 1971. *Bangwa Funerary Sculpture.* Toronto: University of Toronto Press.

Braudel, Fernand. 1979. *Civilization and Capitalism, Fifteenth to the Eighteenth Century.* Vol. 3. Trans. Sian Reynolds. New York: Harper and Row.

Bravmann, René. 1973. *Open Frontiers: The Mobility of Art in Black Africa.* Exhibition catalog. Seattle: University of Washington Press.

Brown, Elizabeth Jean. 1980. "Traditional Blacksmiths and Metalworking in Kenya: An Ethnoarchaeological Approach." Ph.D. diss., University of Edinburgh.

Bruner, Edward M. 2004. *Culture on Tour: Ethnographies of Travel.* Chicago: University of Chicago Press.

Burdo, Adolphe. 1880. *The Niger and Benueh: Travels in Central Africa.* Trans. Mrs. George Sturge. London: Richard Bentley & Son.

Byng-Hall, F. F. W. 1907. "Notes on the Okpoto and Igara Tribes." *Journal of the Royal African Society* 7, no. 26: 165–174.

Cameron, Roderick. 1955. *Equator Farm.* London: Heinemann.

Carroll, Kevin. 1967. *Yoruba Religious Carving: Pagan & Christian Sculpture in Nigeria & Dahomey.* London: G. Chapman.

Cartwright, Justin. 1993. *Masai Dreaming.* Australia: Sceptre Australia.

Cary, Joyce. 1944. *The Case for African Freedom.* London: Secker and Warburg.

——. 1939/1952. *Mister Johnson.* New York: New Directions.

Chanler, William Astor. 1896. *Through Jungle and Desert: Travels in Eastern Africa.* New York: Macmillan and Co.

Clément, Pierre. 1948. "Le forgeron en Afrique noire: quelques attitudes du groupe à son égard." *Revue de Géographie humaine et d'ethnologie* 2: 35–38.

Clifford, James. 1988. *The Predicament of Culture: Twentieth-Century Ethnography, Literature, and Art.* Cambridge, Mass: Harvard University Press.

Cline, Walter. 1937. *Mining and Metallurgy in Negro Africa.* General Series in Anthropology 5. Menasha, Wis.: George Banta Publishing Co.

Cole, Herbert M. 1969a. "Mbari Is Life." *African Arts/Arts d'Afrique* 2, no. 3: 8–17, 87.

——.1969b. "Mbari Is a Dance." *African Arts/Arts d'Afrique* 2, no. 4: 42–51.

——. 1969c. "Art as a Verb in Igboland." *African Arts/Arts d'Afrique* 3, no. 1: 34–41.

——. 1970. *African Arts of Transformation.* Exhibition catalog. Santa Barbara: Regents of the University of California.

——. 1979. "Living Art among the Samburu." In *The Fabrics of Culture*, ed. Justine Cordwell and Ronald A. Schwarz. The Hague: Mouton.

——, and Chike Aniakor. 1984. *Igbo Arts: Community and Cosmos*. Los Angeles: UCLA Museum of Cultural History.

——, and Doran H. Ross. 1977. *The Arts of Ghana*. Exhibition catalog. Los Angeles: UCLA Museum of Cultural History.

Comaroff, Jean. 1985. *Body of Power, Spirit of Resistance*. Chicago: University of Chicago Press.

Comaroff, John, and Jean Comaroff. 1992. *Ethnography and the Historical Imagination*. Boulder, Colo.: Westview Press.

Conrad, David C., and Barbara E. Frank, eds. 1995. *Status and Identity in West Africa: Nyamakalaw of Mande*. Bloomington: Indiana University Press.

Coombes, Annie E. 1994. *Reinventing Africa: Museums, Material Culture, and Popular Imagination in Late Victorian and Edwardian England*. New Haven, Conn.: Yale University Press.

Crocker, W. R. 1936. *Nigeria: A Critique of British Colonial Administration*. London: George Allen & Unwin Ltd.

Crowther, Samuel Ajayi. 1855/1970. *Journal of an Expedition Up the Niger and Tshadda Rivers Undertaken by MacGregor Laird in Connection with the British Government in 1854*. London: Frank Cass & Co. Ltd.

Cuvelier, J., ed. 1953. *Relations sur le Congo du Père Laurent de Lucques*. Brussels: Institut Royal Colonial Belge.

Danto, Arthur C. 1982. *The Transfiguration of the Commonplace*. Cambridge, Mass.: Harvard University Press.

——. 1988. "Artifact and Art." In *ART/artifact: African Art in Anthropology Collections*, ed. Susan Vogel. Exhibition catalog. New York: Center for African Art.

D'Azevedo, Warren. 1973. "Sources of Gola Artistry." In *The Traditional Artist in African Societies*, ed. Warren D'Azevedo, 282–340. Bloomington: Indiana University Press.

——. 1980. "Gola Poro and Sande: Primal Tasks of Social Custodianship." In *Ethnologische Zeitschrift Zürich*, 1:13–24. Völkerkundemuseum der Universität Zürich.

de Heusch, Luc. 1982. *The Drunken King or The Origin of the State*. Trans. Roy Willis. Bloomington: Indiana University Press.

de Maret, Pierre. 1980. "Ceux qui jouent avec le feu: la place du forgeron en Afrique Centrale." *Africa* 50, no. 3: 263–279.

——. 1985. "The Smith's Myth and the Origin of Leadership in Central Africa." In *African Iron Working*, ed. Randi Haaland and Peter Shinnie. Oslo: Norwegian University Press.

Dick-Read, Grantly. 1955. *No Time for Fear*. New York: Harper Brothers.

Dinesen, Isak [Karen Blixen]. 1937/1966. *Out of Africa*. London: Jonathan Cape.

Douglas, Mary. 1966. *Purity and Danger*. New York: Praeger.

Drewal, Henry, and Margaret Thompson Drewal. 1983. *Gelede: Art and Female Power among the Yoruba.* Bloomington: Indiana University Press.

Drewal, Margaret Thompson. 1992. *Yoruba Ritual: Performers, Play, Agency.* Bloomington: Indiana University Press.

Dumont, Louis. 1970. *Homo Hierarchicus: The Caste System and Its Implications.* London: Weidenfeld & Nicolson.

Duncan, Carol. 1995. *Civilizing Rituals: Inside Public Art Museums.* London: Routledge.

Einstein, Carl. 1915. *Negerplastik.* Leipzig: Verlag der Weissen Bücher.

Eliade, Mircea. 1956/1978. *The Forge and the Crucible.* Trans. Stephen Corrin. Chicago: University of Chicago Press.

Eliot, Sir Charles. 1905. *The East Africa Protectorate.* London: E. Arnold.

Enwezor, Okwui. 2001. *The Short Century: Independence and Liberation Movements in Africa, 1945–1994.* New York: Prestel.

Erim, Erim O. 1977. "A Pre-Colonial History of the Idoma of Central Nigeria." Ph.D. diss., Dalhousie University, Canada.

———. 1981. *The Idoma Nationality, 1600–1900.* Enugu, Nigeria: Fourth Dimension Publishers.

Errington, Frederick, and Deborah Gewertz. 1989. "Tourism and Anthropology in a Post-Modern World." *Oceania* 60, no. 1: 37–54.

Errington, Shelly. 1998. *The Death of Authentic Primitive Art and Other Tales of Progress.* Berkeley: University of California Press.

Evans-Pritchard, E. E. 1940. *The Nuer.* Oxford: Clarendon Press.

———. 1956. *Nuer Religion.* Oxford: Clarendon Press.

Fabian, Johannes. 1978. "Popular Culture in Africa: Findings and Conjectures." *Africa* 48, no. 4: 315–334.

———. 1996. *Remembering the Present.* Berkeley: University of California Press.

Fagg, William. 1965. *Tribes and Forms in African Art.* New York: Tudor Publishing Co.

———. 1970. *African Sculpture.* Washington, D.C.: The International Exhibitions Foundation.

———, and John Pemberton III. 1982. *Yoruba Sculpture of West Africa.* New York: Alfred A. Knopf.

Farias, P. F. de Moraes, and Karin Barber, eds. 1990. *Self-Assertion and Brokerage.* Centre of West African Studies, University of Birmingham.

Fernandez, James. 1966. "Principles of Opposition and Vitality in Fang Aesthetics." *Journal of Aesthetics and Art Criticism* 25, no. 1: 53–64.

———. 1973. "The Exposition and Imposition of Order: Artistic Expression in Fang Culture." In *The Traditional Artist in African Societies,* ed. Warren D'Azevedo, 194–220. Bloomington: Indiana University Press.

———. 1991. "Embodiment and Disembodiment in Bwiti." In *Body and Space,* ed. Anita Jacobson-Widding. Uppsala: Almqvist & Wiksell International.

Fisher, Angela. 1984. *Africa Adorned.* New York: Abrams.

Fischer, Eberhard, and Hans Himmelheber. 1984. *The Arts of the Dan in West Africa*. Zurich: Museum Rietberg.

Foucault, Michel. 1984. *The Foucault Reader*. Ed. Paul Rabinow. New York: Pantheon.

Fraser, Douglas, ed. 1966. *The Many Faces of Primitive Art*. Englewood Cliffs, N.J.: Prentice Hall.

———. 1974. *African Art as Philosophy*, Exhibition catalog. New York: Interbook.

———, and Herbert M. Cole, eds. 1972. *African Art and Leadership*. Madison: University of Wisconsin Press.

Fratkin, Elliot. 1991. *Surviving Drought and Development: Ariaal Pastoralists of Northern Kenya*. Boulder, Colo.: Westview Press.

———. 1993. "Maa-Speakers of the Northern Desert: Recent Developments in Ariaal and Rendille Identity." In *Being Maasai*, ed. Thomas Spear and Richard Waller. London: James Currey.

Frobenius, Leo. 1898. *Masken und Geheimbünde Afrikas*. Halle: Kaiser Leopoldinisch-Carolinische Deutsche Akademie der Naturforscher.

———. 1913/1968. *The Voice of Africa; Being an Account of the Travels of the German Inner African Exploration Expedition in the Years 1910–1912*. Translation of *Und Afrika Sprach*. New York: B. Blom.

Galaty, John G. 1977. "In the Pastoral Image: The Dialectic of Maasai Identity." Ph.D. diss., University of Chicago.

———. 1979. "Pollution and Pastoral Antipraxis: The Issue of Maasai Inequality." *American Ethnologist* 6: 803–816.

———. 1982. "Being 'Maasai': Being 'People-of-Cattle': Ethnic Shifters in East Africa." *American Ethnologist* 9: 1–20.

———. 1993a. "Maasai Expansion and the New East African Pastoralism." In *Being Maasai: Ethnicity and Identity in East Africa*, ed. Thomas Spear and Richard Waller, 61–86. London: James Currey Ltd. and Athens: Ohio University Press.

———. 1993b. "'The Eye That Wants a Person, Where Can It Not See?': Inclusion, Exclusion and Boundary Shifters in Maasai Identity." In Spear and Waller, *Being Maasai*, 174–194.

Ganguly, Debjan. 2005. *Caste, Colonialism and Counter-Modernity*. London: Routledge.

Gavaghan, Terence. 1999. *Of Lions and Dung Beetles*. Devon: Arthur H. Stockwell Ltd.

Geary, Christraud. 1981. "The Idiom of War in the Bamum Court Arts." Working Paper 51. Boston: African Studies Center, Boston University.

Geertz, Clifford. 1973. *The Interpretation of Cultures*. London: Hutchison & Co Ltd.

Gerbrands, Adrian. 1957/1971. *Art as an Element of Culture, Especially in Negro Africa*. Leiden: E. J. Brill.

Gewertz, Deborah, and Frederick Errington. 1991. *Twisted Histories, Altered Contexts: Representing the Chambri in a World System*. Cambridge: Cambridge University Press.

Griaule, Marcel. 1938. *Les Masques Dogon*. Paris: Institut d'Ethnologie.

——, and Germaine Dieterlen. 1965. *Le Renard Pâle*. Vol. 1. Paris: Institut d'Ethnlogie.

Hallen, Barry. 2000. *The Good, the Bad, and the Beautiful*. Bloomington: Indiana University Press.

Hammond, Dorothy, and Alta Jablow. 1970/1992. *The Africa That Never Was*. Prospect Heights, Ill.: Waveland Press. 1992.

——. 1977. *The Myth of Africa*. New York: Library of Social Science.

Hanley, Gerald. 1971. *Warriors and Strangers*. London: Hamish Hamilton.

Hardin, Kris L. 1993. *The Aesthetics of Action*. Washington, D.C.: Smithsonian Institution Press.

Haskell, Francis. 1981. *Taste and the Antique: The Lure of Classical Sculpture, 1500–1900*. Ed. Francis Haskell and Nicholas Penny. New Haven, Conn.: Yale University Press.

——. 1987. *Past and Present in Art and Taste: Selected Essays*. New Haven, Conn.: Yale University Press.

——. 2000. *The Ephemeral Museum: Old Master Paintings and the Rise of the Art Exhibition*. New Haven, Conn.: Yale University Press.

Hassan, Salah M. 1995. "The Modernist Experience in African Art: Visual Expressions of the Self and Cross-Cultural Aesthetics." *Nka: Journal of Contemporary African Art* 2: 30–33, 72.

——, and Olu Oguibe. 2001. *Authentic, Ex-Centric: Conceptualism in Contemporary African Art*. Exhibition catalog. Ithaca, N.Y.: Forum for African Arts.

Herbert, Eugenia W. 1993. *Iron, Gender and Power*. Bloomington: Indiana University Press.

Herskovits, Melville. 1938. *Dahomey: An Ancient West African Kingdom*. New York: J. J. Augustin.

——. 1958. *The Myth of the Negro Past*. Boston: Beacon Press.

Herwitz, Daniel. 1993. *Making Theory, Constructing Art: On the Authority of the Avant-Garde*. Chicago: University of Chicago Press.

Hinde, Sidney Langford, and Hildegarde Hinde. 1901. *The Last of the Masai*. London: Heinemann.

Hjort, Anders. 1979. *Savanna Town: Rural Ties and Urban Opportunities in Northern Kenya*. Stockholm: Stockholm Studies in Social Anthropology.

——. 1981. "Ethnic Transformation, Dependency and Change: The Iligira Samburu of Northern Kenya." In *Change and Development in Nomadic and Pastoral Societies*, ed. John G. Galaty and Philip Carl Salzman. Leiden: E. J. Brill.

Hobsbawm, Eric, and Terence Ranger, eds. 1984. *The Invention of Tradition*. Cambridge: Cambridge University Press.

Hodder, Ian. 1982. *Symbols in Action*. Cambridge: Cambridge University Press.

Hoffman, Rachel. 1995. "Objects and Acts." *African Arts* 28, no. 3: 56–59, 91.

Höhnel, Ludwig von. 1894. *Discovery of Lakes Rudolf and Stefanie*. 2 vols. Trans. Nancy Bell. London: Longmans, Green and Co.

BIBLIOGRAPHY

Hollis, A. C. 1905. *The Masai: Their Language and Folklore.* Oxford: Clarendon Press.

Horton, Robin. 1960. *The Gods as Guests: An Aspect of Kalabari Religious Life.* Lagos: Nigeria Magazine.

———. 1965. *Kalabari Sculpture.* Lagos, Nigeria: Department of Antiquities.

Houlberg, Marilyn. 1979. "Social Hair." In *The Fabrics of Culture,* ed. Justine Cordwell and Ronald Schwarz. The Hague: Mouton.

Huxley, Elspeth. 1948/1975. *The Sorcerer's Apprentice: A Journey through East Africa.* Westport, Conn.: Greenwood Press.

Huyssen, Andreas. 2001. "Present Pasts: Media, Politics, Amnesia." In *Globalization,* ed. Arjun Appadurai, 57–78. Durham, N.C.: Duke University Press.

Jacobson-Widding, Anita. 1979. *Red-White-Black as a Mode of Thought.* Uppsala: [Uppsala University].

Jeal, Tim. 1973. *Livingstone.* London: Heinemann.

Jedrej, M. C. 1980. "Structural Aspects of a West African Secret Society." In *Ethnologische Zeitschrift Zürich,* 1:133–142. Zürich: Völkerkundemuseum der Universität Zürich.

Jell-Bahlsen, Sabine. 1993. "Dada-Rasta Hair: The Hidden Messages of Mammy Water in Nigeria." Paper presented to the conference Body Images, Language and Physical Boundaries, Amsterdam.

Jewsiewicki, Bogumil. 1991. "Painting in Zaïre: From the Invention of the West to the Representation of the Social Self." In Susan Vogel, *Africa Explores: 20th Century African Art,* 130–151. Exhibition catalog. New York: Center for African Art and Prestel Verlag.

Johnston, H. H. 1897. *The River Congo from Its Mouth to Bolobo.* London: Sampson Low, Marston, Searle and Rivington.

Jules-Rosette, Bennetta. 1979. "Rethinking the Popular Arts in Africa: Problems of Interpretation." *African Studies Review* 30, no. 3: 91–97.

———. 1984. *The Messages of Tourist Art.* New York: Plenum Press.

———. 1986. "Aesthetics and Market Demand: The Structure of the Tourist Art Market in Three African Settings." *African Studies Review* 29, no. 1: 41–59.

Kamanju, J., M. Singo, and F. Wairagu. 2003. *Terrorized Citizens: Profiling Small Arms and Insecurity in the North Rift Region of Kenya.* Nairobi: Security Research and Information Center.

Karp, Ivan, and Steven D. Lavine, eds. 1991. *Exhibiting Cultures: The Poetics and Politics of Museum Display.* Washington, D.C.: Smithsonian Institution Press.

Karp, Ivan, Christine Mullen Kreamer, and Steven D. Lavine. 1992. *Museums and Communities: The Politics of Public Culture.* Washington, D.C.: Smithsonian Institution Press.

Kasfir, Sidney Littlefield. 1979. "The Visual Arts of the Idoma of Central Nigeria." 2 vols. Ph.D. thesis, University of London.

———. 1974–1978, 1986, 1989. Field notes, Idoma, Nigeria.

———. 1980. "Patronage and Maconde Carvers." *African Arts* 13, no. 3: 67–70, 91.

———. 1981. Afo and Afo-Related Entries. In *For Spirits and Kings: African Art from the Paul and Ruth Tishman Collection*, ed. Susan Mullin Vogel and Jerry L. Thompson, 152–153, 163–164. Exhibition catalog. New York: Metropolitan Museum of Art. .

———. 1984a. "Masks from the Towns of the Dead: The Igbo-Idoma Borderland." In *Igbo Arts: Community and Cosmos*, by Herbert M. Cole and Chike Aniakor. Los Angeles: Fowler Museum of Cultural History.

———. 1984b. "One Tribe, One Style? Paradigms in the Historiography of African Art." *History in Africa* 11: 63–93.

———. 1985. "Art in History, History in Art: The Idoma Alekwuafia Masquerade as Historical Evidence." Working Papers no. 103. Boston: African Studies Center, Boston University.

———. 1986. "The Mask of Aja." *African Arts* 19, no. 2: 83–84.

———. 1987. "Apprentices and Entrepreneurs: The Workshop and Style Uniformity in Sub-Saharan Africa." In *Iowa Studies in African Art*, ed. Christopher D. Roy, vol. 2. Iowa City: University of Iowa.

———. 1987–2006. Field notes, Samburu District, Kenya.

———. 1988. "Celebrating Male Aggression: The Idoma Oglinye Masquerade." In *West African Masks and Cultural Systems*, ed. Sidney L. Kasfir. Tervuren: Musee Royal de l'Afrique Centrale.

———. 1989. "Remembering Ojiji." *African Arts* 22, no. 4: 44–51, 86–87.

———. 1992a. "Ivory from Zariba Country to the Land of Zinj." In *Elephant: The Animal and Its Ivory in African Art*, ed. Doran H. Ross. Los Angeles: Fowler Museum of Cultural History, UCLA.

———. 1992b. "African Art and Authenticity: A Text with a Shadow." *African Arts* 25, no. 2: 41–53, 96–97 and 25, no. 4: 28–30, 100–103.

———. 1995. "Affect, Efficacy and the Reception of Objects." *African Arts* 28, no. 3: 14–16.

———. 1996. "African Art in a Suitcase: How Value Travels." *Transition* 69: 146–158.

———. 1997. "La basse vallée de la Bénoué: Idoma, Tiv et Afo." In *Arts du Nigeria: collection du museé des Arts d'Afrique et d'Océanie*, ed. Jean-Hubert Martin. Paris: Réunion des Musée Nationaux.

———. 1999a. *Contemporary African Art*. London: Thames and Hudson.

———. 1999b. "Samburu Souvenirs." In *Unpacking Culture: Art and Commodity in Colonial and Postcolonial Worlds*, ed. Ruth B. Phillips and Christopher Steiner, 67–83. Berkeley: University of California Press,

——— 2000. "Artists' Reputations: Negotiating Power through Distance and Ambiguity." *African Arts* 33, no. 1: 70–77, 96.

———. 2002a. "Jenseits von Schattenwürfen und Spiegelungen: Das Verständnis von Lokalität in einem globalisierten Kunstdiskurs" (Beyond Shadows and Mirrors: Understanding Locality in a Globalized Art Discourse). In *Ethnologie der Globalisierung: Perspektiven kultureller Verflechtungen*, ed. B. Hauser-Schäublin and D. Braukämper, 47–62. Berlin: Reimer Verlag.

——. 2002b. "Slam-Dunking and the Last Noble Savage." *Visual Anthropology* 15, no. 3: 369–386.

——. 2003. "Thinking about Artworlds in a Global Flow: Some Major Disparities in Dealing with Visual Culture." *International Journal of Anthropology* 18, no. 4: 211–218.

——. 2004. "Tourist Aesthetics in the Global Flow: Orientalism and Warrior Theatre at the Swahili Coast." *Visual Anthropology* 17, nos. 3/4: 319–343.

Kennedy, Duncan. 1993. *Sexy Dressing, Etc.: Essays on the Power and Politics of Cultural Identity.* Cambridge, Mass.: Harvard University Press.

Kituyi, Mukhisa. 1990. *Becoming Kenyans: Socio-Economic Transformation of the Pastoral Maasai.* Nairobi: ACTS [African Centre for Technology Studies] Press.

Klumpp, Donna, and Corinne Kratz. 1993. "Aesthetics, Expertise and Ethnicity: Okiek and Maasai Perspectives on Personal Ornament." In *Being Maasai,* ed. Thomas Spear and Richard Waller. London: James Currey.

Knight, Chris. 1991. *Blood Relations: Menstruation and the Origins of Culture.* New Haven, Conn.: Yale University Press.

Knops, B. 1959. "L'artisan Sénoufo dans son Cadre Ouest-Africain." *Bulletin de la Societé Royale Belge d'Anthropologie et de Préhistoire* 70: 83–111.

Knowles, Joan N., and D. P. Collett. 1989. "Nature as Myth, Symbol and Action: Notes toward a Historical Understanding of Development and Conservation in Kenyan Maasailand." *Africa* 59, no. 4: 433–460.

Kopytoff, Igor. 1986. "The Cultural Biography of Things: Commoditization as Process." In *The Social Life of Things,* ed. Arjun Appadurai. Cambridge: Cambridge University Press.

Krapf, Ludwig [J. Lewis]. 1860. *Travels, Researches and Missionary Labours During an Eighteen Year's Residence in Eastern Africa.* Boston: Ticknor and Fields.

Kratz, Corinne A. 1981. "Are the Okiek Really Maasai? Or Kipsigis? Or Kikuyu?" *Cahiers d'Etudes Africaines* 79: 355–368.

——. 1986. "Ethnic Interaction, Economic Diversification, and Language Use." *Sprache und Geschichte in Afrika* 7, no. 2: 189–226.

——. 1994. *Affecting Performance.* Washington: Smithsonian Institution Press.

Kriger, Colleen E. 1999. *Pride of Men: Ironworking in 19th Century West Central Africa.* Portsmouth, N.H.: Heinemann.

Kubler, George. 1962. *The Shape of Time: Remarks on the History of Things.* New Haven, Conn.: Yale University Press.

Kuhn, Thomas. 1970. *The Structure of Scientific Revolutions.* 2nd ed. Chicago: University of Chicago Press.

Lamphear, John. 1993. "Aspects of 'Becoming Turkana': Interactions and Assimilation between Maa- and Ateker-Speakers." In *Being Maasai,* ed. Thomas Spear and Richard Waller. London: James Currey.

Langer, Susanne. 1957. *Philosophy in a New Key: A Study in the Symbolism of Reason, Rite, and Art.* 3rd ed. Cambridge: Harvard University Press.

Larick, Roy. 1984. "Sedentary Makers and Nomadic Owners: The Circulation of Steel Weapons in Samburu District, Kenya. Part I: Weapons, Past and Present." Seminar paper no. 163. Nairobi: Institute of African Studies, University of Nairobi.

———. 1985. "Spears, Style, and Time among Maa-Speaking Pastoralists." *Journal of Anthropological Archaeology* 4: 206–220.

———. 1986a. "Age Grading and Ethnicity in the Style of (Loikop) Samburu Spears." *World Archaeology* 18, no. 2: 269–283.

———. 1986b. "Iron Smelting and Interethnic Conflict among Precolonial Maa-Speaking Pastoralists of North-Central Kenya." *The African Archaeological Review* 4: 165–176.

———. 1987. "The Circulation of Spears among Loikop Cattle Pastoralists of Samburu District, Kenya." *Research in Economic Anthropology* 9: 143–166.

Lawal, Babatunde. 1974. "Some Aspects of Yoruba Aesthetics." *British Journal of Aesthetics* 143, no. 3: 239–249.

———. 1996. *The Gelede Spectacle: Art, Gender and Social Harmony in an African Culture.* Seattle: University of Washington Press.

Leach, Edmund. 1958. "Magical Hair." *Journal of the Royal Anthropological Institute* 88, no. 2: 147–164.

———. 1965. "The Nature of War." *Disarmament and Arms Control* 3, no. 2: 165–183.

Liep, John. 2001. "Introduction." In *Locating Cultural Creativity,* ed. John Liep, 1–13. London: Pluto Press.

Lincoln, Bruce. 1989. *Discourse and the Construction of Society: Comparative Studies of Myth, Ritual, and Classification.* New York: Oxford University Press.

Llewelyn-Davies, Melissa. 1981. "Women, Warriors and Patriarchs." In *Sexual Meanings,* ed. Sherry Ortner and Harriet Whitehead. Cambridge: Cambridge University Press.

Lock, Margaret. 1993. "Cultivating the Body: Anthropology and Epistemologies of Bodily Practice and Knowledge." *Annual Reviews of Anthropology* 22: 133–155.

Lonsdale, John. 1992. "The Conquest State of Kenya, 1895–1905." In *Unhappy Valley: Conflict in Kenya & Africa,* ed. Bruce Berman and John Lonsdale. London: James Currey.

Lugard, Sir Frederick. 1919/1968. "Report on the Amalgamation of Northern and Southern Nigeria." In *Lugard and the Amalgamation of Nigeria,* ed. A. H. M. Kirk-Greene. Frank Cass & Co. Ltd.

Lutz, Catherine A., and Jane L. Collins. 1993. *Reading National Geographic.* Chicago: University of Chicago Press.

MacCannell, Dean. 1976. *The Tourist: A New Theory of the Leisure Class.* New York: Schocken Books.

MacGaffey, Wyatt. 1993. *Astonishment and Power.* Washington, D.C.: National Museum of African Art, Smithsonian Institution.

Mafeje, Archie. 1998. *Kingdoms of the Great Lakes Region: Ethnography of African Social Formations.* Kampala: Fountain Publishers.

Magid, Alvin. 1976. *Men in the Middle: Leadership and Role Conflict in a Nigerian Society.* New York: Africana Publishing Co.

Maquet, Jacques. 1970. "Rwanda Castes." In *Social Stratification in Africa,* ed. Arthur Tuden and Leon Plotnicov. New York: Free Press.

——. 1986. *The Aesthetic Experience: An Anthropologist Looks at the Visual Arts.* New Haven, Conn.: Yale University Press.

Margarido, Alfredo, and Francoise Germaix Wasserman. 1972. "On the Myth and Practice of the Blacksmith in Africa." Trans. Simon Pleasance. *Diogenes* 78: 87–122.

Masolo, Dismas. 1994. "Outside Boundaries, Internal Lines: 'Kwer' as an Aesthetic Inscription on Social and Material Reality." Seminar paper, African Studies Program, Northwestern University.

Mbembe, Achille. 2000. "At the Edge of the World: Boundaries, Territoriality and Sovereignty in Africa." *Public Culture* 12, no. 1: 259–284.

McCarty-Cooper, William A., and Dorothy M. Kosinski. 1992. "A Rare Idoma Female Figure." In *Important Tribal Art and Antiquities from the Collection of William A. McCarty-Cooper,* 127. Auction catalog. New York: Christie's.

McLynn, Frank. 1992. *Hearts of Darkness: The European Exploration of Africa.* London: Hutchison.

McNaughton, Patrick. 1988. *The Mande Blacksmiths.* Bloomington: Indiana University Press.

Merker, Moritz. 1910. *Die Masai: Ethnographische Monographie eines ostafrikanischen Semitenvolkes.* Berlin: D. Reimer.

Meek, C. K. 1925. *The Northern Tribes of Nigeria.* 2 vols. London: Oxford University Press.

——. 1931. *A Sudanese Kingdom.* London: Kegan Paul, Trench, Trubner & Co., Ltd.

Mohanty, Manoranjan, ed. 2004. *Class, Caste, and Gender.* Thousand Oaks, Calif.: Sage Publications.

Morphy, Howard. 1995. "Aboriginal Art in a Global Context." In *Worlds Apart: Modernity through the Prism of the Local,* ed. Daniel Miller. London and New York: Routledge.

Murdock, George Peter. 1959. *Africa: Its People and Their Culture History.* New York: McGraw-Hill.

Napier, David A. 1986. *Masks, Transformation and Paradox.* Berkeley: University of California Press.

Nevadomsky, Joseph. 2005. "Casting in Contemporary Benin Art." *African Arts* 38, no. 2: 66–77, 95–96.

Nicholls, Robert. 1984. "Igede Funeral Masquerades." *African Arts* 17, no. 3: 70–76, 92.

Nicklin, Keith. 1974. "Nigerian Skin-Covered Masks." *African Arts* 7, no. 3: 8–15, 67–68.

——. 1977. "European Replicas of Traditional African Art Objects in Their Cultural Contexts." *Baessler-Archiv* NF, Band XXV.

——. 1979. "Skin-Covered Masks of Cameroon." *African Arts* 12, no. 2: 54–59.

——, and Jill Salmons. 1984. "Cross River Art Styles." *African Arts* 18, no. 1: 28–43, 93–94.

Noever, Peter, ed. 2001. *The Discursive Museum*. Ostfildern-Ruit, Germany: Hatje Cantz.

Nunley, John. 1987. *Moving with the Face of the Devil*. Chicago: University of Illinois Press.

Obeyesekere, Gananath. 1991. *Medusa's Hair*. Chicago: University of Chicago Press.

Odhiambo, Atieno. 1973. "'The Song of the Vultures': Concepts of Kenya Nationalism Revisited." In *The Paradox of Collaboration and Other Essays*. Nairobi: East African Literature Bureau.

Ogbechie, Sylvester Okwunodu. Forthcoming. *Ben Enwonwu: The Making of An African Modernist*. Rochester, N.Y.: University of Rochester Press.

Oguibe, Olu. 1996. "Photography and the Substance of the Image." In Okwui Enwezor, Olu Oguibe, and Octavio Zaya, *In/sight: African Photographers, 1940 to the Present*, 231–250. Exhibition catalog. New York: Solomon R. Guggenheim Museum.

Okeke, Chika. 1995. "The Quest: From Zaria to Nsukka." In *Seven Stories about Modern Art in Africa*, ed. Clementine Deliss, 38–75. London: Flammarion.

Okoye, Ikem. 1996. "Tribe and Art History." *Art Bulletin* 68, no. 4:610–615.

Ottenberg, Simon. 1975. *Masked Rituals of Afikpo*. Seattle: University of Washington Press.

——. 2006. *Igbo Art and Culture, and Other Essays*. Ed. Toyin Falola. Trenton, N.J.: Africa World Press.

Palmer, H. R. 1928/1967. *Sudanese Memoirs*. London: Frank Cass & Co. Ltd.

Papastergiadis, Nikos. 2000. *The Turbulence of Migration: Globalization, Deterritorialization and Hybridity*. Cambridge, England: Polity Press.

Partridge, Charles. 1905. *Cross River Natives*. London: Hutchison and Co.

Pavitt, Nigel. 1991. *Samburu*. London: Kyle Cathie Ltd.

Pemberton, John. 1987. "The Yoruba Carvers of Ila-Orangun." In *Iowa Studies in African Art*, Vol. 2, ed. Christopher D. Roy. Iowa City: University of Iowa. 1987.

Perani, Judith, and Norma Wolff. 1999. *Cloth, Dress and Art Patronage in Africa*. Oxford: Berg.

Pernet, Henry. 1992. *Ritual Masks: Deceptions and Revelations*. Trans. Laura Grillo. Columbia: University of South Carolina Press.

Phillips, Ruth B., and Christopher B. Steiner, eds. 1999. *Unpacking Culture: Art and Commodity in Colonial and Post-Colonial Worlds*. Berkeley: University of California Press.

Picton, John. 1974. "Masks and the Igbirra." *African Arts* 7, no. 2 (Winter): 38–41.

——. 1993/1999. "In Vogue, or the Flavour of the Month: The New Way to Wear Black." In *Reading the Contemporary: African Art from Theory to the*

Marketplace, ed. Olu Oguibe and Okwui Enwezor. London: Institute of International Visual Arts.

Pred, Allan, and Michael John Watts. 1992. *Reworking Modernity: Capitalisms and Symbolic Discontent.* New Brunswick: Rutgers University Press.

Price, Sally. 1989. *Primitive Art in Civilized Places.* Chicago: University of Chicago Press.

Rainy, Michael. 1989. "Samburu Ritual Symbolism: An Adaptive Interpretation of Pastoralist Traditions." *Social Science Information* 28, no. 4: 785–819.

Rasmussen, Susan. 1992. "Ritual Specialists, Ambiguity, and Power in Tuareg Society." *Journal of the Royal Anthropological Institute* 27, no. 1: 105–128.

——. 1987. "Window or Mirror? Notions of 'Other' in Images of Social and Physical Distance, Concealment, and Marginality among the Kel Ewey Tuareg." Paper presented to the African Studies Association.

Ricciardi, Mirella. 1977. *Vanishing Africa.* New York: Holt, Rinehart and Winston.

Richter, Dolores. 1980a. "Further Considerations of Caste in West Africa." *Africa* 50, no. 1: 37–54.

——. 1980b. *Art, Economics and Change: A Study of the Kulebele of the Northern Ivory Coast.* La Jolla, Calif.: Psych/Graphic Publishers.

Ricoeur, Paul. 1971. "The Model of the Text: Meaningful Action Considered as Text." *Social Research* 38: 529–562.

Ross, Doran, and Agbenyega Adedze. 1998. *Wrapped in Pride: Ghanaian Kente and African American Identity.* Los Angeles: UCLA Fowler Museum of Cultural History.

Ross, Doran H., and Raphael X. Reichert. 1983. "Modern Antiquities: A Study of a Kumase Workshop." In *Akan Transformations,* ed. Doran H. Ross and Timothy F. Garrard. Los Angeles: UCLA Museum of Cultural History.

Roth, H. Ling. 1903. *Great Benin: Its Customs, Art and Horrors.* Halifax, Eng.: F. King & Sons Ltd.

Routledge, W. Scoresby, and Katherine Routledge. 1910/1968. *With a Prehistoric People: The Akikuyu of British East Africa.* London: Frank Cass.

Rowlands, Michael, and Jean-Paul Warnier. 1988. "The Magical Production of Iron in the Cameroon Grassfields." Paper presented to the conference African Material Culture, Bellagio, Italy, May 19–28.

Sadler, M. E. 1935. *Arts of West Africa.* London: Oxford University Press.

Saitoti, Tepilit Ole, and Carol Beckwith. 1980. *Maasai.* New York: Abrams.

Salmons, Jill. 1985. "Martial Arts of the Annang." *African Arts* 19, no. 1: 57–63, 87.

Sassen, Saskia. 2001. *The Global City: New York, London, Tokyo.* 2nd ed. Princeton, N.J.: Princeton University Press.

Schildkrout, Enid, and Curtis Keim. 1991. *African Reflections: Art from Northeastern Zaïre.* Seattle: University of Washington Press.

Schlehe, Judith. 2001a. "Income Opportunities in Tourist Contact Zones: Street Guides and Travellers." Paper presented at 3rd EUROSEAS Conference, London, September.

——. 2001b. "Street Guides und Beach Boys in Indonesien: Gigolos oder Kleinunternehmer?" *Beiträge zur feministischen Theorie und Praxis* 58: 127–137.

Schor, Naomi. 1992. "Cartes Postales: Representing Paris 1900." *Critical Inquiry* 18: 188–245.

Schwartz, Sabine. 1980. *Wenn Laeduma Träumt.* Dusseldorf: Econ Verlag.

Scott, David. 1999. *Refashioning Futures: Criticism after Postcoloniality.* Princeton, N.J.: Princeton University Press.

Sieber, Roy. 1961a. "African Art and Culture History." In *Reconstructing African Culture History,* ed. Creighton Gabel and Norman R. Bennett. Boston: Boston University Press.

——. 1961b. *Sculpture of Northern Nigeria.* New York: Museum of Primitive Art.

——. 1966. "Masks as Agents of Social Control." In *The Many Faces of Primitive Art,* ed. Douglas Fraser. Englewood Cliffs, N.J.: Prentice Hall.

——, and Arnold Rubin. 1968. *Sculpture of Black Africa: The Paul Tishman Collection.* Los Angeles: Los Angeles County Museum of Art.

Silverman, Eric Kline. 1990. "Clifford Geertz: Towards a More 'Thick' Understanding?" In *Reading Material Culture,* ed. Christopher Tilley. Oxford: Basil Blackwell.

——. 1999. "Tourist Art as the Crafting of Identity in the Sepik River (Papua New Guinea)." In *Unpacking Culture: Art and Commodity in Colonial and Postcolonial Worlds,* ed. Ruth B. Phillips and Christopher B. Steiner. Berkeley: University of California Press.

Smith, John. 1968. *Colonial Cadet in Nigeria.* Durham, N.C.: Duke University Press.

Smith, M. G. 1978. *The Affairs of Daura.* Berkeley: University of California Press.

Sobania, Neal. 1991. "Feasts, Famines and Friends: Nineteenth Century Exchange and Ethnicity in the Eastern Lake Turkana Region." In *Herders, Warriors, and Traders: Pastoralism in Africa,* ed. John G. Galaty and Pierre Bonte. Boulder, Colo.: Westview Press.

——. 1993. "Defeat and Dispersal: The Laikipiak and Their Neighbours at the End of the Nineteenth Century." In *Being Maasai: Ethnicity and Identity in East Africa,* ed. Thomas Spear and Richard Waller, 105–119. London: James Currey Ltd.; Athens: Ohio University Press.

Soja, Edward W. 1989. *Postmodern Geographies: The Reassertion of Space in Critical Social Theory.* London, New York: Verso.

Sommer, Gabrielle, and Rainer Vossen. 1993. "Dialects, Sectiolects, or Simply Lects? The Maa Language in Time Perspective." In *Being Maasai: Ethnicity and Identity in East Africa,* ed. Thomas Spear and Richard Waller, 25–37. London: James Currey Ltd.; Athens: Ohio University Press.

Sorrenson, M. P. K. 1968. *European Settlement in Kenya.* Nairobi: Oxford University Press.

Spear, Thomas. 1993."Introduction." In *Being Maasai: Ethnicity and Identity in East Africa,* ed. Thomas Spear and Richard Waller, 1–18. London: James Currey Ltd.; Athens: Ohio University Press.

Spencer, Paul. 1965. *The Samburu.* London: Routledge and Kegan Paul.

——. 1973. *Nomads in Alliance.* London: Oxford University Press.

——. 1985. "Dance as Antithesis in the Samburu Discourse." *Society and the Dance: The Social Anthropology of Process and Performance,* ed. Paul Spencer, 140–164. Cambridge: Cambridge University Press.

——. 1993. "Becoming Maasai, Being in Time." In *Being Maasai: Ethnicity and Identity in East Africa,* ed. Thomas Spear and Richard Waller, 140–156. London: James Currey Ltd.; Athens: Ohio University Press.

Sperling, Louise. 1987. "Labour Organization of Samburu Pastoralism." Ph.D. diss., McGill University.

Spooner, Brian. 1986. "Weavers and Dealers: The Authenticity of an Oriental Carpet." In *The Social Life of Things: Commodities in Cultural Perspective,* ed. Arjun Appadurai, 195–235. Cambridge: Cambridge University Press.

Steiner, Christopher. 1994. *African Art in Transit.* Cambridge: Cambridge University Press.

Stewart, Susan. 1984. *On Longing: Narratives of the Miniature, the Gigantic, the Souvenir, the Collection.* Baltimore, Md.: Johns Hopkins University Press.

Stigand, C. H. 1910. *To Abyssinia through an Unknown Land.* London: Seeley & Co. Limited.

Strother, Z. S. 1998. *Inventing Masks.* Chicago: University of Chicago Press.

——. 1999. "Gabama a Gingungu and the Secret History of Twentieth-Century Art." *African Arts* 32, no. 1: 18–31, 92–93.

Szombati-Fabian, Ilona, and Johannes Fabian. 1976. "Art, History and Society: Popular Art in Shaba, Zaire." *Studies in the Anthropology of Visual Communication* 3, no. 1: 1–22.

Talbot, P. Amaury. 1926. *Peoples of Southern Nigeria.* 4 vols. London: Oxford University Press.

Taub, Emily. 2002. "Thought for Sale: The State of the 1960s Art Market System." Seminar paper, Emory University, 13 December.

Taussig, Michael. 1993. *Mimesis and Alterity.* New York: Routledge.

Temple, O., and C. L. Temple. 1922. *Notes on the Tribes, Provinces, Emirates and States of the Northern Provinces of Nigeria.* Lagos: C. M. S. Bookshop.

Thompson, Robert Farris. 1971/1976. *Black Gods and Kings: Yoruba Art at UCLA.* Exhibition catalog. Los Angeles: University of California, Museum and Laboratories of Ethnic Arts and Technology; rep. Bloomington: Indiana University Press.

——. 1973. "Yoruba Artistic Criticism." In *The Traditional Artist in African Societies,* ed. Warren D'Azevedo. Bloomington: Indiana University Press.

——. 1974. *African Art in Motion.* Exhibition catalog. Berkeley: University of California Press.

——. 1981. Catalog entry no. 104. In *For Spirits and Kings: African Art from the Tishman Collection,* ed. Susan Vogel. Exhibition catalog. New York: Metropolitan Museum of Art.

Thomson, A. A., and Dorothy Middleton. 1959. *Lugard in Africa.* London: Robert Hale Limited.

BIBLIOGRAPHY

Thomson, Joseph. 1887. *Through Masai Land*. London: Sampson Low, Marston, Searle and Rivington.

Tilley, Christopher. 1990. "Michel Foucault: Towards an Archaeology of Archaeology." In *Reading Material Culture: Structuralism, Hermeneutics and Post-Structuralism*, 281–347. Oxford: Basil Blackwell.

Todorov, Tzvetan. 1984. *The Conquest of America: The Question of the Other*. Trans. Jonathan Friedman. New York: Harper & Row.

Tremearne, A. J. N. 1912. *The Tailed Head-Hunters of Nigeria*. 2nd. ed. London: Seeley, Service & Co. Ltd.

Turner, Victor. 1962. *Chihamba, the White Spirit: A Ritual Drama of the Ndembu*. Manchester: Manchester University Press for the Rhodes-Livingstone Institute.

——. 1967. *Forest of Symbols: Aspects of Ndembu Ritual*. Ithaca, N.Y.: Cornell University Press.

Tylecote, R. F. 1975. "Iron Smelting at Taruga, Nigeria." *Historical Metallurgy* 9, no. 2: 49–56.

Vansina, Jan. 1964. "The Use of Process-Models in African History." In *The Historian in Tropical Africa*, ed. J. Vansina, R. Mauny, and L. V. Thomas. London: Oxford University Press.

——. 1969. "Anthropologists and the Third Dimension." *Africa* 39, no. 1: 62–67.

——. 1972. "Ndop: Royal Statues among the Kuba." In *African Art and Leadership*, ed. Douglas Fraser and Herbert M. Cole. Madison: University of Wisconsin Press.

——. 1978. *The Children of Woot*. Madison: University of Wisconsin Press.

Vaughan, James H. Jr. 1970. "Caste Systems in the Western Sudan." In *Social Stratification in Africa*, ed. Arthur Tuden and Leonard Plotnicov. New York: Free Press.

Vogel, Susan. 1991. "Extinct Art: Inspiration and Burden." In Susan Vogel, *Africa Explores: 20th Century African Art*, 230–239. Exhibition catalog. New York: Center for African Art and Prestel Verlag., 230–239.

——. 1999. "Known Artists but Anonymous Works: Fieldwork and Art History." *African Arts* 32, no. 1: 40–55, 93–94.

Walker, Roslyn Adele. 1994. "Anonymous Has a Name: Olowe of Ise." In *The Yoruba Artist: New Theoretical Perspectives on African Arts*, ed. Rowland Abiodun, Henry J. Drewal, and John Pemberton III. Washington, D.C.: Smithsonian Institution Press.

——. 1998. *Olówè of Isè: A Yoruba Sculptor to Kings*. Exhibition catalog. Washington, D.C.: National Museum of African Art, Smithsonian Institution.

Waller, Richard. 1993a. "Acceptees and Aliens: Kikuyu Settlement in Maasailand." *In Being Maasai: Ethnicity and Identity in East Africa*, ed. Thomas Spear and Richard Waller, 226–257. London: James Currey Ltd.; Athens: Ohio University Press.

——. 1993b. "Conclusions." In *Being Maasai: Ethnicity and Identity in East Africa*, ed. Thomas Spear and Richard Waller, 290–302. London: James Currey Ltd.; Athens: Ohio University Press.

Wallerstein, Immanuel. 1974. *The Modern World System*. 2 vols. New York: Academic Press.

Wellby, Capt. M. S. 1901. *'Twixt Sirdar and Menelik: An Account of a Year's Expedition from Zeila to Cairo through Unknown Abyssinia*. London: Harper & Brothers.

Were, Gideon. 1986. *Samburu District Profile*. Nairobi: Government Printer.

Weule, Karl. 1909. *Native Life in East Africa*. Trans. Alice Werner. London: Sir I. Pitman & Sons.

Willett, Frank. 1978. "An African Sculptor at Work [Lamidi Fakeye]." *African Arts* 11, no. 2: 28–32, 96.

Wilmsen, Edwin. 1994. "Pots and Power in the Pastoral Economy of Precolonial South Africa." Seminar paper, Institute for Advanced Study in the African Humanities, Northwestern University.

Wilson-Haffenden, J. R. 1930. *The Red Men of Nigeria*. London: Seeley, Service & Co. Ltd.

Wreschner, Ernst E. 1980. "Red Ochre and Human Evolution: A Case for Discussion." *Current Anthropology* 21, no. 5: 631–644.

INDEX

SIDNEY KASFIR is Professor in the Department of Art History at Emory University, where she is also Faculty Curator of African Art in the Michael C. Carlos Museum. She is author of *Contemporary African Art* and editor of *West African Masks and Cultural Systems*.